BLUEBEARD'S LEGACY

NEW ENCOUNTERS
Arts, Cultures, Concepts

Published

Conceptual Odysseys: Passages to Cultural Analysis
ed. Griselda Pollock, 2007

The Sacred and the Feminine: Imagination and Sexual Difference
ed. Griselda Pollock and Victoria Turvey Sauron, 2007

Bluebeard's Legacy: Death and Secrets from Bartók to Hitchcock
ed. Griselda Pollock and Victoria Anderson, 2009

Forthcoming

Digital and Other Virtualities: Renegotiating the Image
ed. Antony Bryant and Griselda Pollock

The Visual Politics of Psychoanalysis in a Post-Traumatic Era
ed. Griselda Pollock

New Encounters Monographs

Published

Helen Frankenthaler: Painting History, Writing Painting
Alison Rowley, 2007

Forthcoming

Eva Hesse: Longing, Belonging and Displacement
Vanessa Corby

Outfoxed: The Secret Life of a Fairy Tale
Victoria Anderson

Witnessing Abjection: Auschwitz and Afterimages
Nicholas Chare

BLUEBEARD'S LEGACY

Death and Secrets from Bartók to Hitchcock

EDITED BY

GRISELDA POLLOCK AND VICTORIA ANDERSON

UNIVERSITY OF ROCHESTER

Published in 2009 by I.B.Tauris & Co Ltd
6 Salem Road, London W2 4BU
175 Fifth Avenue, New York NY 10010
www.ibtauris.com

Distributed in the United States and Canada Exclusively by Palgrave Macmillan
175 Fifth Avenue, New York NY 10010

ISBN: 978 1 84511 632 3 (HB)
 978 1 84511 633 0 (PB)

A full CIP record for this book is available from the British Library
A full CIP record is available from the Library of Congress

Library of Congress Catalog Card Number: available

Printed and bound in Great Britain by CPI Antony Rowe, Chippenham, Wiltshire
from camera-ready copy edited and supplied by the editors

CONTENTS

ILLUSTRATIONS

Preface

0.1 Sir John Tomlinson as 'Duke Bluebeard' and Sally Burgess as 'Judith' in a concert performance of Belá Bartók's *Duke Bluebeard's Castle*, produced by Opera North, May–June 2005, directed by Richard Farnes. Photograph copyright Bill Cooper.

0.2 Still from *Judith of Bethulia* (D. W. Griffiths, 1914). Reproduced courtesy of the British Film Institute Stills Library, London.

0.3 Still from *Bluebeard* (Alice Anderson, 2007), 12 minutes, English, French subtitles, colour, 16/9, sound 5.1, Anna Leska Films, Paris-Brest Productions, HBOX. Courtesy Yvon Lambert Gallery, Paris.

Introduction

00.1 Gustave Doré, Illustration to 'Red Riding Hood' from *Les Contes de Perrault, dessins par Gustave Doré*, ed. J. Hetzel (Paris: J Hetzel, 1867). Dover Pictorial Archives Series.

Chapter 1

1.1 Still of Ingrid Bergman from *Notorious* (Alfred Hitchcock, 1946). Reproduced courtesy of the British Film Institute Stills Library, London.

1.2 Publicity Still for *Secret Beyond the Door* (Fritz Lang, 1948). Reproduced courtesy of the British Film Institute Stills Library, London.

Chapter 2

2.1 Gustave Doré, Drawing for 'La Barbe Bleue', from *Les Contes de Perrault, dessins par Gustave Doré, c.*1868, pen and wash on paper, Hermitage, St. Petersburg, Russia/The Bridgeman Art Library.

Chapter 3

Chapter 4

Chapter 5

Chapter 6

ACKNOWLEDGEMENTS

The research for this book was undertaken with the financial support of the Arts and Humanities Research Council and the University of Leeds whom we wish to thank here. We would also like to acknowledge the collaboration with Dominic Gray of Opera North with whom the series of studies on sexuality and music was initiated.

Permission to reproduce Elisabeth Bronfen 'The Enigma of Homecoming: *Secret beyond the Door*', first published in *Home in Hollywood: the Imaginary Geography of Cinema* (2004), was granted by Columbia University Press.

This book is dedicated with gratitude and love to James Andrews and Bronwen Andrews.

SERIES PREFACE

NEW ENCOUNTERS
Arts, Cultures, Concepts

Griselda Pollock

How do we think about visual art these days? What is happening to art history? Is visual culture taking its place? What is the status of cultural studies, in itself or in relation to its possible neighbours art, art history, visual studies? What is going on? What are the new directions? To what should we remain loyal?

New Encounters: Arts, Cultures, Concepts proposes some possible ways of thinking through these questions. Firstly, the series introduces and works with the concept of a *transdisciplinary initiative*. This is not a synonym for the interdisciplinary combination that has become de rigueur. It is related to a second concept: research as *encounter*. Together transdisciplinary and encounter mark the interaction between ways of thinking, doing and making in the arts and humanities that retain distinctive features associated with disciplinary practices and objects: art, history, culture, practice, and the new knowledge that is produced when these different ways of doing and thinking encounter one another across, and this is the third intervention, *concepts*, circulating between different intellectual or aesthetic cultures, inflecting them, finding common questions in distinctively articulated practices. The aim is to place these different practices in productive relation to one another mediated by the circulation of concepts.

We stand at several cross-roads at the moment in relation to the visual arts and cultures, historical, and contemporary, and to theories and methods of analysis. *Cultural Analysis, Theory and History* (CATH) is offered as one experiment in thinking about how to maintain the momentum of the momentous intellectual, cultural revolution in the arts and humanities that characterized the last quarter of the twentieth century while adjusting to the different field of analysis created by it.

In the 1970s–1990s, the necessity, or the intrusion, according to your position, was Theory: a mythic concept with a capital T that homogenized vastly different undertakings. Over those decades, research in the arts and humanities was undoubtedly reconfigured by the engagement with structuralist and poststructuralist theories of the sign, sociality, the text, the letter, the image, the subject, the postcolonial, and above all, difference. Old disciplines were deeply challenged and new interdisciplines—called studies—emerged to contest the academic field of knowledge production and include hitherto academically ignored constituencies. These changes were wrought through specific engagements with Marxist, feminist, deconstructionist, psychoanalytical, discourse and minority theory. Texts and authors were branded according to their theoretical engagements. Such mapping produced divisions between the proliferating theoretical models. (Could one be a Marxist, and feminist, and use psychoanalysis?) A deeper split, however, emerged between those who, in general, were theoretically oriented, and those who apparently did without theory: a position easily critiqued by the theoretically minded because being atheoretical is, of course, a theoretical position, just one that did not carry a novel identity associated with the intellectual shifts of the post-1968 university.

The impact of 'the theoretical turn' has been creative; it has radically reshaped work in the arts and humanities in terms of what is studied (content, topics, groups, questions) and also how it is studied (theories and methods). Yet some scholars currently argue that work done under such overt theoretical rubrics now appears tired; theory constrains the creativity of the new generation of scholars familiar, perhaps too familiar, with the legacies of the preceding intellectual revolution that can too easily be reduced to Theory 101 slogans (the author is dead, the gaze is male, the subject is split, there is nothing but text, etc.). The enormity of the initial struggles—the paradigm shifting—to be able to speak of sexual difference, subjectivity, the image, representation, sexuality, power, the gaze, postcoloniality, textuality, difference, fades before a new phase of normalization in which every student seems to

bandy around terms that were once, and in fact, still are, challengingly difficult and provocative.

Theory, of course, just means thinking about things, puzzling over what is going on, reflecting on the process of that puzzling and thinking. A reactive turn away from active engagement with theoretical developments in the arts and humanities is increasingly evident in our area of academe. It is, however, dangerous and misleading to talk of a post-theory moment, as if we can relax after so much intellectual gymnastics and once again become academic couch-potatoes. The job of thinking critically is even more urgent as the issues we confront become ever more complex, and we now have extended means of analysis that make us appreciate ever more the complexity of language, subjectivity, symbolic practices, affects and aesthetics. So how to continue the creative and critical enterprise fostered by the theoretical turn of the late twentieth century beyond the initial engagement determined by specific theoretical paradigms? How does it translate into *a practice of analysis that can be consistently productive?*

This series argues that we can go forward, with and beyond, *by transdisciplinary encounters with and through concepts.* Concepts, as Mieke Bal has argued, are formed within specific theoretical projects.[1] But, Bal suggests, concepts can and have moved out of—*travel from*—their own originating site to become tools for thinking in the larger domain of cultural analysis their interplay produces, a domain that seeks to create a space of encounter between the many distinctive and even still disciplinary practices that constitute the arts and humanities: the fields of thought that puzzle over what we are and what it is that we do, think, feel, say, understand and live.

Our series takes up the idea of 'travelling concepts' from the work of Mieke Bal, the leading feminist narratologist and semiotician, who launched an inclusive, interdisciplinary project of cultural analysis in the 1990s with *The Point of Theory: Practices of Cultural Analysis* and *The Practice of Cultural Analysis: Exposing Interdisciplinary Interpretation.*[2] In founding the Amsterdam School of Cultural Analysis (ASCA), Bal turned the focus from our accumulating theoretical resources to the work—the practice of interpretation—we do on cultural practices, informed not only by major bodies of theory (that we still need to study and extend), but by the concepts generated within those theories that now travel across disciplines, creating an extended field of contemporary cultural thinking. Cultural analysis is theoretically informed, critically situated, ethically oriented to 'cultural memory in the present'.[3]

Cultural analysis works with 'travelling concepts' to produce new readings of images, texts, objects, buildings, practices, gestures, actions.

In 2001, a Centre for Cultural Analysis, Theory and History was founded at the University of Leeds, with initial funding from the Arts and Humanities Research Council, to undertake what it defines as a *transdisciplinary* initiative to bring together and advance research in and between distinct but interrelating areas of fine art, histories of art and cultural studies: three areas that seem close and yet can be divided from one an other through their distinguishing commitments to practice, history and theory respectively. Founded at a moment of emerging visual studies/visual culture contesting its field of studies with art history or inventing a new one, a moment of intense questioning about what constitutes the *historical* analysis of art practices as a greater interest in the contemporary seemed to eclipse historical consciousness, a moment of puzzling over the nature of research through art practice, and a moment of reassessing the status of the now institutionalized, once new kid on the block, cultural studies, CentreCATH responded to Mieke Bal's ASCA with its own exploration of the relations between history, practice and theory through a exploration of transdisciplinary cultural analysis that also took its inspiration from the new appreciations of the unfinished project of *Kulturwissenschaft* proposed by Aby Warburg at the beginning of the twentieth century. Choosing five themes that are at the same time concepts: hospitality and social alienation, musicality/aurality/textuality, architecture of philosophy/philosophy of architecture, indexicality and virtuality, memory/amnesia/history, CentreCATH initiated a series of encounters (salons, seminars, conferences, events) between artists, art historians, musicologists, musicians, architects, writers, performers, psychoanalysts, philosophers, sociologists and cultural theorists. Each encounter was also required to explore a range of differences: feminist, Jewish, postcolonial, politico-geographical, ethnic, sexual, historical. (See <http://www.leeds.ac.uk/cath/ahrc/index.html>)

Each book in this new series is the outcome of that research laboratory, exploring the creative possibilities of such a transdisciplinary forum. This is not proposing a new interdisciplinary entity. The transdisciplinary means that each author or artist enters the forum with and from their own specific sets of practices, resources and objectives whose own rigours provide the necessary basis for a specific practice of making or analysis. While each writer attends to a different archive: photography, literature, exhibitions, manuscripts, images, bodies, trauma,

and so forth, they share a set of concerns that defy disciplinary definition: concerns with the production of meaning, with the production of subjectivities in relation to meanings, narratives, situations, with the questions of power and resistance. The form of the books in this series is itself a demonstration of such an transdisciplinary intellectual community at work. The reader becomes the locus of the weaving of these linked but distinctive contributions to the analysis of culture(s). The form is also a response to teaching, taken up and processed by younger scholars, a teaching that itself is a creative translation and explication of a massive and challenging body of later twentieth century thought, which, transformed by the encounter, enables new scholars to produce their own innovatory and powerfully engaged readings of contemporary and historical cultural practices and systems of meaning. The model offered here is a creative covenant that utterly rejects the typically Oedipal, destructive relation between old and young, old and new, while equally resisting academic adulation. An ethics of intellectual respect—Spivak's critical intimacy is one of Bal's useful concepts—is actively performed in engagement between generations of scholars, all concerned with the challenge of reading the complexities of culture.

One of CentreCATH's key research strands is *Aurality, Musicality, Textuality*. During the opening years of the twenty-first century, CentreCATH collaborated with Opera North on a series of events that focused on the theme of sexuality and music. A production of Puccini's *Manon Lescaut* (dir. Daniel Slater, 2004), which cast the eponymous heroine as a femme fatale and designed the opera as a film noir from the 1940s, was the first occasion for exploring the ways in which cultural analysis and musical performance could be brought into conversation, notably mediated by visual culture and cinema. Another event was created around a production of Strauss's *Salome*, which tracked the relations between Strauss's music, Oscar Wilde's play, and the rich visual archive of representations of Salome in late nineteenth-century art (*Words, Women and Song: The Fatality of Desire in Strauss's and Wilde's Salome*, January 2006). Both these projects allowed us critically to examine the cultural figure of the femme fatale and its underlying proposition that woman and her sexuality can be fatal, deadly, and dangerous, to men. Yet this runs in the face of statistical trends that indicate that women are far more at risk from masculine sexuality than vice-versa. So what about the sexual violence and threat of men?

The third collaboration provided an occasion for such an inversion. It was initiated around a special concert production of Béla Bartók's

opera *Duke Bluebeard's Castle* at Leeds Town Hall in May 2005. Opera North and CentreCATH organized a transdisciplinary event bringing together scholars of the literary fairy tale, musicologists, film theorists and feminist cultural analysts to explore the diffusion of the Perrault fairy tale, *Bluebeard*, through opera, music, literature and cinema and in specific relation to the cultural condition of Modernity and modernist cultural forms from opera to cinema. This book is the product of that encounter and its incitement to the participating authors to reflect and extend their thoughts into a collective study: *Bluebeard's Legacy: Death and Secrets from Bartók to Hitchcock.*

Centre for Cultural Analysis, Theory and History
University of Leeds 2008

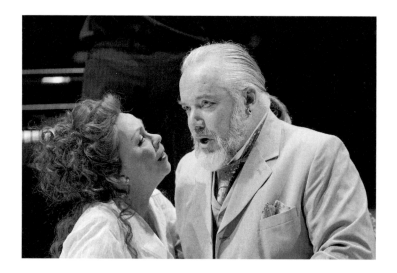

0.1 Sir John Tomlinson as 'Duke Bluebeard' and Sally Burgess as 'Judith' in a concert performance of Belá Bartók's *Duke Bluebeard's Castle*, produced by Opera North, May–June 2005, directed by Richard Farnes. Photograph copyright Bill Cooper.

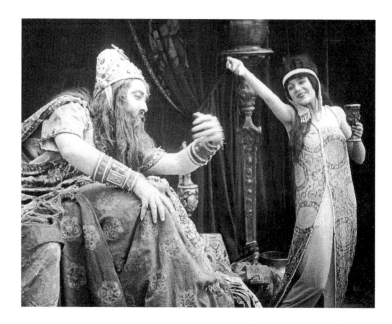

0.2 Still from *Judith of Bethulia* (D. W. Griffiths, 1914). Reproduced courtesy of the British Film Institute Stills Library, London.

PREFACE

Griselda Pollock

To be sure, music's beauty is often overwhelming, its formal order magisterial. But the structures graphed by theorists and the beauty celebrated by aestheticians are often stained with such things as violence, misogyny and racism. And perhaps more disturbing still to those who would present music as autonomous and invulnerable, it also frequently betrays fear—fear of women, fear of the body.

<div align="right">Susan McClary[1]</div>

JUDITH
(She frees herself from his embrace.)
Open the seventh and last door!
(He remains silent.)
I have guessed your secret, Bluebeard.
I can guess what you are hiding.
Bloodstain on your warrior's weapons,
Blood upon your crown of glory.
Red the soil around your flowers.
Red the shade your cloud was throwing.
Now I know it all, oh, Bluebeard,
Know whose weeping filled your white lake.
All your former wives have suffer'd,
Suffer'd murder, brutal, bloody.
Ah, those rumours, truthful rumours!

<div align="right">Béla Bartók[2]</div>

Susan McClary's path-breaking feminist intervention into musicology, *Feminine Endings*, first published in 1991, opens with her own, author-ial, identification with the character of Judith, in Béla Bartók's opera *Duke Bluebeard's Castle*, composed in 1911 and revised for performance in 1918. The libretto was written by one of the founders of emerging film theory, Béla Balázs, based on a play he had written in 1910 (0.1). In the Balázs/Bartók opera, Judith, the current wife of the enigmatic, powerful, and bearded Duke, is a figure of defiant and persistent curios-ity who must confront the entwining of sexuality and violence in the fortress-home of her husband which is itself an allegory for a modern, anxious masculinity.

In the course of this psychologically, as well as musically, modernist opera (explored fully in this volume by David Cooper in Chapter 3), Judith, whose evocation of the defiantly brave, Biblical Jewish heroine, Judith, Carl Leafstedt has argued is extremely significant (0.2), traverses the seven-chambered interior of the Duke's castle-home.[3] This modern Judith does not discover a single, secret chamber filled with all her bloodily murdered predecessors, as does the final wife in Charles Per-rault's *Contes du Temps passé* of 1697 titled simply 'La Barbe Bleue' ('Blue-beard')—the early modern tale that could be said to have initiated the modern cycle of engagements with this story of secret chambers and deadly husbands. Nor does she find the murdered corpses of her pred-ecessors in any of the many rooms she investigates. Instead, behind a series of doors that she obliges the Duke to open for her, Judith discovers, according to McClary, 'those aspects of Bluebeard that he wishes to claim—his wealth, strength, political dominion, love of beauty and so forth'.[4] Yet, citing the passage in the libretto used here as an epigraph, McClary points out also that Judith discerns traces of blood—signs of violence and suffering—on all these glorious and glittering things for which the Duke wishes her to adore him. The penultimate door opens onto the deepest and unspeakable secret: his pain, vulnerability and fears. It is a lake of tears. Behind the final door, and seemingly connected to the previous discovery/revelation, Judith does come upon three former wives, imprisoned in a kind of sus-pended animation, decked with all their husband's wealth, not actually dead but effectively mortified. Judith's fate is to join them in this ulti-mate chamber of silence and darkness that hides and houses the Duke's impossible loneliness—the result of his inability to withstand the curiosity of women in their desire to understand a beloved other. Judith's interrogative gaze perhaps stands for an emerging, and modern,

demand for genuine reciprocity in marriage to displace the ancient destiny of the woman in a phallocentric culture who is cast only as the mirror reflecting man's material glory and social presence. Thus, the Duke—masculinity—becomes, in effect, the real secret chamber within the fortress. 'He' is hiding behind the façade that is but his projected, externalized, armour-image.

If the theme of the femme fatale is based on the pairing of a beautiful and alluring surface that disguises a dangerous and horrifying—castrated and castrating—interior, cultural tales that deal with what is threatening in masculinity, rare as they are, disclose what Lacan called the phallic *parade* as opposed to the feminine *masquerade*. Beyond both *parade* and *masquerade*, however, lies the threat posed by a more searching feminine curiosity that Laura Mulvey has positively defined as feminine epistemophilia—the desire for knowledge that might expose subjectivity's fragile foundations on a phallic illusion, or, as Julia Kristeva has phrased it, on the illusoriness of the phallus.[5] Stephen Heath elucidates the absent phallus behind Lacan's *parade*:

> No one has the phallus but the phallus is the male sign, the man's assignment; so [Moustapha] Safouan talks about his benefit in having 'the attribution of the penis to his person'. The man's masculinity, his male world, is the assertion of the phallus to support his having it. To the woman's masquerade there thus corresponds male display (*parade* is Lacan's term), that display so powerfully described by Virginia Woolf in *Three Guineas*: 'Your clothes in the first place make us gape with astonishment ... every button, rosette and stripe seems to have some symbolical meaning.' All the trappings of authority, hierarchy, order, position make the man, his phallic identity: 'if the penis were the phallus, men would have no need of feathers or ties or medals ... Display [*parade*], just like the masquerade, thus betrays a flaw: no one has the phallus.'[6]

By identifying herself as feminist investigator of the masculine fortress of the Western musical canon with the intrepid curiosity of Judith, Susan McClary does not want, however, to succumb to her fate: like all the previous women by whose curiosity the Duke has felt himself betrayed, Judith is silenced by the man who cannot bear such a scrutiny of his mortality and prefers to live alone rather than see inside himself, past the façade that is masculinity's *parade* and protective armour. Analysis of any kind, curiosity to know the inside, becomes

the problem that this figuration of the feminine poses for a masculinity that shores itself up against investigation and punishes she who would know his inner, human truth in all its human ambiguity. Feminist or feminine, the linkage between sexuality, curiosity and violence is complexly woven together in, and revealed by, this modern version of Bluebeard, which, in its stark simplification of the confrontation between the Bluebeard husband and Judith, between masculinity and femininity, has prompted this new collection of studies by established and emerging scholars who must also negotiate their relations to their own positionalities in, as well as the implications of culture's narratives of, sexual difference which we find encoded for us in those fascinating cultural forms that we know as fairy tales.

With roots worldwide in oral storytelling, what in English is known as the fairy tale, in French as *conte des fées* and in German as *Märchen*, has very little to do with fairies. While myth and legend, equally deeply embedded in cultural memory and storytelling, are the stuff of epic tales of heroism and tragedy that often contribute to formation of national or cultural identities and 'mythic' histories, stories of origins of dynasties, peoples, cultures and practices, the fairy tale also serves, according to cultural analysts, social purposes. But these are different from the epic uses of myth. In its sociological aspect, the fairy tale is often associated with socially marginal, oppressed, struggling characters or situations. Its stories deal with ordeals and dangers that can be read as indications of actual social and economic struggles or as psychological dramas of coming of age, or of negotiating sexual initiation, or even as existential portraits of human dilemmas and propensities for good or evil. The space of the fairy story is, however, the space of the unexpected, the fabulous—derived, of course, from the Latin term for story itself: *fabula*. It is the space of magical changes, unexpected possibilities, and, above all, transformations that come about through strange acts and equally powerful words, incanted, declared, or simply said. Both explicable in terms of the struggle to negotiate the social and historical conditions in which often powerless people (classes, genders) find themselves and in terms of inner psychological struggles experienced across generation and class, the fairy story touches upon the realm of the fantastic and marvellous rather than that of destiny, fate, and hence, tragedy or the epic.

The fairy story is, perhaps, a view of the world and society from below, from its often powerless margins, where the imaginative recasting of the possible world allows us to glimpse anxiety, longing, danger,

resilience and hope in the face of power, written in different forms, transcoded into stories that intend to create another, parallel universe where animals talk and humans fly, or to re-order the world, setting it upside down, or yet again to retell the actual world with the possibility of negotiating perhaps not social and economic change, but the rage, fear or danger in it. The conflict between those interpretations that read fairy stories in terms of telling us something of the social and historical conditions and those that read it in more structural and perhaps psychoanalytical terms converge in this particular form of cultural narrative and imagination that dramatizes particularly human emotions in relation to ordinary, everyday transactions that relate specifically to questions of the sex–gender system.

In our collection, we are focusing on one particularly grisly but fascinating story that became part of the modern canon of the literary fairy tale at the end of the seventeenth century: that of a murderous husband, an old and socially powerful figure, a man with a beard, a man marked facially by his potent masculinity and his class privilege: his *blue* beard and, in some versions that make him an aristocrat, his blue blood.[7] It is also the story of a virginal and defenceless young woman pitted against him as his last, in some versions, eighth wife—moving beyond the special number seven. In the Bartók opera, it is the equally symbolic number three. The story stages this final confrontation that will challenge the secret vices of the serial killer and end the reign of terror. The story hinges on the *prohibition* uttered by the *father/husband* about using a *key* to enter a *secret chamber*: the chamber being so often a metaphor for the hidden interior and sexuality of woman, the key functioning as a masculine sign, the phallus that the woman should not herself insert to gain knowledge. In this story, however, the interior of the man—his psychic space—is further suggested in an interesting reversal. Like Eve in Biblical legend, the eighth wife must transgress the prohibition not to enter the secret chamber since the two—prohibition and transgression—are a co-dependent pair. Her discovery is, however, horrific. In the room she encounters a collection of dead women: her predecessors. This discovery forewarns her of the fate awaiting her too. Occurring within the narrative, however, the discovery opens the history that the room encodes to possible redirection and to a different outcome. Not a repetition of the same—another dead wife—but a change is located in this young, defenceless, usually mute, but curious bride. The key is, however, the give-away. It becomes stained with the blood of the dead wives and thus the latest wife's transgression is

exposed, in blood, to Bluebeard when he unexpectedly returns. Shed but also irremovably staining blood introduces a counter-colour, transgressively associated not only with death, but with the female body, with menstruation, defloration and childbirth. This has led many to see the tale as a exemplary patriarchal story of the dangers of female curiosity which blames the woman for her seeking for knowledge and links this tale with that of the Hebrew Eve and the Greek Pandora.[8]

There are various outcomes of this tale as we know it from Charles Perrault's seventeenth-century formalization of collected stories into published editions that initiated the literary genre of the fairy story in elite and later bourgeois culture. Our book is not so much concerned with the origin of this tale, or of fairy tales themselves, complex and fascinating as that history is.[9] We are focusing on the resilience and endless fascination exercised by this one particular tale which has a number of themes: adult sexualities—men's and women's; initiation, repetition, curiosity, marriage and its dangers. These leave their origin in the Perrault textualization of the tale to find different forms of telling in theatre, cinema, visual art and opera at the beginning of the twentieth century when, in particular, cinema emerged to claim at once the ability to document the world and the capacity to become the engine of the marvellous and the fantastic.

In her introduction, editor Victoria Anderson draws on her recent monographic research to demonstrate how the key themes of the Bluebeard tale have haunted so much of Western women's literature in varied ways running through the nineteenth and twentieth centuries (*Jane Eyre* to the *Story of O*). She invites us to consider why the structures and possibilities of certain folkloric tales (perhaps inspired by actual and horrific events such as recorded serial wife-murderers like the late medieval Gilles de Rais or the early twentieth century Henri Landru) become such repeating motifs through which dissident women writers negotiate, in rewriting in their own imaginative texts, the already patriarchally freighted literature, the enigmas of their subjectivities and sexualities under a phallocentric order. Victoria Anderson furthermore draws on contemporary feminist literary and cultural studies to review the gender politics of Perrault's late seventeenth-century writing of his *contes* while also plotting out the legacy of these murderous gender politics with which women writers and filmmakers up to Jane Campion have had to do battle.

David Cooper offers a theoretically sophisticated and searching musicological analysis of the operatic rewriting of the tale in the work of

Balázs and Bartók in 1911 while Michael Hiltbrunner analyses the earliest cinematic rendering of the Bluebeard story, drawing closely on Perrault's tale, by the spectacular cineaste Georges Méliès in 1901. Ian Christie explores a truly transdisciplinary exchange by his contextual reading of the great British director Michael Powell's mature cinematic translation of a German staging of Bartók's opera in 1963, drawing our attention to the specificity of each medium in which the telling of the tale produces its own new experience, situating us each through its particular processes in relation to the seemingly inexhaustible possibilities for interpretation offered by that form of cultural memory that we call the fairy tale. Linking literature and the textuality of the operatic libretto, Victoria Anderson undertakes a critical feminist reading of the negotiations of sexual and ethnic difference—Jewishness—in the Bartók/Balázs text.

Why, however, did the Bluebeard story incite so many retellings and dramatizations in Germany at the beginning of modernism? This is the topic of an extensive analysis by Mererid Puw Davies in her book-length study, from which a special and focused exploration has been written specially for this volume. The examination of such repetitions with differences is the topic of the chapter by one of the leading analysts of the fairy tale and of the Bluebeard story in particular, Maria Tatar. Tatar reminds us that any story is reinvented in every telling. The Bluebeard variations across literature and cinema thus performatively excavate and produce anew insights into some of its core problematics: fidelity and infidelity, repression, curiosity and repetition.[10] As story, the tale has the potential for change in retelling, its 'transformative energy' not only guaranteeing 'survival' but also a rich 'after-life' which Tatar herself tracks through novels such as *Jane Eyre* to films by Hitchcock (*Notorious*, 1946) and Jane Campion (*The Piano*, 1993). Tatar insists that in dealing with Bluebeard now, in the light of feminist sensibilities, we must be equally alert to the meanings of both the husband-figure and the wife-figure and their varying possibilities to negotiate the nexus of issues thrown up by the tale in each culturally and historically transformed retelling. Following in the same vein, and exploring the wife-position as the locus of complex psychological motivations, Elisabeth Bronfen provides an extended, in-depth, psychoanalytically informed film analysis of just one such cinematic transformation of this material, also mentioned by Tatar, the film *Secret Beyond the Door* (Fritz Lang, 1947). Indicating, by lengthy and close analysis of just one text, the density of any one cultural text, Bronfen's work on the cinematic staging of the

themes of the Bluebeard tale is taken up by Griselda Pollock. She reverses the cultural mytheme of the femme fatale to draw attention to the existence of the *homme fatal*. In a series of films referencing the Blue-beard tale in different ways from the 1940s to the 1970s, Pollock argues that such Hollywood films negotiate the challenge to masculinity posed by the Bluebeard figure who seemingly reveals a disturbing link between masculinity and violence, by rendering the serial murderer a patholog-ical deviant and homicidal monster. His crimes are, however, really incited by an originary, traumatic encounter with a woman, who returns as the hidden femme fatale to exonerate this terrible exception, the serial murderer.

Thus we come back to the question of who and what is the centre of this story that so many have wanted to tell again: does it not lead us to reflect on masculinity as the psychological puzzle of desire linked to violence? Or does it serve to make us think about femininity as the psy-chological puzzle of a curiosity that becomes dangerous only within patriarchal culture? Or, yet again, does it simply stage yet again the enigma of sexual difference itself in the field of the heterosexual, social contract: marriage? Does the non-unitary story, extending across and reinvented by its many retellings in so many different forms of cultural narrative and regimes of representation, reveal some of the disturbing and contradictory psychic structures underpinning heterosexual sub-jectivities? Or is the narrating itself a structure that allows for endlessly renewed social and historical materials to find imaginative form through the limitless potential of its highly symbolic and freighted elements, the old powerful man, the powerless virgin-bride, the secret chamber, the bloodied key, curiosity, and above all the terrifying interlacing of power and violence?

In her twelve-minute film *Bluebeard* (2007), contemporary artist Alice Anderson has radically revisited and reworked the theme by staging it as the tale of a lonely, blue-bearded princess who falls in love with a young boy still too closely attached to his mother (0.3). Maud Jacquin writes of the work in her preface to the book edition:

In Alice Anderson's film adaptation of Charles Perrault's literary tale, *Bluebeard*, she explores this notion of passage, emphasizing the violence of the transformations engendered by the loss of innocence. This is the way she modifies the original meaning of Bluebeard. A comment on forced marriage and the mysteries of sex becomes an illustration of the wrench that is the separation

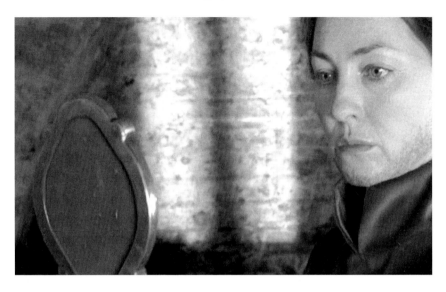

0.3 Still from *Bluebeard* (Alice Anderson, 2007), 12 minutes, English, French
 subtitles, colour, 16/9, sound 5.1, Anna Leska Films, Paris-Brest Pro-
 ductions, HBOX. Courtesy Yvon Lambert Gallery, Paris.

with the mother, returning to an omnipresent theme in her work.
Spilt blood is not that of defloration but of the cutting of the
connection joining child and mother. The classic symbol of Blue-
beard, the blood-stained key evoking soiled virginity, is replaced by
two sharp tools, scissors and a razor. By establishing a visual and
symbolic parallel between these instruments, the artist reveals an
essential affinity between Bluebeard and the apprentice. In Ander-
son's tale, they both manifest this sexual indifferentiation that is the
mark of a troubled identity, both are victims of the mother's
betrayal and abandon and carry their indelible trace, the blue of
the beard for one, the wound of the cord for the other.[11]

Our collection explores what happens to the charged elements of
this tale when they are creatively worked over by the specificities of
different cultural and aesthetics forms in the modernist century across
literature, drama, music, visual art, cinema. How do formal elements
of language, music and the visual image performatively rework their
unstable pre-text to render it, each time, a new screen on which new ele-
ments characteristic of emerging Modernity's struggles with gender

and with sexual difference are projected in unexpected and provocative ways?[12]

By plotting a series in interconnecting studies of a shared topic through the specific disciplines of the field of cultural analysis, this book aims to weave a collective text, criss-crossing a formal story told by Perrault, an opera composed by Bartók/Balázs, three films made by Méliès, Lang and Powell. These are set into resonating contexts of literary practices, social and historical changes, aesthetic politics and cultural dissemination. The readings register the continuing challenge of thinking about the aesthetics and politics of sexual difference as they are worked through and renewed in Bluebeard's legacy in Modernity.

Short note on terminology: Blue Beard or Bluebeard?

'Bluebeard' will be used when authors are discussing the theme of the generic tale and its main character. Perrault's tale 'La Barbe Bleue' is translated as 'Blue Beard' but it is common practice to elide the two words in English. The Hungarian title of the Balázs/Bartók opera is translated as *Duke Bluebeard's Castle*.

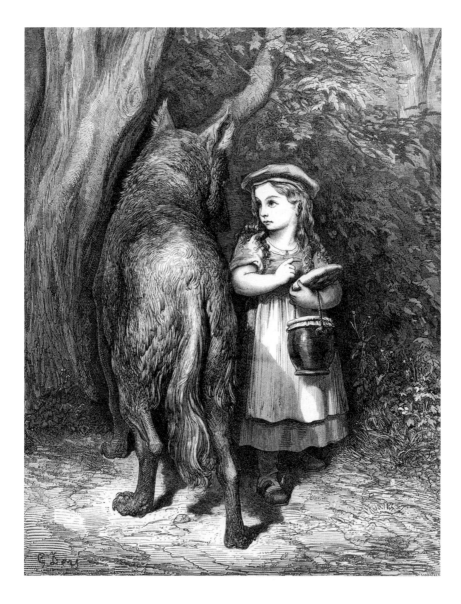

00.1 Gustave Doré, Illustration to 'Red Riding Hood', from *Les Contes de Perrault, dessins par Gustave Doré,* ed. J. Hetzel (Paris: J. Hetzel, 1867). Dover Pictorial Archives Series.

INTRODUCTION
A Perrault in Wolf's Clothing

Victoria Anderson

To begin with a tangent. Jane Campion's 2003 film *In The Cut* was not especially well received by either critics or the viewing public. The story of a writing professor (Meg Ryan) who becomes embroiled in a series of sexual homicides, the core of the narrative details Ryan's vaguely unsettling sexual relationship with the investigating detective against which the increasingly gory murders become increasingly superfluous. And perhaps the key to this superfluity (which evokes every serial killer flick from *Psycho* to *The Silence of the Lambs*) is in an exchange between Ryan's character and one of her students in class. Discussing Virginia Woolf's novel *To The Lighthouse*, the student expresses dissatisfaction with the book—is bored by it—nothing happens, he says, but one old woman dies. At which Ryan asks the question: How many dead women does it take to make a good story? And the answer comes back: at least three.

Bluebeard occupies a peculiarly central and yet ambivalent positioning in cultural history. 'La Barbe Bleue' was written by Charles Perrault in 1697, although oral variants appear to have been pre-existent (however not, as far as we know, featuring the blue beard). In Perrault's tale, adapted from these thematically similar tales circulating in the European oral folk tradition, the wife of a serial-murderer discovers the mutilated and bloody corpses of his previous wives within a sequestered and forbidden chamber. The price of her curiosity (read: the seeking of knowledge) is death—or it would be, were she not rescued by her

brothers at a fortuitous juncture. But in terms of framing Perrault's Bluebeard as the inaugurator of a genre, it is important to note the specificities of the tale within its contemporary context; that is as a tale circulated at the Court of Louis XIV, and against a highly specific backdrop in terms of the public and private status of women at the time and of their access to language, the production of meaning and their active participation in society.

The genesis of the European novel form itself was in the seventeenth-century French court, almost exclusively between female writers and *conteuses*, amongst them the infamous *précieuses* and Madame Lafayette. The novel was, in a sense, born of the Salon (which translates literally, of course, as 'room').[1] The original salon was the *Chambre Bleue*, designed and initiated by Catherine de Rambouillet. Charles Perrault himself frequented the salons in the latter half of the seventeenth century, and indeed his famous collection of tales derives entirely from the salon environment. As I will argue, Perrault's tales seemingly mark the intersection between oral and print culture as a dominant mode of dissemination, between epic and novel, and between women telling tales and men writing them; and this, in turn, becomes the more interesting when one notes the peculiar violence committed in his tales, both against his female characters and against the feminine tradition from which the Mother Goose Tales claim to derive.

As Victor Laruccia has observed, 'it is during Perrault's time that the very use of representation was beginning to be seen as a political tool'[2] and that certain of Perrault's tales are very much tied up with this question. The tale to which Laruccia confines his analysis is 'Le Petit Chaperon Rouge' ('Little Red Riding Hood', 00.1), in which Laruccia identifies the wolf's manner of manipulating his prey as hinging on his manner of representing himself, his victim, and her options. The Perrault scholar Philip Lewis, in a more recent and artful analysis, identifies the wolf's manipulations as entirely linguistic; yet the most important facet of his analysis for the present purpose is that he identifies 'Le Petit Chaperon Rouge' and the tale that follows it within Perrault's collection—'La Barbe Bleue'—as forming part of the same story.[3] The two females murdered within the closed, domestic sphere of Granny's cottage presage the dead women sequestered in a forbidden chamber.

The beginning and the end of Mother Goose

Following the publication of several single tales in the influential paper *Le Mercure Galant*, Perrault's collection of fairy tales was duly published

in 1697 under the title *Histoires ou Contes du Temps passé avec des Moralitez* (Stories or tales of times past with morals), and bearing on the frontispiece the subtitle 'Contes de ma Mère l'Oye' (Tales of Mother Goose). These were 'La Belle au Bois Dormant' ('Sleeping Beauty'), 'Le Petit Chaperon Rouge' ('Little Red Riding Hood'), 'La Barbe Bleue' ('Bluebeard'), 'Le Chat Botté' ('Puss in Boots'), and 'Les Fées' ('The Fairies'). These were the five stories originally gathered together in manuscript form in 1695, and to these were added 'Cendrillon' ('Cinderella'), 'Riquet à la Houppe' ('Ricky with the Tuft') and 'Le Petit Poucet' ('Tom Thumb') in 1697. Perrault compensated for the more simple, direct style adopted by the *contes en prose* by the addition of versified morals appended to each tale.[4] The tales were, moreover, published in the midst of a fairy tale vogue that had engulfed aristocratic circles. It was characteristic of the many other fairy stories being published that they were resolutely aristocratic in presentation, full of baroque curlicues and elegant type. Although many of the writers were women, most notable amongst whom was Catherine d'Aulnoye, there was a significant proportion of male writers as well. However, Perrault's were the only stories that assumed a rustic appearance, bearing not only a title that proclaimed them to be tales of times past, but on the frontispiece was an image of an aged nurse recounting the tales to a group of well-heeled children. It is, no doubt, at least partially on account of this that they became assimilated as timeless classics, rather than more timebound tales that revolved around stately life and improbable lilac fairies.[5]

One might consider that Charles Perrault was also the inaugurator of *La Querelle des Anciens et des Modernes*, and his own carefully literate cultivation of the oral tradition can in many ways be seen as a strand of his modernist strategy in the ongoing war against the classicist Nicolas Boileau. As such it becomes possible to see in the tales of Perrault a 'modern' mythology, a downsized sub-pantheon of miniature heroes with a comparable purpose: that of *culturing*. The timing of Perrault's tales, positioned in the middle of what Paul Hazard has termed the 'European crisis of consciousness'[6] is certainly not coincidental. Perrault did not, in fact, attach his name to his published collection, although everyone knew that he had written them. They were sold as 'Mother Goose' tales, and the nurse on the frontispiece may be assumed to be this same 'Mother Goose'. So although this most famous and influential book of children's stories was written by a man, it evokes a feminine tradition of storytelling as well as springing from the avowedly

feminine space of salon literature. As such, then, it may or may not strike us as peculiar that the thrust of the tales was somewhat antifeminist, particularly when one compares Perrault's tales to the oral folk tales that would have been in circulation at the time, and from which Perrault undoubtedly derived a great many of his themes.

Most of us are familiar with the version of Little Red Riding Hood made popular by the Grimms, and which filtered down to generations of children via nursery collections. The Grimms' version features the little girl and her grandmother who are eaten by the wolf only to be saved by an expedient woodcutter who slices open the wolf's belly. The wolf thus despatched, Little Red Riding Hood is free to be admonished for straying from the path and disobeying her mother. This, then, is a suitable cautionary tale for children,[7] but in Perrault's tale the little girl is not warned by her mother and so cannot be blamed for straying; the wolf meets her, tricks her, eats grandmother and the girl, and there the story ends. To this Perrault appends a moral which states that little girls ought to be careful where they go since there are wolves everywhere, and that the quiet ones are the most dangerous of all. We are given to understand that the interaction between wolf and girl has been less about the wolf's nutritional requirements and more about his sexual whims, if not his sociopathic mores; and it is telling that this short tale in which a child and her grandmother are, in effect, raped and murdered, is succeeded immediately by the tale of a necrophilic wife-slaying Bluebeard.

There are a number of stories circulating in the oral tradition that clearly pre-existed Perrault's 'La Barbe Bleue'. They are worldwide in distribution, but in the European tradition they followed one of two patterns; in the first, a story would typically feature three sisters who are abducted one by one to be the wife of a wizard,[8] troll,[9] or some other supernatural agent; there is an Italian version where it is the devil himself.[10] In these stories the abducted girl is given a key, or an egg, or some other object that she must never set down. The wicked husband then tells her he is going away for a short while, and that there is one room in the house into which she must not peek. Of course, the wife does peek into the room, and in the room is usually contained the blood and bodies of all the previous wives who had gone before, but this varies: in the Italian tale which features the devil, for instance, the door is opened onto a fiery pit that is hell itself. Inevitably the wife drops the egg or key that she has been told to carry and it becomes stained with

blood or otherwise magically marked by the room's contents. On his return the husband sees that she has entered the room and so kills her for her disobedience. In these stories this is the fate that befalls the first two abducted sisters, but the third sister shows more cunning by hiding the magical object before she opens the door. The object is thus unmarked, and on his return the husband sees that she has passed the ultimate test and as a result loses all his magical power. He is then in her thrall and must do as she bids, and the denouement sees her magically revive her dead sisters and kill their assailant.

There is then another trend that comes under the heading of 'Robber Bridegroom' stories. In these tales there is one girl, not three, and she is not abducted but is either unwillingly betrothed to her unlikely suitor by her father, or falls in love with him independently. However, she becomes suspicious of him for one reason or another, and so goes to his house alone only to find that it is a murderer's den. Occasionally these stories feature a locked chamber, such as in the English story Mr Fox, but more often the girl spies on her paramour from behind a barrel or some other obscuring object, and sees him murder, mutilate, and sometimes eat, another girl. She escapes, and subsequently exposes the murderer publicly.[11]

As can be seen by these examples, the girl is the heroine of these stories; she is resourceful and independent and defeats the evildoer alone. Perrault's tale, however, despite his claims for modernism, harks back to a more ancient patterning of narrative than turns on an injunction–transgression. The nearest relation comes in fact from the Arabian Nights tales, and reflects, ironically, the tendency to orientalize Bluebeard that has characterized his renderings by generations of illustrators. The Tale of the Third Royal Mendicant features a young man who is taken to reside in a realm of delights, but is forbidden access to one door alone. He opens the door only to find a wild horse behind it; the horse rears and kicks out his eye, and the young man finds himself back in the streets of the city, just one of a surprising number of one-eyed beggars thereabouts.[12] This in turn relates to the original injunction–transgression, that of Adam and Eve, where the fruit of the Tree of Knowledge is forbidden. By the same token, the opening of a door represents the pursuit of hidden knowledge in a precisely equivalent manner.[13]

In the oral tales of the European tradition, the female protagonist does not really transgress an injunction; or at least, she is shown to be

wise in her decision to transgress this particular injunction, and foolish only if she is caught in doing so. However, Perrault's 'La Barbe Bleue' reinstates transgression at the heart of the narrative. In the Arabian nights tale it is a man who transgresses, while in the biblical tale both Eve and Adam transgress the law of God, even if Eve is more commonly identified as being the culprit, and even though she is persuaded by the serpent. In Perrault's tale it is a wife who transgresses the law set out by a husband, and although he is finally defeated, it is only because the wife's brothers happen to arrive just in time to save her; and the story ends with her new marriage to an honest man who would help her forget about the whole thing.[14] The wife is firmly contained by patriarchal structures and is in no way autonomous. Unlike the resourceful heroines of oral narratives, Bluebeard's wife is unconscious; she does not possess the consciousness to effect her own escape. This lack of consciousness is underscored by the ending where the success of her new marriage is explicitly identified by its ability to effect her forgetfulness.

The same may be said of 'Le Petit Chaperon Rouge', since pre-existing oral versions present a female protagonist who successfully outwits the wolf and escapes, whereas Perrault's version maintains little Red Riding Hood in a state of complete unawareness. Lewis has suggested that in reading Little Red Riding Hood and Bluebeard as a pair, one could argue that Bluebeard's defeat effectively resolves the cycle of violence set in motion by the wolf.[15] However, on another level it must be noted that, unlike the oral versions, Perrault's tale ends not with the defeat of Bluebeard, *but with the new marriage*, thereby reaffirming the wife's subordination. Combined with the unconsciousness of the female protagonist and the cyclic nature of the violence depicted in both these stories, this creates a suggestion not of resolution but of *perpetuation*; a perpetuation effected through unconsciousness. It is notable that the exact phrase used at the beginning of the tale ('un fort honnête homme'), with regard to the wife's decidedly misplaced feelings about Bluebeard, is repeated precisely, word for word, at the end of the tale, but with reference to the *new husband*. Furthermore, by 'forgetting about the whole thing', in other words by *repressing* it, the possibility of endless repetition is created. In many of the European oral tales, not only is the wicked abductor vanquished by his victims, but they burn down his house. In Bluebeard, both the house and the institution of marriage are preserved, intimating the perpetuation of the system that shelters Bluebeard's activities.

Transvestite Perrault

It is important that we recognize the context in which Perrault's *contes* came into existence. Given Perrault's place as a man within the decidedly feminine space of tale-telling, within the feminine space of child-rearing, as creator of a book fronted by the image of an invasion of female space, a book published anonymously but under the subheading 'Tales of Mother Goose', we can give credence to the idea advanced by Elizabeth Harries that Perrault simulates not only orality, *but femininity itself*, describing his actions as 'narrative cross-dressing'.[16] Given this suggestion, which Harries does not connect to 'Le Petit Chaperon Rouge', what are we then to make of this wolf disguised as Grandma who invites the child into bed with him—and (unlike the folk version, which tale we shall duly examine) succeeds? Catherine Orenstein points out that the (part-) model for the wolf might well have been Perrault's fellow Academician, the famed transvestite-of-letters the Abbé de Choisy.[17] In his memoirs he relates how, dressed as a woman, he received *salonnières* from his bed, bade young ladies come into the bed with him and even (so he claimed) had full intercourse with them there and then, with only bedclothes separating the locked bodies from a salon full of eyes.[18]

Entertaining as it is, this story does not much appear to advance the present inquiry. It does, however, point to yet another avenue. This same abbé is also thought to be the model for the protagonist of an anonymous story published in the *Mercure Galant* in February 1695: 'L'Histoire de la Marquise–Marquis de Banneville'. This is the story of an aristocratic boy whose mother does not wish him to join the army when he becomes a man; for this reason, she dresses the infant as a girl and continues to do so throughout childhood. Of course, we are aware that womanhood was, at that time, conferred young on aristocratic girls, and by the age of twelve this Marquise–Marquis was already attracting the attentions of all the men … and so on.

But 'L'Histoire de la Marquise–Marquis de Banneville' itself plays a prominent role in the play of identities that surround *Histoires ou Contes du Temps passé*. Soriano, tells us that exactly one year later, in February 1696, the *Mercure Galant* published '*La Belle au Bois Dormant*'; Donneau de Visé, the editor, attributes the anonymous story to the same author as that of the Marquise–Marquis. The play continued, with a revised version of the Marquise–Marquis being published later in the same year, now featuring an extended digression in a conversation between characters within the text which refers to 'La Belle au Bois Dormant', and

stating that it was written by the 'Master's son'. The confusion then spirals into the centuries long debate over whether it was Perrault junior or Perrault senior who really wrote the tales.[19] But we must put all that aside in order to go back to the Marquise-Marquis. For both the text itself and Donneau de Visé's editorial indicate clearly that the author is a woman. We work on the assumption that Perrault (senior) wrote both. But what is important to note is that not only is it the *story* of a man masquerading as a woman; it was *written* by a man masquerading as a woman.

Is there not, then, an undeniable correlation between Perrault's masquerade as Mother Goose and the wolf's masquerade as the Grandmother? And is this not further underscored by the fact that the action of 'Le Petit Chaperon Rouge' takes place in—of all places—a *ruelle*? The term 'ruelle' means, literally, the space between the wall and the bed, and this is the naïve interpretation assumed by commentators. However, the term 'ruelle' had a very specific meaning in seventeenth-century literary circles, since it was the precisely the term used for the space where a *salonnière* would receive her guests. If the Salon (literally: 'room') was the pool of feminine literary activity, then in the parlance of the day, the *ruelle* was its wellspring.[20]

The folklorist Alan Dundes points out that 'in purely oral fairy tales (Aarne–Thompson tale types 300–749) the initial victim is rarely if ever killed permanently. If the victim is female, either she saves herself, or she is saved by a male hero.'[21] Although there are of course no written (and therefore verifiable) records of a folk version of 'Le Petit Chaperon Rouge' that precede Perrault's, it is widely believed to be the case that such a story was in circulation prior to the publication of Perrault's *contes*,[22] and this story was brought into the spotlight by Paul Delarue some fifty years ago, in *Le Conte Populaire Française*. This story, 'The Grandmother's Tale', features a young girl (without a red cloak) who goes to visit her grandmother and is waylaid by a wolf. He finds out where she is going and gets there first, devouring the grandmother and setting aside some of her flesh and blood. When the girl arrives, the wolf is tucked up in Grandmother's bed. Come in, says the wolf, have some bread and wine. He gestures to the Grandmother's flesh and blood, and the girl duly partakes of the grim fare. At this point the grandmother's cat says: 'A slut is she who drinks the blood and eats the flesh of her grandmother!' Then the wolf bids the girl undress bit by bit, and as she removes each item of clothing, tells her to throw it in the fire. Finally the wolf tells the girl to get into the bed; the girl says

she really needs to go outside to defecate. The wolf allows her to go, and ties a piece of string to her leg so that she can't escape. Once outside, however, the wolf's ill-conceived method of entrapment fails as the girl slips the string from her ankle and escapes.[23] As Jack Zipes observes, 'Perrault's changes were substantive in both style and content [...] The irony of his narration suggests that he sought to appeal to the erotic and playful side of adult readers who took pleasure in naughty stories of seduction,'[24] although arguably 'The Grandmother's Tale' also enacts this same kind of playfulness that appeals to the risqué tastes of adults as well as becoming a didactic tale of warning for children (and indeed women at risk of sexual assault).

It is notable that 'La Barbe Bleue', another 'skeletal drama of female victimage flowing from a male monopoly of reason and force',[25] also radically alters pre-existing oral versions. When I speak of 'radical changes', it is not to be imagined for an instant that I am suggesting 'authentic' oral narratives should or do preserve an identical storyline; oral tales vary considerably even within the same Aarne–Thompson tale-type. The difference with these versions published by Perrault is that in both these tales, the female actant is presented as foolish and culpable, as has been remarked, and the aggressive male actant as sympathetic.

Certain scholars have taken issue with Aarne's definition of AT 312 as set out in terms of the girl being saved by her brothers,[26] as if such a narrow definition is missing the point of the story (the point apparently being that husbands like to terrorize their wives). Somehow such scholars have failed to note that the girl's rescue by her brothers is precisely the defining feature of these particular tales, since in all other corresponding tale-types she saves herself. This is no trifling variation. Further, it is highly likely that all tales—written and oral—of AT-type 312 are derived from written sources, just as all post-Perrault versions of 'Little Red Riding Hood' show our heroine as gullible, culpable and as having to be saved by the woodcutter rather than using her own wit and resources (though they stopped short of seeing her get eaten).

One might argue that *Histoires ou Contes du Temps passé* is a parody of itself; a parody of old tales, for these are not old tales at all. The very title—'Stories or Tales'—signals the ambiguity worm-holing the collective text. Neither are they oral, though they, as Elizabeth Harries phrases it, 'simulate orality';[27] as we might phrase it, they parody orality. But more than this, since we cannot but observe the grinding irony that in his telling of the tales Perrault himself becomes a mocking parody of a woman precisely as does the wolf.

By the time Perrault's tales were published, the gains made by women in terms of personal and political freedoms had been significantly reduced under the absolutist regime. Furthermore, Louis XIV had moved his court from Paris to Versailles, meaning that court society and possibility of influence was now far removed from the Parisian salons. It was now commonplace to ridicule the *précieuses* as bogus, foolish and pretentious women, the more so since Molière's 1658 production of *Les Précieuses Ridicules*.[28] Like the verbally adept Mascarille in Molière's play, the star of 'Le Petit Chaperon Rouge' is undoubtedly the wolf. His verbal manipulations and linguistic sophistication are designed to make us laugh with him at the expense of the females that he tricks and murders. Not only is his verbal sophistication far in excess of that of either the child or the old woman, he uses his verbal skill to imitate the female characters. By using his verbal skills to imitate and manipulate his victims, he ridicules them before destroying them; but by taking them into himself, he also becomes them—or they become him. By referring to the 'ruelle' as a place where women need not feel themselves safe, he issues an encoded threat whilst ridiculing women's linguistic aspirations in the face of violent masculinity.

Is it possible, then, to speculate that Perrault was marking, somewhat in the manner of a tomcat, a masculine usurpation and destruction of the feminine role through trickery and sexual murder? In 'Le Petit Chaperon Rouge', the wolf both masquerades as female and ingests his female victims. At the same time, Perrault effectively ingests the feminine role whilst masquerading as a woman storyteller. He thereby becomes both the wolf's double and, since the clandestine nature of the wolf's activities are transferred to the subsequent tale ('La Barbe Bleue'), a stage in the development of Bluebeard himself. If one can discern the annihilation of the female storyteller—or even just the oral form per se—in 'Le Petit Chaperon Rouge', then this annihilation becomes the literal cornerstone of Bluebeard's house, which then is symbolic of the system. The cycle of violence is not so much resolved as contained by a patriarchal absolutism from which it is impossible to escape, and within which transgression remains punishable by death. The most troubling aspect remains Perrault's own ambivalent and clandestine positioning within these narratives: a murderer–narrator.

'Le Petit Chaperon Rouge' inhabits a tangible intersection between oral and print culture, not only in its mockery of what has gone before, but in its prescient awareness of what is to follow; for the plotline and paratextual apparatus of 'Le Petit Chaperon Rouge' pre-shadows the

eighteenth-century Seduction novel as surely as 'La Barbe Bleue' pre-empts the Gothic novel. According to Bakhtin, parody is part and parcel of the development of the novel: 'The novel parodies other genres (precisely in their role as genres); it exposes the conventionality of their forms and their language; it squeezes out some genres and incorporates others into its own peculiar structure, reformulating and re-accentuating them.'[29] If we use this framework, it is possible to see Perrault's *contes* as both parodying the folktale and as a 'study' for the novel: Perrault's is the story of a story. As he does so he masculinizes—rather, re-inserts into the phallic domain—the novel form by eliminating women (amongst whom both the novel form and the oral folk tale originate) from the storytelling arena. He does so by using a figured rape, and its logical extension, murder. Not so much a tale of warning, but a tale of threat.

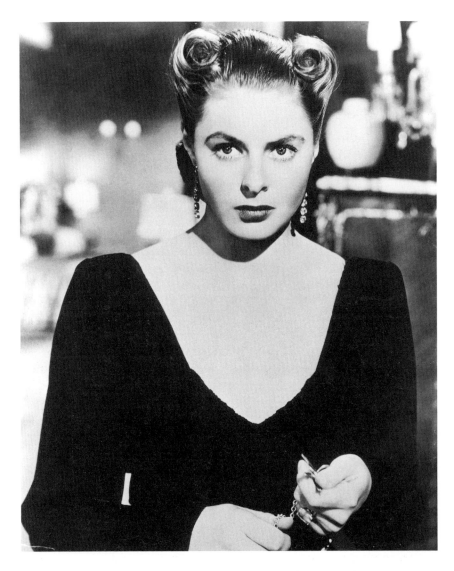

1.1 Still of Ingrid Bergman from *Notorious* (Alfred Hitchcock, 1946). Repro-
duced courtesy of the British Film Institute Stills Library, London.

1

BLUEBEARD'S CURSE
Repetition and Improvisational Energy in the Bluebeard Tale

Maria Tatar

'Bluebeard' as told by Charles Perrault, may end with a marriage, but it is more horror story than fairy tale, revealing that there may be more to the institution of marriage than 'happily ever after'. The marriage of Bluebeard and his wife, haunted by suspicion, betrayal, and homicidal impulses, troubles the serene marital bliss represented at the end of many fairy tales. Despite the many unattractive features of the story— its chamber of horrors and raised scimitars—our cultural fascination with it remains constant, if unconscious. Although few can recite its plot, 'Bluebeard' leads a robust subterranean life, surfacing from time to time in explicit ways to remind us that it is a story that refuses to go away.

Willa Cather once declared that there are only 'two or three human stories, and they go on repeating themselves fiercely as if they had never happened before.'[1] Each of us might have a different candidate for those two or three stories—the dramas of Oedipus or Hamlet, the tales of Eve or Cassandra, the adventures of Jack or Odysseus—but the repertoire of human stories still seems at times astonishingly limited. Cather implies that we are doomed endlessly to repeat ourselves, that there are certain timeless, universal stories that we constantly replay in our cultural imagination without ever working through or transcending their terms. Betrayal and revenge, transgression and punishment, leaving home and coming back—these seem to constitute themes that are perpetually present in the narratives produced by every culture.

And yet, if we tell one of these 'human stories' to someone from another part of the world, it quickly becomes evident that traditional tales exist in many different versions, that my Jack is not exactly like Ivan or Hans and that my Cinderella bears only a passing resemblance to Yeh-Hsin or Mufaro's Beautiful Daughter. Fairy tales have an extraordinary cultural elasticity, expanding to accommodate new details and contracting to eliminate foreign elements. They rarely repeat themselves, for each new voice adds a new inflection or adds a new twist or turn to the traditional path. Their expansive range and imaginative play guarantee that listeners and readers will never tire of listening or reading. Italo Calvino once declared that the beauty of a story derives from the addition of new elements. Each telling of the story recharges its power, making it hiss and crackle, but only when new narrative energy is added. As J. R. R. Tolkien put it, 'the Cauldron of Story has always been boiling, and to it have continually been added new bits, dainty and undainty.'[2]

'Bluebeard' is one of those stories that has fiercely repeated itself even as it indulges in narrative promiscuity, combining and commingling with other stories, splitting off from itself and merging with other plots to create new versions of itself, always changing as it reproduces itself. The tale's transformative energy has guaranteed its survival but it has also led to a cultural afterlife that takes the form of repression, for the story often flashes out to us in nothing more than bits and pieces—a barbaric husband, a curious wife, a forbidden chamber, a blood-stained key, or corpses in a hidden chamber. Often the chief elements remain intact, but disguised in ways that make them recognizable only when we approach the new form with the old tale clearly in mind. Jane Campion's *Piano* may have been an obvious adaptation of the story, but few critics saw the shadows of the Bluebeard story in the film or took the trouble to refer to the folktale in their reviews.

That the story of Bluebeard and his wife continues to be recast, rewritten, and adapted suggests a certain cultural resilience, and yet the name 'Bluebeard' often elicits a blank stare or an erroneous association with piracy on the high seas (the wealthy Frenchman is often confused with the seafaring Blackbeard). Despite the prominent position that 'Bluebeard' occupies in the cultural archive of the West—the number of writers, artists, and musicians with Bluebeard skeletons in their closets is staggering—most adults seem only dimly aware of the plot outlines of the story. Dismissed as a tale of antiquarian interest, it is thought to belong to another time and place.

The Bluebeard story, like the character whose life it stages, exhibits an uncanny repetition compulsion. Driven by the need for variation, Bluebeard and the tales formed around him endlessly repeat themselves even as they enact the mechanism of repression. Just as Bluebeard conceals his dead wives in a remote chamber, his story has become part of our cultural unconscious, closeted away and yet, like the dead wives, remaining a haunting presence.

Margaret Atwood once warned that we should never ask for the 'true story', for stories are always 'vicious, multiple and untrue'.[3] Nothing could be closer to the truth about folklore. When it comes to folktales, there is no authoritative, original version. We have only variants, 'multiple' and 'untrue', each unfaithful to the previous telling and inflecting the plot in a slightly different way. And yet all the variants—whether on screen, on stage, or in books—can lay claim to unwavering fidelity to their own time and place. In every sense, we are right to perpetually reinvent the story, for the 'true' one fails to ring true to our cultural values.

'Bluebeard', true to its self-reflexive nature, takes up questions of fidelity and invites us to consider how infidelity engages our critical faculties, obliging us to rethink the terms of the tale and endorsing creative acts of investigation, disruption, and improvisation. If repression and repetition are the hallmarks of Bluebeard's life, investigation, disruption, and improvisation are aligned with his wife, a figure who, in her latter-day incarnations, cannot rely on her brothers for rescue. The woman known as Fatima in nineteenth-century versions of the tale may not take an active role in her rescue, but her twentieth-century cinematic counterparts take on agency in startling new ways.

Although there are numerous films with the name Bluebeard in their titles (made by filmmakers ranging from George Méliès and Ernst Lubitsch to Claude Chabrol and Edward Dmytryk), there are even more films that take up the terms of the story without invoking its title. These films almost consistently focus on the efforts of the wife to extract herself from a life-threatening situation, to find a way to end the repetition compulsion ceaselessly performed by the husband. In the 1940s, Hollywood produced more than a dozen films modelled on the Bluebeard plot. The titles, ranging from *Suspicion* and *Caught* to *Experiment Perilous* and *Undercurrent*, imply risk, describing a menace that has been captured by one critic in the sentence 'Someone's trying to kill me, and I think it's my husband.'[4]

Before turning to an earlier era, let us look at one contemporary re-scripting of the Bluebeard plot as evidence that the story is very much

alive in our own culture. Jane Campion's film *The Piano* (1993) contains within it a scene from a pantomime version of 'Bluebeard'. Sword in hand, Bluebeard is about to decapitate his seventh wife as he stands next to a bloody display of the heads of his previous wives. The play within the film mirrors the violence in the marriage between Ada McGrath, who has travelled to New Zealand with her daughter as a mail-order bride, and Alisdair Stewart, a strait-laced settler who regards Ada as his property. But it also encourages us to meditate on the richly nuanced relationship between the folktale and the cinematic context in which it is embedded.

The Bluebeard folktale, as staged in the shadow pantomime, is so palpably real to the Maori tribesmen who witness it that they storm the stage to disrupt the performance, bent on rescuing the hapless wife from an axe-wielding tyrant. At first blush, this episode seems designed to highlight the naiveté of the Maoris, revealing that they are unable to distinguish a representation from reality. Yet is also serves as an interesting parallel to how Campion herself disrupts the folkloric tradition of Bluebeard narratives through her cinematic intervention. As subsequent events make clear, the play pantomimed in the film foreshadows in a strangely literal sense the very real violence that follows in the wake of its performance on stage. Unlike Stewart, who is enthralled by the actions on stage, the Maoris recognize that those actions have a contagious force that can contaminate reality.[5]

In a sense, one of the fatal effects of the Bluebeard story has to do with its habit of inspiring fascination and imitation rather than intervention and adaptation. At the performance of the folktale, Stewart is transfixed, gazing with more visual pleasure than dread at the tableau played out before his eyes. This visual curiosity becomes his undoing, for it marks him as a man who is profoundly alone in his desires, transfixed by what he sees but unable to release himself from the prison house of visual pleasure.

The Maoris may, in the end, prove to be the shrewdest readers of the play, but Ada herself, as a musician, aligns herself with those who understand the importance of expressive performance. Moving from playing the keys (can there be any doubt that Campion was punning on the key in Perrault's story?) on the piano to establishing intimacy through physical touch, Ada learns to resist the lure of the 'darkness all around' and the 'great stillness' of the oceanic depths into which she is pulled by the piano. Unlike Stewart, she makes a connection that releases her from the spell of the Bluebeard story.[6] Experimenting even

as she offers up resistance, defying her husband even as she succumbs to pain, and improvising even as she obeys cultural dictates, Ada emerges triumphant to live happily after with Baines.

When Alfred Hitchcock made *Notorious* in 1946 (1.1), he may not have had the Bluebeard story in mind, but he managed to take up its terms in ways that are oddly prophetic about the direction it was to take in the latter part of the twentieth century. Alicia, the woman to whom the attribute 'notorious' is attached, is framed from the start as the target of the male gaze. As she leaves the courtroom where her father has been sentenced to prison for Nazi espionage, she is engulfed by reporters and photographers seeking to capture her response. 'Notorious' both for her own loose ways and for her father's politics, Alicia is persuaded to redeem herself and prove her patriotism by assisting in a spying operation. Through the activity of surveillance, she reverses the gaze, turning her eyes on a circle of men who are unaware of her double role.

Alicia becomes an arch-investigator, rising to every challenge assigned her, including the securing of a marriage proposal from one of the Nazi ringleaders. Once in the marital home, she succeeds in procuring the keys to the rooms and closets of her husband's house. But like Bluebeard's wife, she is denied access to one critical space.[7] We see Alicia, accompanied by the butler, opening one door after another until she is finally stopped at the door to the wine cellar, the forbidden space she must enter in order to accomplish the mission of fathoming her husband's scientific secrets. Alicia becomes the consummate dissimulator, so adept at deceit, duplicity, and disguise that she fools her husband, Alex Sebastian, completely, leading him to believe that she harbours tender feelings for him. In Alicia's moment of supreme triumph, when she succeeds in purloining the key to the wine cellar, she passionately embraces the man who has given her his full trust, putting on display her double political and sexual betrayal.

Alicia becomes an investigator with complete confidence in her powers, a 'notorious' woman who knows how to outwit, out-strategize, and out-manoeuvre her love-smitten husband. But the exuberant confidence in her investigative skills wanes, and even before she is slowly poisoned by Alex's mother, we see her fall prey to very real anxieties about getting caught. As she takes one dose after another of the coffee that turns out to be far more toxic than the alcohol in which she had earlier indulged, she yields the role of investigator entirely to Devlin. Transported by Devlin into the dark, claustrophobic interior of his car,

she turns into a 'sleeping beauty' who is virtually inert in the end. Alicia may succumb to Devlin in the end, but throughout the film she remains in a position of superiority, a knowing wife who is never in the dark in her husband's mansion and ensures that his secrets come to light.

Fritz Lang's *Secret beyond the Door* (1948) [see also Chapter 7, in this volume], like Hitchcock's celebrated film, draws the viewer into a cinematic world shaped by the Bluebeard plot (1.2). But the German director, who likely had more than a passing acquaintance with Perrault's fairy tale, works self-consciously with the folkloric subtext, developing constant explicit points of contact with the Bluebeard narrative and positioning the heroine as a canny investigator of both the murderous secret locked in a physical space (room number *seven* in the marital home) and the traumatic secret locked in her husband's mind. As Celia does her Freudian detective work in *Secret beyond the Door*, she is ever more aware of the risks to which she is exposing herself, yet she perseveres. Like Dr Petersen, the 'love-smitten analyst playing a dream detective' in Hitchcock's *Spellbound*, Celia must unlock the door to a childhood memory and show how it is the source of the hero's psychosis.

The epigraph to *Spellbound* reveals just how intimately the knowledge system of psychoanalysis is linked to a mythic discourse connected with the stories of Bluebeard's wife and of Pandora. Psychoanalysis becomes the key to decoding trauma, a deeply analytic investigative move that opens up a space containing forbidden impulses. But psychoanalysis, in bringing those evils to the light of day, also exorcizes them. *Spellbound* opens with the following words on screen:

> Our story deals with psychoanalysis, the method by which modern science treats the problems of the sane. The analyst seeks only to induce the patient to talk about his hidden problems, to open the locked doors of his mind. Once the complexes that have been disturbing the patient have been uncovered and interpreted, the illness and confusion disappear, and the devils of unreason are driven from the human soul.[8]

Secret beyond the Door initially puts Celia in charge of the narrative and the events that unfold in it. Her voice-over ensures that we see events from her point of view, from the flashback giving us the particulars of her family history to the moment when we hear an off-screen scream

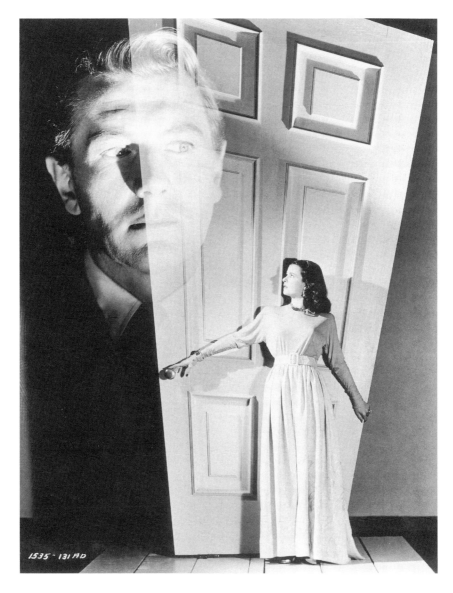

1.2 Publicity Still for *Secret Beyond the Door* (Fritz Lang, 1948). Reproduced
 courtesy of the British Film Institute Stills Library, London.

that seems to signal her death.[9] Once Celia opens the door to room number seven, she possesses knowledge of her husband's murderous intent and lives in perpetual fear that Mark will turn on her. When it appears that Mark has indeed made his homicidal move, his voice takes over, relating the events that lead to the avoidance of tragedy and to the installation of a postnuptial happily-ever-after ending.

Operating as an expert detective, Celia, like Alicia, secures a key to the forbidden chamber in her marital home. Armed with a flashlight and key, she enters the secret space constructed by her architect husband. Through her voice-over, Celia had already dominated the narrative in acoustic terms. Now she takes full charge of the cinematic apparatus through her control of light and of the path it takes through the house, a path that will lead directly to door number seven.

Reading *Secret beyond the Door* as a successful investigative project, one that begins with a dark, Oedipal secret and ends with its disclosure and effacement, has a certain seductive appeal, particularly since this reading would buttress the view that the Bluebeard plot can serve as a gendered master narrative of the psychoanalytic process, with the husband as analysand (suffering from repression and repetition) and the wife as analyst. Yet this reading misses the disturbing elements in Celia's character, the ways in which her passion for Mark is tainted by a dangerous mix of erotic and destructive desires. Richard Maltby has described the protagonists of film noir—and Celia is the female noir detective par excellence—as 'less than perfect, frequently neurotic, sometimes paranoid'.[10] In the female noir, the women are, like their male counterparts, strangely immobilized, despite their investigative vigour. Slavoj Žižek has observed that the '*noir* narrative reduces the hero to a passive observer transfixed by the succession of fantasy scenes, to a gaze powerlessly gaping at them: even when the hero seems "active", one cannot avoid the impression that he simultaneously occupies the position of a disengaged observer, witnessing with incredulity the strange, almost submarine, succession of events in which he remains trapped.'[11]

Combining cerebral investigative powers with dark romantic desires, the women in Bluebeard films use their brains to penetrate the secret pathologies of the men they love and to dismantle sophisticated defences against intimacy. Their aim is to shift the site of affective investment from espionage (as in *Notorious*) and childhood trauma (as in *Secret beyond the Door*) to the marriage partner of the opposite sex. Yet while these films highlight the heroine's spirit of adventure, curiosity, and desire for knowledge, they also freely indulge in spotlighting her

terrorization and victimization. For Linda Williams, the woman's investigative gaze is punished by representational practices that turn curiosity and desire into masochistic fixation.[12] Nowhere is this more evident than in Francis Iles's *Before the Fact*, which, unlike Hitchcock's *Suspicion* (the film it inspired), ends with Lina's death. In its last chapter, Lina lies in bed, indulging in self-pity, yet at the same time submitting to her own murder by swallowing the poisoned draught Johnnie gives her:

> Lina flung herself down among the pillows. Let him then! Quickly! If Johnnie could do that, Lina no longer wanted to live.
> She burst into a torrent of sobbing.
> No, it was impossible. Johnnie could not be going to kill her. Not Johnnie [...].
> At any moment Johnnie might come in—break the door down and kill her in her own bedroom: throw her out of the window on to the flagstones below and say she had fallen—anything. At any moment Johnnie might come and kill her; and what was she going to do?[13]

Bluebeard films stage a double movement between agency and victimization, between a sense of adventure and timidity, between investigative curiosity and masochism, always within the confines of marriage.

Campion, Hitchcock and Lang alike position women as active bearers of the gaze and as detectives, analysts, or interpreters, but they simultaneously ensure that those investigative powers, analytic skills, and interpretive talents are confined to the site of domesticity, restricted to problem-solving within the context of a marriage. For this reason, the happy endings are often a letdown. When the secrets beyond the door to marriage are solved, there is real closure. The woman who has passed beyond the door is now permanently encased behind it, with nothing left to investigate, analyse, and interpret once she has figured out what is behind or at stake in her husband's threatening behaviour. No more secrets, no more mysteries, no more adventure. And this, above all else, can become the real curse of living happily ever after.

Over the centuries, the centre of gravity for the Bluebeard narrative continues to shift, with repression and repetition serving at times to stabilize the plot, and with curiosity and improvisation taking over the narrative work at other times. Bluebeard is a story that ceaselessly meditates on its own terms through its telling, which can range from faith-

ful repetitions of earlier narratives to playfully transgressive improvisations. Just as the history of the narrative maps a move from compulsive repetition to creative improvisation, so the interpretive history of the tale moves in unexpected directions, beginning in the seventeenth century with a focus on Bluebeard's wife and her sins and ending in the twentieth with an emphasis on the emancipatory potential of the tale.

When Charles Perrault published the tale of Bluebeard in his *Stories or tales from past times with morals* (*Histoires ou Contes du Temps passé avec des Moralitez*) in 1697, he crafted two different morals to it. The first of the two morals concerns the perils of curiosity and points out the high price of satisfying that urge:

> Curiosity, with its many charms,
> Can stir up serious regrets;
> Thousand of examples turn up every day.
> Women give in, but it's a fleeting pleasure;
> Once satisfied, it ceases to be.
> And always it proves very costly.[14]

Curiosity is coded as a feminine trait, one that has its 'attractions', not the least of which is the 'pleasure' it provides. The moral encapsulates a concise cost–benefit analysis, pointing out that the high price for satisfying curiosity never compensates for the small dose of pleasure afforded by it. Restraint, constructed as the product of reason and logic, is consequently affiliated with the authority of the male narrator, who has marked its opposite as a supremely feminine trait.

The 'other moral' appended to 'Bluebeard' is less a moral than a disavowal of any lessons transmitted in the tale about husbands:

> Take the time to stop and think,
> And to ponder this grim little story.
> You surely know that this tale
> Took place many years ago.
> No longer are husbands so terrible,
> Demanding the impossible,
> Acting unhappy and jealous.
> They toe the line with their wives.
> And no matter what colour their beards,
> It's not hard to tell who is in charge.

If women's curiosity formed the subject of the first moral, men's behaviour would logically serve as the subject of the second moral. One would hence expect a commentary on Bluebeard's vices to follow the meditation on the failings of his wife. While the wife's curiosity is seen as a quintessentially feminine trait, Bluebeard's behaviour is framed as exceptional, deviating from the norm of masculine behaviour. The second moral insists that no husband today has the 'terrifying' qualities of a Bluebeard. It discredits the notion that men could draw any lessons at all from his behaviour. Quite to the contrary, men today are obliged to ingratiate themselves with their wives, and, these days, it is not hard to tell which of the two is 'master'.

Perrault's two morals are not only nearly mutually exclusive (the one prescribing correct conduct by endorsing a limit to women's innate desire for knowledge, the other proclaiming that women are free agents and reign supreme), they are also not at all congruent with the story's plot. But for Perrault, it was not unusual to preach about matters not practised in the tales. We need only turn to his 'Donkeyskin', a tale about a girl who has to ward off her father's incestuous advances, to get a clear sense of how the lessons attached to the tales of Mother Goose do not square with the facts of each plot. The conclusion to the account of Donkeyskin's flight from her father and of her marriage to a prince stresses, in the mode of high nonsense, that 'clear water and brown bread are sufficient nourishment for all young women provided that they have good habits, and that there is not a damsel under the skies who does not imagine herself beautiful'. What we have here can hardly be described as a clear sense of the moral drift to the tale. The narrator not only disavows the issue of incest and the daughter's courage in deflecting her father's amorous advances, but also dismantles the notion that the story has any message at all by engaging in self-parody through the proliferation of irrelevant messages.

Folklorists have shown surprising interpretive confidence in reading Perrault's 'Bluebeard' as a story about a woman's failure to respond to the trust invested in her. The homicidal history of the husband takes a back seat to the disobedience of the wife. 'Bloody key as sign of disobedience'—this is the motif folklorists consistently single out as the defining moment of the tale. The bloodstained key points to a double transgression, one that is both moral and sexual. For one critic it becomes a sign of 'marital infidelity'; for another it marks the heroine's 'irreversible loss of her virginity'; for a third it stands as a sign of 'defloration'.[15] Bruno Bettelheim's reading is representative:

When the male gives the female a key to a room, while at the same time instructing her not to enter, it is a test of her faithfulness to his orders, or, in a broader sense, to him. Then these males pretend to depart to test their partner's fidelity. Returning unexpectedly, they find that their confidence has been betrayed. The nature of the betrayal may be guessed by the punishment: execution. In certain parts of the world in times past, *only one form of deception on the female's part was punishable by death*: sexual infidelity.[16]

If we recall that the bloody chamber in Bluebeard's mansion is strewn with the corpses of previous wives, this reading of the bloodstained key as a marker of sexual infidelity becomes wilfully wrong-headed in its effort to vilify Bluebeard's wife.

Bluebeard's repetition compulsion seems to have tainted the critical arena, with Perrault's morals perpetuated by virtually every interpreter of the story up until the 1940s. And just as repression operates in the story to produce distortions, so too the move to act as if the husband's test of obedience is the only motif that matters in the tale created, for many decades, troubling interpretive results. Bluebeard's curse seems to have been lifted only of late, with attention paid to how the wife's curiosity may indeed be viewed as having redemptive possibilities.

In order to explore the full potential of the tale, it is important to consider carefully how the language of fairy tales operates in special ways, particularly when it is a matter of the curses and wishes uttered by characters with magical powers. How do those kinds of expressions affect what happens in the tale? We have seen how the tale enacts a dialectic of mobility and restraint, sounded first when Bluebeard tells his wife: 'Open anything you want. Go anywhere you want,' then warns her: 'I absolutely forbid you to go into that one room—if you do, my anger will know no limits.' Vladimir Propp educated us long ago about how interdictions function as commands.[17] The enunciation of a prohibition inevitably turns into an invitation to engage in a transgression.

The curses, threats, spells, wishes, and charms of fairy tales are deeply connected to what J. L. Austin termed 'performative language' in his landmark work *How To Do Things with Words*. As important as it may be to engage with the complexities of the many critiques, commentaries, and responses to Austin's work from John Searle, Jacques Derrida, and Judith Butler,[18] Austin's insights about how the uttering of certain words is 'usually a, or even *the* leading incident in the performance of the act' represent the pertinent point for the spells uttered in

fairy tales.[19] Think of the Grimms' Cinderella, who tells a tree to shake its leaves and produce silver and gold and—no sooner said than done—the dress is hers to wear to the ball. Or the Goose Girl, in the tale of that title, who invokes the winds, conjuring them to blow away the hat of the boy annoying her. Her words too are translated into action. Nearly all the fairy-tale transformations from man into beast derive from a curse, and, in many cases, wish-fulfilment requires only words rather than caps and wands.

In fairy tales, magical thinking reigns supreme, and the performative is often linked to the transformative. The uttering of certain words in certain contexts produces real physical change. If Austin's version of the performative exists anywhere in an uncontested form, it is in the enchanted world of the fairy tale, where thoughts, wishes, and curses can be realized more easily than anywhere else. Curses, spells, charms, and wishes show the power of the mind over matter and can be seen to confirm our worst suspicions about magical thinking—that thinking can make it so and that our mere thoughts can reach out to transform reality. And yet the fact that the power of words to work magic reveals itself to be limited to the realm of fairy tales—'Open Sesame' opens no door in the real world—may be the most powerful possible way of giving the lie to magical thinking, for children soon learn that those phrases operate successfully only in the world of fiction.

We know that Bluebeard's prohibition has the power to move his wife, to tempt her to violate the very interdiction he has issued. The prohibition functions as a provocation, leading the wife to engage in precisely the act that has been forbidden to her. There is one other moment in the text when words have an almost magical power, seeming to invoke precisely what is desired. Before her impending execution, Bluebeard's wife calls out to her sister, whose existence in Bluebeard's castle has been suppressed up until the moment when we hear the words of the desperate wife: 'Sister Anne, Sister Anne, can you see anyone coming?' Those words work magic, for the triple relaying of the question leads not only to the triple scanning of the horizon but also to the materialization of the brothers, who are sent a signal to hurry and who appear in the nick of time to rescue their sister.

'Bluebeard' may send many different messages and offer many forms of folk wisdom and counsel (as Walter Benjamin emphasized in his essay on the power of storytelling), but if it imparts any lesson at all through its rescue scene, it is that you have the power, through words, to summon help.[20] If early versions of the tale presented Bluebeard's

wife as the agent of her own rescue (she dispatches a pet dog carrying a letter in its mouth or trains a talking bird to say the right words), literary versions like Perrault's propose that it is through words and the relaying of messages that the wife's salvation lies.

The performative utterances embedded in 'Bluebeard', like the repetition compulsion found in it, become self-reflexive. Like the words chanted by Bluebeard's wife, the words used to tell the story of Bluebeard have a transformative power. Marjorie Bard has called attention to the need of those under duress to engage in a practice she calls 'idionarrating'—talking to yourself as much as to others and using words to get your story 'out there'.[21] If we reflect on that fact that certain Bluebeard variants produce a *mise en abyme* effect by including the broadcasting of abuse in a tale of abuse, then it becomes evident that storytelling can become a kind of double performative event, both enacting an event and precipitating action that will change its terms. The Grimms' 'Robber Bridegroom' ends with the bride narrating her own story at her wedding feast: 'I will tell you about a dream I had,' she reports to the assembled guests. In the British tale entitled 'Mr Fox', the title figure becomes anxious when he sees his wife's pallor. At the wedding breakfast, he makes anxious inquiries about the health of his betrothed, and she replies: 'I had a bad night's rest last night. I had horrible dreams.' Mr Fox makes the mistake of pressing for more information: 'Tell us your dream.' When the bride tells her story, the assembled guests are outraged and murder Mr Fox.

The story of Bluebeard, much as it can be framed as a tale about homicidal violence and its repression and repetition, also has an emancipatory potential in its invocation of the performative as a source of transformation. In 'Bluebeard', liberation comes when the brothers are summoned with calls for help. In 'The Robber Bridegroom' and 'Mr Fox', it is the telling of a story that breaks a tyrant's hold. Like Dorothy Gale in *The Wizard of Oz*, the heroines of fairy tales discover that magic is embedded not in the world but in words. The Wizard in that 'modern' fairy tale (as Baum called it) may prove to be a charlatan or 'Great Humbug', but even after he has been exposed as a fraud, he still possesses a 'magic art' and is able to give the Scarecrow brand-new brains, endow the Woodman with a heart, and fill the Lion with courage. For Dorothy, and the children reading her story, all adults possess wizardry in their control over symbolic forms of expression—they can create illusions, effect changes, and take on agency through words. Oddly, even as the fairy tale debunks magical thinking (the existence of mighty

wizards who can work magic), it also affirms the magical power invested in language—the power to shape yourself and others through words. 'Take me home to Aunt Em'—these are the words that Dorothy uses to transport herself back to Kansas, and those words carry as much weight as the silver shoes of the book or the ruby-red slippers of the 1939 MGM film.

Real-world effects come through the discovery that words have the power to construct our cultural values, attitudes, and ideals. In an essay reflecting on her reading of the Grimms' fairy tales as a child (she read a volume that had 'every bloodstained axe, wicked witch, and dead horse' in place), Margaret Atwood concluded her reflections on the vertiginous effects of reading fairy tales by asking: 'Where else could I have gotten the idea, so early in life, that words can change you?'[22]

Trust, fidelity, commitment, and reliability: these never disappear from the scene, nor do betrayal, abandonment, and capriciousness. And so Bluebeard is, in many ways, here to stay. Our Bluebeard need not resemble Perrault's foundational story, but instead take from it a set of ingredients that are measured out in new doses and proportions to keep the cauldron of storytelling constantly bubbling.

2.1 Gustave Doré, Drawing for 'La Barbe Bleue', from *Les Contes de Perrault, dessins par Gustave Doré*, *c*.1868, pen and wash on paper, Hermitage, St. Petersburg, Russia/The Bridgeman Art Library.

2

BLUEBEARD, HERO OF MODERNITY
Tales at the *Fin de Siècle*

Mererid Puw Davies

In Frank Wedekind's play *Spring Awakening* (1891), emblematic of *Jugend-stil* art and some key currents in contemporary European culture, the teenager Hänschen Rilow performs a melodramatic monologue in the lavatory as he flushes away a reproduction of a painting of a nude Venus. He tells her: 'There's something tragic in the role of Bluebeard. All his wives put together didn't suffer as much when he strangled them as he did each time!'[1]

In his speech, Hänschen reveals that his interest in the Venus image is less aesthetic and intellectual than pornographic. He also reveals that the Venus is the latest in a long line of such reproductions which he had first treasured and then destroyed. Hänschen stylizes this collection of nudes as his harem and its serial destruction as *crimes passionnels* or sexual murders. This comic scene in *Spring Awakening* may be read both as an anticipation and, paradoxically, as a parody of a sea-change in tellings of 'Bluebeard' which becomes noticeable in versions of the tale in German from 1905.

Such tales as 'Bluebeard' are constantly refigured to reflect issues in the contemporary world. Thus, European Modernity offered a variety of new possible tellings of 'Bluebeard', of which the opera *Duke Blue-beard's Castle* is one. This essay highlights the broader context of this particular version, with its libretto by Béla Balázs, an Austro-Hungarian from a 'predominantly German cultural background'.[2] I shall look at the way the Bluebeard material was made into a modern, and Mod-

ernist, tale around the turn of the nineteenth century, and how, different as the German-language texts to be discussed here are from the opera in some ways, they are also closely linked with it.

The story so far

The tale of Bluebeard first emerges in German in the late eighteenth century, and its model is Charles Perrault's 'La Barbe Bleue' (1697) (2.1).[3] Perrault's *conte* is a complex, riddling account of contemporary *mores* which can arguably be read as a proto-feminist, even joyful account of the overthrow of patriarchal authority; the end of a cycle of vicious violence; and the triumph of a curious woman which flies in the face of traditional Western narratives about women and knowledge based, *inter alia*, on the Genesis myth itself. By contrast however, the canonical German Bluebeard tradition as represented by the best-known versions, those of the Brothers Grimm (1812) and Ludwig Bechstein (1845), emphasized an enforcement of patriarchal authority, legitimized by a supposed return to an idealized, medieval man's world.[4] Nonetheless, nineteenth-century Germany also knew a different, comedic, and more genuinely popular Bluebeard tradition. In that tradition, Bluebeard's violence was eradicated, and his cruelty exposed as a mere old wives' tale. Nonetheless, such tellings were not necessarily emancipatory for their women characters (or readers). Rather, by relocating Bluebeard's violence in the mind, they marked a shift to more modern forms of oppression which operate psychologically rather than physically, for example through the internalization of a model of the love match in which a woman must submit willingly and completely to her husband. Such control is not as easily overthrown as that practised by a violent husband who may be simply disposed of by summary execution, and his reign of terror ended.

The group of new German-language literary texts from the turn of the century to be discussed here returns, however, to a gorier vision of the tale. The years 1905–13 produced an unusual quantity of Bluebeard texts in German.[6] Moreover, in terms of content also, these texts are remarkable, since they are unprecedented in the merciless, consistent savagery which they direct at women. In addition to Hänschen Rilow's monologue quoted above, this group of texts includes Herbert Eulenberg's *Sir Bluebeard: A Tale in Five Acts* (1905); Georg Trakl's fragmentary *Bluebeard: A Puppet Play* (1910); Karl Schoßleitner's *Prince Bluebeard* (1911); Reinhard Koester's poem *Sir Bluebeard* (1911); Alfred Döblin's

Sir Bluebeard (1911); El Hor's short prose text *Sir Bluebeard* (1913); and Georg Kaiser's play *Gilles and Jeanne* (1922).[7]

By and large, these texts are forgotten today. Even to German scholars, only *Spring Awakening* is well known. Eulenberg's play, however, was the subject of much scandal on its opening night, and inspired a more successful, but now equally forgotten opera of the same title by the neo-romantic Austrian composer Emil Nikolaus von Reznicek in 1920. Kaiser and Döblin are celebrated Modernist writers, but not for their Bluebeard texts; and while Georg Trakl is well known today as an Expressionist poet, his fragmentary puppet play, unpublished during his lifetime, remains obscure. Nonetheless, remarkable consistencies between all these texts indicate that they articulate something central to views of Bluebeard and associated themes in German-speaking areas at that time.

In Eulenberg's play, Bluebeard Raul is a violent, introspective man who kills five wives and two sisters, Judith and Agnes, before being killed in turn by their relatives. In Schoßleitner's story, Prince Bluebeard is the son of the original Bluebeard, a king in this version. Prince Bluebeard first kills the woman he loves because he is terrified of intimacy with her, and subsequently becomes increasingly like his father, murdering a further series of women, and finally destroying himself and his kingdom. Koester's poem of nine lines is a brief psychogramme of a super-Bluebeard who loves and desires more than other men. El Hor's short prose text or prose poem consists mainly of a short dialogue between Bluebeard and a nameless woman in which he informs her that he is going to kill her. The woman, smitten by an unconditional, masochistic love for Bluebeard, is delighted and Bluebeard realizes that she would suffer more if he were to imprison her. The woman dies in his (phallic) tower, writing in blood on her clothes: 'I love you, my dear master.'[8] Bluebeard, however, is unable to destroy her persistent, sickening love and is, therefore, driven to suicide himself. In Döblin's story, the Bluebeard figure, Baron Paolo di Selvi, builds a castle on a cliff edge by the sea in which three successive wives mysteriously die. The fourth woman, the adventuress Miss Ilsebill, discovers a secret chamber in the castle and learns from an old man that Paolo 'had sold himself, body and soul, to an evil monster. From time immemorial, it had lain on the old sea bed where the heath is now; it lived in the rock and needed a human being every couple of years. It sounded like a fairy tale, and yet it was true'.[9]

Ilsebill plans to leave and destroy the castle. But she is attacked by a sea monster and literally disappears into thin air. In Trakl's horrific, yet possibly also comic, fragment, Bluebeard marries the fifteen-year-old Elisabeth and then kills her in an evidently sexual murder. Finally, Kaiser returns to a speculative tradition which linked Bluebeard to the historical figure Gilles de Rais (1404–40), a *maréchal de France* who fought with Joan of Arc.[10] In this version, Gilles is plagued by unrequited desire for the virginal Jeanne so that, in his frustration, he accuses her of witchcraft, thus ensuring her execution. Later, Gilles employs an alchemist to recall Jeanne from the dead. The alchemist, however, tricks Gilles by kidnapping six young women and disguising them as Jeanne. Gilles kills these women in turn too, and when he confesses to the murders before a religious tribunal, he is celebrated as a hero and goes to the stake 'for all our sakes'.[11]

Time and topography

One striking feature which nearly all these texts share is their setting in a fantastic past, most often a version of the French or German Middle Ages. Just as Wilhelm Grimm's editorial interventions in the *Children's and Household Tales* one hundred years before were a rejection of a disturbing present, so these texts react against an increasingly threatening, technological Modernity accompanied by all kinds of societal and symbolic changes. Setting the tale in the past deflects attention away from any possible contemporary relevance of its content and imbues them with the (spurious) authority of historical and moral authenticity.

The topographies of these texts are also strikingly similar. Perrault set his tale in a contemporary *grand bourgeois* home, and it was only in the eighteenth and nineteenth centuries that the German tale began to be set in a medieval castle. That convention was, however, fully established by the end of the nineteenth century, and it has been argued that the use of the medieval, aristocratic castle is another distancing strategy designed to deflect attention from contemporary bourgeois man.[12] Furthermore, the castle and its topography become an increasingly important symbol of the psychological issues involved. Bluebeard's house in such earlier versions of the tale as Perrault's was important as material proof of Bluebeard's wealth and status. But in these texts, Bluebeard's home has become a cipher for his psyche. In the first scene of Eulenberg's play for example, one of the characters describes Bluebeard's castle as follows: 'it filled me with dread, how all at once […] this cas-

tle leapt at us, with its dark windows that glared at us.'[13] These dark windows are the very windows of Bluebeard's soul.

In earlier versions of the narrative too, there was no indication in such texts that the forbidden chamber or other parts of Bluebeard's home were underground.[14] But the typical relocation in these texts of the forbidden chamber underground is closely linked with this reinvention of the castle as Bluebeard's psyche, since underground spaces are traditionally used in literature to represent the secret regions of the mind. For example, in Döblin's story, the ominous secret room which Ilsebill discovers is not part of the castle structure itself, but dug deep into the cliff behind it; and in Kaiser's play, Gilles's murders take place in a cellar. These developments explain why, too, in those many texts where Bluebeard is destroyed, his castle is generally destroyed too, because he and his castle, or psyche, are inseparable. And when these castles are destroyed, the agent is always fire.[15] In the pre-modern era in which most of these texts are set, being burnt was a traditional punishment for heresy and witchcraft: that is, for crimes which concerned the soul rather than the body. Thus, the burning of the castle and Bluebeard along with it ties in with the increasing psychologization of Bluebeard texts during the High Modernist period.

Bluebeard's women

Bluebeard's women share significant similarities in the texts in question here; and here too, there are striking changes to the familiar versions of the Bluebeard tale. Traditionally, the female protagonist, and her experiences, choices and fears had been the major subject of narrative interest. Here, however, the women characters are distinguished above all by their dispensability, marginality, and often their namelessness. Significantly, in Hänschen's monologue in *Spring Awakening* for example, the putative lovers are not women at all, but cheap, dispensable, mass reproductions of paintings. In other words, they are easily available, replaceable images that are at several removes from the real women who modelled for the original paintings copied in the prints. And even in the cases where the women *are* named, their characterization remains schematic, stereotypical or inconsistent.

Nonetheless, the texts blame women either directly or indirectly both for their own fate and that of Bluebeard. Within this larger pattern, even absent mothers are indicted. For example, Schoßleitner's Prince, meditating on his traumatic experience of love, and addressing his dead

father, says: 'You did not choose a good mother for me! It is from her
I have this slave-like baseness that forces me down, to diminish myself
and to cling.'[16] And interestingly, Bluebeard's women are in almost all
cases no longer his wives but his lovers, a factor which helps to incul-
pate them in their own fate. In earlier versions of the Bluebeard tale,
the suggestion that the wife might have committed a sexual transgres-
sion which deserves punishment is only latently present, if at all.[17] But
here, the fact that these women run off with Bluebeard in a manner
which is not socially sanctioned explicitly turns them into sexual trans-
gressors who forfeit their social status and rights. Since Bluebeard's
lovers are drawn to him voluntarily, by love and desire rather than famil-
ial coercion or material expediency as in earlier versions, they may be
deemed to take more of the responsibility for their own fate and pre-
sumably to derive some pleasure from it; and, it is implied, to deserve
punishment for it.

In earlier versions of 'Bluebeard', women were scared or suspicious
of Bluebeard, such that he had to undertake strenuous efforts to per-
suade them to marry him. But here, Bluebeard's attraction is so strong
that he no longer needs to press or even woo these women, as he did
in the earlier versions. This is a masochistic attachment on the women's
part, often provoked by a show of aggression or cruelty. In El Hor's
text, the dialogue between Bluebeard and the woman runs as follows:

> 'Will you kill me?'
> 'Yes.'
> 'Why do you kill women?'
> 'Do not ask.'
> 'When will you kill me?'
> 'Are you afraid?'
> 'No—I love you for it.'[18]

These women consciously put themselves in danger in order to fulfil
their excessive desire to be with Bluebeard and to be oppressed and
perhaps hurt by him.

In other words, the notion that women are to blame permeates all
these texts. In Döblin's story, the peasant who tells Ilsebill about the sea-
monster (which seems to be more female than male, a fact which also
inculpates the feminine) adds: 'If sexual vice and godlessness were not
so great among women now, the poor knight would be free of that

beast.'[19] In other cases however, some women characters are punished for refusing to participate in 'sexual vice'. In Kaiser's play for example, Gilles has Jeanne executed for refusing him. In *Spring Awakening*, Hänschen (ironically) blames his inanimate Venus for her 'inhuman modesty'.[20] In all cases then, it seems that sex and woman, whatever she does, are linked and that she must be punished for this association, either for provoking Bluebeard's sexuality, for responding to her own, or indeed for not responding to Bluebeard's advances.

While these women's lives become less important ethically, their deaths and the sight of dead women become absolutely central thematically, in contrast to the milder, later nineteenth-century tradition. Eulenberg's play dwells in horrible detail on the corpses of the dead wives kept in the cellar, as in the following stage direction for example: '*A vaulted cellar in the castle, bare and cold. Only at the back* [...] *there lie on white dishes five bloody, decayed women's heads.*'[21] And the euphoric effects of murder can be highlighted too, as in Trakl's fragment which ends with the following stage direction to Bluebeard and Elisabeth: 'He drags her down into the depths. A piercing scream is heard. Then deep silence. After some time Bluebeard appears, dripping with blood, and beside himself, intoxicated.'[22]

So not only is murder restored to the plot and given an unprecedented importance, it comes to mark a further break with the Bluebeard tradition to date. The earlier versions in which the last woman survived ended with an emancipatory, utopian or at least an open moment. Here, that openness is eliminated, since in all cases, all the women, including the last, are killed. Also, Bluebeard himself dies in most cases, ensuring an absolute closure. Thus, there is a shift from a comedic plot structure, as in Perrault's text which ends with a new series of marriages, to a tragic structure. This shift is accompanied by a new interest in character, generally associated with tragedy, rather than in the logic of the plot, which is traditionally the province of comedy. The new tragic hero and psychological subject who emerges here is Bluebeard himself.

'A man worthy of tears': Bluebeard as tragic hero

Earlier versions of the material focused not on Bluebeard's, but on the wife's actions, character and escape, with Bluebeard fulfilling a principally mechanical function in the plot. But in this new group of Bluebeard texts that relationship is reversed. When Eulenberg's Bluebeard

Raul dies, another character says: 'That man who had to die was worthy of tears.'[23] This, not regret for the two lost sisters, is the closing note of the play, despite the fact that the speaker is the women's bereaved brother. Similarly, in a theoretical essay written to accompany his story, Schoßleitner portrays Bluebeard as a tragic man because of:

> [t]he fact that he should feel the strongest necessity to kill precisely when this is the hardest thing of all for him, to kill the woman who would suit him best, whom he most loves […] If even this case ends in tragedy, then absolutely no salvation may be expected, for he will get rid of those women who suit him less well, whom he loves less even more easily.[24]

Rather chillingly, it is implied that the tragedy lies in the fact that Bluebeard loses the woman he loves, rather than in the fact that several women are killed, a deadly serious reiteration of Hänschen's comic comment in *Spring Awakening* that Bluebeard suffers more than all his women put together. Here then, Bluebeard's fatal flaw, the desire to murder, acquires a tragic grandeur. He is distinguished by his challenge to the norms of an inferior world and also by his superior spiritual capacities and sensuality. Schoßleitner's Prince Bluebeard complains: 'The world wants mediocrity' and Eulenberg's protagonist is a philosopher of death who rejects all conventional morality, saying: 'We all hate each other. We are simply too cowardly or too lazy to say so.' By contrast, his murders provide privileged existential insight: 'It is through blood that we see into all things. Every knife solves the enigma of blood.'[25] Moreover, in some cases in this group of texts, Bluebeard is even elevated to Christ-like status.

Traditionally, Bluebeard's anti-social behaviour was punished by summary execution. Here however, his superiority puts him above normal moral standards with the result that summary execution takes place only in one case. He more usually commits suicide, or his fate remains open. So even in those cases where Bluebeard is said or supposed to die, either his corpse is seldom shown or the texts end before his death; and he may even be praised as a hero. Such ambivalent endings reflect Bluebeard's new status as a heroic figure who should neither be humiliated nor experience public or private censure. Thus, the figures of Bluebeard and the Nietzschean *Übermensch*, who became a cult figure in the same period, are in close proximity. At the same time, such end-

ings map with my observation that these new versions of Bluebeard are tragic and non-utopian, since there is no foreseeable end to the murderous cycle of violence except through violence done to the self.

Bluebeard and Don Juan

While in earlier versions of 'Bluebeard' the wife's curiosity could be interpreted as a sexual transgression only very speculatively, in these turn of the century versions, sexuality becomes for the first time an explicit issue, since these Bluebeards are not only (anti-)heroic and admirable, but also very sexy. The motif of the blue beard comes into its own as a symbol in this new treatment of the Bluebeard material. No compelling reason has been found in scholarship for the strange blueness of the beard, such that it has been authoritatively suggested that in the very first place, the weirdly blue beard was no more than an invention of Perrault's.[26] Thus, in earlier German versions of the tale, the blue beard could only be understood either as some kind of joke, as in Ludwig Tieck's versions (1797), or an inexplicable mystery, as in the case of the Grimms. Even while the Grimms suggested that a 'Bluebeard' might be a man with a profuse beard, they implied no obviously sexual connotation. From the late nineteenth century onward however, the beard acquired an evident, but new meaning: that of a potent, sexualized and dangerous masculinity.[27] El Hor's text describes the beard in such terms:

> His beard was trimmed to a point and as smooth and gleaming as the coat of a black panther, with a steely blue gleam to it [...] then she laughed and caught in the hollow of her hand the rain water which dropped from his beard and drank it.[28]

Two things are important and typical in this quotation. First, the sexual allusions are very evident. Second, in line with the nineteenth and twentieth centuries' drive to rationalization, a naturalistic explanation is sought for the blue beard, apparently responding to a new need to explain the figure of Bluebeard.

Hand in hand with these developments, the perceived nature of Bluebeard's murders changes, such that they too are explicitly sexualized. For instance, Trakl's Bluebeard announces that he will kill Elisabeth as follows:

Hate, decay and death whip up desire
[…] If I am to possess you wholly, child,
God willing, I must slit your throat![29]

This consistent stylization of Bluebeard's crimes as serial sexual murders is also part of the new attempts to couch the material in naturalist terms. It might be argued that, like the characterization of Bluebeard as an *Übermensch* to whom usual moral standards do not apply, this rationalization is also part of a pattern of exculpating Bluebeard, for it brings his behaviour at least into the range of potentially realistic, rather than fantastic or absent motivation, as in earlier versions. Moreover, if Bluebeard's actions become explicable in human terms, then they are to an extent normalized, or even apparently more excusable.

This new insistence on seriality is a characteristic feature of Modernist culture. For instance, this period saw the rise of the serial detective story in which evil constantly emerges, and must be repeatedly countered, usually by a celibate detective, since sex and evil seem to correlate consistently. The new interest in seriality was also expressed, for instance, in Freud's study *Beyond the Pleasure Principle* (1920), in which, prompted by such modern phenomena as neuroses arising from the Great War, he identified a compulsion to repeat trauma which defied the creative pleasure principle. From this, Freud deduced that a primitive, regressive death drive must lie at the heart of the human psyche, which produces a sadism like that of Bluebeard. Such interest in the repetition of evil marks the twentieth century as a whole and the Bluebeard tradition in particular; and seems to be a response to the new problems posed by Evil after the collapse of a Christian cosmogony, in which Evil was either explicable or redeemable. After the Death of God, Evil was no longer containable and this idea is clearly reflected in twentieth-century treatments of the Bluebeard material which frequently focus on a pathological seriality.

Interestingly, aspects of Bluebeard's new characterization as a sexual serial killer are shared by another celebrated literary figure who haunted thinking about masculinity around the turn of the century: Don Juan. It is striking how, in the literature of the period, persistent associations are made between Bluebeard and Don Juan. In a short article on Bluebeard (1883), Konrad Hofmann noted: 'According to sixteenth-century collections of proverbs, Bluebeard means a man who has a thick, black beard. According to the opinion of that time, such a *Bluebeard*

was held to be a born *Don Juan* and *seducer of women*.'[30] But because Hofmann does not cite any sources (and none can be identified) it may well be, especially in the case of his second claim, that he is presenting a very contemporary idea in the guise of historical fact. In his theoretical essay on Bluebeard, Schoßleitner also associated Bluebeard and Don Juan; and a reviewer of the opera by Reznicek, based on Eulenberg's play, also noted that its protagonist was a Don Juan type.[31]

Both literary figures are, of course, associated with serial lady-killing. One difference remains, however, between the two traditions. If Don Juan uses sexuality in order to conquer femininity and metonymically to rule the world, Bluebeard uses murder. Nevertheless, around 1900 this important difference began to be disregarded and the figures of Bluebeard and Don Juan became explicitly identified. Here, then, serial love affairs and serial murders are perversely condensed into sexual murder.

In this sense too, there is a strategy of subliminal exculpation at work, for murder in this context acquires a less serious aspect and becomes a heroic game. The identification of Bluebeard with Don Juan also implies that the difference between a love affair and sexual murder is quantitative and not qualitative. Yet for the women characters of course, the qualitative difference between the end of a love affair and being murdered is considerable. This point of view demonstrates how absolutely the male protagonist has become the centre of attention, since it is only from his point of view that the similarities could be perceived. And yet, surprising as it might seem, following the lead of these texts, the transformation of Bluebeard into an irresistible lover became quickly accepted by the twentieth century.

The aetiology of the crimes

In the late nineteenth and early twentieth centuries then, authors, critics and folklorists became interested in explaining Bluebeard's motives rationally for the first time, since it was in that period that secondary articles began to appear which sought supposedly to explain the *Blaubartmärchen* and to establish its correct meaning, content, and origin, beginning with Hofmann's article of 1883 quoted above. Such writings reflected the new interest in the figure of Bluebeard himself and perpetuated the attempts to exculpate him by providing (pseudo-) rational explanations for his behaviour and making it appear humanly comprehensible, or even normal, by grounding it, for instance, in social prac-

tice. In this respect, such secondary texts are very similar to the primary texts being discussed here since they, too, focus sympathetically on the motives for Bluebeard's crime and make it appear rational or worthy of pity.

The new desire to explain Bluebeard coincides with the availability of a new idiom with which to describe human behaviour at the *fin de siècle*, namely ideas derived from psychology and specifically, from psychoanalysis. Bluebeard, in this context, represented a fascinating condensation of criminal and analysand as imagined by Freud.[32] These texts' psychological narratives are intimately linked with gender issues. At first sight, they seem to present a schematic view of gender relations and sexual murder in which women are the willing, masochistic objects of sadistic, psychologically complex male violence. But this simple binary view is contradicted by powerful undercurrents in the texts. In fact, in contact with women, Bluebeard senses that the traditional masculine/feminine binarism on which his subjectivity is based is precarious; and this realization precipitates within him a profound crisis of masculinity. Bluebeard cannot suppress his sense of loss of confident selfhood with the result that this issue is the major interest of the texts being discussed here.

Koester's poem sums up Bluebeard's motive most succinctly: 'And if he found himself in that lustful pleasure/desperately demanded by his own blood/flowing over into a woman/he would kill her.'[33] Schoßleitner's Prince Bluebeard fears in the love relationship: 'All this love, this […] flowing away and dissolving—: a raving, lecherous lust to murder one's own self, a staggering through the violent deaths of our own sense of self.'[34] It seems that Bluebeard fears for the integrity of his self which he perceives to be under threat. That threat involves sexuality, most often sex itself, and Bluebeard responds by attacking the woman who catalyses the threat. This consistent fear of a loss of a stable sense of self in the sexual act is repeatedly expressed by means of fluid imagery, the 'flowing over' described by Koester and the 'flowing away and dissolving' in Schoßleitner's text. Similarly, in Döblin's story, the native element of Paolo's monster is the watery ocean.

Such consistent use of the fluid metaphor in connection with the threat to Bluebeard's selfhood is revealing. It recalls the way in which Bluebeard's castles, in these texts, are almost all on elevated sites, especially cliffs, and surrounded by, or near water, especially the sea. Such locations are interesting if the German Bluebeard tale is read as a history of the civilized subject, which is imagined as masculine and con-

stitutes itself by marking itself off from and violently controlling all that it perceives to be its Other, both inside and outside itself.[35] And where that civilized self is often imagined as armoured, solid and defensive, the Other tends to be fluid. The Bluebeard castles in question here involve precisely such imagery, being strongly identified with Bluebeard himself and fortified against the dangerous water outside. Thus, these tellings stage the manner in which the civilized masculine self, which imagines itself to be armoured like Bluebeard's castle, marks itself off from the fluid, feminine Other.[36]

Consequently it is no coincidence that for some of these Bluebeards, the crisis is provoked when they literally take off their medieval suits of armour. These Bluebeards all realize that the armour of the masculine self is vulnerable and repeatedly broken through by desire so that they feel compelled to turn against their lovers who seem both to incorporate and provoke desire. But because this act of aggression is directed against the signified rather than the signifier the murder must be continually repeated. In Freudian terms, such serial killing represents the compulsive repetition of a profound repressed trauma which constantly re-emerges, and this trauma is Bluebeard's discovery of the non-integrity of the self. And in Lacanian terms, to constantly attack the signifier and not the signified, as Bluebeard does here, is a marker of neurosis: here, it seems, of a profound cultural neurosis about masculinity which permeates a whole group of texts.

But what is worse for Bluebeard is that he also senses that he is threatened not only by forces outside himself which provoke his desire and fear, but also by forces that are an inalienable part of himself. Not only does the ocean wash around the castle walls, but it appears within these castles too. For example, Döblin's sea-monster looks feminine and lives within the castle itself, because that castle is located on land which used to be covered by the sea which has now retreated. Or in other words, the feminine or the Other is inside as well as outside Bluebeard. A rigorous division is not possible and Bluebeard is consistently confronted with his own fluid, feminine unconscious, his libido, and other aspects of himself identified as somehow irrational. As a result, Bluebeard's attempts to control or repress the Other by serial murder are doomed to failure. Only a dramatic act of destruction or self-destruction will completely resolve Bluebeard's crisis, since in order to eliminate the alien feminine from his castle, Bluebeard must destroy himself. And to return to the observations above about the mode of Bluebeard's self-destruction, the consistent emphasis on fire may also

involve gender confusion because in the German tale tradition, death by fire is a punishment often reserved for transgressive women.

Bluebeard's crisis is aggravated too by the fact that the women characters in these texts often behave in ways which challenge conventional notions of femininity, thus revealing their bisexuality which is so disturbing for Bluebeard himself. In Perrault's tale of course, the wife is disobedient in opening the forbidden chamber. Such disobedience may be interpreted as a case of mimetic rivalry in which the woman, by making use of the phallic key, challenges traditional gender boundaries. In Eulenberg's play, the very name of one of Bluebeard's partners, Judith, emphasizes this possibility by recalling the Biblical heroine who assumes a masculine role and decapitates Holofernes with his own sword, which conveniently hangs over the bed where he has attempted to seduce her. Or least subtly of all, Kaiser's Jeanne wields a phallic sword. No wonder, therefore, that Bluebeard's masculinity is threatened by these women.

Thus, what is at stake in these modern German texts is the crisis of a masculinity which has become aware of its non-integrity, its persistent openness to desire and the constant possibility that it may take on feminine roles while apparently female figures may suddenly appear bisexual or masculine. This crisis is so profound that it is expressed in terms of tragedy and can be temporarily and compulsively alleviated only by sadistic attacks on women who represent the incontrollable Other within and outside of Bluebeard himself. While earlier versions such as Perrault's, and even the Grimms', permitted the wife to transgress over gender boundaries and thus to break out of a cycle of violence in a manner which could be positively evaluated, here, such transgression is no longer seen as positive, but rather as negative and frightening. So while Perrault's version can even be read as pro-feminist, this group of texts presents a savagery towards women which exceeds anything the nineteenth century had to offer.

These texts can also be viewed in the related, broader context of European Modernity. Not only did Modernity in German-speaking areas at the turn of the century involve the threat of a women's movement, in contemporary conservative thought it was also a related commonplace to imagine Modernity as being immoral, corrupt and threatening, and to identify it, *inter alia*, as both feminine and sexualized.[37] As the reactionary philosopher Otto Weininger wrote in his phenomenally influential work *Sex and Character* (1903) the present, degenerate era was also the most feminine of all historical eras.[38]

These perceived threats of a gendered Modernity provoked a defensive reaction on the part of many writers and thinkers which involved a defiant, misogynistic assertion of masculinity. But Weininger proposed a more fanciful solution to the ills of a feminized Modernity than a mere return to an idealized, more masculine past (which echoes these authors' turn to the past too). In Weininger's view, the only possible redemption would be for women to overcome their womanhood altogether: '*if all femininity is immoral, Woman must cease to be Woman and become Man.*'[39] This elimination of the feminine is Bluebeard's project, too. But while Weininger argued that the cultural and moral crisis of the modern, feminized world must be overcome by the self-sacrifice of woman, Bluebeard achieves that end by aggressive violence. Just as the vision at the end of *Sex and Character* is apocalyptic, so the denial of the 'feminine' in the Bluebeard texts can only end in catastrophe, with the murder of women and sometimes also the destruction of Bluebeard himself, a scenario which leaves open no future perspective.

Alternative traditions

Thus, the texts in question here may also be read as a reaction to historical and symbolic developments of the time. But these texts also seem to be responding to alternative, yet related developments within the European, and notably the French-language, Bluebeard tradition itself. A comparison between the German-language texts discussed here and some contemporary 'Bluebeard' versions in French may explain why there is also an insistence in many of these texts on their supposedly essentially German character.

Precisely this theme of feminine empowerment, central, of course, to contemporary women's movements, was crucial to some French-language versions of the Bluebeard material, which would have been known to cultivated German audiences around the turn of the century. For instance, Anatole France's *Les sept femmes de Barbe-bleue* (1907) made rationalist fun of the Bluebeard material and its supernatural overtones by presenting Bluebeard not as a murderer but as the victim of his scheming last wife. With reference to France's text, a contemporary German critic, Paul Wiegler, concluded dismissively in 1909:

Never have the Germans felt such a need to expiate the Breton knight, to whom they were drawn as if by an elective affinity, with sentimentality. They wanted him as a murderer. They left the ma-

terial's forms untouched, along with its barbarity, which accommodated the German lust to marry the sensual and the spiritual.[40]

Wiegler is criticizing what he perceived as the weakening of the material's original, murderous force, and underpinning his critique with notions of cultural difference, whereby the French versions are inferior.

In Jacques Offenbach's earlier comic operetta *Barbe-bleue* (1866), with its libretto by Henri Meilhac and Ludovic Halévy, Bluebeard is a merry widower who, in order to be able to marry a series of wives, orders his alchemist to murder them as and when necessary. But at the end of the operetta it transpires that the alchemist has merely been drugging the women and then admitting them to his own harem. Thus, the women's survival allows a happy ending, in which Bluebeard himself marries a young woman who will evidently stand no nonsense. There are resonances between this plot and that of the play of 1922 by Georg Kaiser, discussed above. It seems that Kaiser rewrites the plot of the opera but while in that earlier work the alchemist kept women alive while pretending to kill them, Kaiser's alchemist does the reverse: he facilitates the killing of women while he is supposed to be restoring life to Jeanne. Here then, there may be a rejection of a milder, comic, French tradition in favour of a more emphatically savage vision.

In this respect, another important intertext is the opera *Ariane et Barbe-bleue* (1901), with music by Paul Dukas and libretto by the Symbolist poet Maurice Maeterlinck. In some ways *Ariane et Barbe-bleue* shares features with the German texts discussed here, for example its setting in a medieval castle surrounded by the sea, and with an underground river running through it; and its patent interest in the characters' psychology. It also portrays Bluebeard as a beleaguered man threatened by femininity. In responding, however, to contemporary women's movements and in being a serious parable about liberation and oppression, *Ariane et Barbe-bleue* also presents these issues in gender-specific terms, thus making a strong, potentially feminist statement.[41] The courageous Ariane enters Bluebeard's castle with the sole object of freeing Bluebeard's five imprisoned wives on the principle: 'First of all, one must disobey: this is one's first duty when the order of things is threatening and offers no explanations. The [other women] were wrong, and were lost, because they hesitated.'[42]

But, although Barbe-bleue's five wives are freed by Ariane, in the end they prefer their imprisonment to an unknown freedom with her, and so she leaves Bluebeard's castle on her own. In other words, Maeterlinck

and Dukas present the Bluebeard plot as a psychological issue in which liberation is a question not of physical constraint but of psychological coercion, since the women have internalized the laws of their imprisonment.

Ariane's name and actions recall the Ariadne of classical mythology, who according to some sources became the wife of Dionysos.[43] At the turn of the century, Ariadne was celebrated, notably by Nietzsche, as the embodiment of Dionysian Woman.[44] Given which, *Ariane et Barbe-bleue* can also be read as an attempt to smash up the frozen, Apollonian reign of Bluebeard which is symbolized by his treasure chambers full of jewels. These possess the colours of nature but not its vitality. By contrast, the Dionysian Ariane, who is associated with the fluid, thundering sea that washes around the castle walls, (for she too evokes a fluid metaphor when she speaks of her departure into a 'world flooded with hope'), threatens to sweep away the rigid prohibitions and values which hold up those very walls.[45]

Duke Bluebeard's Castle: some conclusions

It is possible to see Béla Bartók's and Béla Balázs's opera as a pendant to *Ariane et Barbe-bleue*, which was its primary influence.[46] The operas share the transformation of Bluebeard's castle into a castle of the mind; an emphasis on the opening of a series of doors; the initially confident heroine who is gradually foiled in her aims to liberate the castle's inhabitant(s); the aesthetics of colour and ornament typical of the period; and the conflict staged between a feminine, Dionysian vitality and a masculine, Apollonian *rigor mortis*.

But where *Ariane et Barbe-bleue* focuses on the women's psyches, the later work explores Bluebeard's psyche. In this, and in other ways too, *Duke Bluebeard's Castle* certainly shares similarities with the group of German-language texts discussed here and can also be seen as a darker response to the more optimistic, contemporary, French-language Bluebeard tradition. Béla Balázs was familiar with the theoretical and cultural context of at least some of the texts discussed here. For example, he was a reader of the journal *Der Brenner*, in which some of these texts were published, and which also contained enthusiastic reception of Weininger.[47] Like the German-language texts, Balázs's libretto is also associated with the figure of Don Juan, for it has its origins in an unfinished, earlier stage work entitled *Don Juan and Bluebeard*.[48] It is also possible that the highly unusual, symbolic name Judith may have been inspired by its use in Eulenberg's play of 1905.

Thematic similarities between the group of German texts discussed here and *Duke Bluebeard's Castle* include the central symbol of the castle representing Bluebeard's psyche, which is emphasized even more here than in the texts discussed above. The opera is not merely entitled 'Duke Bluebeard', but *Duke Bluebeard's <u>Castle</u>* (my emphasis), and it is made clear that the rooms that Judith opens are not only his property but symbols of his state of mind and his past. Indeed, this imagery is especially stressed here, for the castle takes on psychological characteristics of its own. When Judith approaches the first door, the castle expresses itself as in the following stage direction (and echoed in the music itself):

> *She hammers on the door. As though in reply, a cavernous sigh is heard, like night winds sighing down long, dismal corridors.*

Judith responds by saying:

> Ah! Ah! What was that? What was sighing?
> Who was sighing? Tell me Bluebeard!
> It's your castle! It's your castle! It's your castle![49]

Elsewhere, Judith exclaims: 'All your castle lies in darkness! [...] It is wet here my beloved./What's this liquid in your castle?/Is it weeping? Is it weeping?'[50] This quotation also shows that there is liquid inside, as well as outside, the fortifications, in a way which matches the patterns described above. The castle's physical structure is similar in other ways too to those in the German texts with their underground chambers, in that the opening stage directions specify that to enter the castle, Bluebeard and Judith must *descend* a long flight of stairs, not *ascend* them, as might seem more usual in a castle.

Not only does the opera's Judith share a name with one of Eulenberg's characters, but she resembles the women discussed above also in that she also gives up a life of respectability and carefully sanctioned relationships, controlled by male relatives, when she runs away from her 'family', 'brother' and 'intended bridegroom' for unconditional love of a mysteriously fascinating Bluebeard.[51] And like the texts discussed here, *Duke Bluebeard's Castle* resists any utopian perspective whatsoever. In contrast to the ending of *Ariane et Barbe-bleue*, where the heroine has the last word and departs from the castle amid imagery of natural light, Balázs's libretto ends with Bluebeard saying 'Now all shall be dark-

ness…/Darkness… darkness…' and the stage direction: '*Complete darkness, and Bluebeard disappears in it.*'[52] Therefore, there is no chance of rescue for Judith, and that finality is emphasized by the fact that all four women are associated with times of day and that she, as the last, is associated with Night, the close of that series.

The differences between the focus and endings of *Ariane et Barbebleue* and *Duke Bluebeard's Castle* may have been a factor in the latter opera's comparably greater popularity, since the twentieth century had, as I have discussed, an avid interest not in Bluebeard's wife, but in Bluebeard himself; and since the fatalistic, non-utopian analysis of the relationship between Bluebeard and his wife or lover would also become a typical feature of many twentieth-century reworkings of the material. It may be that the opera reflects that profound sense of cultural pessimism which afflicted Europe as the Great War came closer, as the opera's Prologue may hint. It may also be that, at the start of the century of women's liberation, the fatalism of *Duke Bluebeard's Castle* acted as a tacitly reassuring reaffirmation of the *status quo* in the face of the unprecedented changes heralded by the women's movement, represented in the opera by Judith's implicitly dangerous name.

Alternatively, it may be that *Duke Bluebeard's Castle* is less an outright rejection of the changes and role reversals to be ushered in by feminism than an exploration of a masculine psyche's complex response to those changes.[53] While Maeterlinck's Ariane discovered that it is not easy to liberate women, Duke Bluebeard shows that men cannot be liberated either from the accoutrements of civilization or the castles in which they imprison themselves at such great human cost. Just as in *Ariane et Barbe-bleue*, the problem of freedom is couched in psychological rather than physical terms; and here, it proves to be insoluble.

This Bluebeard does not, however, resort to blind violence as the protagonists of the other texts discussed here do. Rather, he is involved in a much more complex and mysterious relationship with Judith. On one level, the implication of the opera's ending might be that love ends by trapping women; on another, that closing scene can be read as a dramatization of Bluebeard's memory itself, in that tragically, Judith's very desire to discover more about Bluebeard in order to redeem him must lead to the end of their relationship and her transformation into a reified memory, symbolized by the closed chamber.

Thus, Balázs's and Bartók's Bluebeard suffers because he is plagued by a new problem: memory. This accent dovetails with the *fin de siècle*'s great interest in that theme, explored as it was in crucial new ways by

Weininger, Nietzsche in *The Genealogy of Morals* (1887), and most influentially of all, by Freud, beginning with *The Interpretation of Dreams* (1900). Here, Bluebeard's memory is deadening, melancholic and can affect not only its subject, but also others around it. It seems, therefore, that there is something deeply problematic and painful about the production of memory. It seems too that with the dawn of the modern world, despite the throwback to violence evident in the strand of tellings explored here, Bluebeard's threats are taking on a new, radically modern form: not the physical, but the psychological. Within that universe, memory is the curse of the riven, self-conscious subject of Modernity.

3.1 Set design for a production of *Duke Bluebeard's Castle* by Belá Bartók,
 1911, pastel and charcoal on paper, European School (twentieth
 century). Private Collection, Archives Charmet/The Bridgeman Art
 Library.

BÉLA BARTÓK'S
DUKE BLUEBEARD'S CASTLE
A Musicological Perspective

David Cooper

A familiar story, a familiar scene…
But my friends, what does it mean?
Attend!

<div align="right">

Duke Bluebeard's Castle [1]

</div>

In a letter written to Béla Bartók on 13 August 1910, the Bradford-born composer Frederick Delius remarked that he most admired the third (slow) movement of Bartók's Second Suite for Orchestra, which he felt to be 'full of genuine feeling'. Delius, however, also considered that Bartók

> sometimes employ[s] dissonances, which are not in themselves called for in the music, in a characteristically arbitrary way. I imagine that you feel this as a certain reaction against the banal, which indeed can be perfectly fair: I believe, however, that music should be apart from all such preoccupations—flowing purely from one's own feeling and without too much intellectuality. —So, feeling! [2]

Bartók subsequently gave the title 'Scena della Puszta' to a two-piano arrangement of the movement, a significant reference to the pastoral Hungary that was the source of many of the traditional songs and instrumental melodies that exerted such an important influence on the development of his mature style. In later correspondence, on 27 March 1911, Bartók remarked to Delius that:

I have now started a difficult job—that is to say a one-acter. I haven't written any songs before—you can well imagine how much the text bothered me at times—in the beginning. But it's going better now. And I think the music will be rather to your liking.[3]

The work in question was *A kékszakállú herceg vára (Duke Bluebeard's Castle)*, an opera based on a dramatic poem written by Bartók's friend and compatriot, the Jewish writer Béla Balázs.[4] Despite the completion of the first version of the work (dedicated to Bartók's first wife Márta) on 20 September 1911, it was not until 24 May 1918 that the opera was premiered at the Royal Hungarian Opera House in Budapest. This delay was partly caused by the war (though Bartók was rejected for military service because he was underweight), but was also a consequence of his virtual ostracism as a composer. In a letter to Géza Vilmos Zágon in August 1913, he notes that 'a year ago sentence of death was officially pronounced on me as a composer. […] Therefore I have resigned myself to write only for my writing desk. […] Anything I support is prejudged as suspect by official musical circles—and rightly so from their point of view.'[5] Later, in December 1915, in a letter to the Board of Directors of the Budapest Philharmonic Society, he writes of the 'deplorable state of Budapest's musical life [that] has forced me to forego all public appearances as a composer during the last four years and to withhold all my works written since then from public appearance'.[6]

Béla Balázs and *A kékszakállú herceg vára*

Balázs published his one-act 'mystery play' *A kékszakállú herceg vára* in the Hungarian periodical *Színjáték* (Drama) in June 1910, with a dedication to both Bartók and Zoltán Kodály.[7] Although the work references the Bluebeard fairy tale tradition established by Charles Perrault, Balázs simultaneously evokes ancient Hungarian folklore and modern symbolist poetry and drama exemplified by Mallarmé, Maeterlinck and Wilde. Maeterlinck's anti-patriarchal version of the tale *Ariane et Barbe-bleue*, the source of the libretto for the opera by Paul Dukas, undoubtedly influenced Balázs, just as *Pelléas et Mélisande*, in Debussy's operatic setting, casts its shadow on Bartók's score for *Bluebeard's Castle*.[8] According to Balázs, in Maeterlinck's dramas 'Nothing happens […] Life happens,'[9] and this could equally be taken to characterize his own play in which the narrator remarks in the opening prologue that 'the curtains of your eye-lids all are raised. But where is the stage? Within us, or without?'[10] In a set of 'notes on the text' produced by Balázs around

1915 for the Viennese producer Josef Kalmer, he comments that 'my ballad is the "ballad of inner life". Bluebeard's castle is not a real castle of stone. The castle is his soul. It is lonely, dark and secretive: the castle of closed doors [...] The man's dream kills her [Judith], the very dream she herself has conjured up in him.'[11] Figure 3.1 shows a set design for *Duke Bluebeard's Castle* created in 1911.

Balázs discussed the folkloric character of his text in the newspaper *Bécsi Magyar Újság* in 1922.[12] By drawing on folk ballads from the Székely region of Transylvania as models he hoped to 'delineate modern souls with the plain primitive colours of folk songs', for in his and Bartók's belief 'complete novelty could be derived only from what was ancient, since only primeval material could be expected to stand our spiritualization without evaporating under our fingers.'[13] *A kékszakállú herceg vára* reflects this approach by being written largely in archaic-sounding octosyllabic lines organized into trochaic tetrameters, Bluebeard's dialogue with Judith near the start of the opera offering an example of this metric approach, which in Christopher Hassall's English translation recalls the rhythm of Longfellow's *Hiawatha*:

Nem hallod a vészharangot?	Do you hear the bells a jangling?
Anyád gyászba öltözködött,	Child, thy mother sits in sorrow;
Atyád éles kardot szijjaz,	Sword and shield thy father seizeth;
Testvérbátyád lovat nyergel.	Swift thy brother leaps to saddle.
Judit, jössz-e még utánam?	Judith, answer, art thou coming?[14]

The explicit identification of Bluebeard's wife as Judith in Balázs's version of the story is of considerable interest. Herbert Eulenberg had given the name Judith to one of the two sisters who marry Raul (his Bluebeard figure) in his 1905 Märchenstück *Ritter Blaubart* (which was used by Emil N. von Reznicek as the libretto for his Bluebeard opera composed in 1920), and as Leafstedt notes, Balázs's use of the name may well allude to the biblical story of Judith and Holofernes from Chapter 13 of the Book of Judith in the Apocrypha:

In a drama imbued with symbolism at every turn, it can hardly be an accident that Balázs chose as the name of Bluebeard's newest wife the name of the well-known Biblical woman who kills a man to save her people. In the early twentieth century, at the time Bartók and Balázs were writing *Bluebeard's Castle*, the name Judith

was strongly identified with the *femme fatale* image in visual arts. Like Salome, whose popularity as the subject of artistic representations far surpassed that of Judith's, Judith was often depicted as a young woman of considerable sexual allure. In paintings of the time [such as Gustav Klimt's *Judith 1* of 1901 (4.2) and *Judith II* of 1909] she is shown semi-clothed or naked, holding in her hand a sword or the head of a man. [...] Judith and Salome were symbols of the women men feared, women whose physical attractiveness enabled them to wield enormous power over men. To love them, or to lust for them, was to court violent death.[15]

Christian Friedrich Hebbel's play *Judith* (1841), based on the biblical story of Judith and Holofernes, excited Freud's interest by its implicit examination of the taboo of virginity. For Freud, Judith—whose first husband was unable to consummate their marriage, and who beheads the besieging Assyrian general Holofernes after sleeping with him, leading to the liberation of her home city of Bethulia—is 'the woman who castrates the man who has deflowered her'.[16] Balázs took a scholarly interest in Hebbel, completing his doctorate on the 'pan tragicness' of his drama in 1908 at the University of Budapest and publishing the article 'A tragédiának metafizikus teóriája a német romantikában és Hebbel Frigyes' in *Nyugat* in the same year; and there can be no doubt he was familiar with Hebbel's *Judith*.[17]

A synopsis of the libretto of *Bluebeard's Castle* reveals the similarities to, and differences from, earlier versions of the Bluebeard fairytale and its source in Perrault. After a spoken introduction from a minstrel which sets the scene (the first five strophes following a 6, 6, 8, 8, 6 syllable metrical scheme which is not found in the rest of the libretto), we are immediately introduced to the opera's two protagonists—Bluebeard (bass or baritone) and Judith (soprano or mezzo-soprano). We discover that Judith has jilted her intended bridegroom and has followed Bluebeard of her own accord, but against the wishes of her family, to his cold, dark, sunless castle, whose dank walls appear to her to be weeping. In response to Bluebeard's questions as to why she has followed him, she answers that she will 'dry these weeping flagstones, with my own lips',[18] and that she will overcome his sadness and darkness with her love. Seeing the seven locked doors, she enquires why they are bolted, and asks that they be opened. Bluebeard warns her of rumours about him, but he allows her to open the doors to the first six rooms in turn: the torture chamber (suffused with a bloody red light), the ar-

moury (yellow–red light), the treasury (golden light), his garden (blue–green light), his kingdom (white light) and the lake of tears ('darker as though a shadow were passing over'). Although Bluebeard acknowledges that Judith has now brought him from the darkness into the light, he tells her to make no further enquiry about his former loves, and leave the seventh door unopened. Judith demands that he unbolt it, believing that the blood she has seen in the previous six chambers and the weeping castle walls indicate that he has murdered his former wives and that their bodies lie in the final room. When she opens the door, she discovers that all three women are still alive—the first whom Bluebeard had met at dawn, the second at noon, the third at twilight, and now Judith, the last, at midnight. He places a crown on her head, a mantle on her shoulders and jewels around her neck, intoning:

> Thine is now the starry mantle,
> Thine is now the crown of diamonds.
> Thine is the wealth of my kingdom.
> Thou art lovely, passing lovely,
> Thou art queen of all my women,
> My best and fairest.[19]

Judith follows the other women back into the seventh chamber and as the door closes, darkness and solitude return to Bluebeard's castle.

Kroó offers what appears to be an irredeemably patriarchal interpretation of Balázs's symbolism, in which both protagonists are seen as essentially the victims of their nature:

> The man's tragedy follows from his greatness: he is unable to find a worthy mate. Accordingly, a 'man of integrity' would seem to be doomed to walk the paths of life in solitude. The woman's originally idealized figure is debased. By obeying the dictates of her blind, instinctive passion, she brings about her own ruin. […] Judith's figure retains the permanent features of feminine tragedy: passionate craving for the unattainable, the whole of man, which refuses to tolerate the limits of consideration and experience.[20]

For Susan McClary, however, Bluebeard's 'tragedy' is that 'he is forever being betrayed by women who do not take him at his word, who insist on knowing the truth: the truth of his human rather than transcendental status'.[21] Bluebeard is a man of clay, but cannot allow his ego

to be undermined by Judith's comprehension of his imperfection. After the lake of tears episode, we find her uttering a single line of text which could be taken to imply sexual congress in the ellipsis: 'Kékszakállú ... szeress engem' ('Bluebeard ... love me'), and from that, like her name-sake's physical decapitation of Holofernes, to Judith's psychical castration of Bluebeard, as he is forced to reveal how his ego was formed:

> They shall ever live immortal.
> They have gathered all my riches.
> They have bled to feed my flowers.
> Yea, they have enlarged my kingdom.
> All is theirs now all my treasures.[22]

Béla Bartók's *Bluebeard's Castle* and Hungarian popular music

Bartók had a fourfold career—as a pedagogue and professor of piano at the Royal Hungarian Academy of Music, as a concert pianist playing on the international stage, as one of the most influential of twentieth-century composers, and from 1906 as what in modern terms would be seen as an ethnomusicologist. It was the interpenetration of the latter two activities that was to have the greatest impact on the development of his approach, in particular through his recourse to a form of traditional music that he regarded as an anathema to the urban Hungarian 'cultured classes' of the early decades of the century. In 1904, on a visit to the village of Gerlice Puszta, he made his personal discovery of a rural 'peasant' music which stood, he would come to believe, in complete contradistinction to the tunes performed by the urban Gypsy bands he had hitherto regarded as exemplifying the 'authentic' music of Hungary. *Cigányzene* (Gypsy music) largely consisted at this time of the virtuosic instrumental genre known as *verbunkos* and its derivative the *csárdás*, and Magyar *nóta* (popular Hungarian songs). Hungarian Gypsy music was most closely associated with the Magyar nobility who appear in many cases to have been the composers of the Magyar *nóta*. Bartók contended that peasant music offered a more 'authentic' and 'purer' stimulant, which was free from the overtly chauvinistic Magyar overtones of 'Gypsy' music.

While the Gypsy-disseminated *verbunkos/csárdás/nóta* tradition may not be as explicitly brought into play in *Bluebeard's Castle* as it was in his early symphonic poem *Kossuth* (1903), the song 'Est' (1903?) or the Rhapsody Op. 1 (1904), its residual traces can still be heard throughout the score.[23] The markers of *Cigányzene* (or in art-music terms, what has been called *style hongrois*) which are invoked include: the performance in

parallel thirds by clarinets and oboes in the opera's second major musical gesture; the music played by a solo clarinet which precedes the opening of the first door which is apparently influenced by the highly decorated improvisational technique known as *hallgató* (the clarinet imitating the Gypsy band's *tárogató*); and the assertive short–long 'Scotch-snap' rhythm at the climax of the scene in Bluebeard's garden (immediately after he sings 'thou hast made them swiftly wither, only to revive in glory!').[24]

Bartók adopted many of his compositional resources from the traditional musics of Hungary (especially the region of Transylvania, which was, until the settlement of the Treaty of Trianon of 1920, part of the Kingdom of Hungary), Romania, Slovakia, the Balkans, North Africa and other regions. These resources included modes and melodic figures, rhythmic characteristics and aspects of instrumental and vocal performance practice. He seldom quoted directly from traditional sources in his original compositions (as opposed to the many arrangements of folk tunes he made) but incorporated elements from them such that his music took on a hybrid or syncretic character. It took some time for this approach to stabilize, however, and during the period when he was composing *Bluebeard's Castle* he was still near the beginning of the phase of compositional development which would eventually lead to the acerbic modernism of *The Miraculous Mandarin* in 1918–19— a dance work that bears comparison with Stravinsky's visceral ballet *Le Sacre du Printemps*.

The most immediately striking influence of traditional Hungarian music to be found in *Bluebeard's Castle* is the four-phrase pentatonic melody which opens the opera and brings it to its conclusion. This theme admirably conjures up the archaic world that Balázs suggested should be invoked by the 'plain primitive colours of folk songs'. Judith's early statements project the same antique spirit, her almost trance-like recall of the family she left weeping when she eloped with Bluebeard being set to a melody whose simple repetition equally recalls folk melody. In moments of lyricism such as the flower garden scene, where Bluebeard sings 'Ev'ry flower nods to greet thee', a similar folk-like melodic structure is evoked, but in essence this not a folkloric work, and the traditional material functions to help maintain the musical antinomies that support the opera's symbolic content.

Establishing musical meaning in *Bluebeard's Castle*

Musical semiotics is a notoriously slippery area.[25] Music is widely, though by no means universally, regarded as having (in Jakobson's

terms) an emotive function or at least an emotive potential, whether this involves the simulation or stimulation of emotional states. However, while it is usually accepted that it has a syntactical component,[26] it clearly does not have unambiguous semantics of natural languages.[27] I have noted in connection with film scoring that 'music has often been considered to be semantically neutral in itself, its power to signify largely coming about through its interaction with other forms of communication, particularly poetry, where meaning is less ambiguously encoded.'[28] Musical settings of texts, especially in a theatrical situation, present the opportunity to consider the relationship between the context provided by the libretto or scenario and a composer's musical response.

I have proposed two basic underlying assumptions in consideration of film music: 'that meaning, in however constrained and limited a sense [it] is understood, can *become attached* to music (that is, meaning is not a fixed or necessarily inherent property of the music); and that music is able to interact with other elements of the narrative to form compound signifying tokens.'[29] Such tokens depend on the temporal location of the associations such that they are either synchronous (the musical event is simultaneous with the narrative event) or contiguous (the musical event is close in time to the narrative event, beginning either immediately before or after its onset). The associations so formed may give rise to multiple simultaneous meanings which can alter during the course of a work according to context, and thus one can perhaps think of a semantic web woven from the different strands.

Associations may be entirely arbitrary, formed through the 'accident' of their situation (the music may seem to have no specific properties which directly relate it to the narrative context, it simply occurs at the same time), or they may involve inherent musical or music-theoretical characteristics, constructs or conventions (whether only understood within a specific culture or subculture, or more widely) which link sound and action. This latter group includes: isomorphisms whose coding may depend on graphical identity, involve sonic imitation as a kind of musical iconicity, utilize cryptographic procedures to translate from words to notation, present linguistic translations of terms or concepts into their metaphorical musical equivalents, employ parallel structural organization or stimulate physical sensation; and intertextual references to other musical works, whether from the composer's own compositions or the wider corpus, which bring with them semantic content derived from their original context. Naturally, the level of 'decoding' of

many of these tokens depends upon the relative 'competence' of the listener—the degree of musical knowledge or experience they possess.[30]

If we consider, as an example, the pentatonic melody in F♯ that begins *Bluebeard's Castle*, we observe that it connotes night both by context (the opera begins in darkness) and through its musical properties (it is quiet, slow moving, monophonic and in a low register). Later in the opera, the brilliant white light shining on Bluebeard's kingdom is accompanied by loud, majestically paced music set in the tonality of C. The tonality of F♯ can be regarded as being the inverse of C in several music-theoretical ways:

- It lies at the logarithmic midpoint of the octave above or below C, and on the twelve-notes-per-octave keyboard instruments of western art music it divides the octave in half.[31]

- In the model of Bartók's practices theorized by Ernő Lendvai as an extension of late nineteenth-century harmonic practice, it sits directly opposite C as the counterpole of the main branch of what he describes as the tonic axis.

- In a more metaphorical sense, by forming the interval of the tritone with C (the *diabolus in musica*—an intracultural semantic of western art music), it offers an implicit reference to Satan the 'Prince of Darkness'.

Although these features may only be accessible to listeners with the relevant musical 'competence', they are part of the composer's private symbolism, and as such they play their role in the complex semantic web constructed around and through the opera.

Given Bartók's idealistic view of peasant music as a natural phenomenon, the opening melody may be construed to symbolize nature itself through its pentatonicism and folksong-like structure. In retrospect it also performs a framing function, by beginning and ending the work and appearing at one of its key narrative junctures, immediately after Judith demands that the doors be opened and the castle sighs in reaction to her hammering on the first door. Equally the tonality of C (which in Lendvai's reading of Bartók's tonality is both the opposite of and the most direct substitute for F♯ as its counterpole) is used to underpin a specific image of the natural world, the vista of Bluebeard's kingdom in brilliant sunlight which lies through the fifth door, with its

'silken meadows, velvet forests, tranquil streams of winding silver. Lofty mountains blue and hazy!'[32]

This brief instrumental prelude has a second element, a fragment played by oboes and clarinets that opens with an inverted mordent that can be regarded as an isomorphism of a shiver or shudder. It recalls the opening gesture of Bach's D minor Toccata and Fugue for organ BWV 565, a figure which became enshrined as a topos of the horror film genre. The idea as it appears in the opera offers a second level of symbolism through its invocation of the gypsy-band technique of doubling a melodic line a third lower. It reappears as Bluebeard and Judith are first seen in silhouette (an approach to lighting that prefigures one of the key technical devices of German expressionist film, first exposed in Robert Wiene's *Das Kabinett des Dr Caligari* of 1919), and a little later when Bluebeard looks to Judith, who has stopped halfway down the stairs, and asks her if she is frightened. It is further attached, as a foil, to the pentatonic melody in a version in which the clarinet takes on the role of the Gypsy *tárogató*, superimposing an elaborately decorated line that climaxes on a reiterated shudder as Judith sings the words 'mournful dwelling'. Bartók converts the gesture into an even more explicit isomorphism of a shiver as Judith turns the key in the first lock and a sigh reverberates through the castle.[33] In the opera's final moments, with the return to darkness, the gesture makes its ultimate appearance, now superimposed upon the pentatonic melody as a vague echo of its overwrought first exposition. Thus music's semantic plasticity allows the subtle redeployment of its signifiers in a flexible way such that collectively these two elements can initially represent darkness, then the castle and the frisson of fear it generates in Judith, and finally as the opera dissolves into nothingness, all of these *and* the solitary figure of Bluebeard himself.

Musical symbols in *Bluebeard's Castle*

The primary symbols which Balázs employs in his libretto are provided with musical counterparts in the opera. The castle, Bluebeard's soul, has already been considered but we also find musical symbols for the blood that Judith sees oozing throughout the castle and the rooms which open into the various aspects of his psyche—his violence, cruelty, sadism and avarice, his love of nature, and his anguish and despair. The encoding of these symbols is briefly explored in the ensuing discussion.

Immediately after Judith opens the first door, which leads into Blue-
beard's torture chamber, the strings and clarinets present a shrill grind-
ing sonority. This involves clarinets playing high trills between A♯ and
B, supported by the violins in octaves using the *tremolo* and *sul ponticello*
techniques.[34] The combination of the dissonant interval, the 'shiver-
ing' repetitions and trills, and the curious tone colour (a type of sonor-
ity which would later become commonplace in the horror film genre)
produces a musical gesture that seems sinister and threatening. The dis-
sonance of the interval of a semitone, whose 'painfulness' has a psy-
cho-acoustic explanation, is directly linked to the symbol of blood later
in the section, immediately before Judith sings 'look your castle walls are
bloodstained', as muted trumpets and oboes play the interval G♯–A
against another high trill between A♯–B, this time performed by the
flutes. In retrospect, the symbolic significance of the earlier use of the
interval of the minor second, heard as Judith was seen to feel her way
through the darkness and touched the castle walls which seemed to her
to be sweating or weeping, now becomes apparent.

Sándor Veress traced the vertical and horizontal evolution and ex-
pansion of this musical figure through the opera in a pair of articles
published in the journal *Tempo* several years after Bartók's death.[35] He
remarks that 'the basic motif of the libretto is the symbol of blood
which impresses Judith with increasing force at the opening of each
door, leading her inevitably to final extinction.'[36] There is no doubt that
in the crudest sense this symbol of blood is simply a Grand Guignol
gesture. However, drawing on Perrault's tale of Bluebeard and the
Grimm Brothers' 'Fitcher's Bird', both children's stories which involve
objects which cannot be cleansed of blood, Bruno Bettelheim offers
the following analysis:

> The key that opens the door to a secret room suggests associa-
> tions to the male sexual organ, particularly in first intercourse
> when the hymen is broken and blood gets on it. If this is one of
> the hidden meanings, then it makes sense that the blood cannot be
> washed away: defloration is an irreversible event.[37]

The symbol of blood, which runs through Balázs's play much as that
of the moon persists through Oscar Wilde's *Salome*, is implicit in the
score almost from the opera's opening notes. The *verbunkos*-like mate-
rial that follows the initial pentatonic melody is derived from multiple

linear unfoldings of the minor-second blood motif, and as the work moves inexorably towards its climax at the opening of the seventh door, the interval of the semitone increasingly saturates the texture.

In the light of the prominence given to this symbol, I would like to propose at this point an interpretation of *Bluebeard's Castle* which is at variance with Balázs's analysis, and which traces Judith's progress into the adult world. In this perhaps perversely Freudian reading, Bluebeard represents not the husband, but the father figure for the adolescent Judith on whom she has developed an Oedipal fixation, and who exposes her to the adult psyche with its joy and pain, and beauty and horror, as she progresses through the first six chambers. With the seventh—conceivably representing the dissolution of the Oedipus complex for the Freudian—she is forced to accept the end of childhood and adopt the heavy mantle of adulthood, something she is incapable of escaping from.[38]

Several aspects of Balázs's play and Bartók's treatment might be taken to lend some credence to this reading:

- Unlike Strauss's *Salome*, which is in some ways a model for *Bluebeard's Castle*, and despite Judith's early intimations that she will dry the weeping walls with her lips and warm the marble with her body (and the implicit sexuality of Balázs's symbolism of keys, locks, doorways and blood), *explicit* eroticism is largely suppressed in both the literary text and the score.[39] For Leafstedt, this absence of sexuality is explained by the fact that the love the pair have for each other 'transcends the physical', but it could equally be interpreted to reflect a daughter's relationship with her father.

- Judith's musical persona, scored for a mezzo-soprano voice, is for much of the time understated technically. Other than the single top C (which is like a gasp of astonishment) as she looks on Bluebeard's kingdom, she employs a relatively restricted register and little of what might be seen as virtuosic writing. Her colourless response to the rich orchestral sonority and to Bluebeard's gravitas in this scene, in particular, is thin and piping (marked *senza espressione*), like a child unimpressed with an adult's boasting.

- Throughout the opera Judith reacts in a rather literal and superficial way to the unfolding events, and there is a reflection of this in the pronounced tendency towards repetition of musical figures in her lines, especially those heard near the beginning of the opera. For example, the melody associated with her reminiscence of her departure

from her mother and father, and her questioning of the lack of day-light in the castle, has the naive quality of nursery song.

The musical semiotics of the seven chambers

The symbols which support the first six doorways and rooms involve relatively simple and unpretentious musical imagery. For the first, the torture chamber, a very rapid figure (the isomorphism of a shudder) that is initiated by a rising semitone (referencing the blood motif) and outlines a tritone, alternates between compressed and expanded ver-sions, as if repeatedly stretched on the rack. The use of the keyboard xylophone (an extremely rare instrument) invokes death by its inter-textual recall of the skeletal sounds invented by Saint-Saëns in his *Danse Macabre*. Towards the end of the section, upper woodwinds relentlessly reiterate a *verbunkos*-derived idea like the torturer's repeated application of his instruments of torment. The music of the second room, the armoury, relies on fanfare-like figures in brass and dotted 'galloping' motifs in woodwinds to make a rather crude military allusion. For the treasury, metallic sounds are used to isomorphically reference the 'mountains of gold': over a sustained D major chord played by brass instruments (three trumpets playing in low register), flutter-tongued flutes and tremolo strings, the celeste performs rapid arpeggios. This generates a 'brilliant' and saturated musical 'halo' through which a pair of solo violins briefly outline a melody that provides chromatic en-richment of the texture.

The music representing the flower garden follows immediately and begins in a Lydian E♭. Here the semiotics are rather more obscure, the shimmering tremolo strings and placid horn melody not instantly of-fering an obvious musical metaphor, though the Lydian inflection may suggest the 'natural' scale of the bagpipe (and hence a bucolic land-scape). With the sonic isomorphism of birdsong we find a more fa-miliar cultural referent, and this leads into a delicate texture that is akin to that which represented the treasury. The dynamic highpoint of the opera occurs with opening of the fifth door. Although the fundamen-tal tonality of this section is C, Bartók harmonizes each note of the chorale-like melody with a major triad, ringing out across the natural world of Bluebeard's kingdom as if from the bells in a church tower, the organ, woodwinds and upper brass sustaining long held chords at the termination of each phrase.[40]

To underpin the symbol of the lake of tears, Bartók returns to tex-tures which can be taken as the musical equivalent of Gustav Klimt's elaborate gilded mosaic ornamentation.[41] The underlying A minor triad,

an intracultural referent for grief in the western art-music tradition, appears in a supersaturated texture of arpeggios, glissandi and tremolos in a subtle and delicate orchestration, that elaborates earlier gestures in the opera encoding shudders or shivers; and at the heart of the music, the minor second so closely associated with Judith's discovery of blood plays a prominent part. This material is the natural extension of the music associated with the first room, the torture chamber, and functions as a kind of decorated recapitulation.

Bartók draws on an intertextual reference to the *recitativo* 'Ach, Golgotha' from Bach's *St Matthew Passion* with his music for the seventh chamber. The upper *oboe da caccia* line accompanying the alto recitative which contemplates Christ's crucifixion in Bach's passion is transformed into an inner polyphonic voice performed by a solo cor anglais in the opera. It is ironic, perhaps, that Bartók, an avowed atheist and follower of Nietzsche, who signed himself 'AN UNBELIEVER (who is more honest than a great many believers)' in a letter to his close friend, the violinist Stefi Geyer in September 1907, should apparently cite one of the central points of the canon of Christian art music.[42] 'Ach Golgotha' presents Bach's chromaticism at its most extreme, all twelve pitches appearing in the course of the short movement, but more importantly, it ponders Christ's sinless death and in its highly charged climactic moment laments 'Die Unschuld muss hier schuldig sterben,/Das gehet meiner Seele nah' ('the innocent must die here as guilty, it cuts my soul to the quick'). Bluebeard's placing of the mantle on Judith's shoulders, the crown on her head, and jewels on her neck may well be a covert allusion to the crown of thorns, robe and staff which Christ was forced to wear by Pilate's soldiers, but in *Bluebeard's Castle* these adornments were selected from the treasury by Judith herself, and no mockery seems to be intended. If anything, both Bluebeard and Judith appear to be presented as victims—Judith freely accepting her fate to be but one of Bluebeard's memories and he returning to the solitary darkness of the opera's opening.

A final apparent piece of intertextual encoding, which has been noted by a number of analysts, relates to Bartók's private cipher for Stefi Geyer, to whom he dedicated his First Violin Concerto (1907–8). In a letter written to her sometime in the middle of September 1907, he includes a musical quotation in which a phrase has been marked: 'this is your "Leitmotiv".' The figure in question involves an ascending minor triad (C♯–E–G♯) which culminates by rising to B♯, to form a

musical idea with a very strong feeling of irresolution within a tonal context, and which Lendvai has labelled the hyperminor because of its heightened minor-mode semantic characteristics. As a melodic or harmonic gesture it is frequently to be found in Bartók's music of the period and seems to have had an autobiographical significance for him. Interestingly, the first time Judith sings 'Kékszakállú' it is set to the pitches F_5–Db_5–A_4–Gb_4 (=E♯–C♯–A–F♯), a descending broken-chord version of the hyperminor on F♯. Given that none of the other renditions of his name by Judith have this, or any other regular or consistent intervallic structure, it may seem implausible to suggest through this single usage that Bartók had a 'secret programme'. However, at the climax of the opening expository section, over the neurotic ostinati which support Judith's lines and perhaps suggest a form of repetition compulsion on her part, she focuses around (C_5)—the upper pitch of a further hyperminor chord on C♯ played by the orchestra—as she sings 'I shall brighten your sad castle./You and I shall breach these ramparts./Wind shall blow through, light shall enter.'[43] Later the hyperminor chord on A (A–C–E–G♯) underlies the shivering arpeggiated motif for the lake of tears, and at the conclusion of this scene, just before Judith sings 'Bluebeard ... take me, love me', strings softly and sweetly sustain the chord in its original tonality, before sliding to an E major chord. In the succeeding bars, it makes itself powerfully felt on B♭, F and E♭ in a musical moment that suggests sexual union. Finally, in the grief-laden orchestral prelude heard as the seventh door opens, which presents the quotation from 'Ach Golgotha', hyperminor chords first on C and then on D♭ lie in structurally prominent positions. As a musical symbol, it retrospectively connotes that from her first invocation of Bluebeard's name, and her subsequent desire to bring daylight to her partner's gloomy soul, their relationship has been doomed.

Conclusion

Judit Frigyesi remarks that:

> for most of the opera Judith and Bluebeard remain within the framework of the rubato of old-style songs, which means, symbolically speaking, that they are ultimately part of the same musical world. Within this framework, Bartók maximises the contrast between more neutral and more emotional singing styles. Typically, the characters move in opposite directions: if Judith's voice

becomes more emotional, Bluebeard's retreats into neutrality, and when Bluebeard opens up, Judith confronts him with a cold voice.[44]

While it would undoubtedly be misleading to suggest that there is an absolute musical opposition between the material sung by or accompanying the two characters, as well as the distinction noted by Frigyesi, there is no doubt that Bluebeard does more often sing lines that have a pentatonic bias, while Judith's tend to be more chromatically inflected. This is by no means an invariant characteristic, but an underlying trend, which provides an element of stylistic differentiation, and links the relationship of the couple back to the opening two ideas of the opera—the 'old style' melody associated with Bluebeard and the *verbunkos*-inflected motif linked with Judith. In the opera's expository section, for example, Bluebeard's voice is seldom heard against the ostinati that underscore Judith's apparent haematophobia—indeed, on three occasions the orchestra settles on sustained chords when he sings. In the course of this section, the tonal basis of the ostinato figures subtly changes from the pentatony at the start (referencing both Bluebeard and his castle) to increasingly chromaticized (and arguably feminized) versions, which underline the transformation that she wishes to make, from dark antiquity to bright modernity.

In the end, of course, Judith cannot resolve the various antinomies that are symbolically presented in the opera and bring light into the darkness of Bluebeard's soul. She is crushed by the attempt, whether into acquiescent adulthood, or to become another exhibit in his Playboy Mansion museum of fantasy females. Equally, Bluebeard is locked into an endless cycle of futile repetition from which he seems incapable of escaping. For all the exquisite beauty of much of Bartók's music, this may seem a bleak and nihilist vision: man left psychically castrated and in solitude; woman reduced to a crude gender stereotype. Nevertheless, *Duke Bluebeard's Castle* is an opera which does afford multiple potential readings, and the plasticity of its musical symbolism encourages the listener to reassess its personal meaning afresh on each performance.

> We look at each other, look,
> Sing the tune.
> Who knows where from we bring it?
> Let's hear it and wonder at (it),
> Men and women.[45]

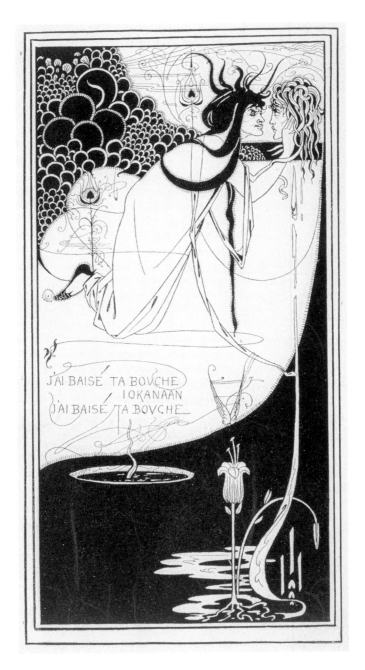

4.1 Aubrey Beardsley, 'J'ai baisé ta bouche Iokanaan', design for The Climax
 from Oscar Wilde's *Salome* (1891), 1893, line block print, London, Vic-
 toria and Albert Museum (E.456-1899).

4

A TALE OF AN EYE
Revealing the Jew in *Duke Bluebeard's Castle*

Victoria Anderson

Henceforth all shall be darkness,
Darkness, darkness.

<div align="right">

Duke Bluebeard's Castle[1]

</div>

Bluebeard, at least in its original inception by Charles Perrault in 'La Barbe Bleue' in 1697, is a tale that properly belongs to the set of narratives which we may term 'Forbidden Chamber' tales.

The earliest recorded narrative featuring a Forbidden Chamber is generally considered to be 'The Tale of the Third Royal Mendicant', being one of Scheherazade's stories from the *Thousand and One Nights*. In this story a prince, having been shipwrecked and undergone various other odd and death-defying experiences, finds himself deposited in a strange land within a jewel-encrusted palace where he experiences the full array of earthly delights. After a year, his hosts—forty princesses—are compelled to leave him for forty days, and, handing him a set of a hundred keys, give him the run of the place, with a single exception: that he should not open the door of red gold. Agreeing to this, the prince wanders through the palace with his one hundred keys, moving through chamber after chamber filled with precious stones and singing birds until, on the thirty-ninth day, he comes to the hundredth door, the red gold door, and, bedevilled by curiosity and impatience, he opens it. What he finds in the room is, however, nothing more terrifying than a winged horse. He mounts the horse, and the two of them soar into the air. After some distance the horse alights on the roof of a strange palace. The horse then throws the prince down and kicks him so hard

as to put out an eye. When the prince comes to he finds himself cast out in the street with a multitude of one-eyed beggars.

If we can focus *not* on the beggar–prince but rather his displaced eye, we shall find that the objective of this essay will be to follow the trajectory of such an optic. The tale that we know as Bluebeard is implicitly concerned with eyes, as I shall argue; and so by drawing lines of connection and distinction between various incarnations of the story I hope to arrive at a new and hopefully interesting set of interpretations.

In the first (and possibly longest) scholarly paper ever written on 'The Forbidden Chamber' in 1891, folklorist Edwin Hartland remarked that the motif of this forbidden space signifies a taboo.[2] Taboo *qua* taboo—certainly if we follow Lévi-Strauss—serves a cultural need to preserve (or, indeed, create) social and societal boundaries. As such it is the principle of the injunction, at *least* as much as its context, that matters. In 'La Barbe Bleue', which derives from a number of sources but finds its unique and definitive treatment in Perrault's 1697 collection *Histoires ou Contes du Temps passé*, the contents of the room are an apparently horrific combination of death, blood and femininity: the mutilated corpses of women. In 'The Tale of the Third Royal Mendicant', however, there is nothing within the room itself that should elicit a negative reaction: no corpses, no terrible skeletons, no fiery pit of hell (which last motif is found in the Italian tale 'How The Devil Married Three Sisters'). In 'The Tale of the Third Royal Mendicant', it is the *principle* of transgression itself rather than the contents of the room that is of sole importance. It is not the substance of the prince's discovery, but rather his transgression, that causes his fall from grace. It is as a result of his transgression *qua* transgression that he is expelled from paradise, and loses an eye.

This expulsion from paradise links to the Adam and Eve myth. For the purpose of this reading I am not much concerned with Eve's transgression as being exclusively feminine, since both Adam *and* Eve transgress the law set in place by God. The cultural baggage surrounding Eve's specificity as a woman need not distract us from the esoteric principle at stake in such a myth, which expresses the idea that esoteric secrecy itself is to be preserved, that the divine must in some way be unknowable. In 'The Tale of the Third Royal Mendicant', it is the transgressor who is male while the holders of the keys are female, and it is they who have placed the injunction. An injunction of this sort may be viewed differently, then, from that of Pandora, whose box contains not

'the divine unknowable' but tangible horrors. In other words, Pandora's box *contains something terrible*, and although 'woman' is generically blamed for unleashing evil upon the world, arguably the contents of the box are at least as relevant as the injunction itself. This may seem like a minor point, but it is possible to distinguish between tales that may *feature* an injunction, but do not necessarily *turn* on an injunction.

A great many folk and fairy tales collected from the oral tradition do *not* use the forbidden chamber in a way that supports the prohibition function of transgression, but rather *advocate* transgression. Typically an oral tale of the Bluebeard-type will feature a female heroine who not only defies the male antagonist by looking into the forbidden chamber, but defeats him altogether, the tale typically ending with the villain's death. 'Fitcher's Bird', a well-known tale collected by the Grimms, is typical of the folk variant in that it features a wizard (other versions might use a troll or devil, for example) who abducts three sisters one at a time. He forbids them access to one chamber, handing them a magical key, egg or other object that will signal any transgression by some irremovable marker. The first two sisters open the chamber and find a horrifying scene of blood and corpses; in their shock they each drop the magical object in the blood, and the blood will not wash clean. When their transgression is recognized, the wizard (or devil, or troll, etc.) kills them. The third sister, however, puts the magical object away before she opens the chamber, hence evading detection. She defeats the wizard and ultimately burns down his house with him inside. The transgression here, then, is presented as desirable rather than taboo; *revealing* the contents of the room is the issue at stake rather than transgressing a prohibition. The heroine's resourcefulness is presented as a precisely heroic quality, rather than a transgressive and punishable offence.

A great many oral tales which feature a secret or forbidden chamber seem to refer to the process of initiation. Marguerite Loeffler-Delachaux alleges the tradition of secret rooms in fairy tales to connote initiation, particularly where there is a set of rooms and various keys, for example, made of gold, silver or diamond. She describes a trio of rooms, the first of which is 'la salle de Purification', 'la salle de la Connaissance', and finally 'la salle de Pouvoir'. These 'salles' are organized spatially so that they go from a relatively public space to one increasingly private and secreted.[3] A secret chamber that is, moreover, filled with blood has further symbolism. Mircea Eliade describes a generic set of customs which, although specific to certain traditional cultures, are sufficiently

common in type to constitute a widespread pattern of initiation rituals which may be linked to traditional tales. For example, initiates will be physically, *overtly* separated from their mothers, and therefore the realm of childhood.[4] The commonplace initiatory practice of cutting or blood-letting marks the passage from the symbolic death of childhood to the new life as an adult; blood binds the novice to his mother, and the ritual enables him to transform into a man. 'Since female blood is the product of female feeding, the novice [...] is subjected to numerous dietary prohibitions. The mystical interconnection between food, blood and sexuality constitutes an initiatory pattern.'[5] According to Eliade, boys are initiated in groups when they attain a certain age, whereas girls tend to be initiated individually when they begin menstruation:[6] 'For boys, initiation represents an introduction to a world that is not immediate—the world of spirit and culture. For girls, on the contrary, initiation involves a series of revelations concerning the secret meaning of a phenomenon that is apparently natural—the visible sign of their sexual maturity.'[7]

Blood, then, is linked to the mother—both the old, dead mother and the new maternal capability of the young female—and as a blood-filled chamber is transparently associated with the womb. According to Paul Saint-Yves, the ideal or essential type of initiation consists in simulating the slaughter of a novice followed by resurrection, and that this initiatory tradition is visible in certain folk tales.[8] For example, many Breton variations of the Bluebeard-type tale consist in the wife's being slain and then immediately revivified, precisely as in 'les initiations primitives'.[9] We recall also that many folk tales of the 'Fitcher's Bird' variety have the third sister reassembling and reviving the dismembered bodies of her sisters. In the oral folk tradition, then, it would seem to be *necessary* for the initiates/protagonists to gain knowledge of the mysteries of blood, life and death, by which turn the chamber indicates neither transgression nor taboo. Knowledge, here, is not only power but is advocated as such, and thus is distinctly at variance not only with the esoteric and mythological models described earlier, but with many modern narratives that are more or less influenced by Perrault's 'La Barbe Bleue'.

The visual metaphor

When studying the vicissitudes of a narrative such as Bluebeard (if one is to gain a sense of the cultural importance and significance of its heavily laden symbolism and metaphor) it is often at least as important

to see what has been left out as that which has been included. We see, for instance, that in Perrault's 'La Barbe Bleue' we lose numerous elements vital to the oral folk variant, such as that the female protagonist is presented as foolish and culpable in Perrault, whereas in folk versions she is a worthy heroine. The folk heroine saves herself (and, in some versions, her sisters) whereas in Perrault she must wait to be saved by her brothers. As Marc Soriano points out, in Perrault the wife does *nothing* to effect her escape; it is only a coincidence that her brothers turn up when they do.[10] We lose the sense of initiation present in folk versions. What we find, however, are numerous elements that would seem to connect to the Arabian Nights tale. 'The Tale of the Third Royal Mendicant' shares distinct motifs with 'La Barbe Bleue', including the departing agent who leaves the protagonist with care of a vast number of keys and permission to enjoy the castle's bountiful pleasures but *with a single exception*, being this one forbidden closet. Both tales differ from the oral folk forbidden chamber narratives such as 'Fitcher's Bird' in that the protagonist is in the castle consensually (as opposed to having been tricked, abducted, imprisoned and so on) and that the secret chamber would seem to represent taboo rather than initiation. In Perrault's Bluebeard, the wife does not try to escape or defeat her husband on seeing the contents of the room, but instead tries to pretend that she has *not* transgressed the prohibition. *She tries to pretend she has seen nothing.*

One very distinct element from the Arabian Nights tale that is not evident in Perrault's Bluebeard is the loss of the eye. It is possible, however, to track the progression of this motif *not* evident in Perrault's or any other Bluebeard, to secondary narratives which obliquely, yet very directly, reference Bluebeard, and which are very explicitly concerned with eyes and the loss thereof. 'La Barbe Bleue' and 'The Tale of the Third Royal Mendicant' both operate within a strongly visual dynamic, the latter very squarely expressing the idea that *the prince has seen something he should not have seen*, and therefore must lose an eye. Anything that refers to the loss of an eye recalls us, of course, to Freud's famous meditation on the Uncanny. The Uncanny is famously isolated as 'something that should have remained hidden but which has come to light'.[11] The tension, then, is between the visible and the invisible; in a corruption of *Hamlet*, it is rather to *see*, or not to see, that is the core of the issue. In Perrault's tale, this is the crisis facing the wife of Bluebeard. On opening the door to the forbidden chamber, she is, for a protracted moment, effectively blind:

At first she saw nothing, since the windows were closed; after
some moments she began to see that the floor was completely
covered with clotted blood, and that in this blood were reflected
the bodies of several dead women hung from the walls—these
were all the women that Bluebeard had married and then slit their
throats one after the other. She thought she would die of fright
[…].[12]

Philip Lewis describes this scene of discovery as 'a drama of percep-
tion, focused on what the young woman can see' when she opens the
door of the forbidden chamber and is confronted by a slick of clotted
blood, the blood forming a reflective surface in which she sees not only
the dangling corpses but herself.[13]

Freud, of course, spends a significant portion of his paper on The
Uncanny describing and discussing E. T. A. Hoffmann's story *The Sand-
man*. We know the great emphasis upon eyes that characterizes Hoff-
mann's tale, and furthermore perhaps the even greater emphasis
maintained by Freud in his discussion of the work. The child Nathaniel
has a great dread of the Sandman—a horrifying creature communi-
cated to him by his nurse and who 'comes after children when they
won't go to bed and throws handfuls of sand in their eyes, so that they
jump out of their heads all bloody, and then he throws them into his
sack and carries them up to the crescent moon as food for his little
children, who have their nest up there and have crooked beaks like owls
and peck up the eyes of the naughty children'.[14] The child related this
frightful Sandman to the heavy footsteps he hears stomping into his fa-
ther's room on many a night; 'From my little room I would hear him
go into my father's, and soon afterwards it would seem to me that a
subtle, strange-smelling vapour was spreading through the house. As
my curiosity grew, so did my courage, and I would resolve to make the
Sandman's acquaintance by some means or other.'[15]

In view of this primal scenario, which after all is the root cause of
all Nathaniel's adult anxieties, it is possible to discern very clearly the
parallels between 'La Barbe Bleue' and *The Sandman*. The Forbidden
Chamber is, on this occasion, his father's room. For Freud, the scene
inside the father's room (the evil dollmaker Coppélius, a myriad eye-
less doll-heads, and ultimately his father's death) is representative, psy-
choanalytically speaking, of castration. In a certain sense the figure of
Coppélius resembles that of Bluebeard, both in terms of his physically
repulsive, even abnormal, larger-than-life appearance as well as his

tyrannical bearing. Of course, nothing resembles 'La Barbe Bleue' so much as the moment of recognition, of seeing, what the room contains; in the case of 'La Barbe Bleue', corpses, but in *The Sandman* the 'corpses' are those of dolls—which, to Nathaniel, whose expectation of the Sandman is one who plucks out the eyes of children, will resemble nothing so much as the corpses of such children. As with the protracted moment of recognition in 'La Barbe Bleue', so it is with *The Sandman*; thick black smoke obscures much of the room, until: 'I seemed to see human faces appearing all around, but without eyes—instead of eyes there were hideous black cavities.'[16]

Jane Marie Todd's assessment of Freud's *Unheimliche* points to the figure of the woman —the 'castrated' doll, Olympia—from which, she argues, Freud looks away: 'One suspects that he had himself repressed something, that if he failed to see the meaning of the *Unheimliche*, it is because he averted his eyes.'[17] Todd argues against Freud's reading of *The Sandman* which operates exclusively in terms of its father–son dynamics. For Todd, Freud refuses to see that Olympia herself is an uncanny figure, and that this figure is directly related to Woman herself, the castrated body. For Todd this vision of castration is emphasized in Hoffmann's text by the satirical manner of Olympia's presentation: woman is castrated, yes, but that castration is enacted at the level of culture; society makes of woman a faintly uncanny and not quite animate doll.[18] As Todd points out, Nathaniel's horror at seeing Olympia's eyes come out is not just reducible to 'a representation of Nathaniel's imagined castration by the father',[19] but rather hinges on the figure of castrated woman; since, as Freud described, 'no male human being is spared the fright of castration at the sight of a female genital.'[20]

Although ostensibly there is little to connect 'La Barbe Bleue' to *The Sandman*, there are numerous striking similarities. These include the somewhat peculiar ending to Hoffmann's tale, which closely shadows Perrault's. The ending to Perrault's story has Sister Anne ascend to the top of the tower from which vantage point she acts as lookout for the brothers who will come and rescue the soon-to-be beheaded wife. They are visible at first only as an approaching cloud of dust ('une grosse poussière'). This is oddly shadowed in Hoffmann's tale when Nathaniel and Clara ascend the tower of the town hall together; gazing out over the landscape beyond, Nathaniel suddenly spies 'a funny little grey bush that seems as if it is coming towards us'.[21]

Sure enough, this inexplicable 'little grey bush' precipitates a final burst of madness from Nathaniel, who promptly attempts to pitch

Clara from the top of the tower. Clara's brother Lothario flies to her rescue, and thence Nathaniel, spying Coppélius (we can only guess that somehow Coppélius was something to do with the 'little grey bush') in the gathered crowd below, hurls himself to his death. Thus, Nathaniel's tentative recovery seems almost fully realized when, at the close of the tale, he is safely positioned atop the highest phallic erection in the town; it is the murky sight of a 'little grey bush' advancing in the distance that sets him off again, gibbering about puppets and trying to kill Clara by throwing her from the tower, and finally killing himself. Do we doubt that the 'little grey bush' is a mound of feminine pubic hair?

Mapping this back onto 'La Barbe Bleue', we find Sister Anne atop the tower, peering into the distance; like Nathaniel, she at first sees nothing but clouds of dust: 'Anne, ma soeur Anne, ne vois-tu rien venir?' ('Anne, Sister Anne, do you see nothing coming?') This famous phrase is repeated three times, while Anne replies: 'Je ne vois rien que [...]' 'Anne, ma soeur Anne' rhymes with 'rien'—indeed, this may be the only reason why Anne comes into it at all, since she has figured in the tale neither by name nor reference prior to her sudden appearance on the tower.[22] Sister Anne sees *nothing*; even when she sees *something*, it is cast as *nothing*, since it is not the approach of the two phallic brothers. 'Je ne vois rien que le soleil qui poudroie et l'herbe qui verdoie.' ('I see nothing but the dappled sunlight and the rippling grass.') Finally she sees a cloud of dust ('une grosse poussière') which turns out to be a flock of sheep. Only after this does she spy the brothers, in the distance at first, coming closer. Once one has had the experience of reading Freud's statements with regard to the male child's desire for the view of the female phallus as a talisman against his own castration, it is very difficult not to interpret Sister Anne's endeavour as a search for the missing female phallus which emerges, finally, after being confronted with an apparently hopeless nothingness, from the fluffy mass of sheep and dust clouds.

Villiers de l'Isle Adam's *fin-de-siècle* novella *Claire Lenoir* is a text that Samuel Weber has already linked to Hoffmann's. The most literal markers of connection between the two, Weber points out, is that the name of the novella's namesake Claire Lenoir (literally 'light the dark') is a parallel of Clara, and that a literal sandman is figured in the novella in the shape of the 'Ottysor' who beheads Clara's lover, holding the head aloft before disappearing uncannily into the sand. Weber also draws the connection between Hoffmann's preoccupation with eyes and Claire Lenoir's deteriorating eyesight.[23] Claire's final moment finds her

in a room where the walls have been painted with the photographic medium silver nitrate to produce a silver–white mirroring effect to aid (supposedly) her failing vision, which itself is mediated by a pair of thick blue spectacles. Suddenly Claire is stricken with some kind of vision, imperceptible to the observer Tribulat Bonhomet. This vision frightens her, literally, to death. Bonhomet decides that this is too good an opportunity to miss; having heard that the last thing seen by slaughtered animals is preserved on their retinas, he wishes to peer thus into Claire's eyes to see what lay therein. However, because the image on the retina is inverted, he considers hanging the dead woman upside down from a hook on the wall so as to see the image the right way up. He decides against this and lies her on the bed with her head hanging over the side.[24] But one cannot help but note that this final scene of *Claire Lenoir* shadows Perrault's 'Bluebeard', from the mirrored interior, to the inability to see, and to the cadavers hung from the walls. Claire dies of fright; in Perrault's tale, Bluebeard's wife thinks she will do likewise ('Elle pensa mourir de peur'). As Weber notes, *the moment of death occurs at the point of actually seeing.*[25] What for Philip Lewis is a 'drama of perception' becomes, for Weber, a 'crisis of perception'. To see is, literally, to die. Moreover, the figure of the woman becomes the literal marker of this anxiety linked to castration and death, and where the terrifying sight links women to mirrors.

The Jewish metaphor

Although we are moving away from the most obvious associations of Bluebeard as a set of mythic motifs (that is, serial wife-slaying and bloodied keys), it is also true that the version presented to us in Balázs's libretto also omits these themes; certainly the bloodied key is absent, indeed there is not even a specific prohibition attached to the 'forbidden' room, and the women contained within that room are not decisively dead. What I wish to do is to retain this figure of the woman herself as being the site of disquiet, for this aspect would certainly seem to be evoked in Bartók's opera.

If we read Perrault's 'La Barbe Bleue' against 'The Tale of the Third Royal Mendicant', *The Sandman* and *Claire Lenoir*, all narratives that are, consciously or not, intertexted with 'La Barbe Bleue', what we find is that the motif of serial wife-slaying (which motif is found otherwise chiefly in the oral tradition in which the female protagonist is unambiguously victorious) is *absent*. The themes, however, of sight, blindness, castration and, certainly in Hoffmann and Villiers, abject and

morbid femininity, remain. Viewed in this context it would seem to be the case that what in the folk tradition was used to signify 'the mysteries of blood' as a necessary function of initiation, now seems to function as part of this same abject and morbid femininity. If we accept the Freudian perspective that connects eyes and blindness to castration, then it seems reasonable to assume that the bloody and horrific room of women, linked intra- and intertextually to eyes and blindness, also takes on this function. To read the bloody chamber as a visual metaphor for castration may in fact seem obvious, but the importance of this as a notion reflects the subsequent positioning of the female protagonist in derivative narratives where she takes on, as does Olympia, a role not as vanquishing heroine, but abject castrator and, by extension, femme fatale.

By the time we reach the staging of Bartók's opera, we find several motifs that have filtered through the German-speaking tradition, post-Perrault, and which incorporate some very distinct features such as an apparently talismanic use of the number seven and the wife's appellation as Judith. Balázs's libretto does not deal with many of the motifs typically identified with Bluebeard the fairy tale, since the Duke does not forbid access to any of his rooms, nor apparently does he kill women. Meanwhile Perrault's 'La Barbe Bleue' does not feature seven wives nor seven doors; the usage of the number seven appears in the German tradition, associated particularly with Ludwig Tieck's various restagings of Bluebeard. Neither is Perrault's wife given a name. Again, Judith as Bluebeard's wife turns up in the *fin-de-siècle* German tradition.[26] The name Judith, of course, and as Carl Leafstedt points out, is closely associated with the apocryphal Judith who slays Holofernes. Leafstedt writes:

> In the early twentieth century, at the time Bartók and Balázs were writing *Bluebeard's Castle*, the name Judith was strongly identified with the image of a fatally seductive woman. Like Salome, whose popularity as the subject of artistic representations far surpassed that of Judith's, Judith was often depicted as a young woman of considerable sexual allure. In paintings of the time she is shown semi-clothed or naked, holding in her hand a sword or the head of a man.[27]

Bluebeard's reputation as a wife-killer, then, is contradicted by his wife's reputation as a destroyer of men. Furthermore, the association

of Judith with Salome is interesting on numerous levels. Unlike Judith, Salome is a very unambiguous femme fatale who beheads, not a tyrannical oppressor such as Holofernes but rather the very antithesis of tyranny, being John the Baptist. Not only does contemporary visual representation closely link Judith with Salome, but Balázs's libretto closely resembles that of Strauss's opera *Salome*, based on the play by Oscar Wilde (4.1). Like Strauss's/Wilde's *Salome*, and unusual in the operatic repertoire, the intense drama is played out entirely by the two protagonists. Judith, like Salome, does most of the talking while the man is distinctly laconic. Almost the entirety of Judith's and Salome's speech is designed to obtain more from the masculine protagonist than he is prepared to give, and their demands transparently breach the bounds of propriety:

> SALOME: Suffer me to kiss thy mouth, Iokanaan.
> IOKANAAN: Art thou not afraid, daughter of Herodias? Did I not tell thee that I had heard in the palace the beating of the wings of the angel of death, and hath he not come, the angel of death?
> SALOME: Suffer me to kiss thy mouth.[28]

In Salome's case the repeated demands are for nothing less improper than a kiss from the mouth of John the Baptist, a request which, finally, becomes a demand for his head. Not only does she desire carnal knowledge of Jesus Christ's blessed and sexually taboo cousin, she ultimately demands not only a kiss from his mouth but the severed head to which those lips are attached. The scale of Salome's transgression increases to the point where, on finally having his head in her grasp, we understand (as does she) that her final transgression is one step too far; the unnaturalness of her desires is punctuated by the absolute abjection and taboo of necrophilia. She is stalked to the final curtain by the giant wings of death.

Salome is also associated with the number seven, specifically with the Dance of the Seven Veils. There is a direct correspondence between the seven-stage unveiling of her body and the seven-stage unveiling of Bluebeard's kingdom in Balázs's libretto. This 'unveiling', driven by Judith, leads us to the same conclusion that we have previously encountered; being that the uncovering, the revelation, is reducible to the abject female body. Judith rather beseeches him to open each door in turn, in much the same way as Salome cajoles and begs for a kiss from John the Baptist whilst performing a slow strip. The seventh door is finally

opened, not in Bluebeard's absence (as in the fairy tale), but with his permission; we do not find a bloody chamber full of corpses of women, rather we find his three previous wives who are not even dead. Indeed, we are not quite sure what they are, apart from mute and somehow uncanny. We see once again that it is woman herself who is the figure of discord and disquiet, and as the opera ends on the same ambiguous note as does *Salome*, Judith duly joins the women in what appears to be a state of living death. The libretto ends with the return to blindness, as 'The stage is slowly plunged into darkness, blotting Bluebeard from sight.'[29] Sightlessness becomes a site of closure.

The mythology surrounding Judith does not, however, only relate to the figure of the femme fatale. Both Judith (4.2) and Salome were specifically and identifiably Jewish. But if Judith (who not only *is* Jewish but whose name, *Yehudit* in Hebrew, derived from Judah, quite literally *means* 'Jewish'—of the tribe of Judah, one of the sons of Jacob) was originally a Jewish heroine who frees her people from foreign oppression, then Salome is not only a necrophiliac femme fatale and destroyer of men, she is a *Jewish villain* in the sense that she is firmly aligned with the anti-Semitic view of Jews as being the destroyers of Christ.[30] Salome is the stepdaughter of none other than Herod himself, and the cultural slippage which knowingly allows Judith to be identified with this sort of figure then conspires to position Judith too as a veritable anti-Christ. By the same token, if Judith may be associated with Salome, then Bluebeard, one might argue, is now identified on the side of righteousness alongside John the Baptist.

If we are to follow this line of pseudo-religious reasoning, then we cannot fail to take note of the talismanic usage of the number seven. Seven of course has numerous mystical and magical associations, not least in the Kabbalistic system, but it arguably assumes its most pronounced and emphatic symbolical Christian functionality in the Biblical book of Revelations. The language of Judgement Day is the language of the number seven, where everything appears in multiples of seven, from the seven-headed lamb to the opening of the seven seals. The opening of the seven seals corresponds in no small way to the opening of Bluebeard's seven doors, where his seven kingdoms are an apparent pastiche of the seven kingdoms of God, with Bluebeard himself assuming the characteristics of a God. This brings us back full circle to the notion of the original taboo *qua* taboo, not precisely because of a transgression prohibition (there is no stated injunction in *Duke Bluebeard's Castle*), but because Judith represents *transgression itself*. She does

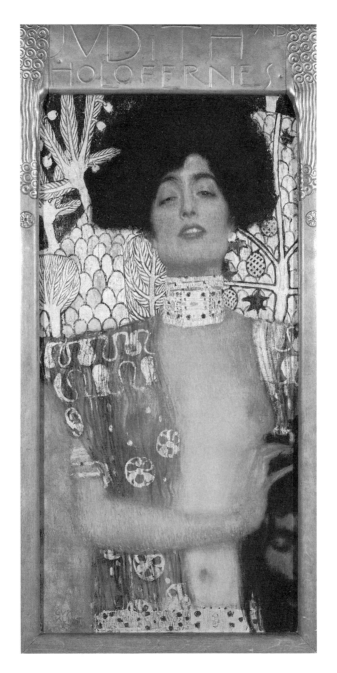

4.2 Gustav Klimt, *Judith I*, 1901, oil on canvas, 153 × 133 cm, Vienna, Os-
terreichische Galerie Belvedere. Copyright 2004, Photo Austrian
Archive/Scala Florence.

not need to transgress because she *is* transgression, as both a woman and a Jew—by name and by association—she stands in opposition to rectitude. On opening the seventh door we are greeted by this mystifying vision of Bluebeard's undead wives, three women apparently condemned to, not death, but eternal life, or an eternal death-in-life. This death followed by immediate revivification operates as an elaboration of this bizarre parody of Judgement Day. If Bluebeard's wives can be said to exist now in a state of perpetual death, an inversion of the Christian ideal of perpetual life, this might also be read as an unconscious allusion to the fate of the Jew who will be similarly condemned on Judgement Day.

Another way of reading the Jewish metaphor in *Duke Bluebeard's Castle* takes account (albeit problematically) of Sunday Circle member Béla Balázs's own Jewishness (born Herbert Bauer), as well as his well-documented political affiliations. This would present a far more ambivalent and even sympathetic positioning of the Judith/Salome character, despite the pervasive negative associations with which the culture was saturated. This would have Bluebeard as an unambiguous (German) patriarch and Judith an unwitting Jewish hostage in a hostile environment. The fate of the Jew according to such a reading is not the religious and spiritual torment of eternal death, but rather the unending earthly misery of the persecuted and ghettoized. To create a fate for such a one-time heroine as Judith is profoundly troubling since it reverses the trajectory of the victorious Biblical Judith and condemns her now to perpetual imprisonment. As such *Duke Bluebeard's Castle* becomes not just a question of masculine or feminine sovereignty, but a depressingly prescient portrait of Europe in the early twentieth century, where the castle is a thinly veiled metaphor for pre-fascist Europe, and Judith a doomed Jew.

Duke Bluebeard's Castle is a complex *mélange* of a diverse array of themes, reflecting the cultural shifts of two centuries; between Perrault's seventeenth-century treatment of an already old tale and Balázs's High Modernist interpretation. If we fail, as undoubtedly we must, to reach a definitive reading of the libretto, then we can at least observe the development of a theme that somehow sidesteps serial femicide and forbidden chambers and revolves instead around abject femininity. Furthermore, we can note that, in Germanic interpretations from the early twentieth century, this morbid femininity is routinely attached to an identifiably Jewish femme fatale. It remains unclear as to whether we should read Balázs's Judith's fate as analogous to that of Salome, i.e. a

just punishment for a transgressive woman; or whether Balázs's Judith is a doomed heroine, a Judith who fails to save her people and instead is assimilated by the system that is Duke Bluebeard's castle. The blindness and darkness that ends the work perhaps underscores the absence of resolution to be found in Balázs's creation; but if we fail to reach resolution we should note that, at the close of *Duke Bluebeard's Castle*, it is Bluebeard, too, who is himself condemned to darkness. At the same time, a shadow falls across Europe.

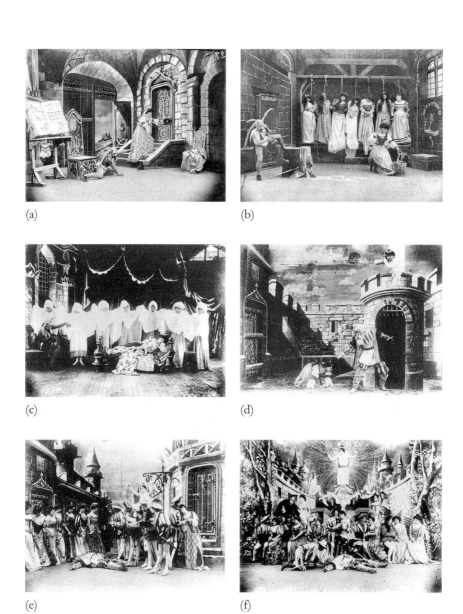

5.1 Stills from *Barbe-bleue* (Georges Méliès, 1901). (a) *Going into the Forbidden Room*; (b) *Finding the Dead Wives*; (c) *Dreaming*; (d) *You must die*; (e) *The Brothers kill Bluebeard*; (f) *The Godmother unites the resurrected wives and the seven gentlemen*. Reproduced courtesy of the British Film Institute Stills Library, London.

HIDDEN DEBATES
UNDER A BAROQUE SURFACE
Barbe-bleue by Georges Méliès (1901)

Michael Hiltbrunner

I want to compare some specific qualities of the nine-minute short film by Georges Méliès, *Barbe-bleue* (1901) to the revisions of the *Bluebeard* tale by Eugène Sue, Jacques Offenbach and Joris-Karl Huysmans. I shall argue that Méliès manages to create a unique version of the story by remaining close to the original by Charles Perrault and introducing mainly two new figures: an imp and a godmother.

Films of attraction

The French film pioneer Georges Méliès (1861–1938) was the third son of a shoe manufacturer and used his part of the family inheritance to buy the small Théâtre Robert-Houdin on the Boulevard des Italiens in Paris in 1888. He was an admirer of the famous magician and illusionist Robert Houdin, and reopened the theatre in order to continue organizing *soirées fantastiques*.[1]

Méliès attended the first film screening staged by the Lumière brothers in 1895, film being a medium that immediately caught his attention. But the Lumière brothers refused to share their technical facilities with him, so Méliès bought the necessary material in London and developed his own set. In 1897, he opened a studio in Montreuil near Paris, where he produced films until 1913, and showed them in his theatre. Throughout this period, Méliès produced about thirty stage plays for his theatre and more than 500 movies,[2] selling them in Europe and the USA through his company Star Film. From 1902 to 1914 the company even

had an agency in New York run by his brother Gaston Méliès. At the time, movies were shown as a special attraction in amusement parks as the film industry was relatively small. Tom Gunning named the era of cinema production before 1906 the 'cinema of attractions'.[3] The audience did not want to see the films because of its authors or content only, but also because of the strange and novel technology presented.[4] In this market Star Film was one of the leaders, and Georges Méliès one of the most important filmmakers of this whole era.

The films Méliès made in 1896, the first year of his production, were mostly travelogues and records of newsworthy events. Continuing to produce such films, he would later on add documentaries, advertisements to his programme, replay newsreels or even stage them before they happened (e.g. the crowning of King Edward VII in 1902). Some of the events Méliès filmed in 1896 were his sketches, in which he continued his work as a magician and illusionist.

The Théâtre Robert Houdin had famously been equipped with all kinds of technical devices designed to trick the audience. But in the film studio in Montreuil Méliès improved these devices and adapted them to the new medium. He would soon add film tricks like substitution (e.g. *Escamotage d'une dame au théâtre Robert Houdin*, 1896), double exposure (*La caverne maudite*, 1898), performers acting opposite themselves (*Un homme de tête*, 1898) and tricks for the dissolving, apparition, disappearance, metamorphosis and decapitation of bodies. Having the camera fixed on the floor of the studio in Montreuil, which was an exact remake of the Théâtre Robert Houdin, allowed Méliès to work with high precision.[5] The entertaining qualities and the technical preciseness of some of these sketches remain impressive even today. The quick and sometimes disturbing changes between life and death, reality and dream, animate and inanimate and, especially, the often violent alterations of bodies make the audience laugh, but work at the same time as reminders of *vanitas* and mortality.

In his films Méliès hid the skeleton of a story under many *arabesque* embellishments, as he said in 1912, noted by Jacques Deslandes:

> He who composes a cinematic subject of fantasy must be an artist possessed by his art [...], seeking above all to make the skeleton of the scenario disappear beneath the delicate arabesques in which it is enveloped[...]. I am always attached to this which is my passion and my joy.[6]

This statement might lead to the assumption that Méliès would not care about the content or the narration of his stories. But Méliès' oeuvre shows a conscious choice of stories, figures and narrative forms, not only in his sketches. In 1897, Méliès supposedly made two films that could be the first existing films to be based on a dramatic plot, by way of two versions of the story of Faust: *Faust et Marguerite* and *Le cabinet de Méphistophélès*.[7] Dramatic films would soon become an important part of his work, again based on canonical literary works, as in *Les Aventures de Guillaume Tell* (1898), *Le miroir de Cagliostro* (1899) or *Hamlet* (1907). Méliès would present historical events (*Jeanne d'Arc* in 1899), Greek mythology (*L'Oracle de Delphes* in 1903) or science fiction. Indeed, one of his most famous films, *Le voyage dans la lune* from 1902 is a science fiction story, which consolidated his fame as a narrator creating fantastic worlds. His films are overfilled, restless and sometimes even colourful. This fullness reminds us of baroque aesthetics, where emptiness in the stage setting or in the chain of action would raise fear. Méliès mostly took the ideas for his adaptations of stories, novels and plays from other authors of his time, especially from plays at the Boulevards of Paris, where his own theatre was located. Méliès also made films of fairy tales, like *Le royaume des fées* in 1903 and *Les palais de mille et une nuits* in 1905, but they remained infrequent in his work. His first fairy tale movie was *Cendrillon* in 1899, an enormous production with over thirty-five actors and, running at 75 minutes, his second longest film ever.[8] In 1901, he produced again two fairy tales, *Le petit chaperon rouge* and *Barbe-bleue* by Charles Perrault.

Versions by Sue, Offenbach and Huysmans

Ever since Perrault published 'La Barbe Bleue' in 1697, the story of the nobleman killing his brides enjoyed continuous popularity in France. Between 1746 and 1898 over thirty different stagings of the fairy tale took place and several books were published.[9] The tale was not only rewritten, but also further developed. Three of these variations known at the end of the nineteenth century are mentioned here: The novels *Le Morne-au-Diable* and *Là-bas* and the operetta *Barbe-bleue*.

Nowadays almost forgotten is the adventure novel *Le Morne-au-Diable* (suggested translation: *The devil's hillock*) by Eugène Sue, released as *L'aventurier ou la Barbe-bleue* in 1841/2 in the French newspaper *La patrie*.[10] On a voyage to Martinique (he dodges the fare!), the poor adventurer Chevalier de Croustillac hears of a rich woman, Angèle, who is believed to have killed three of her husbands. Croustillac wants to

become her fourth husband, simply in order to have another adventure and to live in wealth for a while. In the first part, various issues pertaining to the Bluebeard story are addressed in an astonishing manner, e.g. the intention of marrying somebody suspected of being a spouse-murderer. Croustillac is sure that the power of his charm and the hence inevitable love affair can change the woman's cruel behaviour: 'It is completely simple: this poor woman has no concept of an amiable and gallant gentleman.'[11] In Croustillac's view, the woman must be jaded by her wealth, and she would hunt, capture and even eat men only to amuse her. Croustillac considers that only a very beautiful woman could behave so badly without getting into trouble. He is looking toward to meeting her soon and sure to be able to seduce her:

> Mordioux! I am going to see her, please her, seduce her. Poor Woman... she does not know that her conqueror is at her door [...] and that happiness will come to her on the wings of love...[12]

In the second part of the novel, the Bluebeard tale is deconstructed. It transpires that there is no killer behind the Bluebeard façade, but a royal couple escaping from the king of Great Britain, trying to find asylum in French territory on Martinique. Croustillac does not marry Angèle, but they happen to live together much later on a farm in France. Angèle, her husband, Jacques de Monmouth, their children and the by-then wounded and retired soldier Croustillac. Most interesting about this amusing version with its female Bluebeard is the necessity for the main characters to play other roles (Angèle the Bluebeard to keep away any visitor, her husband Jacques three different uncanny men in order to hide his identity, and Croustillac the nobleman Jacques, saving thus the nobleman's life). Playing roles seems to be a necessity for survival for which the Bluebeard tale is used as a camouflage to hide a royal secret. Other stories by Sue are better known today, like *Les mystères de Paris* (1842–3), *Les sept péchés capitaux* (1847–52) or *Le juif errant* (1844–5)—the latter two are also known as films by Méliès. A connection between these works cannot be explored here, but it is likely that the work of this critical and engaged *romancier* may have left its mark on the work of the film pioneer.

Still known today is *Barbe-bleue* by the German–French composer Jacques Offenbach.[13] This operetta, with the libretto written by Ludovic Halévy and Henri Meilhac, was a travesty of the fairy tale, pointing with black humour at the contemporary hypocritical political situation

under Napoleon III. In this 1866 operetta, the audience sensed the upcoming political changes and the impending catastrophe culminating in the Franco-Prussian war of 1870–1, as Siegfried Kracauer wrote in 1937:

> Exactly in this jugglery, in the sudden shifts from scenes of the fear of death to jolly merriness it answered the demands of the audience to override the imminent catastrophe. […] The operetta allowed—another reason for its success—space for the democratic impulse.[14]

In this version another negative character besides Bluebeard can be found: King Bobèche believes he is killing men he suspects of being interested in his wife. Bluebeard and Bobèche really have a genuine desire to kill, and both of them obviously want to seize power through cruelty, but they do not succeed. In the end all victims reappear, alive and well, and proceed to marry each other. The sixth wife of Bluebeard, Boulotte, leads a revolt of all the wives in Bluebeard's cellar. The operetta was a success, but was soon outplayed by two others, on which Offenbach, Meilhac and Halévy collaborated: *La vie parisienne* (1866) and *La Grande-Duchesse de Gérolstein* (1867).[15] Offenbach, the creator of the French operetta, was quite famous at the time and plays like *Les trois baisers du Diable* (1857), *Orphée aux enfers* (1858) or *Les contes d'Hoffmann* (1881) exist as films by Méliès as well and could, therefore, be adaptations of them.

Still known for its occult content is the story *Là-bas* by Joris-Karl Huysmans from 1891.[16] The French writer Durtal goes through a deep crisis as he conducts his research into the fifteenth-century French mass murderer, Gilles de Rais. Parallel to this crisis, de Rais' story is told alongside occult incidents in nineteenth-century France. Huysmans explains—through the voice of Durtal—his narrative concept, which aims to be Naturalist, but is indeed quite spiritual, or in Durtal's words, a form of 'supernatural realism'. In the 1880s, Huysmans was a leader of the Naturalist movement in France, before he later moved towards what is now called Symbolism. The connection to the Bluebeard tale in *Là-bas* is given through statements, where de Rais is called a Bluebeard.[17] There are no obvious connections between the two contemporaries, Huysmans and Méliès, besides the fact that they often made reference to similar topics, such as phantasmatic dreams, spiritism, occultism or spirituality in general. Méliès treated these topics as obviously visible

tricks in his illusionist work, or dissolved them as charlatan activities of characters in his movies. He, therefore, always used them from an enlightened perspective and never engaged with the fascination we see in Huysmans' life and oeuvre.

Unique new Bluebeard by Méliès

The next known French version, and the first longer version filmed worldwide that is still conserved, is *Barbe-bleue* from 1901 (5.1).[18] This version presumably was known to cinema viewers only. The movie is nine minutes long and has ten scenes, or *tableaux*. Méliès' film was neither based on Offenbach's parody, nor on Sue's deconstruction nor Huysmans' use of it as a myth in a new story. It is directly based on the fairy tale by Perrault, and Méliès does not try to emulate, to deconstruct or to rework the plot. Rather, he seeks for an appropriate manner of using the new medium, silent film. The costumes mostly seem to refer to the eighteenth century, and the film's opening as well as the dialogic scenes resemble a filmed stage play. These scenes operate conventionally. The baroque fullness and the sometimes stiff staging make for difficulties in getting the little jokes hidden in the plot, for example Bluebeard refusing to pay the notary, or a cook falling into the pot and being fished out again only as a frazzled piece of meat. The stage settings are, presumably, as in most of Méliès' films, accurately painted in black and white and different for each scene. Even if they are not very striking, their inconspicuousness proves their functionality. Remarkable is the appearance of a huge bottle of Champagne Mercier during the kitchen scene. Following the documentary by Jacques Mény, the champagne company paid for this shot and we could, therefore, call it the first product placement known in movie history.[19]

When we are confronted with the inner life of Bluebeard's wife, Méliès surprises us with a new perspective on the old story. As soon as Bluebeard leaves his castle for a business trip and thus leaves his wife alone with all his keys, an imp jumps out of a book (maybe even a Bible?), which is placed in the entrance hall. This appearance reminds us of many other films by Méliès, in which a devil, a sorcerer, an ogre, an executioner or a monster appears, most of them played by Méliès himself: 'Méliès' numerous appearances as the Devil must far outnumber that of any other actor, having appeared in as many as twenty-four manifestations in his films.'[20]

In *Barbe-bleue* Méliès presents no good dwarf or funny fool, but a unique mix of devil and jester, influencing the wife and forcing her to

enter the forbidden chamber (5.1a,b). Having done his evil work, he even closes the door behind her. In the puppet play *Blaubart* (1859) by the German writer and graphic artist Franz Graf von Pocci the fool Larifari performs the same role; he obviously manipulates the wife and leads her to open the forbidden door. He argues that giving a key to her and not allowing to use it would be like offering him an empty beer mug to drink from:

> Fool: It offends me, just as somebody would give me a beer mug with nothing in it. What an offence and disgrace! I couldn't stand that.[21]

Though the fool is right in his argument, he nevertheless helps to provoke a direct confrontation with her angry husband, giving Bluebeard the licence to kill her. In the movie by Méliès, the imp seems to be, like the fool in Pocci's play, subordinate to Bluebeard. While Méliès' imp disappears when his master is dying, the fool in the puppet play finishes the narrative with a moral, in which he emphasizes the negative consequences of curiosity, thus copying Perrault. But the fool's argument is not very truthful if we take into account what he has done. His moral can also be seen as a kind of excuse. Aside from these parallels, the imp in the film by Méliès seems to be less an independent character but more an extension of the evil will of Bluebeard, with a godmother appearing in the next scene as their opponent. This scene in the forbidden chamber shows again the elegance of Méliès introducing the two new figures. At first, the story stays close to the original. The room is dark, the wife cannot see anything until she opens the shutters and sees blood everywhere, as Perrault writes in 1697:

> At first she saw nothing, for the windows were closed, but after a few moments she perceived dimly that the floor was entirely covered with blood, and that in this were reflected the dead bodies of several women that hung along the walls. These were all the wives of Bluebeard, whose throats he had cut, one after another.[22]

In both versions the wife sees dead women hanging in a row, one beside the other, a mute collection of terror. The uncounted number of corpses in the Perrault version is defined as seven in the film—and she would be the eighth. In this situation of terror, with the key stained with blood and looming large in the mind of the wife, a beautiful *fin de*

siècle godmother appears and turns the imp away, scolds the bride and calms the situation.[23] For Darragh O'Donoghue this scene in the forbidden chamber contains a central metaphor of the cinema of Méliès: 'The locked room, containing forbidden sights, darkened but illuminated, becomes the metaphor for Méliès' cinema, a manifestation of private desires in a public or communal medium.'[24]

Imp and godmother can, therefore, be seen as both sides of inner desire, two opponents already given by the wife and her husband, but now shown to the visitor of the cinema amplified by two standard characters representing the fight between good and bad. The imp appears one more time in the next scene, giving the bride nightmares: he makes the dead women appear to her (5.1c), then her husband intending to kill her, and many huge keys dancing over her. Again the godmother appears, but she does not need to fight like the archangel Michael fighting Satan. This imp obeys immediately and disappears, together with his bad dreams. Finally, the godmother blesses the bride and the audience is ensured of a happy ending to come.

From here on, the story follows the well-known path (5.1d) until Bluebeard is killed by the bride's brothers, a *Dragoon* and a *Musketeer*.[25] During the ensuing fight, the imp appears a last time, trying to prevent the death of his master, but he is unable to act. As Méliès often played the protagonists of his films himself and in respect of how Bluebeard and the imp are played in this film, I would assume that Méliès played both of them. If this is true, a film trick must have been used in this scene when they are both on the screen at the same time. This climax is completed by the reappearance of the godmother and her reviving of the seven dead women (5.1e), who show their merciless anger towards the dying Bluebeard. Seven gentlemen, who spontaneously join the scene, are ready to marry these women. This group marriage with revived wives and (unknown) gentlemen could have been inspired by Offenbach. But contrary to Offenbach, where the wives were just imprisoned, they are really dead in Méliès' film and need to be revived. Again, contrary to Offenbach, Bluebeard still has to die, instead of spending his future with his last wife. Méliès takes from Offenbach's operetta certain motives, ideas for costumes and stage design, but not the plot. This repeats the situation that Guy Gauthier identified for Méliès' science fiction films, which seem to be based on novels by Jules Verne, but obviously are influenced by illustrations in books and magazines only.[26] It seems that Méliès would use images as an inspiration

for his adaptations, but not the texts. This proposition could be tested on other adaptations of literature in his work.

The final *tableau* of the film, which is sadly almost cut from the preserved copy, is a *tableau vivant* with all the couples and the dead Bluebeard on their feet (5.1f). Hovering over them is the godmother and a bird giving the film an introspective and comforting ending.

Marriage and women's rights

The film *Barbe-bleue* has a completely different background from the new versions which emerged at the beginning of the twentieth century, such as the libretto by Maurice Maeterlinck written in 1899, published in 1901 and used in the opera by Paul Dukas in 1907.[27] It seems that Méliès avoided new forms such as Symbolism (chosen by Maeterlinck or Huysmans), the absurd (as presented by Alfred Jarry, with the play *Ubu Roi* in 1897) or the already well-established Naturalism (staged in Paris by André Antoine since 1887). Méliès' work could even be described as nostalgic and idyllic if it were not for his stringent choice of media, topics and forms, which gave his oeuvre such lasting value.

From an avant-garde perspective Méliès may have appeared to be conservative, traditional and heavily focusing on entertainment. From today's perspective, however, Méliès managed to discuss relevant topics of his time in an unobtrusive and sophisticated manner. In *Barbe-bleue*, these are, for instance, marriage and women's rights. Divorce was legalized in France in 1884, yet the article 324 of the *Code pénal* (known as the 'article rouge') was still in power, which legalized the murder of a wife if the husband found her in bed with another man. In 1896 a famous *Congrès féministe international* was organized, and the feminist newspaper *La Fronde* was founded in 1897.[28] Without mentioning it, the film *Barbe-bleue* from 1901 declares a clear position on these topics. The behaviour of the imp shows that it is not the wife who should be considered the guilty party because of her curiosity, but rather the husband and his malicious helper. As this helper jumps out of a book standing open on a bookrest, it could be a book as important as the law or the Bible. The wrong-doings by the husband and his helper are attacked by the revived wives in a vivid manifestation in the penultimate scene. The final death of Bluebeard shows belief in progress, this time realized in equal rights for women, and the scenery is finally blessed by the godmother and a bird. There is a certain resemblance in the two to the Holy Mary and the Holy Ghost—and if we take up again the idea of

Bluebeard's book as law or Bible, it would even show a superiority of 'myth' and 'spirit' over the written word.

But all too quickly, the women and men are remarried. By bringing all the dead wives back to life, Méliès chooses an ending that is even more positive than the one by Perrault, where only the last wife survives. Such an ending is questionable, especially in comparison with many other variants, where Bluebeard survives and cannot be stopped any more. In Offenbach's version he is described as tamed, but lives on. In the version by Maeterlinck he lives on and the women stay with him—they prefer the prison instead of the fight for freedom. We cannot be certain that the blessings from heaven like the ones Méliès places in the final *tableau vivant* make it safe. We could well assume that the weddings at the end indicate the tragic restart of the same terror.

Conclusion

I do not think that thematic and critical aspects in the films by Méliès were noticed by many contemporaries for the same reasons that led to Offenbach's career to peter out after a while. Both Offenbach and Méliès worked in a literary style, disguising their messages in an ambiguous manner. The *arabesque* embellishments and the will to entertain and impress eclipsed the thematic and critical content. As Méliès made reference to works by Eugène Sue and must have known the works by Joris-Karl Huysmans, his decision to base his film *Barbe-bleue* exclusively on the seventeenth-century fairy tale by Charles Perrault, only referring to Jacques Offenbach in the use of settings and costumes, it becomes clear that Méliès wanted to establish the story as a battle between good and evil. This contest, too swiftly finished with the final marriages and the re-consolidation of the civic façade, is visualized by the appearance of the imp and the godmother. Méliès used conservative forms and a baroque surface in his film under which a debate can be discerned that leads to an opening of a dark chamber. This dark chamber, shown as the connection between imp, book and Bluebeard is resolved by the cooperation of the wife, her sister and brothers, the godmother and a bird. It illustrates nothing less than a strong statement for the rights of women. Thus the public statement of a very political message takes place through a film itself projected in the dark room of the cinema, which thus becomes a kind of platform of illumination. It is in no way an instruction for revolt. All the protesting women get re-married immediately. But it is, none the less, a literal statement in the sense of enlightenment.

6.1 Gustave Doré, after illustration to 'La Barbe Bleue', from *Les Contes de
 Perrault, dessins par Gustave Doré*, ed. J. Hetzel (Paris: J. Hetzel, 1867),
 engraving, 1893. Private Collection/Roger Perrin/The Bridgeman Art
 Library.

6

HOMMES FATALS
Murder, Pathology and Hollywood's Bluebeards

Griselda Pollock

On the average, more than three women are murdered by their husbands or boyfriends every day.

<div align="right">

Bureau of Justice Statistics, 2003[1]

</div>

Feminist cultural analysis works, as Gayatri Spivak has insisted, on a double axis: *against* sexism and *for* feminism.[2] It must work *against* sexism that is institutionally structured into ways of thinking and imagining; feminism thus insists on raising the repressed question of gender as an active factor in all of culture that not only causes exclusions of women from the canons of culture on the basis of sex but also plays its active part as an axis of power and difference in cultural representation which, as it were, stages gender as itself a representation. All culture, according to Teresa de Lauretis, including feminist deconstructive work itself, is a technology of gender:

> The sex–gender system, in short, is both a sociocultural construct and a semiotic apparatus, a system of representation which assigns meaning (identity, value, prestige, location in kinship, status in the social hierarchy etc.) to individuals within society. If gender representations are social positions which carry differential meanings, then for someone to be represented and to represent oneself as male or as female implies the assumption of the whole of those

meaning effects. Thus, the proposition that the representation of gender is its construction, each term at once the product and the process of the other, can be restated more accurately: *The construction of gender is both the product and the process of its representation.*[3]

Feminist cultural analysis must, therefore, also work *for*, that is produce, *other* ways of thinking and imagining that are not complicit with the dominant psycho-sociological structure of phallocentric configurations of gender and sexual difference such as are exposed in Béla Bartók's monumental and ambiguous study of modern masculine subjectivity by the instrument of his final wife, Judith's loving investigations. Feminist critical rewriting is a transformative *reading* of dominant cultural themes and images, reading against the very grain of what they are striving to propose as the way things are, in a double process of identifying the problem and generating possibilities for other understandings and ways things could be.

One powerful cultural *idée fixe* of the phallocentric imaginary that we need to interrupt is that *women* are dangerous, fatal even, to men, either through their sexuality or, as importantly, through their curiosity and desire to understand something beyond the pompous surface, to deal in interiorities and fragilities of human needs, loves and fears. The notion of the femme fatale has become embedded in Western patriarchal culture through a variety of myths, legends, stories and their constant re-circulation through visual, dramatic and musical representation in which the idea itself acquires the added powers of all the aesthetic effects that each of these arts can create to delight, move or overwhelm us by their beauty or their magisterial order, in the words of Susan McClary cited as epigraph to the preface to this volume.

How do we pierce the prevailing fantasy of the femme fatale all the better to reveal it as, in fact, deeply counter-intuitive? In the ordinary way things are in social life, women are not really dangerous to men in any way comparable to the statistically proven menace that men pose to women in terms of spousal murder, domestic violence and rape, itself a kind of killing.[4] Official statistics indicate that women are being raped and murdered minute by minute, hour by hour and that the proportion of men murdered by their wives is minute compared to the statistics of men regularly killing their wives and partners. Moreover, in the majority of the cases, women kill husbands or partners in self-defence against violent and abusive men.

So where are the images, stories, myths and legends that incarnate and warn us of the much more widespread fact of the *homme fatal*?

Amidst all the elaborate figurations of feminine sexual danger—Lilith, Salome, Cleopatra, Judith, Delilah, Eve, Morgan Le Fay to name but a handful (and note their often-times ethnic otherness as Jewish or Oriental)—there are almost no stories in the western canon of comparable longevity or cultural resonance that register the much more sinister, sociological and historical fact that women are systematically at risk from masculine violence and sexuality.[5]

The story of Bluebeard is, therefore, highly significant as a rare, if not the unique, representation of the figure of the *homme fatal*. Fairy stories, as Maria Tatar has noted in this volume, often end 'and they lived happily ever after'. The trajectory of the folk tale typically tracks the vagaries of the hero's voyage into adulthood; his ordeals of manhood conclude with his finding and winning of a bride. *The fairy story of Bluebeard is different*. It *begins* with a marriage, creating a setting for the playing out of conflicts between man and woman, old and young, powerful and powerless, in ways that would seem to represent, culturally, what is for women, statistically, an extremely dangerous situation. Men do murder their wives, or enact upon them terrible and violent abuse in greater numbers than the reverse. So what does any retelling of the Bluebeard theme of the murderous husband allow culture to contemplate and, virtually, rather than in the real social realm, to challenge, since any retelling is always a transformation affected by the socio-ideological conditions of its moment of enunciation? The conjunction of Modernity and a tale, with multiple origins in culture (other variants of the story's key elements, old, strange, husband-killer, secret chamber, curious wife) and history (in the historical figure of Gilles de Rais) that was written into European high culture in 1697 by Charles Perrault, took the story in a psychological direction, intimated, but betrayed, in Balázs and Bartók's operatic collaboration at the beginning of the twentieth century. Thus we need to track the relations between two attributions of deadliness to women as threats to masculinity that unleash violence: sexuality and curiosity, and plot out the secretion of the Bluebeard tale into that most modern of psychological technologies for the representation of gender and subjectivities: the cinema.

In this chapter I shall discuss three American films which variously, directly or indirectly, invoke the Bluebeard theme. Two have 'Bluebeard' in the title *Bluebeard* (Edgar G. Ulmer, 1944) and *Bluebeard* (Edward Dmytryk, 1972). The latter is a straightforward retelling of a tale of a murderous husband with many wives; the former uses 'Bluebeard' as a moniker for a serial murderer of women set in early nineteenth-century Paris, which is indebted to the detective fiction of Edgar Allan Poe

rather than Perrault's moralities. The third, *Love from a Stranger* (Rowland V. Lee, 1937), was based on a short story by Agatha Christie, *Philomel Cottage*, rewritten as a play by Frank Vosper and takes on the character of both a horror story and a thriller.[6] None is regarded as a specially significant film in the canon of modern cinema. None has any claim to innovation in cinematic techniques or film form. Indeed, at least one of them, could be a cause of some embarrassment to both its star, Richard Burton, and its otherwise quite respected working director, Edward Dmytryk. So the choice of topic for this chapter will need to be situated in a territory other than canonical film studies. I shall suggest 'frames' for the reading of these films that draw into transdisciplinary encounter concepts from feminist anthropology and psychoanalysis.

As I have already suggested, my neologistic title quite obviously inverts the more famous phrase: *femmes fatales*. This femininized shadow serves to underline, firstly, that while we have become accustomed to accept the idea of the fatal sexual allure of women over men, culture does not offer us a comparable number of stories or images that acknowledge or explore the dangers men may pose, sexually and in related gender violence, towards women. Secondly, the gender inversion, *hommes fatals*, does itself violence to the prevailing notions of masculinity that are already complexly figured in and by the myth of the femme fatale that links femininity, sexuality and death and projects these onto masculinity's sexual other whose own sexuality and human agency is thus abolished, as 'she'/'woman' is recast as a sign of what menaces the fragile integrity of masculinity. The difficulty of reconciling the strong man brought low by the sexual power of woman with the acknowledgement of the ordinary and regular violence by (not all) men towards women leads, I shall show, to distortions and compensations in the manner in which such cultural forms as will acknowledge the violence of masculinity negotiate what can only be treated as a *deviation* into masculine murderousness. Put simply, while statistics tell us the sad and banal tale of the regularity of male violence towards women and girls, cultural representations tend to make the murderous man exceptional, mad or deranged: he will be represented as an outcast from proper men (the rescuers, the police and other representatives). He will be othered by pathology, feminization, and by his apparently incomplete accession to 'proper' masculinity. He will be shown as damaged, a victim of circumstance, history, or, of course, a woman. The *fatality of women* thus often returns in disguise as the ultimate cause or source for the derangement that produces the aberrant *homme fatal*.

Thus the films I shall discuss deal with the murderous husband/ serial killer by rendering him a psycho-pathological exception, insane and monstrous, who has, however, been created thus because he has been psychologically traumatized and ruined by some formative earlier encounter with a fatal woman: in one case a prostitute, in another an overbearing mother. Woman will thus still be ultimately to blame: fatal indirectly to the other woman whom the Bluebeard murders through a chain of harm in which the Bluebeard figure becomes a victim-turned-executioner. Whatever the story, however, it is the woman who will be punished by the cinema in the telling of the tale, even if, to confirm the *exceptionality* of the wicked man, he cannot survive the film itself. Thus does phallocentric culture admit, but also rid itself, of the burden of knowledge signified by the rare admission of masculinity as Bluebeard, the serial murderer.

Insisting on the normalcy of masculine violence against women and the rarity of its cultural acknowledgement, I might begin to sound like the worst caricature of the man-bashing feminist. I shall need, therefore, to distance myself from such a fate through a theoretical digression into the construction of the sex–gender system of which the terms men and women are to be understood as a socio-semiotic and psycho-symbolic effect. We cannot explain or justify masculine violence by reference to evolutionary necessity for male strength and domination, or to an innate typology of given, biologically or anatomically derived gender. Gender is not a fact of nature. It is the product of culture. The conditions that make men violent or white people racist, or any other privileged group supremacist, are the social–economic–political systems that dispose the subjects, that they themselves shape, in asymmetrical relations of power and forge the situated identities and subjectivities that accord with the historically changing necessities of those social relations and systems of power.

Structuralism argues that there is no nature, later overlaid by culture. There is always system. Systems *create* meaning by marking the open potentiality of the world with difference. The most basic of impositions of a difference which distinguishes x from y (the initiating act of culture) generates between the differentiated pair a binary opposition and thus a structurally related and relative pairing of concepts that emerge simultaneously and cannot be disentangled even as they appear merely to name radically opposing states. Plus/minus. Culture/Nature. Man/ Woman. Thus there are no positive, self-identical terms; meaning is always produced in such binary oppositions, in relational difference

which implicates the pair in hierarchy: Culture/Nature within a system of signification. Feminist analysis does not only focus on the social relations of class in which we are deposited in relation to capitalist or other relations of production. Following the insights of structuralist anthropologist, Claude Lévi-Strauss, feminists such as Gayle Rubin have argued that sex–gender must be grasped as a product of social relations, but, in this case social relations of kinship which is a system of exchange and, furthermore, a system of signification. Lévi-Strauss applied Saussurian structural linguistics to what seemed the infinite variety of cultural organizations of marriage and property: kinship systems. He argued that these kinship systems are the foundations of society because they articulate social connections forged by means of exchange which are also to be understood at the same time as systems of communication. Exchange involves people and goods, but also signs, and also some people: women as signs.[7]

Social groups (society) form through exchange: something is passed from one 'family' to another 'family' thus creating socially and semantically both the distinction between them (difference) and the cultural bond that links them into relations that constitute society/culture, superseding by virtue of significance attached to this exchange any so called 'natural' habits. This circuit of exchange creates difference and forms social bonds by means of the exchanges between the groups. What moves between the groups becomes the sign of connectivity: not a meaning for itself, but the sign of the culture that the exchanging is constituting. The system creates further difference: between those who exchange and those who are exchanged—the latter becoming thereby a signifier in, and the signifier of, the bonding system that works to distinguish and then link. According to Lévi-Strauss, the study of kinship systems shows that the sign/gift that moves between the groups the practice of exchange constitutes is named a *woman*. 'Woman', therefore, signifies 'exchanged'. 'Woman' is to be understood not as a given person or a real body, but as a sign. The concept 'Woman' is thus an *effect*, a product and result, not a *condition* of the exchange system which is a system of differentiations by means of which clusters of meaning are produced. The exchange or what Rubin called 'the traffic in women' creates the structure of the social bonding that can take various forms without changing its meaning-producing character.

Kinship—exchange of women—systems thus create an asymmetrical hierarchy within two groups of human people in the same species; *gender* is the demarcation between two, arbitrary but socially significant

groups created by the system of exchange. Those who exchange are bonded into social relations of connection and difference by means of the passage between them of what is *other* to them, the exchanged. The linguistic notation for exchanger is 'men' and for the exchanged 'women'. This is, Lévi-Strauss stressed, a sign system, a communication system producing meaning through these socially generated, differentiating markers. Woman then signifies the bond created between the exchangers: the bond—society/culture—between men. Through this system a human person defined as 'woman' also becomes property and her body and its potential products in labour and children are also experienced as property belonging to the exchangers (father/husband), hence the widespread regulation of women's independent sexuality/agency by social rules, honour cultures and even by physical forms of genital mutilation and murder for transgression through any signs of independence: looking at men, desiring men, acting sexually. The less rigorous is the power of direct control of the physical women who function as these critically social signs of men to men bonding, the more potent the forms of cultural, ideological, representational management. Thus, in modern cultures, the technologies of gender are powerfully enacted through representation and cultural technologies such as art, cinema, literature.

Kinship structures are initially very visible—worn on the outside, as it were—and powerful in human cultures. But they are also increasingly embedded in and transmitted by cultural narratives which replay the formation and functioning of these structural relations of exchange. *Structuralist* analysts of folk tales, therefore, argue that there are, in fact, very few narratives in the world; there are core narratives and their endless variations and adaptations which often replay, restage, and rework the basic relations of kinship, coming of age, constitution of heteronormativity and marriage.[8] We know from our own childhood exposure to fairy stories that the ending of the adventure, the ordeal, the quest is often: 'they lived happily ever after'—*they* being the heterosexual prince and his new bride and the occasion of the ending of the story being a marriage, the foundation of a new family by means of the journey of the young man to secure his prize: the sign of his coming of age as a man: a woman. These one-sided stories often deal with conflicts and difficulties in the social arrangements of kinship and succession by means of personification, making characters perform the *functions* designated by the kinship and narrative system. Structuralist analysis has enabled us to pierce the cultural veil of romantic storytelling and

identify the architecture of the system that *produces* gender and sexuality, that creates the asymmetrical system of gender, as effects of the kinship systems.

Charles Perrault's version of the Bluebeard tale, 'La Barbe Bleue', stands out amongst these stories as a counter-narrative. In the first place, the story *begins* with a marriage, although it, too, ends with a second, this time a 'proper', marriage. It starts with a couple who do *not* live happily ever after—but the authority and order of marriage is spoiled by the disobedient succumbing of the wife to her desire: curiosity being the sign of an agency which in woman is deemed transgressive. Yet there would be no tale without her action. This plot opens up the story to two levels of conflict. There is a contest between the husband's authority and the wife's disobedience: so the story might be said to be dealing with the issue of gender and rule. The other conflict is between the older man's excessive and misdirected power and the power of the younger men—the brothers—who appear in Perrault's story, unbidden, and come to the rescue, redirecting their sisters to other marriages in which the brothers have gained the property of the usurped tyrant. The women are, therefore, but the tokens in this game of power *between men*. Perrault's 'La Barbe Bleue' might be read on this structuralist level as staging the confrontation between an older, archaically patriarchal, social formation, signified by the greedy rich man, who must be deposed and replaced, but only by the proper, newer form of the same, still patriarchal gender system. This reveals two hidden themes in the story.

From anthropology, we must now stray into psychoanalysis which has been presented as a complement to the former study of kinship because it reveals how the rules of the kinship system are engraved into individual psyches by means of the incest taboo and castration anxiety to produce subjects fitted for this system, subjects who interiorize the constituting prohibitions and embody and enact, subjectively, the phallocentric system.[9]

In his much-maligned foray into anthropology, *Totem and Taboo*, Sigmund Freud argued, and he never deviated from this unpopular view, that he could trace in individual psyches and in the stories cultures tell themselves, a foundational, cultural act of murder: namely, the killing of the primal father by the aggrieved sons. Freud hypothesizes, from material presented in dreams and free association by analysands to whom he listened in his Vienna consulting rooms, an archaic cultural moment in human prehistory in which an over-powerful father of the

primal horde was a monomaniac gathering all property and all things to himself—including all the women (*droits de seigneur* in feudalism retain this trace). Polygamous to a point of excess, the sons had no access to women and hence to their own realization as heterosexual reproductive men and their own futurity: fatherhood (i.e. acceding to the place of the Phallus). To move from the blockage of this first paternally dominated impasse into history, the sons bond together and kill the father. They then consume him. The guilt for their crime, however, haunts them and they make a totem of the dead father, raising him up symbolically as their guarantee, often ritually transposing him onto an animal that they ritually sacrifice and consume—symbolically incorporating the paternal/masculine potency in doing so.[10]

Features of Perrault's text, 'La Barbe Bleue', exhibit this structure. Without internal narrative explanation, the text sets up the monstrous Rich Man/Father-figure who is murdered and replaced by a new order of the band of *brothers*. This deep structure is, moreover, animated by a more contemporary (seventeenth-century) political unconscious in marking the deposition of residues of feudal aristocracy by new social formations epitomized by the young absolutist monarchy of Louis XIV. The *blue* beard might function here as a sign of age and of the past, the old, the father-figure who repeatedly uses his accumulating wealth to purchase and uselessly consume (kill) women. The man who has many wives is a symbol of greedy, unproductive excess. The mixture of murdered, i.e. consumed and used-up women, and their possible resurrection, suggests to me a mixture of polygamous traditions in 'Bluebeard' and of unchecked private monstrosity.

The key in Perrault's text is that the women, alive and in search of new partners, are freed when the brothers destroy the man in the castle—an image of the past, *Burg*, as opposed to the *Schloss/Château* of the early modern, tamed non-militarized, acculturated aristocratic courtier—and reclaim his greedy accumulation and wastage of women. The film version of Perrault's tale by Georges Méliès at the beginning of the century of the cinema (discussed in Chapter 5 by Michael Hiltbrunner) makes this aspect more explicit in the device of the reassuring resurrection of the 'dead' wives and their marriages to *seven* rescuing brothers. The interesting figure of Anne, the unexpectedly named sister (the wife does not have a name), who is finally allowed to marry the man she desires, in the Perrault story, also introduces another modernizing note: the possibility of love in marriage, the possibility of choice in lieu of the absolute power of the father over the disposition

of his daughters as property. Muted and rendered marginal, Anne's freedom to be allowed to marry the man of her choice picks up the sub-theme of another displacement of the power of the father to prevent her marriage to her choice of partner.

In *Les Contes de Perrault, dessins par Gustave Doré*, published in Paris by J. Hetzel in 1867, there are four full-page illustrations to 'Bluebeard'. The first (6.1) places the monumental figure of the rich man, with strangely bulging eyes, towering menacingly over the diminutive figure of his young wife as he is about to leave on his journey. In his hands is a ring of huge keys to all the treasures stored in his mansion which she and her visiting friends may explore. A second plate (6.2) shows but two women in a vast room filled with silver and jewel caskets.

The smallest key to a small room is forbidden. The narratively pivotal scene of her curious exploration and horrifying discovery is not imagined by Doré. Instead he draws, and this underlines their mythic significance, two other scenes. Doré visualizes, from beyond the castle, that is the spectator's position, the approach of the brothers on horseback to the vast fortress (not a country house as in the text itself) atop whose highest and most monumental tower the tiny figures of the two sisters waving can just be discerned (6.3).

The final scene (6.4) depicts the particularly ferocious killing of the blue-bearded husband, still holding a fearsome cutlass with which he

6.2 Gustave Doré, after illustration to 'La Barbe Bleue', from *Les Contes de Perrault, dessins par Gustave Doré*, ed. J. Hetzel (Paris: J. Hetzel, 1867), engraving, 1893. Private Collection/ Roger Perrin/The Bridgeman Art Library.

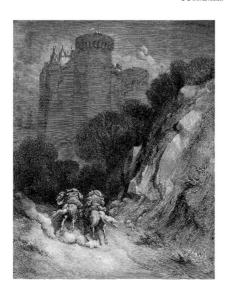

6.3 Gustave Doré, after illustration to 'La Barbe Bleue', from *Les Contes de Perrault, dessins par Gustave Doré*, ed. J. Hetzel (Paris: J. Hetzel, 1867), engraving, 1893. Private Collection/ Roger Perrin/The Bridgeman Art Library.

menaced the head (intelligence) of his curious, transgressive wife. Watching this death—the swords driven phallically into his body as the Perrault text details it—Doré places a Sphinx-like figure, a breasted, winged griffon with bulging eyes, a figure of monstrous hybridity and penetrating gaze which echoes the bulging eyes in the hirsute face of the husband in the opening plate: a man heavy with furs, feathers and his vast beard. Just as the text by Perrault needs to be analysed closely for the semiotic relations between its parts and words and not simply for a storyline that can be extracted from its textual elaboration, so too, Doré's visual *reading* of Perrault's text, translated by both the selection of the scenes and the manner in which they are visualized must be analysed. The wife appears in the first image with her opened hands

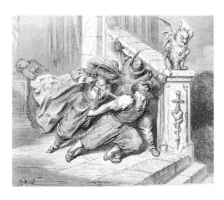

6.4 Gustave Doré, after illustration to 'La Barbe Bleue', from *Les Contes de Perrault, dessins par Gustave Doré*, ed. J. Hetzel (Paris: J. Hetzel, 1867), engraving, 1893. Private Collection/ Roger Perrin/The Bridgeman Art Library.

about to cup the key to the treasures, her eyes fixed on and absorbed by what the key promises. She is then shown like a child in a candy store with her hand inside an opened jewel box (an evocation of Pandora) but being overseen by a menacing ensemble of an armoured knight on an armoured horse. She is not curious, in the manner of Judith in Balázs and Bartók's telling; she is full of limitless desire.

Doré visualizes the husband as too large, too hairy, too rich and as one who abrogates the law to himself: he declares that his wife must die for her disobedient desire. Doré makes sure that we see what the women cannot see, namely the brothers coming—remember three times the wife anxiously asks Anne if she can see their coming. The sisters see nothing coming. We are thus placed behind, on the side of, with the rescuing younger men and we witness their execution of the now disrobed husband by men themselves replete with flowing cloaks and feathered hats, flowing hair, moustaches and a beard. They bring order into a world whose disorder is transposed onto the accoutrement of Bluebeard's castle's architecture, which is, of course, an extension or sign of his body.

In the doubled space of 'Bluebeard', because it opens up the territory of kinship, marriage, father/son rivalries and hence the masculine sexuality between the overpowering father and the emerging son, we must also look to the ways in which it registers the often denied, but here emerging, pressure of the human subjecthood of woman who is, in kinship systems, treated as an object in, rather than a subject of, exchange. It is this confusion that is played out in the field of abusive marriage. Disobedience, as in the case of feminist re-readings of Eve, might function positively as the sign of moral subjecthood. Choice, decision, risk-taking, the search for knowledge as confirmation that the person is a subject not an object or a mere body for use and exploitation can been misread as disobedience to the law which has to repress woman as a subject who can choose. Thus any challenge to such a law is a form of resistance to the violation of humanity of women inherent in patriarchal systems.

The Bluebeard story, as it undergoes the translations in Modernity, reveals a certain kind of reflexivity through the figure of the wife, who can thus be used to stage a dimension that will be enhanced precisely as modernization and the civilizing process contribute to the formation of more elaborate and privatized, psychologized forms of interiority. Whereas, classically, woman is considered to be the dangerous enigma, conceived as a surface hiding a menacing inside, a box like Pandora's containing all the ills of the world, or a will like Eve's that forces

humans into morality and time, in Bartók's *Duke Bluebeard's Castle*, premonitions of which we find in Doré's penultimate plate, we have both the image of the phallic fortress of this militarized feudal masculinity—untamed and brutal, and selfish, a kind of primitive ego—and the image of the old man to be displaced. There is also the image of the house or space that becomes the mirror of the masculine psyche which is shown to have its dark secrets. It houses the evidence of real or hallucinated sexual violence and extreme, humanity-suffocating sadism.

Here psychoanalysis proper can draw our attention to two elements that I wish, speculatively, to consider. Could the castle and its secret chamber evoke the parental bed—and thus contain elements of the trauma of the primal scene, that Freud theorized as the infant's sensing of parental intercourse? This is an event the child cannot comprehend and so it registers as a trauma, an incomprehensible shock. To explain the inexplicable event that is adult sexuality experienced by the erotic but not yet sexual child, Freud discovered three possible confusions in the emerging fantasies generated by the shock which is not only of literal confrontation with parental congress, which could happen as infants do sleep in parental bedrooms, but is to be understood figuratively, fantasmatically, because adults dealing with tiny children cannot but intimate their adult sexualities unconsciously in their relations to the infant they love, feed, tend and hold.[11] The first identifies the sex act with violence; another links sex and murder/death; a third connects sex with castration/genital mutilation. In the fantasy of the primal scene, opposite 'visions' co-exist. One of adult male sexuality killing/piercing/wounding the woman's body; in the opposing fantasy the woman's sex consumes and devours the man's disappearing and later deflated penis. Yet another fantasy may also haunt the image of the bloody chamber—as Maria Tatar and others have suggested—namely, the desired bloody trace of the defloration of the virgin bride that would also suggest, when the sheets are ritually exhibited, that some kind of relation between sex and violence has indeed happened. The 'murdered' bodies of the former wives are transpositions of the penetrated virgins violently entered by the husband, their blood being the trace of that possession about which the new wife is at once curious and by which she is also terrified.

One of the possible historical origins of the Bluebeard story is said to be the case of a feudal nobleman from Brittany, Gilles de Rais, who fought beside Jeanne d'Arc in the Hundred Years War. Accused and executed for a series of horrible sexual crimes against women and children of both sexes, his case has been subject to much speculation that

the crimes of which he was accused were politically motivated and trumped up. Excessive in terms of the rules of the Church, the call sheet of his crimes may reflect the fantasies of his accusers against a political opponent. His homosexuality, paedophilia and sadistic torture of boy and some girl children produce the image of the sexual monster with all the imaginative salacious detailing of what he did that alarms the reader since none of the victims lived to bear witness to the private moments of agony apparently inflicted on them.[12]

It is to the record of this cultural inscription of the sadistic sexual imaginary that is attributed to one exceptional man that I want to turn to show how Bluebeard contains but also mirrors what men dread in themselves. Thus in the twentieth century and in the cinema in particular, the Bluebeard motif has morphed into many powerful cinematic characters. After Méliès, who captures the spirit of the fairy tale as the fantastic and fabulous (see Hiltbrunner in this volume), cinema rewrites Bluebeard in terms of a paranoid suspicion that men can be enigmatic, and hence dangerous. Behind the mask of civilization, they can reveal pathological moral disturbance. But by creating psychopathic serial murderers and torturers, the culture machine can both allow into the light of the cinematic vision the unbridled perversity of heterosexual sadism and, at the same time, disown it—the monster is both a mirror and a displacement onto a monstrous other. The lure of this story lies in re-staging what Freud revealed as components of infantile sexuality, which, if they are arrested at a stage which is not harnessed with the secondary development of human affections, become fixated as perversions, to which, at some point in our formations, all of us were once polymorphously hostage.[13] According to Freud's most radical propositions, all sexuality—originating in the fantasmatic world of infancy—has polymorphous perversity at its core; but it is traumatically (castration complex) and progressively (onset of puberty) subjected to certain social pressures and psychic transformations. What we find monstrous is not, therefore, other to us; it is often merely components of sources of pleasure that remain unattached to adult sexual and emotional transformation and reformulation.

Love from a Stranger

In Rowland V. Lee's film, *Love from a Stranger* (1937), Basil Rathbone, better known as cinema's incarnation of the deerstalker-wearing, pipe-smoking, London sleuth, Sherlock Holmes, gives a convincingly dis-

turbing performance as a smooth-talking but deranged wife-killer. A poor young woman, Carol Howard (Ann Harding), working as a typist in a bank, unexpectedly wins a fortune on the French lottery. Just about to celebrate her new freedom with her fiancé, Ronnie (Bruce Seton), returning after five years in the Sudan, Carol is interrupted by an elegant man who has come to view the apartment she is about to vacate as she plans to set out on her travels financed by the windfall win that will soon cause ructions with said fiancé. Having broken her engagement as a result of his refusal to share her pleasure in sudden wealth and access to a glamorous lifestyle, Carol sets forth for Paris with her friend Kate, only to meet the stranger again on the boat and to be wined and romanced in Paris by what appears to be a worldly, winning and suave lover much more in tune with her new desires that the grumpy, stay-at-home Ronnie (6.5a). Carol can be linked with Doré's and Perrault's vision of women who can be seduced by their delight in things, in pleasures. Carol and Gerald Lovell (Basil Rathbone) marry very quickly, much to the consternation of the abandoned fiancé, Ronnie, who is deeply suspicious of the strange new man and has set detec-

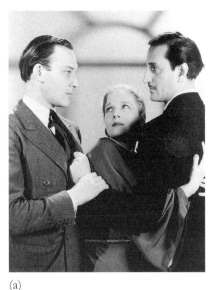 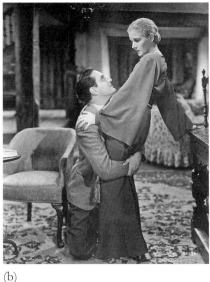

(a)　　　　　　　　　　　　　　　　(b)

6.5　　(a,b) Stills from *Love from a Stranger* (Rowland V. Lee, 1937). Reproduced courtesy of the British Film Institute Stills Library, London.

tives to identify and corroborate Lovell's identity. The couple return to England and, by means of what might appear to be coldly calculated emotional blackmail, the new husband 'allows' his wife Carol to write a cheque for five thousand pounds towards the purchase of a house in the country to which they soon repair. Once there, isolated, without phone and other forms of easy connection to the wider world, serviced only by mentally challenged locals, the husband takes possession of a cellar which is forbidden to everyone else. There, in private, Gerald is revealed to the viewer as a man with obsessions that are beginning to seem increasingly sinister. These involve photographs of elegant women, a fine silk scarf wound around their necks, which are burnt during the ecstatic elation created listening to the climax of Grieg's 'Hall of the Mountain King'.

Woven through the film so far are references to Gerald's heart condition. A doctor is finally called on the night Gerald has noted in his obsessional fashion in the diary as 'the day'. Dr Gribble confirms that Gerald does indeed have a heart condition and must avoid excitement and tension. At the conclusion of the consultation, the doctor notices that Gerald owns a volume he himself recently purchased about some famous murders by the criminally insane, which includes a man called Fletcher who has killed three women. But in Gerald's volume, the photograph of the serial wife-killer has been torn out.

Gerald's madness is beginning to breach the façade enough for the viewer to begin to suspect all the accumulating signs: the plans to leave next day for an unspecified destination that would explain his wife's disappearance, the paying off of the maid that evening, the request that Carol wear a specific dress for their lonely dinner with the scarf seen in the photographs of other women and now given to her as a gift.

By chance, Carol's friend Kate and former fiancé Ronnie decide to visit that same day but they are driven from the house by the enraged husband. The doctor calls once again to leave a copy of the said book, this time with a photograph which the viewer recognizes as Gerald and at which Carol, leafing through its pages, stares without recognition although she senses some uncanny familiarity. Thus the scene is set for the final confrontation between the increasingly demented husband and the terrified but courageous wife who manages his erratic menace with steely calmness (6.5b). The maid has been sent away and so Carol must serve the dinner. She prolongs the meal and finally offers her husband coffee. In increasing excitement, Gerald forces Carol to read out loud the details of Fletcher's modus operandi—which includes the

seduction of a lonely woman, the transfer of her money to him, the isolated house in the country, the plan to go away for a long time which renders the wife's disappearance unsuspicious.

With mounting horror, Carol realizes that now she has to scheme for her life. In desperation she suggests a 'queer thing'. What if the murderer marries a murderess—the idea being that were she too an undiscovered criminal, she would not expose him, if he let her live. By this stage the pretence of the distance between Fletcher and Lovell has disappeared and the killer-husband is apparently in charge. With superb dramatic effect, Carol begins to tell a tale. She 'confesses' to having opened a window in the midst of winter the effect of whose chill was to bring about the death of her first husband, lying ill in bed. But Gerald, although entertained, is not deceived. He recognizes the story from a book they have both read. His violence is met by the formerly calm and appealing Carol who now rises up with studied rage. It does not matter. She reveals that she only told the tale to prolong their conversation long enough for the poison she claims Dr Gribble returned to provide and which she administered through his coffee to take effect. Telling him he will soon be paralysed and choke, she successfully brings on a fatal heart attack. The now distracted wife is then comforted by the doctor and her two friends who arrive to rescue her—too late, for she has saved herself but committed a murder by psychological trauma.

This story contains several Bluebeard elements: the serial killer-husband who lures a young woman to his 'castle' complete with a secret room which contains the photographic evidence of his previous murders. It also differs in critical ways. The fate of the woman is not sealed by any kind of transgressive disobedience or curiosity. Knowledge dawns slowly and is horrifying, creating the grounds for the suspense movie's American title: *A Night of Terror*. The wife is not put to any test, which she has failed; except she was told never to intrude into the cellar which she does as he is engaged in his secret rituals and he banishes her in an uncharacteristic rage. Instead, she was 'hunted', wooed with cynical disdain for 'women's weakness' and desire for romance. She is the fourth victim of a serial killer, a man compelled, according to the script, to repeat the experience of holding *somebody* in his arms, who in an instance of his power, becomes *something*.

Secondly, it is she, who although frightened out of her mind by the discovery that she is locked into the house with a homicidal madman, has the wit and nerve firstly to try to make him drunk, then to spin out

a tale, and finally to precipitate his death by the lie that she has poisoned him. The lengthy final scene is a drawn-out confrontation between his sadistic genius—the murderer who never makes a mistake—and her inventiveness and steely will to live. As the film itself unrolls before the viewer's eyes, the twists and turns of this battle for power—for life or death—seem unpredictable. The pale, slight, blonde heroine with her somewhat hystericized acting style seems no match for the controlling confidence of the experienced murderer played with such suave aplomb and cruel cunning by Basil Rathbone, even while his sanity seems to be unravelling before our eyes. In effect, the wife wins and 'murders' him, even in what could be considered self-defence. The hitherto master-criminal is undone by a woman who, at a certain point in the dinner scene, is made painfully to recognize herself in the eyes of her stalker as precisely the empty, easily deceived woman longing for romance: 'woman's weakness, man's opportunity' is his phrase.

Bluebeard 1944

In Edgar Ulmer's film, *Bluebeard* (1944) the title refers to a legend, a person and not an attribute. Its usage derives from a general cultural knowledge of Bluebeard as a type: a man who murders women, in the plural. The film opens atmospherically with a foggy night. We make out the shape of a bridge across the Seine. Then we see a woman's lifeless body being dragged from the river by two police officers and into their rowing boat. This is clearly not the first event of the type as the scene then cuts to a poster warning the *citoyennes* (women citizens) of Paris to beware of the prowling Bluebeard who has struck again. Thus the city of night becomes not the site of prostitutional exchange so typical of the modernist visual imaginary. More like Edgar Allan Poe's detective story *Murders in the Rue Morgue* (1841), Paris is full of shapeless menace making it unsafe for women to walk out alone. (When is that not the case?)

We are then introduced to the leading female character, Lucille (Jean Parker), a milliner who, walking home with two other colleagues for safety, encounters a single, somewhat sinister figure. He turns out to be known to the other two girls as a puppeteer. A clearly cultured and distinguished man, played by with great intensity and gentleness by John Carradine, the puppeteer creates dramatic operas by means of marionettes he has whittled himself. The puppet opera he is persuaded by the young women to put on several days later is Gounod's *Faust*. Gaston Morell, the puppeteer, is clearly drawn to Lucille and has her

brought to his house one night in order to persuade her to make the costumes for a new opera. There, by chance, she discovers lying on his sofa a torn cravat. It is the cravat with which, earlier, he murdered the young woman who sang Margarete in his puppet opera. She had become jealous of his attentions to Lucille, and waiting in his rooms for his return, enrages him with her distressing anger. Seized by a manic violence, we see Gaston's contorted features as he calmly removes his cravat … and then deposits the lifeless body in the river beneath his medieval house. With nimble fingers Lucille finely repairs the rent and returns it to him. The film turns on the attempts of the baffled police to find any clues to the identity of this serial killer. A young woman who is a reputed detective, Francine (Teala Loring), is summoned by the police chief. She turns out to be Lucille's sister and briefly encounters Gaston when he calls upon the latter.

Gaston is really a painter. His canvases portray the women he has murdered against a dramatic and proto-modernist background. Usually sold discreetly through a conniving dealer, one picture unfortunately is acquired by a collector who exhibits his collection where it is identified by the police chief because of the portrait of the murder victim. A plan is conceived to trap the painter by inviting him to paint Francine posing as a visiting South American. The scheme goes badly wrong and when Francine recognizes the artist as the puppeteer she met in her sister's apartment, Gaston removes his cravat and murders her. Unfortunately, he uses the same cravat and the darn is recognized by Lucille when she is shown the murder weapon by the police. She thus links this horrible murder of her sister to Gaston. She goes to his house where he tells her his story, the story of a virtuous, innocent and struggling artist who finds a woman lying weak and unconscious in the street one night. He takes her in, nourishes and tends her until she is recovered. He paints her. He falls in love. She disappears. His painting wins a prize. He seeks her out to share the moment of glory. He finds that she is not an angelic figure of feminine innocence and helplessness, but a heartless woman of pleasure. Gaston explains that he finds himself painting her face every time he paints any woman, and he has to thus to murder the apparition in each of her new incarnations. Woman is all women. He does not marry in a serial collection. He paints and murders.

This story is not a Bluebeard story at all in terms of the classical elements of the tale. Its logic depends upon the fundamental idea that the shock of discovering that the pure virgin is really a whore is sufficient

to traumatize a man to a point of his justifying his actions as a psychologically uncontrollable, but logically explicable, response to betrayal. The mythic element here is, of course, the construction of femininities polarized between virgin (to be loved, possessed, owned and consumed) and the whore (whose body circulates freely in a money economy defying the proprietorial economy of marriage). In her brilliant rewriting of Marx on the commodity by means of Lévi-Strauss on the exchange of women as the foundation of culture, Luce Irigaray identified the three social roles imposed on women: mother, virgin, whore. 'Neither as mother nor virgin nor prostitute has woman any right to her own pleasure.'[14]

For Irigaray, the virgin is:

pure exchange value. She is nothing but possibility, the place and the sign of relations among men. In and of herself, she does not exist; she is a simple envelope veiling what is really at stake in social exchange.[15]

But what of the prostitute?

Explicitly condemned by the social order, she is implicitly tolerated. No doubt because the break between usage and exchange is, in her case, less clear-cut? In her case, the qualities of woman's body are 'useful.' [...] Prostitution amounts to *usage that is exchanged*.[16]

In one sense, if all women function as signs whose ultimate meaning is the bonding relations between men that, in effect, secure what the men experience as masculinity, all women are commodities of merely slightly different kinds of usage. These minor differences are raised ideologically to the level of extreme oppositions such that the figure of virtue, modesty, faithfulness, lack of interest in sexual pleasure—purity in a single, entirely possessed usage and passivity—is defined and highlighted by the absolute contrast to and incompatibility with the figure of seductiveness, desire, autonomy, repeated circulation. Thus the horror that is the narrative presupposition of Gaston's disabused discovery that his idealized, pure love object is, in fact, a courtesan depends entirely on the patriarchal production in ideology of an opposition in which the prostitute is presented as the vicious betrayal of what the

man idealizes in the virgin who is bloodily deflowered to become mother so that the effect is to damage if not destroy his masculinity. The trauma of this revelation—a discovery, in a sense, of sexuality and hence the intimated sexuality of the mother who conceived him—is made to function as a kind of psychological explication for a man to become homicidal when confronted with any woman who in any way disturbs his complete self-absorbed mastery. Thus painting—image-making and fantasy work—both restages the search for the virginal object and the repeated trauma which is acted out on the body of women by strangulation: symbolically separating their heads from the bodies with the necktie garrotte so that they cannot speak; they again become the apparently lifeless body he found at the beginning of this chain. Repeatedly in this film, we are made to watch 'someone' becoming 'something', a woman becoming a rag-doll to be cast away not quite into the sewers, but into the dismal depths of the city's dark river. Used and cast away in an anti-act of displaced sexual rage, feminine death alone assuages masculine anguish.

The central character is thus a tormented artist-turned-puppeteer suffering from a compulsion to repeat the first murder of a woman he loved, who turned out to be a prostitute and shamed him for that innocence. This narrative thus introduces the compulsion to repeat: and the theme of the representation of the situation that leads to the killing of the women which follows is a parody of Freud's analysis of sexual excitation. In his analysis of sexuality, first formally proposed in his *Three Essays on Theory of Sexuality* in 1905, what puzzled Freud in adult sexuality was the role of foreplay. Foreplay—touching skin, kissing, cuddling and looking at exposed sexual parts—is itself a form of pleasure: yet it becomes unpleasure in that is stimulates mounting desire for another kind of satisfaction. Its unpleasure builds the pressure that seeks release in the specifics of the sexual act itself.[17] The representation of what sets the murderer off is a parody of this double structure so that murdering the woman becomes a necessary release from the tension and unpleasure created by the woman moving from being desirable to being somehow threatening or irritating. Just as one sex act does not do the trick and we seem to want to do it again and again, so once this displacing of the sexual act onto murder is initiated, the killer becomes serially addicted. The addiction cannot be shown, or admitted as such, so the story must always an attempt to explain the origin of the perversion in a crime committed against the man—by a

woman—in which his masculinity is inverted. He seems to be in the grip of a compulsion caused externally which leads him to a sadistic act to relieve the danger of his implied passivity.

Thus Lucille, a median figure of a potential beauty and purity to wipe away the stain of the traumatic encounter with the virgin-turned-whore, enters Gaston's house with a knowledge, written in her stitching on his murder weapon, that he killed her sister. She puts herself at risk in this tête-à-tête with a disturbed man. He wants to tell her and convince her that she could be his saviour. When she resists, he tries to strangle her too. She is rescued, but she has found the secret. She it is who recognized the clue in the cravat and led the police to his house. She it is who solicited his confession. She it is who now betrays, in a different way, his appeal to be cured through a woman's forgiving, maternal and submissive being the object of his love. Thus Lucille takes her place with the modern representations of women who confront the Bluebeard type, risking proximity and their lives in order to extract the secret of the damaged man.

Dramatic gender confrontation and even moments of tragedy make Ulmer's a compelling film that was well-received. Its opening sequence of a woman floating in the Seine is rhymed with its final scene. Escaping over the roofs from his own house when the police break in, Gaston finally falls to his death and his now lifeless body floats in his watery grave, slipping the man into the space of the feminine, a discarded body in the water to be dragged forth by the police.

Bluebeard 1972

My final example is titled *Bluebeard* and was directed by Edward Dmytryk in 1972, starring Richard Burton in the title role (6.6). It is loosely based on the Perrault tale, in a rewriting by Dmytryk, Maria Pia Fusco and Enno di Concini that places the story in Germany in the aftermath of World War I, bizarrely linking this version, anachronistically, with the cultural ethos of early twentieth-century Germany discussed above in the chapters by Puw Davies and Cooper.

The film opens with an airfield over which a tiny biplane circles before landing to great acclaim as Baron von Sepper is welcomed home from war. A leather-helmeted man of great height and distinguished bearing is being rapturously welcomed back as a flying ace and war hero. He unbuttons a flap of leather that has protected his lower face as he moves towards a waiting child clutching a large bouquet of wel-

6.6 Title from *Bluebeard* (Edward Dmytryk, 1972). Reproduced courtesy of the British Film Institute Stills Library, London.

come. The removal of the face's 'skirt' exposes a *blue* beard from which revelation the small child recoils in terror, dropping the flowers and hiding her own face in her mother's skirt. The child, a girl child, a blonde fantasy of a German child in her folkloric costume, witnesses something shocking. The blueness is, in fact, almost invisible. But whatever it is to mean in the film is registered not by what can be seen by the viewer so much as by the shot/reverse shot structure of an exposure registered as something horrifying. The revelation of the heavily bearded man with the beard's curious and unnatural hue twists back from being a signifier of heroic masculinity to revealing a secret which the film will elaborate: a missing phallus. The face exposed as the leather flap is removed shows a dark and hairy void. He will later explain the beard and the colour as the body's response to severe burns received in a plane crash. They do cover his 'wound'.

The scene cuts to this same man seated at an organ. His great hound wanders in. A falcon perches on his shoulder. He is gazing steadfastly at a portrait of a beautiful, white-haired and dominating woman: evidently his mother. (Intimations of *Psycho*?) He takes a photograph of the portrait's face. He manipulates the image, reduces it to mere graphic shapes. He duplicates it and eventually creates a lattice work in which the image disappears into a kind of complex field I am tempted to call a decorative field of matted pubic hair. The symbolic attributes of masculinity—war service, the hunting dog, the falcon—are reduced in the service of the man whose secret space is the darkroom where he turns his fixated adoration of his mother into an artistic hieroglyph.

Cut to a gorgeous ballroom and a huge party in progress. Two groups emerge to give shape to the scene. A group of men, anxious about social unrest and workers' resistance, appeal to the Baron for some statement. He promises action. Thus the film introduces a powerful political dimension, identifying this Baron with the emerging support for the Fascists. Thus in a cut-away, we see SA thugs rioting

through a working class neighbourhood that is also clearly Jewish. Amidst the random violence to property and person, a uniformed SA man pours fuel around the doors and windows of the house of a maker of musical instruments and sets it alight. Through the windows a terrified couple cower, while outside the crowd restrains a young teenage boy who wants to rush in and rescue his trapped parents. He cannot and must watch their horrible deaths, which is clearly a result of the Baron's instigation of action: *Aktion* was the Nazi term for their modern form of pogrom.[18] This seems a complete side-show in a Bluebeard film. Yet this thread will be vital to the resolution of the plot for it sets in motion a character known as the violinist whose vengeance will settle the score.

The other group at the ball is the parents of the young woman with whom the Baron is dancing. A drunken, weak father and a monstrously anxious mother frame a beautiful, blonde young woman called Gerda whom the Baron soon marries; the fire from the burning house of the Jewish musicians dissolving into the candles of the church at their wedding. Cut from wedding to the organ-playing Baron staring at the portrait of his mother. The bride, now garbed for shooting, calls to her husband to hurry to the hunting party—mentioning *en passant* that it is their second anniversary. This ellipse of two years will later be opened up.

The hunting party becomes the scene of an unfortunate death: that of the Baroness, apparently shot by mistake, although suspicion hangs over the unexplained scene, since no reverse shot is offered to identify the source of the bullet. The film then simply shows the slow accumulation of the photographically manipulated emblems hung near the portrait of his mother, suggesting a growing number of wives who, having passed away, are being commemorated as both trophies and offerings to the mother, who is positioned by this chapel-like scene as the dominating presence in the Schloss and her son's psycho-sexual life. The Baron will later reveal he grew up with his mother and her servant, Marthe, and without a father.

Clearly years have passed and the Baron becomes enamoured of a young American dancer—a kind of Sally Bowles character, full of the energy and boyish charm of Christopher Isherwood's sardonic tale of Berlin in the Weimar and early Third Reich years. The Baron sits in the audience for the performance now dressed in a military uniform reminiscent of the National Socialist SA: green rather than brown-shirted. It is in this costume that he first woos the singer. In the orchestra pit, however, we see a young violinist watching the fascist Baron with evi-

dent hatred. Thus the two strands of political violence and sexual desire are woven into a scene without as yet full intelligibility.

Pursued with glamour and wealth, Anne (Joey Henderson) is lured from her partner Sergio, who evidently loves her, and marries the Baron. As a means of presenting their early married life, the film shows a series of photo shoots in which the young American poses with evermore suggestive allure until she finally performs a kind of Salome dance with not seven veils, but only one. Almost complete nudity marks the new age of 1970s cinema but to no avail. The man remains unmoved by the power of her sexuality and rushes to get more film for his camera, resisting her constant beckoning.

If the American represents sexual confidence, vitality and modernity amidst the relics of an aristocratic Germany now collaborating with the rising tide of fascist authoritarianism and racism, the Baron's place in that sick world is marked by these intimations of psycho-sexual disorder: he is a man unable to be aroused by the wholesome allure of a beautiful young woman, and instead finds substitute gratification in photography. Anne, for all her American difference, is but another version of Gerda. (An interesting fact in passing: every key character in the film except the violinist is left-handed.) Both are blonde in a manner calculated to represent the Aryan ideal fantasized by the Nazi regime.

The Baron plans to leave for a while and leaves Anne alone in the Schloss with, of course, the keys to all the locked rooms and storage spaces of the vast pile. One key, small and golden, is not to be used. Temptation. With her maid, Anne explores the castle in a manner reminiscent now of the Perrault tale, noted in Doré's illustration. Not jewels and silver, but dusty old armour and other unused furniture are what they discover in the locked rooms. The maid suddenly remembers she must collect something in town and leaves, having an accident as she drives to town. Anne is now utterly alone. She determines to find the lock which the golden key fits. She does so: it opens a false panel that reveals a hidden hallway in which hangs a vast full-length portrait of the Baron in full regalia as a military aristocrat: the very image of masculinity with all the rhetorics of the *parade* (see also my Preface to this volume): cloaks, boots, and belts, and beards, dogs, guns, and a huge ring. When pressed, the ring opens a door onto a refrigerated store room in which Anne discovers the bodies of the predecessor wives.

No blood to stain the little key, as in Perrault, but ice to preserve in perfect suspension the variously decapitated, and otherwise murdered women.

Anne recoils in horror and fear. The Baron returns. He invites her to his dark room to help him develop new photographs which, in fact, are from his surveillance camera that catches Anne at the threshold of the secret chamber. Proof that she has disobeyed and now knows the secret is her death sentence, which will be executed at dawn.

Now Anne becomes a Scheherazade figure, not unlike Carol in *Love from a Stranger* or Lucille in Ulmer's *Bluebeard*. Showing enormous sangfroid, she encourages the Baron to unburden himself and explain who all these women were. The film then moves between farce and horror for each previous wife is, in his telling, both beautiful and alluring, but ultimately monstrous in some way. One will not stop singing and makes any attempt at love-making impossible. Another becomes a lesbian in her search for means to get him sexually interested. Yet another is a man-hating feminist who discovers that she is really a masochist who wants to be beaten. Yet another is beautiful but utterly without emotion. Another, a nun, reveals a past of innumerable lovers. The singer must be decapitated. The nymphomaniac entombed alive. The masochist is drowned. The doll is 'falconized'. The lesbian is speared, biblically with the body of her prostitute woman lover.

In all the retellings of these scenes, it appears that the Baron is a husband seeking sexual congress with his beautiful wives each of whom interrupts the progress to that act by their perversity. Anne analyses these stories for an opposite meaning. They were not killed for interrupting sex but in each case for the crime of offering themselves sexually to a man who was thereby revealed as impotent. The women, mostly incarnating an image of white beauty, turned into red women at the moment they displayed their own sexual desire. Finally, the missing two years of the Gerda marriage are explained. As the couple entered their honeymoon chamber—all white—and she prepared to undress with obvious sexual expectation, the Baron fell to the floor into a dead faint, which illness he used for at least two years to resist any repetition. We finally are shown a scene prior to the one witnessed earlier. The night before the hunt Gerda enters the Baron's bedroom demanding the consummation of the marriage. She needs and wants a *man*! She is repulsed. The hunting scene is replayed and now, with voice-over, we discover that it was the Baron who cold-bloodedly shot her.

Earlier in the Anne scenes, Anne herself had been driven to a nervous breakdown. Waiting patiently for the Baron's return during the erotic photo shoot, she hears a squeaking sound. Following the sound down the corridor, she is shocked to enter a room and find the old maid, Marthe calmly brushing the hair of the corpse of the Baron's

mother seated in a rocking chair. The scene is lifted and quoted directly from Hitchcock's *Psycho*. Unbeknownst to Anne, the old servant is then murdered by being drowned in a vat of wine by the Baron. The Baron blamed the scene on Marthe's demented loyalty. Anne's illness stalls their congress. But during the retelling of the wives' demise, Anne, and the viewer, discover that the Baron even used the same scene to shake the boring wife out of her apathy. This admission of knowing about the corpse becomes the key Anne uses to discover the truth of the Baron's wreaking his revenge for his impotence on the women, each of whom in her blondeness or her power are traces of the haunting mother he has preserved in image and body.

All is set for suspense as the revelations of the Baron to stall his final killing end abruptly. He is called away by his military friends to a big political event. Anne is then pushed into the freezing chamber to die from cold within a few hours. The Baron leaves: a Nazi big-wig is coming to town and he must go to greet him at the station with his other fascist chums, the men from the opening scene. Dmytryk does not directly represent Nazism and its insignia but borrows their colours and militarism, and creates a strange new insignia which looks like the iron cross.

While Anne is freezing to death, the Baron and his fascists are saluting the incoming dignitary. In the crowd, however, is the violinist. He slowly moves towards and assassinates the Baron. He then breaks into his Schloss further to vent his rage by breaking up the place. With agonizing slowness he moves from room to room, eventually arriving in the room with the secret panel open. He sees the painting and while slashing it, presses the ring, thus opening the freezer and saving Anne.

The final scene (6.7) is wordless, a visual statement of the apparent irony of the film: the political vengeance of the anonymous member of a racially persecuted working class alone saves the woman from the relentless pathology of the fascist Baron. Sexuality intricated with violence is his, linked with the political sadism and perversion of the fascist. Set inside a vast church decked out with all the pseudo-fascist regalia that also marks the collusion of the Catholic church with the Nazi regime, the final scene appears to mark the triumph of the young American. The Baron with his blue beard lies still in his coffin. In widow's garb, Anne looks into the coffin before walking away, free and safe, with her former partner, Sergio.

The ending has the quality of a 'what a turn-up for the books'. In a film apparently focused on the sexuality of the Baron and his nymphomaniac wives, such a reversal is unexpected, although it has been care-

6.7 Still of final scene from *Blue-beard* (Edward Dmytryk, 1972). Reproduced courtesy of the British Film Institute Stills Library, London.

fully seeded into the narrative by means of the political sub-plot. In this strange homage to *Psycho* (1960) and Visconti's *The Damned* (1969), that shares affinities with Bob Fosse's *Cabaret* (1972) and Cavani's *The Night Porter* (1974), Dmytryk might also be said to have anticipated the cultural analysis of Klaus Theweleit first published in German in 1977 as *Male Fantasies*. In two volumes, Theweleit studied the fantasies associated with a body of men in the Freikorps who were, according to Barbara Ehrenreich in her introduction to the English translation, 'organized by officers returning from World War I [...] a kind of rural "petty bourgeoisie" with semifeudal traditions'. They were 'the volunteer armies that fought, and to a large extent, triumphed over, the revolutionary German working class in the years immediately after World War I'.[19] Echoes of this social formation are clearly indicated in Dmytryk's historical setting and characterization of the right-wing businessmen seeking the help of a war-traumatized hero. Furthermore, the Freikorps militias were effectively the foundation of what became the core of Hitler's special forces, the SA, or brown-shirts, and later SS officers such as Rudolf Höss, the commandant of Auschwitz. Theweleit analytically reads a range of personal writings, letters and memoirs, by the Freikorpsmen, to expose the character of fascism. Ehrenreich explains:

What he wants is what he gets, and that is what the Freikorpsmen describe over and over again as a 'bloody mass': heads with their

faces blown off, bodies soaked red in their own blood, rivers clogged with bodies. The reader's impulse is to engage in a kind of mental flight—that is, to 'read' the murders as a story about something else, for example, sex … or the Oedipal triangle … or anything that might help the mind to drift off. But Theweleit insists that we see and not 'read' the violence. The 'bloody mass' that recurs in these men's lives and fantasies is not a referent to an unattainable 'something else', and the murders that comprise their professional activity are not mere gestures. What is far worse, Theweleit forces us to acknowledge, these acts of fascist terror spring from irreducible human desire. Then the question we have to ask about fascism becomes: How does human desire—or the ceaseless motion of 'desiring production' as the radical psychoanalytical theorists Deleuze and Guattari call it—lend itself to the production of death?[20]

I have introduced this most sobering reflection on fascism because fascism is so clearly invoked in Dmytryk's *Bluebeard*, linking this story with the egregious crime of twentieth century mass murder. But it cannot be said that the film functions as a probing analysis of the conjunction between fascism and sexual perversion: as with so many other films of that date and moment, it risks eroticizing fascism, conflating the *parade* of military masculinity with a kind of pornographic game-playing. Theweleit's diligent and terrifying attentiveness to the fantasies that structured the imaginative world of the Freikorpsmen upon which they acted and which they *realized* for their own sake, that is, not as symptomatic substitutions for infantile or archaic structures such as Freudian psychoanalysis and structuralist anthropology theorize (explaining Baron von Sepper's crimes in relation to a domineering-women-dominated childhood for instance), not only introduces what I shall dare to name as the historical Real (where violence really happens to vulnerable bodies and is perpetrated for real) but also exposes the stakes involved in thinking about *hommes fatals* at the intersections of fantasies and political acts, of representations and realizations.

The Bluebeard story is a rare, atypical but significant cultural narrative that acknowledges, or can be used to acknowledge, some of the structural and psychological systems that make those socialized and subjectivized as 'men' capable under certain cultural and historical conditions of becoming not only serial murderers but fascists, a particularly vile and threatening incarnation of *hommes fatals*. Dmytryk's film seems

to be attempting to make that connection even while the film is undermined, if not betrayed, by its also carrying over the legacy of modernist psychological readings of the Duke/Baron Bluebeard figure as a suffering victim of psychological deformation at the hands of a woman: in this case the domineering mother who effectively castrated her son.

Theweleit reveals that in the fantasies of the Freikorpsmen there are three kinds of women who ultimately conflate into an opposition between the white women: chaste, caring, upper-class; and the red women: class enemies, violent, resistant, angry. The white woman is effectively without a body, lifeless already. The red woman is sexual, dangerous, and often armed. Her red, bloody death is closest to the 'bloody mass' he wants. However extreme and shocking the materials Theweleit analyses in his case material, he wishes to argue against the comforting illusion that fascists are other. Unlike the films, there is no way to displace the sadism onto othered, pathological exceptions.

> As Theweleit says, the point of understanding fascism is not only 'because it might "return again"', but because it is already implicit in the daily relationships of men and women. Theweleit refuses to draw a line between the fantasies of the Freikorpsmen and the psychic ramblings of the 'normal' man [...].[21]

Thus he 'leaves open the path from the "inhuman impulse" of fascism to the most banal sexism', which involves 'the man who loves women [...] but sees a castrating horror in every expression of female anger' or experiences a 'distaste for sticky, unseen "feminine functions"'.[22] In Dmytryk's film, the movement is from the white woman desired in her lifeless, model-like imagery, signified by the white-haired Dowager–Baroness as image and preserved corpse to the red women who suffer brutal physical annihilation. Unfortunately, although the film invites the deployment of Theweleit's analysis to reveal its serious engagement, it is unable to sustain the complex balance plotted out with terrifying rigour by Theweleit's study of historical texts.

Thus the method by which we can test the politics of the retellings of the Bluebeard tale must involve this deep engagement with the ways gender structures culture and with the deep structures of those cultures which are systemically sexist. The films I have considered here ultimately allow our culture to condone the men who resort to violence and murder when all they should do is grow up. You do not strangle

someone because they irritate or disobey you. For all the apparent racializing or feminizing of the pathological murderer—the loss of sanity indicated by mad eyes or the noise in the head—the films, none the less, do justify murder by attributing to *woman* characteristics that might threaten *man*. The trope of woman's disobedience is given to account for an otherwise excessively absolute punishment by lawless death. It is this whole structure, locating the cause of deviant masculine behaviour in women's sexuality, independence or desire for knowledge, that must be culturally contested as it is part and parcel of the structure of phallocentric kinship in which the asymmetrical hierarchy operates at the price of women's humanity: symbolically signified as murder while also being fantasmatically enacted on screen and enjoyed vicariously by viewers. Historically shifted from the ancient horde, or the feudal/monarchical conflict, or the old/modern which is structured on the conflict of the old man and young men, onto the modern sense of a traumatically damaged masculinity, the stakes are still the same. The compliance of women is necessary to the stability of masculinity. One overpowering mother can emasculate a man; demanding, talkative, sexually active women can emasculate a man and so forth. This is just rubbish dressed up as fancy psychological self-justification of which Freud would be ashamed. His argument is that we must learn to know ourselves and take responsibility for our fantasies by recognizing what they are, how they were formed, and where they can lead. To enact them or to dramatize them makes little difference, as fantasies form our psychic reality.

Thus we can finally return to where I began in my preface to this volume, with Susan McClary's borrowing of the figure of Judith from Bartók's opera as a figure of a feminist resistance. In the opera, however, Judith–woman is imagined only as the instrument of the Duke's painful self-discovery. The opera stages an old man in the twilight of his life reviewing the passage of that life from dawn to imminent death which he hopes to forestall by his latest love. She makes him yield up, key by key, the key that will take him to his final end. There will be no more dawnings, noons and evenings, moments symbolized by the three women of his life. Judith, the fourth, the figure of midnight, is, in fact, death dressed up as love. At the opera's end, total darkness engulfs the already gloomy castle after the Duke has been taken on a review journey from his prime to his decline. He cannot resist her insistence that she must know the truth and he must know the truth of his violence, the 'bloody mass' of his torture chamber, his armoury, the gardens

watered with women's red blood and the lakes filled with their tears and so forth. But in knowing this truth of a man's life that ceaselessly produced death, he will die, but on the way, so must all the woman, bled white, rendered lifeless.

This is the secret of Bluebeard that requires serious feminist interruption. In Angela Carter's feminist recasting of *The Bloody Chamber*, written in 1979, there is a powerful feminist twist in the ending. Not the brothers, but the wife's mother rides to rescue her daughter. The mother, historically positioned by being empowered by her colonial experience with tigers on a tea-plantation in Indo-China (aka Vietnam) is, in this telling, on the side of the daughter and stands against the perverted sexual violence of the man. Yet even in this telling, the figuration of the Mother is tainted with phallocentric misogyny.

> You never saw such a wild thing as my mother, her hat seized by the winds and blown out to sea so that her hair was her white mane, her black lisle legs exposed to the thigh, her skirts tucked round her waist, one hand on the reins of the rearing horse while the other clasped my father's service revolver, and, behind her, the breakers of a savage indifferent sea, like the witnesses of a furious justice. And my husband stood stock-still, as if she had been Medusa, the sword still raised over his head as in those clock-work tableaux of Bluebeard that you see in glass-cases at fairs.[23]

For all the power of its knowing feminist rhetoric, which restores the musical daughter to her gun-toting (phallicized) mother and gains her a blind piano-tuner for a husband, the imagery evokes the feminine in mythic and even castrating terms. So we are left to ponder: how else will we work *for* feminism and imagine both the opposition to and the undoing of this trope figured by the murderous husband with his blue–gray or blue–black beard? Not by playing with the same fantasies.

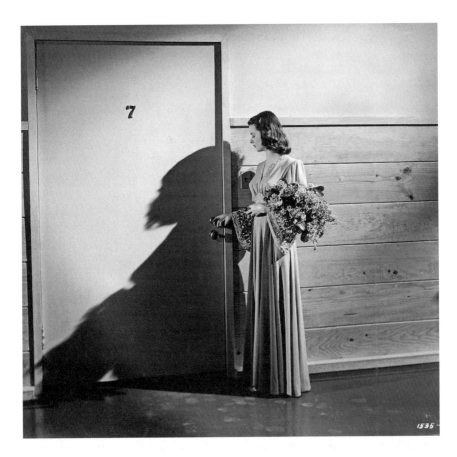

7.1 Still from *Secret Beyond the Door* (Fritz Lang, 1948). Reproduced courtesy of the British Film Institute Stills Library, London.

THE ENIGMA OF HOMECOMING
Secret Beyond the Door—Film Noir's
Celebration of Domestic Anxiety

Elisabeth Bronfen

As Vivian Sobchack astutely notes: 'It is now a commonplace to regard *film noir* during the peak years of its production as a pessimistic cinematic response to volatile social and economic conditions of the decade immediately following World War II.' While the plot of the classic war film generally concludes with the allegedly happy return of the war hero to the home for which he fought abroad, film noir highlights how precarious the veteran's homecoming can be. Sobchack argues that film noir can be seen as 'playing out negative dramas of post-war masculine trauma and gender anxiety brought on by wartime destabilization of the culture's domestic economy and a consequent "deregulation" of the institutionalized and patriarchally informed relationship between men and women.'[1] Indeed, the heroes of film noir repeatedly find themselves penetrating the dark world of an urban war zone and venturing into a disorienting, fascinating, and at the same time threatening counterworld of corruption, intrigue, betrayal, and decadence from which—in contrast to the war front they left behind—they can escape only through death. Thus the sense of a paranoid universe that film noir transmitted—that its protagonists were fatefully trapped in a disempowering world that denied them all agency—must be seen in the context of the transitional and politically unstable historical period from 1941, when America entered the Second World War, to the late 1950s post-war and Cold War era. As Paul Schrader points out, the psycho-

logical and social anxieties portrayed by film noir articulate a war and post-war disillusionment that was a response in part to the false optimism of war propaganda and in part to the suspicions and conspiracy theories that emerged as a result of the new international enmity called the Cold War. Schrader also suggests, however, that film noir responds to the demand for post-war realism, for a more honest and harsh view of the social antagonisms subtending the troubled domestic economy of the period.[2] Particularly central to noir's sober view of American culture's efforts to reassert the lost social order of peacetime are, of course, the veterans returning to the workplace and the family life they had left behind. Not only did they find themselves confronted with women as the 'internal enemy', which, according to Hegel's notes on war, they had initially sought to escape by going into battle. Rather, in contrast to the classic war film as well as the western, the bleak image of homecoming painted by film noir cinematically refigures the fact that the women to whom the war heroes were returning had become economically independent during the war. Called upon by American politicians to 'Give your job to GI Joe', the women were compelled, often unwillingly, to return to the hearth. Because they were often dissatisfied about their removal from the workplace, the idealized home front, which war propaganda had installed as an ideology in the name of which the battle against the Axis powers was fought, proved to be merely a mythic construct. In fact, this allegedly felicitous home became a new site of contention, no longer between two cultures but now between American men and women.

Two fundamental issues thus emerged as culturally relevant in response to this return to the home: the veterans' reclamation of their position as head of the family and dominant breadwinner and the working women's dissatisfaction at being displaced from the workplace and once more confined to the domestic sphere. In what Vivian Sobchack calls scenarios of 'domestic anxiety', feeding off the tension between attempts to 'settle down', to reclaim an idealized situation of pre-war 'stability', 'security' and 'loyalty' and the social reality of the insecurity, instability, and social incoherence that characterized post-war America, we find the character of the femme fatale emerging as a cinematic negotiation of the fears invoked by the successful, empowered, and independent working woman.[3] As Billy Wilder depicts in *Double Indemnity* (1944), this woman, forced to confine herself to the home, will turn this allegedly felicitous space of safety into a war zone, rendering actual death the only way to achieve a successful homecoming. Yet in film

noir we also find the counterparanoia: the fantasy of a post-war *Blue-beard*, punishing the confident woman for her independence and forcing her once more into a subordinate and obedient position at the price of her life.

In addition to provoking issues of gender trouble within the home, the return of the disoriented and disconnected veteran to a troubled domestic economy brought another unresolvable antagonism—the veterans' traumatic war neurosis. Those who had remained at home did not want to confront this problem, privileging instead the image of the valiant war hero over that of the wounded and psychically vulnerable soldier who had horror stories of violence and destruction to tell. As Richard Maltby notes, in many late 1940s noir films, war trauma finds an oblique articulation in which the heroes are haunted by a violent past, mentally disturbed, maladjusted, and driven by a forlorn hope, even though they are often only implicitly marked as war veterans.[4] One might speculate that what was staged as a battle between the sexes served to cover up another scenario that was too dangerous to be enacted in Hollywood mainstream cinema in a world of alleged peace and prosperity, namely the persistent psychic trauma that was part of the war's collateral damage.

Film noir thus engages not only the domestic anxieties arising from the changed social position of the independent working woman but also the equally threatening anxieties surrounding the psychic after-effects of war. While public discourse after World War I privileged physical over psychic wounds of war, Hollywood willingly addressed the psychic difficulties involved in coming home and in readjusting to times of peace.[5]

Astonishingly, as Dana Polan illustrates, a seminal aspect of post-war ideology had to do with the dangers emanating from the home-coming veterans. While war propaganda films had fed off the image of the American soldier whose physical prowess and psychic strength made him fit to conquer all his enemies and return home intact, a concern emerged in the post-war period that this violence, necessary in battle, could seamlessly become an unbridled destructive obsession that would threaten domestic peace. Uncertainty about whether soldiers trained to kill could successfully be reintegrated into the everyday reality of post-war America led to a paranoid refiguration of the valiant soldier as a dangerous psychopath. In his book, *The Veteran Comes Home*, meant to educate the American public about what to expect from the returning veteran, Willard Waller explains: 'The hand that does not know how to

earn its owner's bread, knows how to take your bread, knows very well
how to kill you, if need be, in the process. That eye that has looked at
death will not quail at the sight of a policeman.'[6] Indeed, as Dana Polan
documents, journalists were eager to make the connection between
crime in post-war America and the military past of suspected criminals,
while manuals like one titled *When He Comes Back* were distributed to
help families adjust to the soldiers' return home. Such texts tended to
argue that there was no need to fear any lasting effects of war neuro-
sis, owing to the radical difference between psychic disturbances intro-
duced in an extreme situation like war and normal family problems
emerging from trouble at home. Yet, as Dana Polan points out, 'Dis-
course on the postwar neurotic man ends by instituting a gap between
what it accepts as the awful facts and what it desires as the best alter-
native.'[7] While Benjamin Bowker's *Out of Uniform* begins by suggesting
that, over time, the psychically wounded veterans will come to remem-
ber their traumatic battle experiences with pride and satisfaction, all
resentment having faded to leave a 'memory of full, intense years'. He
ends up admitting that the battleground has simply shifted from a for-
eign to a domestic venue, and thus any imagination that the vet and his
family would once more be unequivocal masters of their home the way
they allegedly were before the war began was erroneous: 'It was only
after victory that the invasion of America [by the neurotic vet] became
a reality.'[8]

Film noir, as I claim in the following reading of Fritz Lang's *Secret
Beyond the Door* (1948), offers a bleak spin on Fleming's dictum 'There's
no place like home.' The world that the noir hero and heroine inhabit
is radically dislocated, the fissures impossible to overlook, all efforts at
happy endings inevitably thwarted. Place as a category plays such a cru-
cial role in these cinematic scenarios precisely because what is at stake
is the recognition that one can never be at home in the post-war world.
As Dana Polan notes, the precarious homecoming of the war veteran,
fraught with ambivalence and anxiety, is connected in the image reper-
toire of film noir with the way the imperatives of war have invested
themselves 'in a particular representation of home. At the extreme, the
forties home is not simply a haven against the outside world but a sep-
arate world of its own, a vast act of the imagination'. It becomes a self-
enclosed environment, working rigorously 'to close out the world of
ambiguous interaction, of ambivalent meanings', even while proving
to be 'no more than a representation', grounded in nothing that assures
its permanence or its invulnerability, 'often only an unstable fantasy'.[9]

In film noir, home thus emerges as a fragile and threatened entity, because, as Vivian Sobchack concludes, while these sombre film scenarios insist that 'the intimacy and security of home and the integrity and solidity of the home front are lost to wartime and postwar America', they also celebrate the uncanny transience of the dispossessed and the displaced: 'a perverse and dark response, on the one hand, to the loss of home and a felicitous, carefree, ahistoricity and, on the other, to an inability to imagine being at home in history, in capitalist democracy, at this time.'[10]

Lang's post-war Bluebeard: war neurosis or childhood trauma?

As I will argue for Fritz Lang's *Secret Beyond the Door*, while film noir rarely depicts homes, concentrating instead on empty streets, bars, hotel rooms, and diners, the domestic space proves here to be a particularly resonant stage for the portrayal of the anxiety provoked by the double issues that emerged from the veterans' precarious homecoming: the psychic effects of the violence that they had experienced and the onset of the battle of the sexes on the domestic front, which, in its most benign form, involves the strife-ridden transition between celibacy and marriage.[11] Lang explicitly deploys paranoia, claustrophobia, and home anxiety visually to perform how both his war veteran, Mark Lamphere (Michael Redgrave), and his wife, Celia (Joan Bennett), must come to accept that they can never be the masters of the Lampheres' family estate, Blade's Creek in Lavender Falls, New York—partly because Mark has been displaced by his sister, Caroline (Anne Revere), who has taken possession of his symbolic mandate during his absence and serves as a constant reminder of his impotent dependence on his dead mother, and partly because a traumatic neurosis renders any happy home romance impossible.

What is significant about Fritz Lang's choice of the family home as the site where these two agents of dislocation—feminine power and psychic disturbance—are negotiated is that the affective pressure left by the traumatic experience of war, of which mainstream Hollywood would allow only oblique representations, was cinematically refigured in the guise of a lethal battle of fatal love, played out in the most intimate part of the home, the bedroom. Like the manuals written to alleviate the anxieties of family members waiting for the veterans to come home, this narrative thrives on a rhetoric of ambivalence, undercutting the very optimism it seeks to present. While representations of the threat of domestic violence may have seemed less disturbing to Hollywood

than those of the lasting effects of war neurosis, the implications are perhaps more insidious, for they place the danger at the very heart and hearth of the home for which wars are fought. In Lang's film noir, the psychically disturbed hero, Mark, can begin to be cured of the traumatic reminiscences that threaten to turn him into a murderous psychopath only at the expense of losing his family estate. In this reading, actual homelessness emerges as the only viable condition for psychic health. Fritz Lang implicitly follows here the psychoanalytic dictum invoked by Gaston Bachelard when he suggests, 'There is a ground for taking the house as a tool for analysis of the human soul' because it is both our memories and the things we have forgotten or sought to repress that are 'housed': 'Our soul is an abode. And by remembering "houses" and "rooms" we learn to "abide" within ourselves.'[12]

Yet Fritz Lang does not subscribe to Bachelard's optimistic conception of topophilia as the imaginative engagement that provides a means of psychically retrieving emotionally charged places of abode as felicitous spaces of love, fascination, and security. Rather, Lang's journey through the paranoid hallucinations of his two protagonists implicitly renders visual the proximity between film noir's obsession with homelessness and Freud's own sober claim that psychoanalysis can only turn unbearable anguish into everyday unhappiness. Lang's film illustrates that in the noir world of post-war America, the ability to abide in one's soul is crucially coupled with the loss of home, indeed to the recognition that there can be no place like home.[13] For Fritz Lang's neurotic war veteran is ultimately able to find happiness in marriage and thus to relocate himself in a world that had grown dangerously strange to him, but he manages to do so only because his wife, Celia, is willing to risk her life by cathartically re-enacting what she deems to be the primal scene of his disturbance, appropriating the hybrid role of detective, psychoanalyst, and mother.

This tale about a rich New York heiress who marries a stranger she happens to meet in Mexico, only to discover that he is a murderous psychopath trying to kill her, is a twofold enactment of the mutual implications of psychic dislocation and literally being a stranger in one's own home. The war is mentioned only twice during the film, both times to note that it was after Mark's return from the battlefield that his relation to his first wife became troubled, leading to her mysterious illness and early death. Lang leaves no doubt in the audience's mind, however, that it was Mark's absence from home during the war that allowed his sister, Caroline, to usurp his place as the head of the family estate. By

way of explaining this vexed sibling rivalry, to which Mark must suc-
cumb because he has repressed all knowledge of its origin, the film's
narrative ultimately reveals a traumatic childhood scene that allows Celia
to explain to her disturbed husband how his sense of being a foreigner
in his own home is directly correlated with the murderous impulses
that have deprived him of feeling that he is master of his psychic appa-
ratus.

At the same time, Mark is not alone in his sense of psychic and lit-
eral displacement. Upon her arrival at Blade's Creek, Celia discovers
that she cannot be master of the house either. It is not, however, Car-
oline's skilful management of the house that stands in her way; it is her
husband's murderous desires, which have rendered her new home dan-
gerously uncanny to her. Here it is useful to recall Michael Wood's claim
that in Hollywood films of the 1940s and 1950s the all-American, ideal
home is actually a site of death for the hero. In *Secret Beyond the Door*, it
is the heroine for whom confrontation of her home romance and death
come to be coterminous.

Lang's noir Bluebeard fairy tale presents a scenario in which the Lam-
phere couple, married in Mexico very quickly after having met there,
can neither turn their backs on home nor have a phantasmatic alter ego
destroy it and thereby spare them direct confrontation with its poten-
tial fatalities, namely that Mark's estate was a site of death, a museum
of murder rooms. Instead, they are forced to play out the death sce-
nario represented by the Lamphere mansion as the abode for their trou-
bled marriage, a scenario that takes the form of a lethal duel involving
clandestine surveillance and trespassing in forbidden places, all staged
in the various intimate rooms of Blade's Creek. This turn toward home
as the battleground implies that the repressed traces of Mark's war neu-
rosis, which is never directly named but is associated with a scene of
early childhood trauma—which Celia reconstructs from stories Caro-
line tells her, rendering it highly subjective at best—can be negotiated
and resolved as a battle between the sexes and the generations. Lang
thus performs the following chiasma: the fatal quality of the home,
encoded as a feminine space in which the hero feels alienated because
of the unbearable proximity of the maternal (or sororal) authority, is
transformed into the site of death for the woman (Celia), who is seek-
ing to take on the maternal position, and thereby completely occludes
the other significant scene of trauma, the literal battleground.

From the start, Lang positions *Secret Beyond the Door* as his heroine's
story, told primarily from the point of view of the disoriented wife

rather than that of the psychically disturbed veteran. Initially her voice-over calls upon us to indulge in the mysterious dangers brought by her sudden marriage, as it is her voice that ultimately posits a coherent pattern for the uncanny events that befall her at Blade's Creek. Indeed, Lang is also very clear that it is her desire for death which finds its abode in the Lamphere mansion. The childhood scene of trauma, with which she finally cures her husband of his murderous urges, serves as a protective fiction that not only obscures the war neurosis, allowing it to remain undiscussed, but also masks the way death and the home of marriage were, from the start, conflated in her romance with Mark Lamphere. Celia proves to be a feminine refiguration of the classic Hollywood hero insofar as home to her is also a site of death; she wants to penetrate it, because it will allow her to work through her ambivalent feelings about marriage and her unequivocal fascination with lethal self-expenditure. Happiness for her ultimately involves turning her back on a home that, as an architectural embodiment of both her and Mark's violently consumptive desire, has literally been consumed by flames and now resides only in the state of blissful transition that exile affords.

Yet this solution can be effected only after she has entered the noir home's heart of darkness and confronted there her own death wish, manifested in the guise of her murderous husband. To emphasize that what is to come is the heroine's tale, *Secret Beyond the Door* begins with a flashback in which Celia recounts the events that led to her sudden marriage to a man who has remained a complete stranger to her. She remembers that as long as her brother, Rick, was still alive, she had resiliently turned down all offers of marriage. After his death, which left her the sole heir of their family fortune, she decided to take a trip to Mexico with her friend Edith Potter (Natalie Schafer), to take her mind off her grief but also to spend some time away from her fiancé, Bob, who had been her brother's lawyer and had started wooing her after Rick's death. Once in Mexico, she meets her dead brother's double—a mysterious older man who is the publisher of an architectural magazine in New York City. Within a few hours Mark succeeds in taking the affective place left vacant by the death of her brother, and she decides to marry the stranger who has made such an irresistible impression on her. But when Mark abruptly breaks off their honeymoon and leaves his wife alone in Mexico while he returns to New York without any explanation, Celia realizes how little she actually knows about her husband. Then, on the morning of her arrival at Blade's Creek, her paranoia begins to be fed by Mark's son, David, who is convinced that his

father was responsible for the sudden death of his mother. To her surprise, she discovers that none of the rooms in the upper part of Blade's Creek have locks, while the special 'felicitous' rooms that Mark has been reconstructing in the cellar of the house are replicas of historical murder sites—and the one room he keeps locked from everyone is a perfect reproduction of Celia's own bedroom.

The psychic excavation work that follows, supported by Celia's ceaseless exploration of the corridors and rooms of the Lamphere mansion, could be viewed as an ironic take on the gesture of cathartic re-enactment that underwrites Freud's talking cure. As Celia penetrates ever deeper both into Mark's psyche and into the innermost chambers of his home—as though, in line with Bachelard's claim, not just his memories but also the things he has chosen to forget were obliquely 'housed' in the wife's bedroom that he has reconstructed—she uncovers past events that allow her to reconstruct a primal scene of early narcissistic wounding, having to do with an enforced and utterly painful separation from the mother he adored. What she surmises, even though she has only Caroline's hearsay and her own intuition to support it, is that because the young boy encoded being locked in his bedroom, and thus severed from his mother, as a traumatic form of abandonment, he developed a pathological hatred of both his own mother and her surrogates—his first wife, Eleanor, and now his second wife, Celia. Working with the analogy between Mark's past, locked away in his unconscious, and the last of his 'felicitous' rooms, which he keeps locked from her, and with the analogy between the wife's body and the maternal bedroom, Celia is able to break his amnesia, or at least his murderous fantasies about having to destroy his new wife, in which he hopes to turn a scene of utter vulnerability (being abandoned by his mother) into a scene of empowerment (rendering the woman he has married because she reminds him of his mother utterly vulnerable by threatening her with death). As Celia slyly surmises, in the logic of Mark's paranoid delusions, killing his wife in her bedroom would function as an antidote to having been locked out of his mother's bedroom. One might, of course, offer the counter speculation that killing the woman, who by virtue of her gender is foreign to him, might also be an apotropaic collateral of a different scene of trauma, the situation of having been threatened by alien soldiers, which he now refigures in the act of overcoming an equally alien internal enemy.

Without ever fully discrediting the possibility that Celia may be off the mark in her reconstruction of the violent urges driving her hus-

band, Fritz Lang foregrounds the trauma at the heart of the mother–child bond by referring to the scenario Freud invoked in *Beyond the Pleasure Principle* to illustrate how the death drive works. Like the little boy's game with a wooden spool, in which he gleefully throws it away and then retrieves it by pulling on a string attached to it, so as to imitate his fantasy of control over the absent mother, Mark's murderous hallucination also involves a game of *fort–da*. Freud suggests that the little boy's game was a form of compensation for having been forced to accept that the mother he so greatly adored would leave him alone in his room for many hours. 'By himself staging the disappearance and return of the objects within his reach,' Freud claims, he was able to gain control over an unpleasant event. At the same time Freud notes the ambivalence at work: the child could not possibly have 'felt his mother's departure as something agreeable', even though the throwing away of the spool, which represented the mother's departure, was 'staged as a game in itself and far more frequently than the episode in its entirety, [had a] pleasurable ending'. Significant, then, for the crossmapping that I am proposing between Freud's discussion of the death drive and Lang's cinematic enactment is that the emotional gain of the *fort–da* game resides in making the beloved object, which punishes one by not being ever-present, disappear.

Mark's reproduction of allegedly 'felicitous' rooms of murder, culminating in the duplication of his wife's bedroom, turns his painful memories of abandonment into a scene of agency. On the one hand, Mark's repetition compulsion allows him to transform a situation in which he is helpless and passive into one where he assumes an active, sadistic role. On the other hand, the act of throwing away his second wife by murdering her also satisfies his desire for revenge against his mother for having seemingly abandoned him, for as Freud notes, throwing away the object so that it was 'gone' satisfied the child's 'suppressed impulse to revenge himself on his mother for going away from him'. Mark's insistence on being locked into his hallucinations, which veer toward murdering his wife, can be translated as a phantasmatic enactment of the statement: 'All right, then, keep me locked up in my fantasies. Go away! I don't need you. I'm sending you away myself.'[14]

Nevertheless, in his cinematic homage to Freud's speculations on the death drive, Fritz Lang includes a double fissure. For one thing, the *fort–da* game that Mark plays is not an example of a young child's great cultural achievement of relinquishing his drives but rather the expression of a regressive resurgence of those archaic drives. The maternal

body is replaced not by a symbol (the toy) but by a second actual body (the second wife). Furthermore, even though Lang explicitly plays with Freud's conviction that in the course of psychoanalysis it is possible to discover a traumatic primal scene that explains the neurotic illness of a potential killer, he leaves open the question of the reason for the re-emergence of Mark's murderous drives. Lang obliquely suggests that it might well have been Mark's experience of war that triggered the initial manifestation of his psychic alienation and that now possibly represents a different wound to Mark's narcissism, one for which no traumatic primal scene can be found. At the same time, Celia privileges a solution to Mark's mental disorder in which his murderous urges are linked to an unsuccessful emotional jettisoning of the maternal body, so that she can also claim that these violent drives have been haunting him since early childhood. As a result of the way Lang sets things up, the viewer is unable to decide whether the origin of Mark's murderous desire is really to be located in his inability to affectively separate himself from his mother or whether Celia simply resorts to this scene of unsuccessful de-navelling so as to find a surrogate representation for Mark's war trauma, for which he has neither visual representations nor words.

If the latter is the workable scenario, Celia can hope to cure Mark of his proclivity toward violence, regardless of whether the primal scene she identifies is accurate or simply a screen memory for Mark. Once we view this solution as one that Celia narrates and that Mark simply passively accepts—much as the entire film scenario is shaped as her wish-fulfilling dreamscape—we might further speculate that it would clearly be more satisfying to Celia to imagine that the strange man she has married is a potential wife killer than to accept that he is a dangerously neurotic survivor of war. Nevertheless, Fritz Lang himself never resolves the question; he subsequently translates this twofold narcissistic wound into the misogynist fantasy that in order to recover his lost patriarchal position of power Mark must seek revenge on all the women in his life who take care of him. The compensation for this way of working out his neurosis, one might surmise, resides in the fact that at the heart of his home he does not have to face the contingency of death, as would be the case in the battlefield. Here, he himself can determine the conditions under which he will look death in the eye. Yet the undecidability performed by Lang is such that one would immediately have to counter any reading that privileges war neurosis by asking whether the latent trauma cannot indeed be read back to a repressed

hatred of the mother, activated by virtue of Mark's experience of abandonment on the battle front.

What is disturbing is that regardless of how one seeks to explain the origins of Mark's murderous desire—be it the traumatic separation from the mother or the shock of war—it is, nevertheless, aimed at the body of the woman who loves him and seeks to cure him. Equally disturbing is that this noir fairy tale corresponds to the wish fantasy of the endangered woman, with this post-war Bluebeard serving as the hero of a scenario shaped from the start by the female narrator's desire to enjoy a situation in which her life is threatened. Elizabeth Cowie astutely distinguishes Celia from the clueless girl of the Grimm fairy tale by pointing out that she is neither young nor inexperienced but 'sophisticated, self-possessed and self-assured', and thus 'not yet or not sufficiently a victim of her circumstances'. She is no innocent player in a murderous love scenario; instead, by emotionally endorsing a connection of desire with death, she actually takes on a role counter to that of the war veteran.[15] Indeed, this beautiful worldly wise woman wants to pit her own confrontation with death against her feeling of psychic numbness induced by her brother's death. In this noir dreamscape, Celia's fantasy of experiencing a threat to her life constitutes a feminine appropriation of the experience of war, even though it is played out as a love duel and not as a fight between political enemies.

Mary Ann Doane has suggested placing Lang's film in a cycle of Hollywood films that she calls narratives of feminine paranoia because they all revolve around the wife's suspicion that the husband she discovers to be a stranger might also be a murderer. The ambivalence of these films resides in the fact that while the protagonist gives in to her anxieties about being threatened by her husband, she is also clearly marked as the 'agent of the gaze, as investigator in charge of the epistemological trajectory of the text, as the one for whom the "secret beyond the door" is really at stake', with the mysterious husband simply an auxiliary player in a fantasy scenario that she fully commands. In these cinematic narratives it is the home, to which women in classic Hollywood cinema have a particular claim, that comes to be 'yoked to dread, and to a crisis of vision'. According to Doane, the uncanniness of these scenarios of feminine paranoia derives from the violence that is anticipated but that also is 'precisely what is hidden from sight'. The marriage, with its architectural materialization of the family home, proves to be a heterotopia of sorts: 'It asserts divisions, gaps, and fields within its very structure.'

Indeed, in these noir refigurations of the anxieties revolving around marriage, an external horror infiltrates the domesticity of the home, rendering visible the instability of the boundary between internal and external and thriving on a split, as Doane claims, 'between the known and the unknown, the seen and the unseen'.[16] Fritz Lang's noir home is shaped as a stage for the uncanny dislocation of domestic familiarity in which, significantly, the murderous fantasies of a traumatized war veteran can be interchangeable with his wife's fantasies about being pursued by an enemy. Celia, much like the unnamed heroine in Alfred Hitchcock's *Rebecca* (1939), discovers her own alienness mirrored in her husband's odd behaviour, as though he were a phantom embodying the gap in her self-knowledge. In her desire for death she is strange to herself, and the Lamphere mansion, as an uncanny abode, functions as an architectural correspondence to the uncanniness inscribed in her psychic apparatus, itself an immaterial, spiritual abode. One can thus add a further layer to the way the psychoanalytic solution that Celia offers for both Mark's and her own delusions in *Secret Beyond the Door* superimposes a scene of early childhood trauma onto the trauma of the war veteran. Ultimately both transform into narratives that describe her own psychic ambivalence, notably the doubts that this self-possessed and independent woman harbours toward marriage as the solution to her desire to break out of her own locked room, namely her sexual inhibitions.

Fritz Lang never denied that Hitchcock's *Rebecca* was the model for his own cinematic refiguration of a psychoanalytic case study in paranoia, but he declined to locate the analogy between the two films in the mysterious death of a first wife and the presence of a jealous housekeeper who spies on the new mistress, then burns down the mansion in the end.[17] Rather, he insisted that the connection between the two was one of failed appropriation. As he explained to Peter Bogdanovich:

> You remember that wonderful scene in *Rebecca* where Judith Anderson talks about Rebecca and shows Joan Fontaine the clothes and fur coats and everything? When I saw this picture (I am a very good audience), Rebecca was there, I saw her. [...] And—talking about stealing—I had the feeling that maybe I could do something similar in this picture when Redgrave talks about the different rooms. Now let's be very frank—it just didn't come through for me.[18]

So it seems that Lang himself felt the inadequacy of his version of Hitchcock's dramatic *mise en scène* portraying the fascination of a secret room and the forbidden—because it is fundamentally dangerous—feminine power harboured there. Nevertheless, *Secret Beyond the Door* does refigure Hitchcock's drama revolving around the traumatic dislocations inscribed in the home romance in a revealing manner, and not least because the dangerous power emanating from the maternal figure of authority is overdetermined in Lang's appropriation of *Rebecca*. Mark is haunted not only by his dead mother but also by his dead first wife, while Celia must confront two maternal figures, who, before her arrival, occupied the position left vacant by the death of Mark's first wife. Caroline, the sister, is transformed into a benign version of Mrs Danvers who is only too willing to hand over her duties to Celia, while the governess of Mark's son, David, Miss Robey (Barbara O'Neil), functions as the malevolent rival who, in contrast to Mrs Danvers, does not seek to preserve the memory of her deceased mistress but rather wants to become mistress of Blade's Creek herself.

Two further transformations prove to be significant, as will be discussed in greater detail later. Firstly, Fritz Lang appropriates the voice-over of a woman remembering the past events that led to her present situation of exile. In contrast to the voice-over in *Rebecca*, however, where the disembodied voice initiates a ghost story and then disappears when Joan Fontaine actually appears onscreen, Joan Bennett's voice-over never stops. Instead, as though it were a jettisoned part of her body, it follows the heroine's every move, superimposes questions and interpretations onto her facial expressions and movements, and forces us to read each scene as Celia's phantasmatic working-through of the doubts, confusions, and anxieties called forth by her ambivalent desire. As Tom Gunning notes, Lang, wishing to emphasize the discrepancy between Celia's interior monologue and her actions, initially had someone other than Joan Bennett speak the lines, so as to stage his conviction 'that the unconscious is another, "someone" in us we perhaps don't know'.[19] Secondly, although Lang's dreamscape is radically shaped by the sombre visual style of film noir, he does, in the end, offer us an image of the restituted couple, which Hitchcock denies us in *Rebecca*. After Blade's Creek has burned down, Celia and Mark return to the hacienda in Mexico where they had begun their honeymoon. A scene at the beginning of the film showed them lying in a hammock, with Celia resting her head on Mark's chest, and in the final sequence of the film we see her sitting in a deck chair, while Mark rests his head in her

lap. No longer suspended in the illusion of marital harmony and happiness, they have arrived at the ground of reality and have come to accept that traces of psychic fallibility will always haunt their marriage. But because they have awakened from the excitations of noir hallucinations into the sobriety of everyday unhappiness, they can begin to dream of a shared future.

An ominous home romance

Fritz Lang's homage to the discursive tropes of Freud's work on the vicissitudes and resilience of early narcissistic wounds does not simply come down to the fact that his heroine, as well as her women friends, are fluent in the language of psychoanalysis. More significant, perhaps, is that the premise upon which Lang's enmeshment of war trauma, fantasies of matricide, and Bluebeard narrative is based recalls Freud's discussion of the work of dream representation. Dreamscapes, he wagers, function like stages for traumatic knowledge, which can find an oblique expression there, but only in a condensed and dislocated manner, under the auspices of psychic censorship. In reference to the tropic language of psychoanalysis, the title sequence of *Secret Beyond the Door* is superimposed on an expressionistic painting of a door, standing upright at a slanted angle, without any supporting walls, in an open space. Behind this door we find a wide, completely flat landscape, as well as a slightly clouded sky, on whose horizon the first beams of a rising sun can be seen. With Celia's voice-over, however, a far more troubled visual language is introduced. Indeed, the very first sentence she utters, describing the dream images that haunt her, functions as a counterpoint to the open, sunlit geography invoked by the title sequence as an allegorical representation of what lies beyond closed doors. For what she invokes, which frames the story she is about to tell, is the dark, archaic forces that draw one back into the realm of psychic delusion and confusion: 'I remember long ago I read a book that told the meaning of dreams. It said that if a girl dreams of a boat or a ship, she will reach a safe harbour, but if she dreams of daffodils she is in great danger.' At the same time we see drops falling into a pool of water, forming concentric ripples. Because the liquid surface is shown in a close-up, however, we have no way of determining its exact parameters. Also visible is the reflection of a multitude of sparkling spots that light up and fade, although it remains unclear whether they are indirectly reflecting the starlight of a nocturnal sky or an artificial illumination. Beneath the liquid surface we can detect the shadowy contours of flowers and stems,

although it is impossible to determine exactly what kind of vegetation they are.

Once the camera has begun to slowly pan over the water's surface from the left to the right of the screen, it captures a small paper ship, folded from a newspaper. As the ship softly floats into the centre of the frame, we see its contours clearly reflected on the liquid surface and watch it cross over the pernicious-looking dark figures, which now prove to be even more mysterious than at first, for upon closer examination we discover that, while this shadowy foliage initially gave the impression that it was submerged in the water, some of the dark shapes are actually on the surface, partly obscuring the reflection of light there. As the camera continues panning along the water, the ship floats out of the upper left corner of the screen and is replaced at the bottom right by white daffodils drifting on the water's surface as well as beneath it. We see them only in fragments, as they are partly overshadowed by the dark, indiscernible figures uncannily superimposed on them. Furthermore, because they are not floating above the water, but are rather partially submerged in it, they, unlike the paper boat, have no reflection on the surface.

With this first sequence, Lang thus situates the incipient noir romance in a dreamscape that recalls a world the heroine once read about in a book, so that it might help her find a name for the strange anticipation she is experiencing on what should be an utterly joyous day, namely her wedding day. At the same time he emphasizes that all three invoked representations, to which Celia will repeatedly refer in the course of her narrative as she recalls the past—the locked door, the boat entering a safe harbour, and the daffodils drifting ominously on the water— are protective fictions in the twofold sense of the term. Like all dream representations they are condensed images that protect the dreamer from the traumatic knowledge she harbours within her unconscious by allowing her to give voice to it in an encoded and thus psychically bearable manner. Yet these representations also function as intermediaries that protect the subject by blocking out and rendering impermeable this dangerous knowledge. Her strange dream rendition of the transient position that she occupies as a young woman about to marry not only combines a proleptic anticipation of the home that marriage will afford her with an analeptic recollection of the dangers that might befall her upon entering this as yet unknown territory because it reminds her of some things she used to read and dream about such that her anticipation of what her future with Mark holds for her looks

like the fulfilment of a prophecy. Staging her uncertainty about her future as the false choice between the safe haven represented by the boat and the danger represented by the daffodils also introduces a further level of undecidability, for it remains unclear whether the force that causes both the boat and the daffodils to float on the surface of the dreamscape emanates from herself or from an external, foreign power. Does her dreaming self inhabit these images or do they inhabit her?

After Celia has named the two choices open to her in relation to her romantic desire, the tone of her dreamy, seductive voice suddenly changes. With a lighter and almost sharp intonation she interrupts her own ominous anticipation at exactly the same moment that Lang cuts from the murky surface of the water to an image of church bells ringing. As though she were scolding herself, Celia exclaims: 'But this is no time for me to think of danger. This is my wedding day!' Given that the visual language of her dream is clearly literary, one might ask whether Celia interprets her wedding as a possible danger precisely because it allows her to give body to a piece of strange wisdom she once found in a book. Or is it that her ominous marriage to Mark allows her to confront a piece of traumatic knowledge that she has been harbouring within her psyche and that is now embodied in the figure of a mysterious husband who could represent either a safe haven or danger? What presents itself as a free choice, however, uncannily collides with its opposite, a forced choice, not because Celia invokes the question of fate but because either choice involves death. Marital security, the ostensible safe harbour, could prove to be as lethal as any direct danger posed by her strange husband. To this one might add another question: if Celia can freely choose to open a door and thus escape the dark forces lurking beneath her romantic desire, wherein the origin of her death drive resides, does her dark desire represent a fate imposed upon her from outside or does it define the most intimate core of her sexuality?

As we are shown a close-up of the church bells ringing, Celia's voice-over reveals another piece of appropriated knowledge: the folk wisdom that on her wedding day the bride should have something old, something new, something borrowed, and something blue. With this seemingly benign antidote to the ominous dream imagery, Lang finally moves to the magnificently decorated interior of a Mexican cathedral. From an arched balcony at the back of the church, his camera initially shows the figures grouped around the altar, viewing them from behind a silhouetted statue of the crucified Christ, as though it were an omen

of the pain overshadowing this wedding ceremony, while Celia's voice explains, 'Something old is this church, four centuries old.' Then the camera slowly moves from the dome, along the magnificent walls and toward the altar, while Celia calls it a 'felicitous structure', built as a place where events of joy could happen. As Lang's camera finally captures the back of the groom, standing before the altar, Celia continues to explain in a confident tone, 'and something new is Mark himself'. With the next cut we finally see the bride, and thus the body that belongs to the voice we have been hearing, as Celia slowly emerges from the side entrance at the left of the altar, dressed in a splendid white wedding gown, her face still hidden in shadow. With a trace of romantic sentimentality in her voice she declares, 'And love is new for me.'

When she has finally left the liminality of this shadowy passage and has fully emerged into the candlelit open space before the altar, Celia's voice once more changes in tone. In a whisper she describes the uncertain emotions she feels as she stands frozen for a moment before approaching the altar. All confidence and self-possession seem to have abandoned her as she explains, 'My heart is pounding so. The sound of it drowns out everything. It says that when you drown your whole life passes before you like a fast movie.' With this ominous utterance Fritz Lang introduces a flashback that plays through the scenes that led to this sudden marriage, always accompanied by Celia's voice-over. The acme of the inserted narrative of the events leading to the wedding is, of course, Mark's proposal of marriage, which, according to Celia's comments, seems to resolve her emotional ambivalences regarding her choice of bridegroom. As Celia explains to Mark, the engagement to Bob, which she had accepted shortly before her trip to Mexico, seemed to promise her 'a quite familiar room where I'll be safe, with a warm fire burning on the hearth'. As she comments in her voice-over, accepting Mark meant that the door to that room of safety closed 'and another opened wide and I went through and never looked behind, because wind was there and space, and sun and storm. Everything was behind that door'.

One must not forget that Fritz Lang does more than introduce this flashback by having Celia compare her recollection of the proposal from Mark to the film that flashes before the eyes of someone about to drown; he also returns to this sombre premonition once the kiss with which Celia seals her engagement to Mark is over. As he shows us the bride's face, smiling at Mark as he approaches her, we once more hear Celia's voice-over, anxiously stating, 'Suddenly I'm afraid. I'm mar-

rying a stranger. A man I don't know at all. I could leave, I could run away, there is still time.' As she notices her friend Edith, who has remained with her in Mexico to serve as her bridesmaid, she recalls that she is a woman well aware of her social position. For a moment she reverts to the confident voice of self-criticism, reminding herself that running away from one's wedding just isn't done. But the demons of her doubt continue to haunt the performance of the wedding vows we are shown on the screen. As Celia finally reaches the altar to accept Mark's wedding ring, she maintains, 'But I'm afraid,' and as she adds in an ominous tone, 'Maybe I should have followed the dark voice in my heart. Maybe I should have run away,' her wedding ceremony ends.

Celia's dislocated voice-over

Deploying another implicit reference to *Rebecca*, Fritz Lang emphasizes that Mark's marriage proposal was premature, for both Mark and Celia secretly harbour doubts as to the loyalty they have pledged each other. Before they can really commit to loving each other they must traverse the hallucinatory space of their emotional ambivalence regarding marriage. By sustaining his heroine's voice-over, Lang (in contrast to Hitchcock) achieves two effects: Celia continues to thematize her discontent with the marriage promise she gave too hastily, and the doubling between screen image and soundtrack performs cinematically how little this bride occupies an appropriate symbolic position. While war movies of the early 1940s had come to use the voice-over to emphasize the authenticity of the represented events and procure a sympathetic identification from their audience, film noir used the technique to present a heavily subjective confession by male protagonists who were searching for the truth behind a conspiracy or intrigue. The tension resulting between narrating voice and visualized flashback, which offers partly a tautological, partly a disjunctive relation between word and image, leads Karen Hollinger to describe the structure of these cinematic scenarios as 'narrative battles that extend out into the narration itself. This strategy prevents them from achieving the sense of narrative resolution and unification of point of view that the films' seek at their conclusions.[20] Fritz Lang himself had written to Lotte Eisner on 1 February 1947, about the beginning of his shooting of *Secret Beyond the Door*, 'I am experimenting with using superimposed sound for the "thought voices" of the leading characters, and I find the idea intriguing to work out.' As Eisner notes, for Lang 'the words of the subconscious are not like asides in a play but are somehow placed on a different plane, belong to

a different dimension.' Although the enmeshment between the hero-
ine's subjective gaze and her acoustic self-commentary 'tightly inte-
grate[s] the whole structure of the action', she goes on to explain, those
two elements also paradoxically 'free the action from its improbabilities,
reinforcing Lang's "fantastic realism".'[21] We not only follow events
through the heroine's eyes, but the self-doubt that accompanies all her
actions—whether she is simply sitting in a room, exploring the halls
and rooms of Blade's Creek, or sleeping at night—allows us to identify
with her voice and thus gives credence to her delusions, as well as to the
solution that she will finally offer to the strange events of her marriage.

A closer examination of Lang's use of Celia's voice-over, however,
reveals a far more disjunctive effect. On the one hand, owing to the
voice-over, the love duel between Celia and Mark is fought through as
a narrative battle that thrives on the internal coherence provided by
Celia's unceasing stream of consciousness, which holds together all the
visual representations of how she perceives Mark and her new home.
On the other hand, her voice-over also corresponds to what Michel
Chion has called an 'acousmatic voice', in the sense that it is not exclu-
sively attached to a character within the diegetic reality of the film, nor
is it simply the voice of a narrator external to the story; rather, it serves
as a spectral manifestation, floating in a mysterious transitional and
intermediary realm that can only phantasmatically be located.[22]

That we sometimes hear her commentary without seeing her body
and that the voice-over actually belongs to two women, a reminiscing
Celia and an experiencing Celia, illustrate the acousmatic quality. Celia's
remembering of past events constructs a narrative sequence under the
auspices of a dream language that she introduces in the first moments
of the film. This part of her recollection is an analeptic narration sus-
pended between two temporal sites—the past that she has traversed
and can now find a coherent explanation for and the future that is about
to set in, both as a break with the past and as a continuation of it. At
the same time, it is an empowered narration, indicating her triumph
over her hallucinations. While the reminiscing Celia is the author of
the entire story that *Secret Beyond the Door* presents to us, the voice-over
at times refers to a second Celia, the one who experiences the events—
a deluded player involved in the story she is narrating, as limited in her
perspective and knowledge as all the other players. This second, com-
menting rather than analeptically narrating, voice exhibits no ability to
translate contradictory fragments into a coherent narrative whole.
Rather, what Celia's stream of consciousness signals is the way she, giv-

ing in unconditionally to her own doubts and delusions, is helplessly drawn into a repetition compulsion. Again and again, Fritz Lang returns to the *mise en scène* that he used for the wedding ceremony, with the voice of Celia commenting on her emotional ambivalences during visualizations of her self-doubt. She is herself caught up in the act of self-analysis, incessantly playing back in thought the strange behaviour of her husband, until she is finally able to come up with a satisfying subjective narrative explanation. One might thus surmise that Fritz Lang intends Celia's voice-over to be a feminine version of the death drive of her traumatized husband. Her voice-over, trying to figure out what disconcerts and alienates her, and his gesture of repeatedly reconstructing rooms where an extreme experience of vulnerability took place, juxtapose the pleasure of repeating something displeasurable, so as to overcome it, and the traumatic experience of fallibility that can be displaced, or transformed into a protective fiction, but never obliterated.

Celia's delirious voice-over makes visible that the fantasy she is indulging in, so as to organize her ambivalent desires regarding marriage, revolves around a masochistic enjoyment of the potential threat emerging from her husband. Yet one might also say that the acousmatic voice-over was so intriguing to Fritz Lang because it allowed him to explore his heroine's homelessness through the visual and acoustic rhetoric that cinematic language offered him. Owing to her search for truth, impelled by her fundamental doubts, Celia remains a restless inhabitant of all the abodes she passes through—the hacienda of her honeymoon, the Lamphere estate Blade's Creek, and in a figural sense also the home that her marriage to Mark is meant to afford her. Indeed, all she can do is pace restlessly up and down the diverse bedrooms she finds herself in, accompanied by the ceaseless readjustments she makes to her critical judgement of her situation, or wander along the dark corridors and up the sombre staircases in her new home, driven by her desire to enjoy her own peril.

The unending stream of consciousness, uncannily dislocating her emotionally wherever she finds herself, forbids her to reside without premonitions in the abodes connected to her marriage and also makes it impossible for her to actually leave the place where her lethal anxieties take on hallucinatory shape. Thus the seamless transition from Celia reminiscing about the past to Celia actually experiencing the dangerous events of this past produces the exact opposite of a coherent, plausible story. Far from having an assuaging effect, Celia's voice-over

forbids an identification with her in the same gesture with which it compels this; the conjunction between her visual rendition and her acoustic inquiry creates a distortion rather than a harmonious marriage between image and sound. Lang's noir heroine is clearly not at home in her present situation, nor is she at ease with her fantasies organizing her desire. Furthermore, because, starting with the depiction of her first, unhappy honeymoon, the difference between the voice of the acousmatically narrating Celia and the voice of the Celia who is involved in the hallucinatory scenario can only imperfectly be drawn, belated narration and immediate experience uncannily collapse into each other.

At the same time, Celia's repetition compulsion points out that something recedes from her epistemological imperative. Her refusal to inhabit any of the abodes available to her without self-doubt allows us to recognize to what degree the wedding vows in the Mexican cathedral thrived on covering over an inherent, but clandestine, gender trouble. The unresolvable antagonism inhabiting this marriage finds its aesthetic analogy in the disjunction that the uncanny voice-over introduces into the cinematic rendition of this noir romance. As Slavoj Žižek has noted, the acousmatic voice in cinema can be compared to a blind spot. By disturbing our common-sense notion of a 'fully constituted reality, in which sight and sound harmoniously complement each other', the voice-over 'cuts out a hole in the visual reality: the screen image becomes a delusive surface, a lure secretly dominated by the bodiless voice' of the one masterminding the narrative. Indeed, in the opening sequence of *Secret Beyond the Door*, we find that the feminine voice-over begins simultaneously with the drops falling on the surface of the pond, rendering it clearly a delusive surface. As a result, Celia's visualized body and her voice do not complement each other; instead, they represent an antagonistic relation, because, as Žižek further argues, the spectral autonomy of the voice-over points to the 'dimension of what eludes our gaze'. The relationship between voice and image 'is mediated by an impossibility: ultimately, we hear things because we cannot see everything'.[23] By virtue of this rhetoric of distortion, however, Lang articulates not only the illusory power of the cinematic image but also the antagonistic kernel on whose repression all psychic and social systems structurally rely, in the sense that an opacity (between voice and image, between representation and reality) must be posited and repressed at one and the same time, if a belief in the harmonious transparency of signs is to hold.

Central to Žižek's discussion of the anamorphotic quality of the voice-over is that because of this cinematic distortion of an accurate representation of reality, the non-symbolizable antagonism is articulated, and around it all psychic reality revolves, even while it is regulated by symbolic fictions that screen out this traumatic real. According to Žižek, this real of antagonism becomes available because psychic reality is split into two fictions: an officially sanctioned narrative, aimed toward stability and harmony (notably the psychoanalytic claim that a jettisoning of the omnipotent maternal body is necessary for adult psychic health), and private fantasies that celebrate destability, distortion, and difference and called publicly sanctioned symbolic fictions into question. In the case of Celia and Mark's marriage contract, an officially sanctioned symbolic fiction regulates their shared relation to reality, which, as the priest declares, unites them as a couple in a harmonious manner, even while our expectations of Hollywood narrative style are premised by another contract, namely that the diegetic reality be governed by a harmonious relation between sound and image, so as to make it a coherent fictional space. From the start, however, Fritz Lang counterbalances this drive toward stability by introducing difference, which takes the shape of an initial incompatibility between the private fantasies of his two protagonists. While Mark uses their marriage as a platform for his efforts toward self-empowerment, Celia uses it to enjoy scenarios of lethal self-expenditure. Even though these two fantasies are initially at cross-purposes, they are ultimately translated into a symbolic fiction promising harmony, but only after the antagonism they represent is literally carried out as a narrative battle in the reconstructed bedroom, where Celia wins by imposing her interpretation of the origin of Mark's murderous impulses and thus enforcing coherence over distortion.

As the element that initially signalled the twofold disjunction—between image and sound track as well as between the marriage vows and Celia's psychic privileging of danger over marital safety—the voice-over itself ultimately establishes the marriage contract instead of hallucination as the victorious symbolic fiction. As Slavoj Žižek notes, official symbolic fictions, such as marriage vows, seek to deny that disharmony and difference might lie at the heart of all conjugal bonds, even while phantomatic fictions embody this disturbing lack of harmony. The psychically and aesthetically satisfying oscillation between symbolic and phantomatic fiction, however, works by virtue of an insur-

mountable occlusion. Even in the battle between narratives that takes place in Mark's reconstruction of Celia's bedroom, the repressed real antagonism can be represented only as another protective fiction. If Celia's voyage through her paranoid hallucinations begins with the fantasy 'the man I love is keeping a secret from me, locked away in his mind', so as to give voice to her own doubts about the stability of the marriage contract, in the peripeteia of the film this delusion is merely translated into a more viable, because more empowering, fiction: 'If I unlock the door to Mark's psychic crypt, nothing will recede from my grasp, neither the dark figures that haunt him nor those that have been haunting me, though I have never being able directly to name them, long before I ever met him.' With this rhetorical short circuit Lang shows Celia's analysis of her strange husband to be an auto-analysis, resulting in a fiction that allegedly clears up both his and her emotional ambivalences in one fell swoop. He also signals that it is as impossible to escape a compulsion to produce interpretive narratives as it is to escape the psychic traces of traumatic kernels that are superimposed on the reflecting surface of our internal mind scene without ever taking on a decipherable shape.

Love at first sight

Celia's voyage across the hallucinatory working through of her home romance involves two discoveries. First is her analysis of her own ambivalent feelings, negotiated as the tension between the two choices that marriage seems to confront her with—a safe room with a fire burning in the hearth or the contingency of an open space, where everything is possible. Second, her detection work-cum-analysis of her traumatized husband allows her to enjoy her own precarious desire for looking death in the face as well as ultimately contain her own death drive. Lang stages the first meeting of his two protagonists in Mexico in such a way that these two analytic trajectories appear, from the start, to be mutually dependent phantomatic distortions of the symbolic fiction of marriage. The flashback of Celia comparing herself to someone who is drowning begins with a scene depicting her older brother, Rick— her 'mother, father, and cheque-signer'—warning her that she should marry because he is worried about dying from heart failure. During this scene he introduces her to the eligible young lawyer Bob, who works for him and who, in the following scene, proposes to her two months after Rick's death. He insists, however, that she take a vacation in Mexico before making her decision.

Lang then cuts to a market scene in a Mexican village, his camera panning left to right across the busy, colourful crowd of vendors, musicians, local shoppers, and tourists until it reaches Celia and her friend Edith Potter looking at the merchandise in one of the stalls. As the vendor, whom we see only from the back, offers a necklace to the taller, blonde woman, Celia turns towards her, showing her the wallet she is holding and asking her whether she thinks it is too commercial. After her friend declares that it is perfect for Bob, Celia hands the leather wallet to the vendor, telling him that the initials she would like to have embossed on it are 'R. D.' Here Lang abruptly shifts the position of his camera to get a low-angle shot from behind. Edith has turned away from the vendor to speak to Celia and now partially faces the open square in front of the stall, but Celia still has her back fully turned to the camera. Edith begins telling Celia about a man whom she was going to marry, who was 'the image of Bob', but at the very moment when she is about to disclose why he broke off his engagement with her, she is interrupted by a woman screaming. With a 180-degree pivot Celia turns away from the vendor, who was facing her, and together she and Edith look in the direction of a street café where two Mexicans, both holding knives, have begun to fight; a Mexican woman can be seen leaning against the wall of the café, calmly watching the battle being fought over her.

Horrified, Edith tries to get Celia to leave this violent scene immediately, explaining, 'I don't want to be an innocent bystander.' Celia, however, remains frozen in place, as if fascinated with what she is seeing. While the camera pans slightly to the left, thus placing Edith outside the frame and presenting Celia alone in a medium shot, we hear her voice-over explaining that she was strangely held, that she had seen fights before, nightclub brawls over a cigarette girl, 'but this was different. A woman and two men fighting for her with naked knives. Death was in that street'. With this scene of interpellation, Lang astutely reiterates the choice his heroine faces, represented by the two conflicting fantasy images: the commercial leather wallet for Bob, a gift meant to seal a marriage engagement that promises a safe haven, and the knife fight, a random altercation that is fascinating but also dangerous. Celia begins to identify with the woman, and as Lang cuts to a close-up of her radiant face, her voice-over explains: 'And I felt how proud she must be.' Suddenly one of the men hurls his knife in the direction of his enemy but misses the mark, and the knife lands in the wooden counter of the stall where Celia is standing, only a few inches to the

right of her black-gloved hand. Fully in line with the scenario that Althusser describes as a paradigmatic scene of interpellation, Celia, who had turned around in response to the cry signalling a death-driven expression of love, now accepts this calling as her own. She acknowledges that, being positioned directly behind one of the fighting men, she, like him, only accidentally escaped being struck by the knife. What she implicitly recognizes is that her own desire does not mirror that of the woman who proudly watches as men fight over her. Rather Celia desires to become a player in a love duel, from which she will only barely escape unharmed. Still transfixed by the scene, she gently pulls her hand away from the counter, for a moment looking longingly at the knife, now embedded in the counter amid the commercial jewellery. Only then does she seem to wake, as if from a trance, as her voice-over explains, 'Suddenly I felt that someone was watching me. There was a tingling in the nape of my neck as though the air had turned cool.' Initially we continue to see only Celia in a medium shot from the front, as her eyes wander over the crowd that has gathered in front of the café. Then, as she continues to explain, 'I felt eyes touching me like fingers,' Fritz Lang cuts to a close-up of Mark.

Unnoticed by anyone but these two noir lovers, a second battlefield has opened up, superimposed onto the Mexican street scene by virtue of a fantasy involving the eroticization of death that these two strangers silently share. While Fritz Lang moves back and forth twice between close-up shots of Mark gazing at Celia and Celia returning his gaze, he has her voice-over recall that there was a current flowing between them, 'warm and sweet and frightening, too'. She imagines that he has seen something behind her makeup that no one had ever seen—a desire to enjoy unbridled violence, a desire that she herself didn't know was there before this incident. Sighing, she finally turns toward her friend and asks her to leave the marketplace with her, leaving behind the leather wallet she had chosen for Bob. In the next scene the two women are sitting in a café and we hear Edith explaining to Celia that when she finally snapped out of her trance she looked as if she had seen Death himself. Celia, as though brooding, replies, 'That's not how he looked,' and reminds Edith, who is surprised at this cryptic remark, that she was going to call her husband, Arthur—Celia's ploy to rid herself of her friend so that she can be alone to meet the strange man whose gaze had caressed her a few minutes earlier. As Tom Gunning argues, 'Celia has responded to a gaze at once deadly and desiring and it is the balancing

act she will have to carry out with her own attraction to death that will drive the film.'[24]

One might, indeed, speculate that Mark appears in Celia's field of vision in the shape of a psychic phantom, along the lines proposed by Nicholas Abraham and Maria Torok, embodying an aspect of Celia's sexual desires that she has, up to this moment in her life, had intimations of but never consciously acknowledged. Instead of the lethal security that marriage to her attorney, Bob, would afford her, the stranger seems to promise something that she has been harbouring as a forbidden desire, the absence of all safety nets. As Mladen Dolar has argued, love has the 'mechanism of forced choice always attached to it. To put it simply, one is compelled to choose love and thereby give up the freedom of choice, while by choosing freedom of choice, one loses both'. The point is apt, because, while on the manifest level of his cinematic narrative, Lang pits safety against danger as the two choices open to his heroine, he implicitly shows that she actually has no choice at all. The accidental meeting between Mark and Celia proves to be the realization of their clandestine wishes. As Dolar continues in his description of the logic behind the notion of love at first sight, 'What happened unintentionally and by pure chance is in the second stage recognized as the realization of innermost and immemorial wishes and desires. The contingent miraculously becomes the place of deepest truth, the sign of fate.' The lovers discover that 'pure chance was actually no chance at all: the intrusion of the unforeseen turned into necessity'.[25] To choose love proves to involve a choice that has already been made for one— by fate or by one's unconscious—even if the two people involved become aware of this only after the event or not at all.

Much along the lines proposed by Dolar, Lang performs the uncanny enmeshment between contingency and fate in the way Celia is so suddenly drawn by Mark's gaze, believing it to contain her truth, to be an outside gaze that corresponds to a piece of intimate self-knowledge. The moment when the gazes of his two noir lovers meet, giving voice to this clandestine desire, is also the moment when her love life suddenly and unexpectedly gains total significance. Thus the narrative of fated love, caused by sight, emerges as a strategy of psychic relief. Celia's oscillation between marriage as a safe haven and marriage as danger is suddenly suspended. Precisely because her love for Mark appears to her as fate, as an unavoidable necessity, Celia can tell herself that when it comes to her desire, she has no freedom of choice. The safe haven

and the danger prove to be two sides of the same coin. As Mladen Dolar concludes, 'If love aims at the extimate—the intimate external kernel—it is also a protection against it, but a protection that is ambiguous and constantly failing. The other side of the extimate is the uncanny, the emergence of the object that brings about disintegration and that becomes lethal.'[26]

A narrative battle is thus being waged in *Secret Beyond the Door* in yet another sense: the symbolic fiction of love at first sight is pitted against the phantomatic fiction of a desire for lethal disintegration, called forth by a traumatic near-death experience. Indeed, the trajectory of Celia's hallucinatory journey, which will end in the precarious restitution that her second honeymoon affords, could be summarized as follows: her ambivalent feelings about marriage are endowed with an irrevocable meaning as she falls in love at first sight with a stranger who shares her fascination with danger. This contingent meeting is encoded as a love dictated by fate, because it allows her to explore the noir implications of her ambivalent desires, collapsing danger and safety even while privileging the fiction of love's necessity. This allows her to avoid the even more disturbing possibility that a desire for destruction is completely without meaning, that it is a pure lethal drive that can never be assimilated into the symbolic structure of marriage. Celia's narrative solution takes hold after she has re-enacted the near-fatal encounter with death that she could only be witness to in the market scene in Mexico; her reprise of that scene takes place in her husband's replica of her bedroom, where at her body two positions collide—that of the fought-over woman and that of one of the endangered fighters—and this restabilizes the symbolic contract of declared marital harmony that had become distorted in the course of her tale. If the entire story begins with her resisting her dead brother's desire that she should finally marry, she ultimately complies with this wish, yet, significantly, she does so by re-encoding it as a different type of law—that of love at first sight. Yet the satisfaction remains uncannily twofold: Celia can tell herself that since destiny had a hand in it, she could do nothing but endorse the choice already made for her, yet she can also insist upon her own agency. Her curiosity, as well as her persistence, allows her to win the narrative battle over her husband. She has given in to her dead brother's demand, by first giving it the face of death that she feared always lurked beneath it and then re-encoding this figuration yet again, into the face of a man so deeply troubled that he requires her as a maternal surrogate.

Voyage to the end of noir fantasies

Celia's homecoming occurs under the auspices of the core trope to which she has recourse in order to describe what accepting Mark's proposal of marriage means to her, namely the closing of one door and the opening of another, the exchange of a quiet, familiar room where she will be safe for an open space of excess, containing everything she can imagine. During their first meeting, Mark offered himself to her as a fairy-tale prince, calling her a twentieth-century Sleeping Beauty, a wealthy American girl who has lived her life wrapped in cotton wool but who now wants to wake up. He hopes that offering to marry her will unleash the turbulent desires that she has been keeping under lock and key. Once they have married, Celia takes it upon herself to open the door to Mark's repressed knowledge about a narcissistic injury, in order to help him return to a state of normalcy. The turning away from the symbolic fiction of love toward the phantomatic fiction of destructive anger is brought about by the obverse—the significant locking of a door. One evening during her honeymoon at the Mexican hacienda, Celia allows the owner to convince her that she would be wise to test her husband's patience. After the old woman has left, Celia sits in front of her mirror and brushes her hair. Suddenly she decides to lock the door so that, in contrast to what they have agreed upon, Mark cannot come to her; instead he must wait for her to come down to him.

On the manifest level this is a form of lover's test, allowing the young bride to see whether she can assert her mastery in the wedding contract that they have both agreed to—to be together for better or for worse. Pleased with her ruse, Celia sits in front of her mirror, proudly gazing at her reflection, and waits to see how her husband will respond to her assertion of feminine power. Mark, unable to enter her room, interprets her game as an effort to call into question his unrestricted access to his wife. When Celia, after waiting a few minutes, follows her husband to the garden in front of the hacienda, she finds a stranger there. Because she has locked him out of her private rooms, he has decided to lock her out of his emotional realm. He pretends that important business requires him to return to New York immediately, and he leaves her that very night, to punish her for having dared to question his superior authority over the abode they inhabit and, concomitant with this, his position within their marriage. Like the *fort–da* game that Freud describes, the sudden disruption of their honeymoon bliss allows Mark to translate a situation of passivity into one of empowerment. To prevent any further narcissistic injuries from his new wife, he prefers to

lock himself out of his own accord. Their battle over the locking of a
door allowed Celia to draw a boundary between an intimate space where
she was mistress and a foreign body seeking to penetrate this space.
Mark, however, uses her game for a different type of boundary draw-
ing. By consciously excluding himself from the transitional abode he is
sharing with his new wife during their honeymoon, he assures himself
that his intimate feelings will remain locked away from her.

Left alone, Celia once more sits in front of her mirror, and now the
voice of brooding sets in, playing through all the possible reasons for
Mark's mysterious behaviour, while her body begins to pace up and
down her room, somatically enacting the painful doubts she is begin-
ning to harbour. Although she quickly realizes that his lie and his sud-
den departure resulted from her having locked the door, she is as yet
unable to find an explanation for their unexpected quarrel. Instead, the
demon of her repetition compulsion takes hold, allowing the discord
at the heart of their marriage and her doubts about Mark's love to
emerge. While she had initially compared her acceptance of Mark's
marriage proposal to the opening of a door onto a wide landscape, she
is now obliquely reminded that during their very first conversation she
suddenly thought of daffodils. The danger that was always part of her
sense of liberation from the secure but stiflingly restrictive safety of
marriage now resurfaces and leads to her turning away from the open
landscape that she had wanted to connect with her choice of the
stranger she met in Mexico. Because she herself has closed a door on
Mark, she must now open a different door, one behind which she will
find neither a safe home with a fire in its hearth nor an open space;
behind this door she will find the crypt in which Mark has preserved
his painful memories. The murky interface between a familiar haven
and an unfamiliar open space at stake in Celia's uncanny home romance
indeed finds its architectural embodiment in Mark's family estate, Blade's
Creek, where an economy of distortions reigns and thus renders visi-
ble the dark core at the heart of Celia's marriage.

The bride is met at the train station by Mark's sister, Caroline, who,
like the old woman at the hacienda, represents a third position, unin-
volved in the phantomatic game that this newly-wed couple has begun
to play. At the very moment that Celia crosses the threshold of her
new home, however, Fritz Lang plunges her companion into shadow,
as though to offer a visualization of how even her reasonable judge-
ment has been drawn into the darkness of this house. While Caroline
does everything to make the bride feel at home in her new abode,

Mark's arrival at the train station the next morning allows Celia to continue to doubt that she will ever feel at ease at Blade's Creek. Upon espying a bouquet of lilacs pinned to the collar of Celia's jacket, Mark suddenly becomes cold and impersonal, whereas a moment before it had seemed as though he had completely forgotten their earlier quarrel.

After he once more abruptly leaves Celia without explaining why, she asks his driver to take her back to her new home, but during the ride an inner monologue sets in, directly articulating her homelessness:

> Home, where is home? Not with Mark, not any more. It was a gamble and I lost, period. I'm going back to New York. Back to what? To the empty life I lived before Mark. If only Rick were alive. I could go home with Rick. But what would he say? There's only one question, he'd say. Do you love him or don't you? And can that stuff about your pride and how your feelings are hurt. Do you want a man or [a] husband off the assembly line?

Unable to fashion for herself a home other than the symbolic fiction of her love for Mark, which has given her psychic support after her brother's death, she decides to return to Blade's Creek after all. In the course of the film she will repeatedly translate her unwillingness to choose a less uncanny material and psychic abode into her insistence that her love for Mark was unavoidable and thus remains an inescapable necessity. Significantly, however, she does so during this car ride by implicitly invoking her dead brother's voice of interpellation. She is able to convince herself by virtue of ventriloquizing the dead brother, who had always wanted her to commit herself to a husband, that to find a home in marriage means accepting another symbolic fiction, namely that the marriage vows are there to shield the couple from the disharmony of gender trouble that is necessarily part of this contract. Her monologue ends as she sternly reminds herself, 'Those were big words you said in front of that altar. Love, honour, for better and worse, including the time when he's worried and moody. After all you're no easy dish yourself.'

With this symbolic mandate intact, she is psychically equipped to return to her new home and to battle the demons locked up in her husband's mind and her own demons of doubt. The evening after their unhappy meeting at the train station, Celia waits for her husband to return, and when she hears his car she rushes out to meet him. Dressed

completely in white, she stands poised in the open frame of the door-
way to the house, mockingly asking him, 'Do you want me to carry you
over the threshold?' On this sunlit threshold, they kiss passionately for
the first time since their lovers' quarrel in Mexico; they are positioned
perfectly within the frame of an open door, marking the boundary
between the uncanny interior of the house and the wide-open space on
the other side. In response to his question of whether she is still angry
with him, Celia replies, 'I buttered my bread, now I have to lie on it,'
cleverly mixing her metaphors to indicate not just a double hunger but
also her obedience to the symbolic vows of marriage that she under-
took. However, she interrupts Mark, who in relief wants to kiss her
again, explaining, 'I choose the weapons and the battleground,' bidding
him to come upstairs with her to her bedroom, which, as she discov-
ered on her first day, has no lock and key, just like all the other rooms
on the upper floor of the Lamphere mansion.

They seem to have survived their first marriage crisis, even though
Celia still senses that Mark is keeping significant parts of his intimate
thoughts from her. During a visit to the 'felicitous rooms' that Mark has
collected in the cellar, Celia's bridesmaid, Edith, discovers a locked sev-
enth door, but Mark insists that a man must have some secrets and
refuses to unlock it. Significant about the architectural trope that Fritz
Lang consistently uses in this noir fairy tale is that the locked door and
the promise of a secret lying beyond it finally offer Celia a spatial em-
bodiment that will allow her to translate the uncanny doubts torment-
ing her into a fantasy scenario of empowerment, in which she will have
agency over the fated love she had previously declared unavoidable.
Mark had explained to her that in architectural discourse 'felicitous'
doesn't mean happy, but 'happy in affect, fitting, apt, an architecture
that fits the events that happen in it'.[27] Accepting his theory, she can tell
herself that by entering the one locked room that he so diligently pre-
serves as his secret, she will gain entrance to all the psychic material he
also insists on keeping under lock and key. As in the first scene of the
film, Lang offers an unequivocal symbolic language.[28] Shortly after the
tour of the felicitous rooms, Caroline tells her sister-in-law the story of
how Mark was once locked into his bedroom and when he emerged
was beside himself with rage, while David, Mark's son, confides in her
that he believes his father killed his mother. These two confessions pre-
cipitate a new string of doubts. Celia's voice-over wonders, 'What goes
on in his mind that he can change so suddenly?' While Fritz Lang pres-

ents a low-angle close-up shot of the seventh room, Celia continues to describe her plan of surveillance and detection: 'He keeps it locked, like this door. I have to open them both, for his sake.'

But just as opening the door of the forbidden room entails opening the passage to a scene of early childhood trauma, it also entails returning to another traumatic scene: the duel in Mexico, which had caused Celia to recognize her own desire for self-expenditure. As Reynold Humphries notes, because Mark is metonymically inscribed into the text by a house that represents danger, Celia's exploration of this home signals that what she wants to give herself in the guise of truth is actually death: 'To discover the secret beyond the door is to discover the secret of life, namely death.'[29] Two traumatic scenes are thus condensed in this room, whose common denominator is that both lovers want to use it as the hallucinatory stage on which they might play through for real a battle between life and death. Beyond the locked door, Celia is no longer an innocent bystander and Mark is not simply the collector of rooms that prove an obscure architectural theory. Serving as the scene for a horrific inversion of the notion that their love was fated, the room will harbour a different kind of fateful encounter. Here they will confront and enjoy the traumatic kernel of their marriage, the dark, indecipherable figuration that floats beneath the liquid surface of Celia's dream work, in which marriage entails the choice between boats (safe harbour) and daffodils (danger), sustaining these and at the same time exceeding the protective fictions that both tropes represent. And like the love they recognized at first sight, the romantic showdown between Celia's and Mark's gazes proves to be one in which neither has a choice. If Celia initially decided to return to Mark because she imagined her brother's call, which demanded that she accept her symbolic mandate, she now must acquiesce to the other interpellation that structures the maturation of the subject: the maternal figure of authority and the danger that emerges when her unbearable proximity has not been psychically jettisoned.

The quarrel that is instigated when Mark refuses to show her the seventh room precipitates Celia's investigation of her husband. In her conversations with the others who live at Blade's Creek she tries to reconstruct the puzzling fragments of Mark's past. Significantly, she chooses a scene, as I have already pointed out, that reveals the ambivalence connected to maternal authority, and thereby she successfully occludes two other questions that have emerged. First, why was Mark's

marriage to his first wife so unhappy that Eleanor, convinced that he didn't love her, died mysteriously? And second, what caused Mark to return from the war a totally changed man? In other words, Celia's focus on the psychic anguish caused by over-identification with the maternal body is crucial because it allows her to undertake a significant reversal in the course of her detective work. She exchanges the role of pursued wife, as she had cast herself in her preferred fantasy scenario of feminine paranoia and had cultivated in relation to Mark since his strange behaviour in Mexico, for the role of protecting mother. As a result of this transformation, the self-confident Celia, who threatened Mark with her insistence on determining when her room—and with it she—would be open to him and when it would not, no longer is a threat to his sexuality. At the same time, by assuming the position of the dead mother, Celia herself can relinquish the view of feminine sexuality that is inscribed by traces of the death drive. She no longer needs to choose between her two preferred notions that marriage entails either a safe but sexually lethal abode or a potentially fatal homelessness. Rather, she can now combine her poise and self-confidence with her fascination for the fallible in the shape of nurturing an infantilized, retraumatized man.

The seventh room

Fritz Lang significantly divides Celia's momentous entrance into the seventh room into two scenes. In the first one, she walks along the uncanny corridor leading to the cellar rooms one night, carrying a flashlight to show the way. With a copy of the key that she has clandestinely procured, she is able to open the door to the forbidden room and, when she enters, turns on the light, and pulls aside the heavy brocade curtain, she, like the young woman in the Bluebeard tale, discovers what she believes to be a scene of death. Initially Celia's voice-over whispers, 'It's Eleanor's room, the bed she died in.' As she begins to survey the space before her, however, she realizes that this can't be so. She recognizes that the candles in front of the mirror are uneven, as the candles in her room are—because she used the wax of one of them to make an imprint of the door's key—and she finally concludes, 'It's my room. It's waiting for me!' Having reached the height of her enjoyment of the possibility of imminent death, she rushes from the room and runs to her actual bedroom on the first floor of the house. She gets her coat, then once more carefully descends the stairs, intending to quietly flee this strange abode. On one of the steps, however, she finds an item

from the third room—the scarf with which Don Ignazio, one of the murderers whose room Mark has reconstructed, strangled his three lovers.

As though to indicate that this is the acme of her hallucinatory enjoyment of the uncanny strangeness that inhabits both her marital home and her fantasy work, Fritz Lang signals here that the boundaries between safety and danger have fully collapsed. Blinded by the fear that she also fully enjoys, Celia runs from the house, losing her way in the fog, and as she wanders back and forth without actually getting anywhere, a male figure appears out of the dark behind her. At this point in the narrative Fritz Lang inserts the only harsh cut within the entire film, and once more we hear the acousmatic voice of his heroine. For a few seconds the screen is completely dark, accompanied by the voice-over of a woman screaming. We have returned to the initial scene of interpellation, where Celia had responded to a woman's cry by turning toward two men who were threatening to kill each other over the woman. But now it is clearly her scream.

With the next scene, a different voice-over is employed, along with a different subjective position. We see Mark leaving the bathroom where he has just shaved; as he dresses, his voice-over describes the trial scene he is inventing for himself. It is a macabre scenario in which he plays both the prosecutor and the man accused of having killed his wife, Celia. He explains that he found himself possessed by the urge to kill the woman whom he loved above all else in the world. The cause of this death drive, he argues, is that women, notably his mother and his sister, Caroline, have always controlled his life, and the impotence that this has imposed on him has resulted in an unconscious desire to destroy them. Since he is helpless against this murderous desire, he had to inflict it upon the privileged representative of feminine power who is currently tormenting him; he confesses as well that he would do so again, even though he is aware of his crime. What is crucial about this scene is less that on the manifest level of the narration it employs an extremely heavy-handed reference to Freud's theory of drives in an effort to exonerate the murderer than that the anticipation of a trial scene can't actually be Mark's fantasy. He knows that he didn't kill Celia the night before. Fritz Lang showed us in the previous scene how, from his bedroom window, he watched her flee into the fog, and shortly afterward he enters her sitting room and, astonished at finding her emerging from her bedroom, asks her why she came back. One might offer a more speculative reading for the inclusion of his voice-over. Having reached the

acme of her voyage through the phantasmatic space of her marriage, Celia has appropriated Mark's fantasy, making the jury scene a part of her inner theatre. Thus she is able to enjoy knowledge of her death by virtue of the traces it has left behind in the form of her husband's confession before the law.

This reading allows Fritz Lang to show how perfectly and how perfidiously Celia represents feminine omnipotence. In the scene following the inserted dream representation, when Mark has found Celia unexpectedly in her part of the house, Lang allows her to reappear in both his and our field of vision as she crosses the threshold between her bedroom and the more public sitting area. She begins to explain that she has returned because she loves him. Walking toward him, fully confident in her movements and her words, she adds that she returned because she married him for better or for worse, thus implicitly signalling to him that, unlike his mother, she will not abandon him—indeed, she will impose her presence on him even if this goes against his wishes. The brilliance of Lang's *mise en scène* resides in what her declaration of love implies. Although he believes he can kill her, she has already incorporated him into her psychic space and is thus fully in control, just as his mother was.

As Tom Gunning suggests, the first scene in the forbidden bedroom 'is the culmination of both Celia's point of view and her interior monologue. In Celia's voyage of discovery [...] she has found her voice and speaks out loud her horrifying discovery'. The two Celias—the one somatically enacting her doubts by wandering homeless through the many different places in Lang's dreamscape, the other endlessly brooding, her mind wandering restlessly from one image or explanation to the next—have finally come together. The cessation of her uncanny voice-over signals the beginning of her actual homecoming. Gunning concludes: 'Far from losing her voice, Celia has learned to speak and located her problem no longer in her fear, or feelings of self-reproach for being an inadequate wife, but squarely in her husband.' She uses this new-found voice to practise a magically effective talking cure for him, which, I would claim, begins with the last of the 180-degree turns that Lang stages for his heroine: her turning her back on the foggy woods, and the escape that they represent, and instead facing the heart of darkness lurking in the home and marriage to which she has symbolically vowed to be loyal.[30]

The second scene in the forbidden room is, indeed, staged as a repetition of the peripeteia enacted in the earlier bedroom scene. This

time, however, rather than walking toward her husband, Celia remains seated on the chair next to her bed, while Mark crosses the threshold into his seventh 'felicitous' room and slowly approaches her, being as unable as she is to avoid this lethal confrontation that they have been anticipating. She explains to him that she would rather be dead than live without him, because that would be a slow death, for a lifetime. In so doing she repeats the formula of fated love, contacted at first sight, in which the choice between life or Mark was a false one. She can only choose Mark, even if it costs her her life. But the magic of interpellation that this noir fairy tale depends upon is that, from the moment when she consciously accepts the position her husband has designed for her—a position that she was so overwhelmed by that when she entered the forbidden chamber the first time she had to flee at the height of her *jouissance*—impotence turns into power. Much as she had during their honeymoon in Mexico, she is now waiting like a spider for her victim to get caught in the web of a fragmented narrative that she will force him to accept as his own truth. The trick that she will try to play on him, so as to cure him of his murderous desire, is to accept that his early childhood trauma, like the love he felt for her at first sight, consists of knowledge he has been carrying around with him, even though he can recognize what is still unfamiliar only by virtue of the cathartic reconstruction that she has performed for his sake.

Yet with the end of Celia's voice-over, a further reversal of her part in this dangerous game has occurred. On the manifest level of the narration, the love duel is presented as Mark's fantasy of self-empowerment, in the course of which he will seek to kill Celia in order finally to assert his power against all the women in his life who have made him aware of his fallibility. But equally manifest is that, in this final stage of their battle, Celia is no longer the one who is threatened; instead, she is the fighter who still has the knife in her hand, while her opponent has already lost his, having thrown it at her and missed. As she hurls at him the fragments of his past that she has been able to piece together—his hatred of lilacs, his anxiety about locked doors— she tells him the version of the story about the locked bedroom that she heard from Caroline, coercing him into explicitly naming his matricidal urges and only then revealing that it was his sister, not his mother, who locked him in. The cathartic power of this declaration is twofold. First, when the son learns of the innocence of the mother, he can relinquish his murderous drives, symbolized by his allowing the scarf that he holds, with which he had meant to strangle Celia, to fall to the

ground. Second, Celia's declaration neutralizes the power that the phantasmatic mother has had over him since his childhood.

But although in this magic moment Mark is actually able to psychically jettison the maternal body, it is only to introduce a new phase of psychic dependence, for he now surrenders himself unconditionally to another omnipotent woman. She is not a substitute for his ever-teasing sister, nor for the first wife whom he could never emotionally accept, but rather for the mother of the family romance of his childhood, who was meant to be there only for him, nurturing and comforting him, comparable to the mothers and sisters who, as William Wyler depicted in *The Best Years of Our Lives* (1946), transformed themselves into nurses and provided unconditional emotional support to the traumatized veterans who were coming home to them after the war. If the matricide fantasy of the paranoid veteran had come to be crossed with the Bluebeard fantasy of the paranoid woman of independent means, Fritz Lang, however, requires a third antagonist for his lovers to finally quit the battlefield that defines their noir romance. As in the duel in Mexico, the battle is waged in the presence of a female onlooker. At Blade's Creek, however, she is not the object over whom two lovers fight, nor does she simply watch the duel. Rather, Miss Robey, the governess, has decided to intervene in the confrontation between the married couple, so as to bring about the demise of her rival in the hope of taking her place. Believing that Celia is alone, she locks the door to the forbidden room and then sets fire to the Lamphere mansion.

On a more cynical note, one might also surmise that, in post-war Hollywood, the psychically fallible veteran must be weaned from his urge to kill, yet he cannot be denied his masculine prowess altogether. After all, he must still be able to fight if a designated external enemy should appear again.

Startled by the smoke that has begun to fill the bedroom, Celia and Mark manage to break open the door, but they succumb to the smoke and faint in the entrance hall of the burning house as Miss Robey watches from a safe position among the trees in the garden outside. With the demise of the traumatized child, the veteran in Mark reawakens. Slowly rising to his feet in the smoke-filled space he is able to make his way to the glass door leading to the veranda, crash it open, take a few breaths of fresh air and return to the burning hall to save Celia from the flames. As Tom Gunning notes, the 'melodramatic rescue [...] remasculinises Mark and has him now break through the locked door', even while it refeminizes Celia.[31] Lying unconscious in the arms of her

husband, she can finally turn her back for ever on the uncanny home, where she had come to enjoy the murky interplay between safe haven and danger. The symbolic fiction of love, with which Lang's film closes, requires a twofold rescue. After Celia has saved her husband from the glowing ashes of his dormant desire to kill, he rescues her from her burning desire for self-expenditure.

Beyond the death waiting for them both in the fateful bedroom, they magically find another door leading back to life and to the restitution of their marriage contract. In the final scene we see the couple returned to the hacienda of their honeymoon, far from their New York home. Celia is leaning back in her hammock chair, while Mark, sitting on the ground next to her, rests his head in her lap. While she gently strokes his hair, he declares, 'That night you killed the root of the evil in me, but I still have a long way to go.' She immediately counters with a narrative of her own: 'We have a long way to go.' Mark takes her hand and kisses it, as she continues to beam down at him mildly.[32] One might conjecture that, like Sam and Pilar at the end of Lone Star, they know that they will never be completely free of the traumatic events of the past, and for that reason they bet with full confidence on the symbolic fiction of love.

As Mladen Dolar insists, at the end of any psychoanalytic cure the law of love persists, even if the subject has recognized the contingent accident on which romance is based, as well as the delusions it can induce, and the lack that the beloved will never be able to fill: 'For that alien extimate kernel that love has to deal with and which lies at the bottom of its paradoxes is the only precarious and evasive hold for the subject, and at the same time what makes its impossibility.'[33] At the end of *Secret Beyond the Door* the voice-over has finally stopped and with it, the cinematic convention that image and word correspond has been restored, so that the mode of representation supports the marital love contract whose restoration we have just witnessed. Distortion is no longer required, because the lovers have accepted the fiction of home that their mutual embrace affords them. Homeless in a cultural–geographic sense, they know that the safe haven of marital happiness, like the paper boat representing it in Celia's dream, floats on the surface of a pond that is inhabited by dark figures. Home can only be a precarious and transient state for them, but one they might sustain as such, a shield against real antagonism for a long time. Then, too, perhaps at the end of this noir fairy tale no further distortions are necessary, since the murderous drives of the husband have clandestinely become part

of the wife. Celia's insistence that 'we have a long way to go' could well also mean that the phantoms haunting this marriage lost their power not only because Celia and Mark were able to fit them into a shared narrative about the past but also because the wife has incorporated her husband's strangeness, making it part of her own psychic abode.

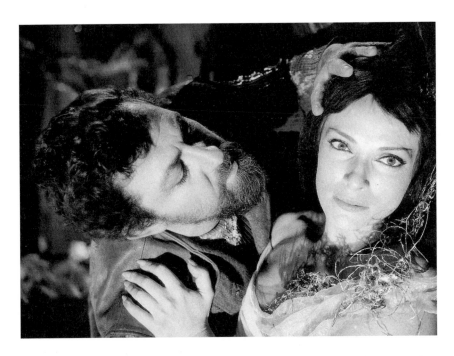

8.1 Film's 'gestural language' (Bálazs) makes possible a new interpretation
 of the opera. Bluebeard (Norman Foster) with Judith (Ana Raquel
 Satre). Production still reproduced courtesy of the Estate of Norman
 Foster.

DYING FOR ART
Michael Powell's Journey Towards
Duke Bluebeard's Castle and the Filmic Art-Work
of the Future

Ian Christie

Behold, the song sounds.
You all gaze (at me), I gaze at you.
Our eyelash-curtain is up:
Where's the stage: is it outside or in,
Lords, Ladies?

Béla Balázs, Prologue to *Duke Bluebeard's Castle*[1]

So much of the history of theorizing cinema has been devoted to defining its specificity, or difference from other arts and media, that the question of how cinema inherited and developed the nineteenth-century arts of spectacle, which was a important focus of early thinking about its significance, now requires a conscious effort to re-frame.[2] Nowhere is this more apparent than in considering the role of film (or the electronic image) as a way of presenting, or perhaps reinventing, opera. Arnold Schoenberg could contemplate using abstract or animated film in his opera *Die glückliche Hand*, as early as 1913,[3] and even while deploring the effects of popular cinema on mass taste, he could still envisage the synchronized 'talkie' in 1927 making possible 'a completely new and independent instrument for innovative artistic expression'.[4] This was the period when Schoenberg was starting work on his opera, *Moses*

und Aron, which would remain unfinished but did not incorporate any novel form of staging or presentation. Schoenberg's pupil, Alban Berg, however, incorporated a film episode into his final (also unfinished) opera, *Lulu*.[5]

Perhaps surprisingly, the most substantial early experiment in fusing opera and film came, not from the Modernist avant-garde, but from what might be considered the leaders of the earlier Symbolist avant-garde, the composer Richard Strauss and his librettist Hugo von Hoffmannstahl. Working with the film director Robert Wiene, already famous for *The Cabinet of Dr Caligari* (*Das Kabinett des Dr Caligari*) (1919), they reworked their greatest popular success of the pre-Great War period, *Der Rosenkavalier* (1911), as a silent film to be shown with live orchestral accompaniment. No doubt because this remained little seen for nearly seventy years, it has acquired the reputation of being a perverse failure—a commercial attempt to exploit an established hit and to revive the flagging reputations of both Strauss and Hoffmanstahl. Yet as Leon Botstein has argued, having examined both reconstructed film and music, both librettist and composer took the opportunity to rethink their most successful work and make considerable changes.[6] They wanted to improve the dramaturgy of the original and to take advantage of the new medium—as well as, presumably, seeking to overcome the central issue of absence of singers in this new combination of silent image and orchestral accompaniment.

The Strauss–Hoffmanstahl–Wiene experiment seems to have left little lasting impression, no doubt because it was rarely performed, and appeared at the precise moment when recorded sound with film had finally reached a viable commercial form.[7] Nor did the fact that both Strauss and Hoffmanstahl were seen as conservatives by the interwar avant-garde encourage archaeology or citation in later cultural history. In a symmetrical fashion, histories of cinema paid little or no attention to other ambitious film–music hybrids, such as Cecil B. DeMille's *Carmen* (1915), accompanied by an adaptation of Bizet's score, or Abel Gance's *Napoleon*, with its original music by Arthur Honegger.[8] Instead, various currents of avant-garde aspiration for film in the 1920s stressed the autonomy of the moving image, by implication intrinsically silent,[9] or the potential of using the new synchronous sound to experiment with audiovisual 'counterpoint',[10] or synesthetic abstraction in the 'optical music' of Len Lye and Oskar Fischinger.[11] Yet there was also a current of thought that found expression in Terry Ramsaye's populist history of cinema, *A Million and One Nights*, which claimed the movies

as the culmination of 'all of the art processes of all the ages'.[12] And in this it is possible to detect a distant echo of Richard Wagner's manifesto *The Art-Work of the Future*, first published in 1849, in which he called for an 'all-embracing' art of drama which would combine all the individual arts in order to make 'a direct appeal to a common public'.[13] Wagner would eventually realize this aim when his series of music dramas, *The Ring of the Nibelungen* (*Der Ring des Nibelungen*), was produced as an integral cycle in the festival theatre specially created in Bayreuth in 1876, with its revolutionary amphitheatre form, concealed orchestra pit and darkened auditorium. In the same year that Ramsaye's book appeared, the Bayreuth Festspielhaus was invoked as anticipating the immersive cocoon of large-scale cinema presentation.[14]

Wagner's conception of music drama as total art work (*Gesamptkunstwerk*) was to cast a long shadow across subsequent opera and theatre, ranging from its influence on Symbolist artists in France and Germany to the radical theatre design of Adolphe Appia and the popular spectacle of Max Reinhardt.[15] Within this broad current of the early twentieth century, we can locate Béla Balázs's *Duke Bluebeard's Castle* (*A kékszállú herceg vára*) (1910), his third play, which he hoped would be adopted as a libretto by one of the emerging young Hungarian composers, his friend Zoltán Kodály, or Béla Bartók. Like these musicians, Balázs was strongly influenced by traditional culture, finding in Transylvanian folk ballads a 'dramatic fluidity' that would allow him to 'depict a modern soul in the primary colours of folk song'.[16] Another model, however, was the recent libretto by the Symbolist Maurice Maeterlinck for Paul Dukas's opera, *Ariane and Bluebeard* (*Ariane et Barbe-bleue*), in 1907. If we see Symbolism as a bridge between Romanticism and Modernism, marked by a particular fascination with psychological alienation and private worlds, then Balázs's questioning of whether the stage is 'outside or in' in his Prologue assumes considerable significance. The fact that he would go on to become a pioneer film theorist and screenwriter further encourages a view of the work as proto-filmic in the sense that Eisenstein identified in his essay on Dickens.[17] However, the Bartók–Balázs opera had to wait until the 1960s before a filmmaker would realize its potential, and bring to it an 'all-embracing' conception of cinema. The result is a little-known work which still has the potential to illuminate the trajectories of both Wagner's aspiration and Michael Powell's pursuit of the 'composed film', as well as offering a significant modern addition to the evolving 'Bluebeard text'.[18]

I

The English director Michael Powell made three opera-based films in the 1950s and 1960s, two of these with his long-term, and Hungarian-born, partner Emeric Pressburger: *The Tales of Hoffmann* (1951) and a version of Johann Strauss's *Die Fledermaus*, entitled *Oh Rosalinda!!* [*sic*] (1955).[19] In 1964, he directed Bartók's *Duke Bluebeard's Castle* at the invitation of another old colleague, the stage and film designer, Hein Heckroth. In addition to these completed works, he also planned at least three other opera-based projects, ranging from a proposed collaboration with Stravinsky around 1952, to a biographical fantasia about Richard Strauss, *The Golden Years*, and finally a collaboration with Philip Glass to film the latter's Poe opera, *The Fall of the House of Usher*, in 1987.[20] Nor does this tally include the 'quotation' of Manuel de Falla's *El Amor Brujo* in his Spanish production *Honeymoon* (*Luna de Miel*) (1959), or his short dance film *The Sorcerer's Apprentice* in 1955, and somewhat fraught involvement with the biographical *Anna Pavlova* in 1983.[21] In spite of this substantial record, opera has rarely been seen as central to an understanding of Powell's achievement, although *The Tales of Hoffmann* has been recognized as a cornerstone of his 'anti-realism'.[22] Instead, it has more often been regarded as symptomatic of a loss of creative independence—as if 'merely' to film an opera was to abdicate responsibility in favour of becoming a purveyor of others' vision.

Yet Powell came increasingly to regard opera, or more precisely the fusion of opera and dance that cinema made possible, as an ideal to which he aspired. In the second volume of his memoirs, published posthumously, he wrote of *The Tales of Hoffmann* as 'a delight. It dares everything and never falters'; and described *Duke Bluebeard's Castle* as 'a jewel of a piece'.[23] This last music-based work to be completed under his control can now be seen as crucial in resolving the search for artistic unity that had preoccupied Powell since the mid-1940s.

The fact that Powell, initially with Pressburger and later independently, was drawn towards musical forms to realize this goal has both a semiotic and an economic dimension. In semiotic terms, the presence of song and dance, together with dramatic and filmic codes, produced a richness of expressive discourse, and also a means of fracturing the implicit realism of cinema which Powell found increasingly irksome.[24] But immediately after the war British filmmakers also found themselves facing hard commercial choices. Losing ground to Hollywood in the struggle for a mass audience, both internationally and domestically, there was an imperative to produce culturally distinctive work. The

Archers' first post-war film, *A Matter of Life and Death* (1946), cast as a fantasy contest between Britain and America for post-war moral supremacy, revived the allegorical machinery of the Jacobean masque in an elaborate display of filmic virtuosity.[25] In *Black Narcissus* (1947) this semiotic complexity was replaced by a synaesthetic fusion of painterly design, choreographed movement and music, echoing a contemporary interest in the integration of music and image that was shared by such apparently diverse figures as Disney and Eisenstein.[26]

The path that lay before Powell and Pressburger after the notable success of *Black Narcissus* pointed towards a continued exploitation of female-centred melodrama, which would prove a dependable formula for at least one British studio, Gainsborough, and was also the underlying genre already being practised by Alfred Hitchcock in Hollywood, where it would soon be developed in different ways by Vincente Minnelli and Douglas Sirk. Powell and Pressburger's approach, however, was oblique and precipitated their first major involvement with musical theatre.[27] Reviving a pre-war project, originally commissioned from Pressburger by the producer Alexander Korda as a vehicle for his wife, the former dancer Merle Oberon, they began to develop *The Red Shoes* as a film that would have at its centre a full-scale ballet conceived in cinematic terms.[28] For Powell, this would be a continuation of two earlier discoveries: the dual approach to extreme psychological states used in *A Matter of Life and Death*, where the pilot's crisis is seen in both medical and allegorical terms; and the integration of scenography, music and movement in the final sequence of *Black Narcissus*, which Powell would later term 'composed film'.[29]

In its new form, *The Red Shoes* ostensibly satisfied the demands of post-war melodrama, as a wish-fulfilment story about a young woman escaping the mundane reality of England to plunge into an exotic international life devoted to art—although the life of the Russian ballet company that Vicky Page enters turns out to be one demanding all or nothing, that will eventually destroy her.[30] Instead of dying for one's country, which had been the theme of so many wartime films, including Powell and Pressburger's own, *The Red Shoes*—as Powell put it sardonically—'told us to go and die for art'.[31] In melodramatic terms, Vicky is forced to choose between two lives, represented by two men, her composer husband Julian and the impresario Lermontov. Unable to choose, she runs from the theatre and throws herself onto a railway line, so living, and dying, the tragic role that she has been performing on stage in the *Red Shoes* ballet.

As in *A Matter of Life and Death*, Powell's concern with a level of 'professional realism' creates a credible framework for the backstage story of the ballet company, loosely based on Diaghilev's Ballets Russes. Likewise, his demand to 'know what she is feeling while she is dancing' would lead to the creation of a phantasmagoric space that is the equivalent of the allegorical space of the earlier film's Heaven.[32] But the central device that links these lives and spaces is the doubling of the heroine as ingénue dancer and as the protagonist of a ballet based on Hans Christian Andersen's story. As in Strauss and Hoffmannstahl's opera *Ariadne auf Naxos* (1916), we see first the preparations for a performance and then the performance itself, which 'leaves' the stage to become an exploration of the heroine's dilemma. However the ballet scenario does not follow this striking example of what Dinah Birch has aptly termed Andersen's 'perverse fantasies of abjection',[33] except in retaining the girl who is punished for desiring the shoes by being 'danced' by them and rejected by the members of her community. Instead, the *Red Shoes* ballet becomes a frame for an intense psychodramatic sequence in which motifs from the ballet are mixed with the key figures from Vicky's own life and a range of nightmare characters.[34] As she passes from the ballet's fairground into a De Chirico-like realm of deserted streets and ruins (8.2), she encounters a will-o'-the-wisp who transforms briefly into her stage lover (Helpmann), before entering a Dead City of Failure, with grotesque statues of Envy and Malice. The

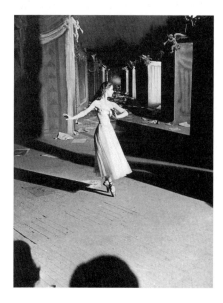

8.2 Vicky enters the Dead City in *The Red Shoes* (Michael Powell and Emeric Pressburger, 1948). Reproduced courtesy of the Estate of Michael Powell.

lover reappears in a vast ballroom, where she is borne aloft in triumph. Then, in a striking and complex visual metaphor, the audience's applause becomes waves breaking, with Lermontov and Julian standing as rocks against this turbulence, before merging into a composite support, as she returns to the ballet's story and to her rejection on the steps of the church.

Vicky interprets the ballet as a text woven around her own desires and conflicts, rather like the fantasy narrative of Maya Deren's film *Meshes of the Afternoon* (1943), or the dreams supposedly told to her psychoanalyst by the successful heroine of Moss Hart's Freudian musical *Lady in the Dark* (1941).[35] As Andrew Moor observes, Vicky displays 'a dangerous over-identification with the image of the dancing Girl' which she sees reflected in the shop window.[36] Moor suggests that the ballet serves to bring together different senses of commodity, with the girls who cluster round the Shoemaker's shop evoking a typical equation between femininity and consumerism, while Vicky herself is in the process of becoming a commodity, albeit cultural, and will ultimately be destroyed by the pressures of such commodification.[37] On a psychosexual level, Lermontov insists on total submission as a condition of Vicky returning to satisfy her narcissistic desire to dance the *Red Shoes*, and when she resists—unable to split into two versions of herself, as she had in the ballet—the conflict between her 'natural' and 'unnatural' desires drives her, in effect, to recapitulate the masochistic gesture of Andersen's heroine, who submits to castration by having her feet cut off.

Just as *A Matter of Life and Death* had imbricated elements of the myths of Orpheus and Eurydice and Alcestis, as well as *A Midsummer Night's Dream* and other cultural motifs, to create a distinctively modern myth,[38] so *The Red Shoes* drew on Andersen's story, pitting it against the myth of Cupid and Psyche, which is the subject of Julian's opera, and combining in Lermontov aspects of the impresarios Diaghilev and Korda, the former relevant to the ballet world and the latter to cinema, as well as echoes of Mephistopheles's and Svengali's powers of persuasion.[39] But more than all these cultural references, perhaps the central discovery, which would propel Powell forward to his future opera films, was the realization of 'the empty stage as the most magical and suggestive area in the world [...] [where] everything is fantasy and invention'.[40] The allegorical and mythic themes of *A Matter of Life and Death* had led Powell and Pressburger to create a series of spatial structures for the afterworld which awaits the pilot, and for its threshold, which

is figured as a vast escalator stretching between earth and heaven, an ironically modernized version of Jacob's Ladder with its inexorable motion symbolizing mortality.[41] In *Black Narcissus*, the Himalayan setting centred on a former harem-palace now being used as a convent allowed for considerable visual stylization in an essentially realistic design. Suggestive wall paintings, the constant eddying of wind and vivid contrasts in colour all contribute to creating a disturbingly erotic setting for the conflicts which will destroy this precarious community, ostensibly dedicated to chastity but riven by unrepressed desires. Twenty years later, the dark studio of *Duke Bluebeard's Castle*, full of statuary and symbolic forms, will become a more abstract space equally riven by contradictory desires.

All of Powell and Pressburger's films from 1943 to 1947 were designed by Alfred Junge, a German-born designer who became a mainstay of the architectural school of production design in British cinema during the 1930s and 1940s. But Powell had chafed at Junge's realist approach to the fantastic and ethereal aspects of both *A Matter of Life and Death* and *Black Narcissus*. Now, faced with designs for 'a real stage in a real theatre', Powell turned to another German designer, hitherto responsible only for costumes, and invited him to assume responsibility for the whole of *The Red Shoes*. Hein Heckroth had come to England in the 1930s as designer for Kurt Joos's dance company, famous for its boldly stylized political allegory *The Green Table*, and had stayed, teaching at Dartington Hall, before entering the cinema as a costume designer. In place of the predominantly architectural approach to design practised by Junge, Heckroth introduced a plastic, painterly approach that was ideally suited to realizing the imagery now demanded by Powell. While much of *The Red Shoes* relied on detailed studio-built interiors linked by location exteriors, the extended ballet sequence was based on a series of paintings by Heckroth that combined Expressionist, Surrealist and Neo-classical motifs, and realized these through a wide range of techniques, including drapery, innovative lighting, and variable camera speed.[42] Heckroth had created a new design idiom that owed more to contemporary Neo-Romantic visual art than to the conventional realism of the period's narrative cinema or indeed its theatre and opera production.[43] Faced with British cinema's limited horizons at the beginning of the 1950s, Powell began to prepare a speculative portfolio of 'tales', which would be films of varying lengths involving the collaboration of previous colleagues and distinguished artists from different media.[44] All of these would remain unrealized, despite Powell's

recognition that television would become a future sponsor of such cultural programmes, but the most ambitious of them—an episode from the Odyssey, *Nausicaa*, with music by Stravinsky, libretto by Dylan Thomas, and design by Heckroth—was a pointer towards the freedom with which Powell and Heckroth would approach *Duke Bluebeard's Castle*.

II

Meanwhile, a further opportunity to develop the 'empty stage' approach arose in 1950, after several compromised experiments in Neo-Romantic inflected period narrative by Powell and Pressburger, *Gone to Earth* and *The Elusive Pimpernel* (both 1950).[45] At the suggestion of Sir Thomas Beecham, who had served as guest conductor of the *Red Shoes* ballet, they undertook a full-scale adaptation of a work with which Beecham had a close personal connection, having conducted the English premiere of Jacques Offenbach's *The Tales of Hoffmann* in 1910. This last of Offenbach's stage works, and his only serious opera, had been left incomplete at this death in 1880, and has since undergone many modifications in performance. The unusual structure of the libretto by Barbier and Carré, drawn from E. T. A. Hoffmann's original stories, casts the author himself as a poet in love with Stella, a singer who is performing in Mozart's *Don Giovanni* at the Nuremberg opera house. While he waits for her in the tavern next door, Hoffmann is persuaded by an audience of students to tell of his earlier ill-fated loves: Olympia in Paris, Antonia in Munich and Giulietta in Venice. In each of these, he has been frustrated by older men possessing magical powers, and he realizes that these have all been manifestations of the same adversary, who as Councillor Lindorf is now trying to steal Stella from him. This he duly does, carrying Stella off as Hoffmann lies drunk at the end of his epic narration, but leaving him with the consolation of being visited by the Muse of poetry.

Powell and Pressburger, guided by Beecham, made their own version of this material, as all interpreters of the opera have had to do. Among their most significant changes were making Stella a dancer, rather than a singer and giving her an extended *pas de deux* (whereas Stella, perversely, is a non-singing part in the usual performing version of the opera);[46] relocating the Antonia story to a Greek island, established by a reproduction of Arnold Böcklin's famous Symbolist painting *The Isle of the Dead*;[47] and omitting the vision of the Muse, inviting the poet to dedicate his life to her, so that the film finishes with Hoff-

mann's drunken despair and loss of Stella. The actual ending, however, is a brief self-referential coda, in which Beecham is seen conducting the final notes and closing the score, which is then stamped 'Made in Britain'.

The significance of these changes and of the coda has been discussed in some detail by Bruce Babbington and Peter Evans, but suffice to note here that this stamp has at least a double significance. It links the film with the year of its release, when the Festival of Britain was proclaiming Britain's recovery from post-war depression and asserting a new confidence and identity, symbolized by the twin figures of the Lion and the Unicorn—strength and fantasy, as interpreted in the Festival's iconography.[48] In his essay on English national identity, 'The Lion and the Unicorn', George Orwell singled out as a defining characteristic 'the lack of artistic ability' (other than in literature), which places 'the English outside the European culture'.[49] For Powell, Pressburger and Beecham, proclaiming their film 'made in England' was an open challenge to this belief.

The Tales of Hoffmann gave Powell and Pressburger an opportunity to pursue the experiment begun with the *Red Shoes* ballet: 'the perfect combination of music, story, mime, singing and dancing.'[50] With the full score and voices pre-recorded, the whole film could be set in an artificial space without reference to the 'real world', nor to traditional opera or ballet staging. For Powell, this freedom was also reminiscent of the silent period, before synchronous sound recording imposed constraints on film's visual practices, allowing him to use variable camera speed and extremes of angle and scale even more than in *The Red Shoes*. Pre-recording the music also meant that actors might or might not sing their own roles, with the result that while Hoffmann is played and sung by Robert Rounseville, a majority of other parts were played by dancers and dubbed by singers. Many of the cast of *The Red Shoes* reappeared, including Shearer as both Stella and the automaton Olympia, Massine as the automaton's creator Spalanzani and a lost soul in Venice; Robert Helpmann as Hoffmann's protean adversary, and Ludmilla Tcherina as the Venetian courtesan Giulietta. The impact of these actor-dancers is considerable, and their appearance in multiple roles also enhances the work's theme of duplicity and diablerie.

Added to this ingenious casting is the extraordinary stylization of settings, costumes and props, all filmed in a richly chromatic Technicolor palette, which led the contemporary music press to protest and one later (film) critic to describe the film's visual intensity, in a notori-

ous purple passage, as 'a pantechnicon of palletical paroxysms'.[51] And yet, Heckroth's approach to the total stylization of the image can now be seen as, simultaneously, a ground-breaking development of the use of Technicolor and bold innovation in film design—and indeed an anticipation of non-naturalistic stage design. Given that this is a film with no 'natural' referents outside the studio, it allowed Powell to break with naturalistic correspondence and Heckroth to establish a dominant colour key for each act: yellow for the Tale of Olympia; black and purple for the Venice of Giulietta; and blue and white for the Tale of Antonia. A joint interview which appeared while the film was in production had Heckroth insisting on colour being used 'dramatically' and invoking a synaesthetic correspondence, with 'every mood and emotion [having] its shade'.[52] Here, after a decade of tension between Technicolor's tendency to produce saturated colour and many filmmakers' and critics' preference for more muted naturalistic colour, was an opportunity to exploit the vivid hues of the dye-transfer process.[53]

Instead of conventional 'harmony', Heckroth embraced the possibilities of colour conflict or montage within the frame, echoing the chromatic intensity of such German Expressionist painters as Alexei Jawlensky, Emil Nolde and Oskar Kokoschka. In terms of film technique, he developed novel means of intensifying the textural impact of key colours, especially with the use of gauze and other fabrics, lit to increase their impact.[54] The use of 'set-ups' rather than box-sets, encouraged a more imagistic than architectural style, with non-naturalistic props often acting as symbolic anchor for a scene. Above all, the theme of delusion that runs through the opera is replicated in a series of optical illusions and devices that constantly undermine the sense of a stable diegesis.

Having now enlarged the dream-world of the *Red Shoes* ballet, they are free to explore the themes first broached by E. T. A. Hoffmann, which fascinated Offenbach and later Freud, through a *mise en scène* which is freed from the normal restraints of dramatic convention and can exploit to the full cinema's own 'uncanny'. Freud found in Hoffmann an early psychopathology of the fear of castration and ultimately of death, played out in tales such as 'The Sandman', where the protagonist Nathaniel is haunted by such father figures as the mechanic Spalanzani and the optician Coppelius, joint creators of the doll Olympia, who will lure Nathaniel away from the 'clever and sensible girl' to whom he is engaged.[55] In both opera and film, Hoffmann enacts Nathaniel's infatuation with Olympia, ignoring the warning of his com-

panion Nikolaus, and makes love to her under the influence of Coppelius's magic spectacles.

The scene might be merely whimsical, costumed and performed in high camp style, if it were not for Shearer's disconcertingly mechanical movements and breakdown, followed by the arrival of the avenging Coppelius, when he discovers Spalanzani's cheque has bounced, and his subsequent savage dismemberment of Olympia. Despite the simple visual effects used to show Shearer 'losing' limbs, and the final shot of her apparently severed head, with a protruding spring and eyes blinking mechanically, this progression from operatic confection to something approaching horror achieves its impact precisely by the transgression of genre.

The fact that the role is played by Shearer is also highly significant, since it has for almost every viewer the inevitable association of her fate in *The Red Shoes*, where she is last seen bleeding and broken, still in her ballerina costume, after her leap onto the railway track. *Hoffmann* may deal in stock Romantic themes and characters, but its hybridized performers and evocative music still have the power to compel our involvement, and to bring alive such venerable stereotypes as the 'artificial woman'; the courtesan who steals reflections, meaning souls, in the Venetian episode; and the singer Antonia who hastens her own death by singing for love.

On one level, to film Offenbach's *The Tales of Hoffmann* in 1950 can be seen as an 'innocent' addition to the middle-brow melodramatic cinema represented by *Black Narcissus* and *The Red Shoes*. It can also be seen as a more significant choice for Powell and Pressburger—following the 'high' Neo-Romanticism of *The Red Shoes* and the more Gothic romanticism of its successor *Gone to Earth*. As Natacha Thiéry has shown, these films treat the issue of female desire in a particularly radical way, through the shockingly abrupt disappearance of the conflicted desiring subject.[56] Sister Ruth plunges to her death in *Black Narcissus*; Vicky's death on the railway line is made spectacular by a performance of *The Red Shoes* in which her absence is represented by a spotlight; and Hazel literally disappears down a mine-shaft in *Gone to Earth*. With each of these abrupt, even if foreshadowed, disappearances, there is a rupture in identification with the character who has attracted most of the spectator's attention, which produces something like a break in the spectator's involvement with cinema itself—a brutal reminder of its paradoxical ontology of presence and absence. *The Tales of Hoffmann* continues but also modulates this theme, signalling a shift towards the

tragic male figure at the centre of *Peeping Tom* and *Duke Bluebeard's Castle*. Olympia and Antonia die before our eyes, one dismembered and the other sacrificing herself for love, while Giulietta and Stella both abandon Hoffmann to his illusions.

For all its spectacular artistry, *The Tales of Hoffmann* was not regarded as radical in 1951, nor during the subsequent two decades. Despite some admiring reviews, notably by C. A. Lejeune, it was treated as second-rate cinema: a mere reproduction of a popular opera, and to many conservative music-lovers, a distracting one. In 1968 Thomas Elsaesser took an important step towards revaluation, comparing it with Jean-Luc's Godard's *Le Mepris* (1963) as another expression of profound cultural pessimism—a portrayal of the artist as inevitable dupe, or cynic, and a protest against the commodification of art under capitalism.[57] This had also the theme of Wagner's manifesto in the 1860s, calling for an art that would transcend the technical and commercial limitations of the present.[58] And for Theodor Adorno, it was Wagner who stood on the threshold of the era when artists would have to choose between the 'false totality' of the *Gesamtkunstwerk* or the production of kitsch, between alienation or avant-gardism.[59] Yet according to Miriam Hansen, revisiting Adorno, it was cinema that provided an escape from this apparent impasse through its creation of a 'vernacular modernism' in the 1920s and 30s.[60] And what we find in Powell's *Peeping Tom* is in many ways a Modernist successor to the Romanticism of *The Red Shoes*, a meta-spectacular work that deals, not with the ontology of ballet, but with that of cinema itself.

III

Even more than *The Tales of Hoffmann*, *Peeping Tom* has become the focus of a sustained revaluation, after its inauspicious initial reception.[61] Originally accused of pandering to a voyeuristic fascination with pornography and violence against women, it has increasingly been seen as a multi-layered work that comments ironically on the social acceptability of various forms of representation, while also creating a fable about the deep roots of scopophilia which is as powerful as such other works of symptomatic modernity as *The Picture of Dorian Gray* and *Dr Jekyll and Mr Hyde*. It has also become a touchstone for the understanding of cinematic reflexivity, acknowledged by Martin Scorsese's wry quotation of a line of dialogue: 'all this filming, it's not healthy.'[62] The protagonist, Mark Lewis, works at a film studio by day, helping to make idiotic comedy-thrillers, while also photographing pin-ups for a sleazy

Soho newsagent to sell clandestinely, and pursuing his own murderous, yet strangely innocent, obsession to film women at the moment of death (8.3).

This obsession, we understand, is the result of his father having filmed him as a child, reacting to various emotional stimuli intended to provoke fear. Mark has been both traumatized and anaesthetized by his childhood experience, and compulsively seeks to repeat the act of filming fear, even though his films consistently fail to deliver what representation cannot offer—the possession of its subject. Mark's obsession has been taken as an allegory, or even a pathology, of cinema itself, with its constant promise of a 'real presence', which is revealed as absence. But for all its apparent contemporaneity, the film also has a clear ancestry. Mark is a damaged male figure familiar from the history of Late Romanticism and Symbolism: he belongs to the tradition of Villiers' heroes Axel and Ewald, of Huysmans' Des Esseintes, of Poe's heroes, of Maeterlinck's Pelléas, Mann's Hanns Carstorp, and of Balázs and Bartók's Bluebeard.[63] He also belongs to the popular Gothic tradition of *Nosferatu*, of *Jekyll and Hyde*, and of the frequent nervous refiguring of the Whitechapel murderer, Jack the Ripper (in, for instance, Wedekind's *Erdgeist* plays, and then in their adaptations: Pabst's film *Pandora's Box* (1928) and Berg's opera *Lulu*).[64] Mark is also, as Laura

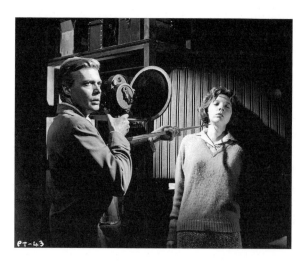

8.3 Mark instinctively threatens Helen before preparing his own murder in *Peeping Tom* (Michael Powell, 1960). Reproduced courtesy of Studio Canal/Optimum.

Mulvey has suggested, a Bluebeard, keeping the celluloid 'bodies' of the women he has killed in a mysterious room which no one else has ever visited.[65] No one, that is, until the intrepid Helen, Mark's lodger from downstairs—since he is the landlord (a modern kind of duke!) of the house that he grew up in—follows her curiosity and attraction, and persuades him to allow her to enter the forbidden realm of his film laboratory.

The 'threshold' scene with Helen outside Mark's darkroom is almost an exact reversal of the opening of Balázs's *Duke Bluebeard's Castle*. Helen persuades a reluctant Mark to allow her to be the first to enter his inner sanctum, pleading it as her 'birthday treat', while Judith has to be encouraged over the doorstep by Bluebeard. What both see, eventually, is similar: like the Duke, Mark shows Helen the evidence for his psychopathology, the clues that will allow her—and us—to understand, rather than merely fear and condemn him. For Mark is simultaneously a figure from the *fin de siècle*, a doomed perfectionist artist, and a figure of modernity, a serial killer acting out his fantasy as repetition compulsion in a recognizably modern technological setting, with a psychiatrist on hand to diagnose him. Trying to exorcize the legacy of being subordinated, 'feminized' as Mulvey says, by his father's filming, he is reversing the process by a super-phallicism, with his sharpened tripod; but he is also trying to make this a reflexive process, so that his victims will 'understand' their fate, in reacting to their fear—which Mulvey links to Perseus reflecting back to the Medusa her own petrifying (castrating) image—when Helen proves able to withstand this distorted 'look'.[66]

In addition to the layers of myth and fable, there is also a fairy tale present here, or at least a modern attempt to produce a children's story. Helen has written a story called 'The Magic Camera', and innocently asks if Mark will help her illustrate it with specially taken photographs. This may be ironic for us, since Mark already takes 'special' photographs for a Soho pornographer. But Helen's request, and love for Mark, also points the way out of his obsessive cycle of repetition. If he cannot be 'redeemed', he can at least be stopped; and as the police close in, Mark prepares to commit his final murder—which is of himself. The sadist is released into masochism, as Mulvey puts it—and in the most powerful passage of the film, he confronts his own fear, simultaneously succumbing to and overcoming it, amid a blaze of photography. The strange therapeutic triumph of this finale is perhaps more disconcerting than anything that has come before—with Mark's father's words (spoken by Powell) eerily playing on a tape from beyond the

grave: 'Don't be a silly boy: there's nothing to be afraid of.' Unlike the romantic suicides and deaths of the earlier films, Mark 'achieves' his self-willed death by overcoming his lack of fear to become, briefly, human and mortal.

IV

A decade after he first foresaw the possibility of television funding the collaboration of artists, Powell received an invitation from Heckroth, now re-established as a stage designer in Frankfurt, to direct a television film of *Duke Bluebeard's Castle* (8.1; 8.4–8.8). It was not an opera he knew: he writes of quickly buying the only available version on record, before agreeing. He had recently begun to direct series shows for American television within strict budgets and schedules, but this would be largely funded by German television, and was being produced by its star, the American singer Norman Foster. Having already worked with Heckroth on a short ballet film in 1955, he looked forward to renewing the close partnership they had enjoyed ever since *The Red Shoes*.[67] Both budget and schedule were limited, with Heckroth being assisted by his students from Frankfurt, and Powell evidently responded to the promise of a production free of the machinations that hindered so many of his projects. The opera is, after all, of an elemental simplicity. Duke Bluebeard ushers his latest wife into his castle. Growing bolder, she insists on entering each of the seven chambers whose doors are visible, against Bluebeard's advice, until behind the seventh door, she discovers his three previous wives, whom she now joins as the fourth, leaving Bluebeard alone in darkness.

From surviving documents, it seems that Powell envisaged making a parallel English version, to the extent that he commissioned a new translation of the libretto from John Press, to replace the standard translation by Christopher Hassall.[68] In the event, the opera was filmed in German, in line with the prevailing performance practice, and no doubt also for the benefit of Süddeutscher Rundfunk, the commissioning television company. Powell also planned a spoken prologue, quite possibly unaware of Balázs's original prologue (not included in the score he used), for which the text survives, although it was not finally used. This voice-over begins jauntily:

> You think we're going to give you the full medieval treatment, don't you? An imitation Gothic castle… with turrets… and ladies with hats like turrets… Well, that's just what we are going to do!

The tone then changes, as the camera closes in on a circle of seven standing stones with carved runes:

> I'd better introduce myself. I'm a Poet. This is an old tale you're hearing tonight, told by two Hungarian poets fifty years ago. Told by Perrault three hundred years ago.

The final words of Powell's initial treatment, not apparently intended to be spoken or reflected in the final version of the film, none the less give the clearest indication of his approach to the opera:

> The credit titles, which come at the end of the production, lead us back from Jung, through the Gothic revival, through Perrault, through the Troubadours, through the Orient, to the Garden of Eden—always by way of the woman—and end on a close-up of THE SERPENT.

Discovering *Duke Bluebeard's Castle* in the 1960s, shortly after Jung's death in 1961 and amid a number of publications that popularized his approach to symbols and the 'collective unconscious', it is perhaps hardly surprising that Powell should view the work in this perspective, seeing it as a timeless, elemental story of woman's curiosity and man's solitude, as expressed in Bluebeard's final words, 'Darkness, darkness.'[69] All that survives of the intended framing are the seven standing stones, which appear behind Bluebeard after a door has hidden Judith—according to Heckroth's note on a sketch for this scene, 'the door within his heart closes'—as he too seems to have turned to stone.

The original stage directions for the opera would have seemed familiar to Powell and Heckroth, relying as they do on a dominant colour for

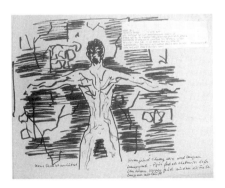

8.4 Hein Heckroth, 'Judith's Words: I Love You', sketch for scene 30, *Duke Bluebeard's Castle* (Michael Powell, 1963). Reproduced courtesy of the Estate of Michael Powell.

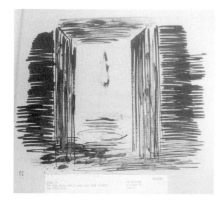

8.5 Hein Heckroth, 'The Tear Falls into a Deep Lake, the Sixth Door', sketch for scene 54, *Duke Bluebeard's Castle* (Michael Powell, 1963). Reproduced courtesy of the Estate of Michael Powell.

each of the rooms that Judith enters. The first, a torture chamber, is bathed in red light; the armoury in yellow, the treasury in gold, the garden in blue–green, and the whole expanse of Bluebeard's realm in full daylight. Behind the sixth door Judith discovers a lake of tears (8.5, 8.6); and behind the seventh, lit only by a silvery beam of moonlight, she discovers the other wives. Powell and Heckroth, however, do not confine themselves to such an austere progression, but fill the castle with a prodigious array of imagery. Two recurrent motifs are runic pillars and human, generally female, torsos. To these are added more specific items, including bright swords from the armoury, with which Judith and Bluebeard engage in a symbolic fight, before the swords return at the end to shackle Judith; and, departing from the opera's scenario, a bed on which Bluebeard and Judith celebrate their marriage.

The space of the film becomes alive with symbolic allusions, but also with emotion made sculptural. Although the traditional interpretation of the opera, as 'a symbolic journey through Bluebeard's soul' is not contradicted,[70] indeed is emphasized through an extraordinary image of Judith superimposed on a giant close-up of Bluebeard's face (8.7), the

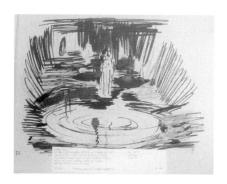

8.6 Hein Heckroth, 'As the scene widens Judith and Bluebeard are standing by the lake of tears', sketch for scene 55, *Duke Bluebeard's Castle* (Michael Powell, 1963). Reproduced courtesy of the Estate of Michael Powell.

8.7 A symbolic journey through Bluebeard's soul in *Duke Bluebeard's Castle* (Michael Powell, 1963). Reproduced courtesy of the Ashbrittle Film Foundation/Sibylle Nabel-Foster.

film also fleshes out their relationship without departing from the verbal and musical text. Instead of a hieratic relationship between Man and Woman, these are creatures of flesh and—an important motif in the opera—blood. Instead of Balázs's complex geometric pattern of symbolic beams of light and closing doors accompanying the progress towards Judith's nemesis, Powell and Heckroth use an equally complex, though fluid, pattern of superimposed images, with extreme changes of shot scale to convey a shifting relationship between husband and wife.

Since Powell and Heckroth chose not to show the earlier wives as in any sense 'living', but rather as dead effigies, and all in Judith's image, her fate seems to be to join Bluebeard's endless series of attempts to find redemption, or release, through love. The text, both verbal and musical, implies that she may be the last—as 'bearer of the crown of night', she represents death for Bluebeard—as implied in his final words. Like the celluloid bodies in Mark Lewis's cabinet, she has become another victim of the wounded male psyche—another woman shockingly extinguished from our gaze in Powell's Neo-Romantic cinema, while Bluebeard joins Mark in having finally achieved oblivion.

Nicholas Vázsonyi has recently proposed that *Duke Bluebeard's Castle* itself should be seen as 'a remarkably early operatic response to film',

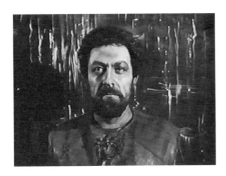

8.8 Bluebeard left 'in darkness' at the end of *Duke Bluebeard's Castle* (Michael Powell, 1963). Reproduced courtesy of the Ashbrittle Film Foundation/ Sibylle Nabel-Foster.

basing his argument on both a close reading of the Prologue, with its teasing implication of an 'inner stage', and on reading Balázs's later film theory back into the dramaturgy of the opera, observing that he may well have been influenced by cinema long before he began writing about it.[71] The argument is in many ways persuasive, and would support a wider claim that the 'cinematic' can be located much earlier than the appearance of avant-garde and specifically Modernist film in the 1920s. Indeed, it would be more plausible to see film as a medium appealing to the Symbolist aesthetic, which formed the dominant avant-garde during the first decades of its growth.[72]

Symbolism had indeed drawn much of its inspiration from Wagner and his call for the integration of the individual arts in drama, hailed in his 1860 manifesto as 'the only true artistic purpose that can ever be fully realised'.[73] For Wagner, this 'wondrous process' could only be realized on the theatrical stage, which declaration gave the stage great prestige among *fin-de-siècle* artists of many kinds. Yet at the same time, within a few years of the emergence of recorded sound and moving pictures, attempts were being made to harness the new media in order to transcend the material limitations of the theatre. And Wagner remained an important focus in the process, which has been termed 'remediation' by Jay Bolter and David Grusin.[74] As early as 1904, an unauthorized American presentation of Wagner's *Parsifal* gave rise to a 'lecture version' using film extracts and slides—an enterprise that followed in the tradition of lantern lecture versions of earlier operas.[75] In 1913, Oskar Messter, the German pioneer of *tonbilder*, films accompanied by recorded sound, produced a full-scale biographical film *Richard Wagner*, which achieved wide international distribution.[76]

The continuing cult of Wagner, however, was not what drove forward cinema's remediation of the Wagnerian theatrical ideal, although there would continue to be echoes of this integrative ambition in, especially, German and American cinema. We have already noted Schoenberg's early interest in the potential of film to 'dematerialize' the poetic stage in 1912–13, even if their ideas remained unrealized at the time. Paradoxically, it was the theorization of film as 'the cultural resurgence of the sensual body' by Balázs in his 1924 book *Visible Man* (*Der sichtbare Mensch*) that provided a better understanding of how film might mediate the traditions of theatre, opera and dance. As Erica Carter has argued, later accounts of Balázs's film theory have obscured the specificity of his earliest writing, focused as it was on the 'physiognomy' of the film image—in effect, the return of the body in a newly mediated

and, through the close-up, magnified form.[77] One passage in particular from *Visible Man* points towards the synthesis later attempted by Powell and his collaborators:

> Music is not just an acoustic matter; it is a separate sphere of the soul. And indeed, facial expressions and gestures are themselves no mere optical matter [...] There appears to be a third realm between the speaker's world of gestures and the decorative expressive movements of the dancer, and this realm has its own form of interiority. The *gestural language* of film is as far removed from the *linguistic gestures* of theatre as it is from dance.[78]

Although working with trained dancers in both *The Red Shoes* and *The Tales of Hoffmann*, Powell was less concerned to preserve the formal conventions of dance than to incorporate their movements into such a 'gestural language', an overall composition of the dynamic image. *Peeping Tom*, with no operatic or high culture elements present, shows a conspicuous interest in combining different registers of performance, ranging from the suggestive posing of a prostitute and glamour models to the self-conscious 'acting' of the film studio, and from Mark's nervous attachment to 'camera vision' to the penetrating 'acoustic vision' of Helen's blind mother. Powell's other opera-related films, *Oh, Rosalinda!!* and *Honeymoon*, include brief passages of experimentation with a subjective point of view and the sporadic use of opera and dance as emotional correlates for inner states. But it was not until *Duke Bluebeard's Castle* that he succeeded in fusing all the elements of libretto, music, performance and décor into a successful filmic whole, reinventing Bartók's and Balázs's threshold work from the climax of the Symbolist–Expressionist stage era at the start of the new age of audiovisual synthesis. For although Powell and Heckroth's *Duke Bluebeard's Castle* is rooted in traditional film techniques, with its use of pre-recording, partial sets and opticals, it stands at the beginning of a new phase of development of the studio, one shaped by television and its new technologies, that would culminate with Hans-Jurgen Syberberg's phantasmagoric works of the 1970s and 1980s, *Ludwig, Requiem for a Virgin King* (1972), *Hitler: a Film from Germany* (1978) and *Parsifal* (1982). Steeped in reflection on the now tarnished legacy of Wagner, in both aesthetic and political terms, Syberberg's films are also anomalous works. Funded by television, and making use of television studio techniques, they none the less aspire to a cinema of epic proportions, while

also, as Susan Sontag observed, 'recalling the artisinal simplicity of its origins'.[79]

During this same period, despite lacking any secure production base, Powell would continue to plan projects premised on this merging of lyric, dramatic and filmic elements: notably a long-mooted version of *The Tempest* and a film of Philip Glass's opera *The Fall of the House of Usher*. In a letter to Glass and the producer Chrisann Verges, Powell discussed his ideas about how to realize this film, using both a real house he had found in Finland and a model, 'so that you're never quite sure whether you're in the real house or the doll's house'. Returning to the implication of Balázs's prologue to *Duke Bluebeard's Castle*, and his later theorization of how cinema works to make us 'part of the picture', Powell drew on a lifetime's experience which covered much of the history of cinema to observe: 'in a film there is no scale [...] People see what you wish them to see and they see everything in the scale that you wish to impose on them.'[80] This conception of a pure space of presentation which the filmmaker controls, described in a preparatory note for *Duke Bluebeard's Castle* as 'the enormous room. Everything is in it and nothing', stands in a direct line of descent from Wagner's vision of the ideal home for his music drama: 'a room designed for nothing else but seeing. Between [the spectator] and the visible picture nothing definite, tangible [...] the remoteness of a dream'.[81]

V

Both of these late projects belong to the same trajectory as *Duke Bluebeard's Castle*, fantastic portrayals of reclusive, insecure men, who are challenged by a female sexuality they cannot ultimately control and which threatens to disrupt their sheltered world. If we consider the course of Michael Powell's 'life in movies' and ignore the conventional view of *Duke Bluebeard's Castle* as a minor work, it emerges instead as a rare opportunity for its maker to grapple in the most elemental terms with a theme that had haunted his career: the equality that love demands but rarely discovers.[82]

Two surviving documents from the production of *Duke Bluebeard's Castle* provide an insight into Powell's interpretation of the opera.[83] One is a handwritten letter, presumably to Pamela Brown, his companion and lover from the 1950s until her death in 1975, in which he explains the conclusion he has pressed on Heckroth: 'that the Seven doors were the Seven Times (mystic number!) that Bluebeard makes love to his wife on their bridal night'. Heckroth is quoted replying, after they have

studied the score and listened together: 'I see now that the doors are all inside the man and not inside the woman.' The other document is a single page typescript which seems to represent first thoughts about the treatment. It begins, arrestingly, 'When the man enters the woman, she also enters him,' and it takes the form of a series of questions and answers. Do we need to know who this man and woman are, or where they are? The answer is no, and 'the setting has no importance except to isolate the woman and the man together', it 'must come from the folklore of films. A convention'. What is central to Powell's interpretation is the equality of the two—'two people in darkness and in love'— and his conclusion that they spend the night together, 'from complete darkness to twilight to dawn'. Nothing else is needed, except:

> Do we need to know why or whether they part at the end of the night? Yes. She must leave him alone at the end. Man is always alone. Even if he dies first which he usually does. Unless he kills.

We might wonder what this last sentence means. A vindication of the man who kills to avoid being 'left alone'? An afterthought about the 'ripper' of *Peeping Tom*, who only kills women that have displayed themselves sexually? There is no further clue here, although there may be in the exploration of Bluebeard's psychopathology elsewhere in this volume.

Balázs's and Bartók's Bluebeard is very different from Perrault's tyrant, who is ready to kill Judith because she has flaunted his authority. This *fin-de-siècle* Duke wants to protect his new love from the reality of his power: 'you shall see, but ask me nothing.' When she discovers that all his treasures are bloodstained, he repeats, 'ask me nothing'; and he resists her wish to go beyond the door that opens onto his 'noble kingdom', and to discover the lake of tears behind the sixth door. But he cannot resist her demand to see all, even what lies behind the last door, which she believes must conceal the bloody secret of his previous wives. In the opera's stage directions, however, the three appear as non-singing actors, 'pale of face with proud and haughty gait', and stand before Bluebeard, who kneels before them 'in homage'. He adorns Judith with similar jewels, that weigh her down before she joins them, 'walking along the beam of moonlight toward the seventh door', which closes after her.

Faithful to his preliminary stripping down of the work's premise, Powell and his collaborators replace the stark stage and row of doors

of the opera's stage directions with a dense forest of symbols that is quickly sketched in the typescript:

> The instruments the flowers the tears the gardens and landscapes formal and informal the blood which is life and the blood which is death are all real. The petals the cutting edges, the pain produced by the impact of objects and images and the micro-photographs of organisms are all real.

Illusionistic space is dissolved in this inner world conjured by means of partial sets, sculptures, screens and superimpositions—a final triumph of the expressive scenography that Powell and Heckroth had pioneered in the *Red Shoes* ballet and brought to fruition in *Tales of Hoffmann*.[84] Here the filmic texture responds eloquently to the shifting accents in Bartók's folk-influenced, yet sumptuous, score, with its traces of Strauss and Debussy. Amid this symbolism, the introduction of a bed, unsanctioned by the opera scenario, anchors Powell's interpretation of it as a wedding night. For Powell, Judith's progress through the rooms represents her gradual discovery of what defines her husband—his weapons, his wealth, his land, his melancholy—while her joining the gallery of past wives at the end, represented only as shop-window figures, in the style of *Tales of Hoffmann*'s extras, amounts to leaving him 'in darkness'. There is an echo here, no doubt unintentional, of the central motif of Jules Verne's novel *The Carpathian Castle* (*Le château des Carpathes*, 1892), in which an opera singer's admirer festishistically preserves her image in photographic transparencies, accompanied by recordings of her voice.[85] Judith may be 'the queen of all my women/My best and fairest', but she has become only an image, lost to Bluebeard after their night of passion. In the course of the film, we experience an exchange of points of view, or subjectivities, which may be the Powell's most distinctive contribution to the continuing 'Bluebeard text'. What began as Judith's journey of discovery through Bluebeard's mansion/mind becomes at the end *his* image of her, objectified, yet endlessly repeatable in what Nicholas Vázsonyi has called 'the thematic ambiguity of loss and retention' that marks the conclusion of the opera.[86] After the pessimistic ending of *Tales of Hoffmann*, and the perverse *liebestod* that forms the climax of *Peeping Tom*, the masculine melancholy of *Duke Bluebeard's Castle* is hardly surprising. But it is nuanced by Powell's discovery of a passionate love story within this profoundly ambiguous work—a discovery that he wanted to pursue by filming Bartók's scan-

dalously erotic pantomime-ballet, *The Miraculous Mandarin*,[88] and that he would celebrate in lighter style in the comedy, *Age of Consent* (1969), the story of a middle-aged artist whose jaded creativity is revived by his love for a carefree young woman.

As a self-proclaimed 'high priest of the mysteries' of film, Powell understood better than most how cinema had transformed art and life during the twentieth century.[88] With the success of *The Red Shoes*, he saw how it could communicate the passion and risk of art to a wide audience. He hoped, as an eternal optimist, that television might continue that process, and *Duke Bluebeard's Castle*, filmed quickly and cheaply in a studio in Salzburg, then all but forgotten for forty years, was his prophetic demonstration of how that might happen.[89] With it, he wanted to show that the blending of song, dance and cinematography could become a new—old kind of spectacle, the art-form of the future.

NOTES

Series Preface

1 Mieke Bal, *Travelling Concepts in the Humanities: A Rough Guide* (Toronto: University of Toronto Press, 2002).

2 Mieke Bal, *The Point of Theory: Practices of Cultural Analysis* (Amsterdam: University of Amsterdam Press, 1994); Mieke Bal, *The Practice of Cultural Analysis: Exposing Interdisciplinary Interpretation* (Stanford: Stanford University Press, 1999).

3 Bal: *The Practice of Cultural Analysis*, p. 1.

Preface

1 Susan McClary, *Feminine Endings: Music, Gender and Sexuality* (Minneapolis: University of Minnesota Press, 1991), p. 4.

2 Béla Bartók, *Duke Bluebeard's Castle*, libretto by Béla Balázs, trans. Christopher Hassall (New York: Boosey and Hawkes, 1952).

3 Carl Leafstedt, 'Judith in "Bluebeard's Castle": the Significance of a Name', *Studia Musicologica Academiae Scientiarum Hungaricae* 36/3–4 (1995), pp. 429–47, reprinted as 'Judith: the Significance of a Name', in Carl Leafstedt, *Inside Bluebeard's Castle: Music and Drama in Béla Bartók's Opera* (Oxford: Oxford University Press, 1999), pp. 185–200. See also Victoria Anderson's chapter in this volume. The illustration chosen here is from American director D. W. Griffiths's first full-length feature film, *Judith of Bethulia* (1914) which is, of course, the reverse story. It recounts the apocryphal Biblical story of how a heroic and virtuous Jewish widow politically assassinated an Assyrian general whose armies were besieging her town in order to save her city and her people.

4 Susan McClary: *Feminine Endings*, p. 3.

5 On epistemophilia see Laura Mulvey, 'Pandora's Box: Topographies of Curiosity', *Fetishism and Curiosity* (Bloomington: Indiana University Press; London: BFI, 1996), pp. 53–64. For a telling analysis of the phallic formation of subjectivity as illusion, see Julia Kristeva, 'On the Extraneousness of the Phallus; or, the Feminine Between Illusion and Disillusion,' in *The Sense and Non-sense of Revolt; The Powers and Limits of Psychoanalysis* [1996], trans. Jeanine Herman (New York: Columbia University Press, 2000), pp. 94–106.

6 Stephen Heath, 'Joan Riviere and the Masquerade', in Victor Burgin, James Donald and Cora Kaplan (eds), *Formations of Fantasy* (London: Methuen, 1986), pp. 55–6. Citations inside the quotation are Mustapha Safouan, *La Sexualité féminine sans*

la doctrine freudienne (Paris: Seuil, 1976) pp. 136–7; Virginia Woolf, *Three Guineas* [1938] (Harmondsworth: Penguin, 1977), p. 23; Eugenie Lemoine-Luccioni, *La Robe* (Paris: Seuil, 1983), p. 34.

7 Charles Perrault, 'La Barbe Bleue', in *Histoires ou Contes du Temps passé avec des Moralitez* (Paris: C. Barbin, 1697).

8 For an important feminist revaluation of Pandora's curiosity, see Mulvey: 'Pandora's Box'.

9 Jack Zipes, *Breaking the Magic Spell: Radical Theories of Folk and Fairy Tales* (London: Heinemann 1979); Jack Zipes, *Fairy Tales and the Art of Subversion* (London: Heinemann, 1983); Jack Zipes, *When Dreams Came True: Classical Fairy Tales and Their Tradition* (London: Routledge, 1999); Marina Warner, *From the Beast to the Blonde: On Fairytales and Their Tellers* (London: Chatto & Windus, 1994); Nancy Canepa (ed.), *Out of the Woods: The Origins of the Literary Fairy Tale in Italy and France* (Detroit: Wayne University Press, 1997).

10 Maria Tatar, *Secrets Beyond the Door: The Story of Bluebeard and His Wives* (Princeton: Princeton University Press, 2004).

11 Maud Jacquin, 'Preface', trans. Sheila Malovany-Chevalier, in Alice Anderson, *Bluebeard* (Paris: Frac Paca, 2007), p.1; quoted from <http://www.alice-anderson. org/texts.htm/MAUD%20JACQUIN%20on%20Fairy%20Tales.pdf> (accessed 27 June 2008).

12 I am drawing on Mieke Bal's proposition of how cultural analysis can rethink traditional notions of iconography which prioritizes a story as a discrete origin with concepts of the pre-text as a screen for novel projection and creative transference. See Mieke Bal, 'Visual Storytelling', in *Reading Rembrandt: Beyond the Word/Image Opposition*, (Cambridge: Cambridge University Press, 1991), pp. 94–128.

Introduction

1 The definitive work on women's influence on the early novel remains that by Joan DeJean, *Tender Geographies: Women and the Origins of the Novel in France* (New York: Columbia University Press, 1991).

2 Victor Laruccia, 'Little Red Riding Hood's Metacommentary: Paradoxical Injunction, Semiotics & Behavior', *MLN* 90/4 (1975), p. 534.

3 Philip E. Lewis, *Seeing through the Mother Goose Tales: Visual Turns in the Writings of Charles Perrault* (Stanford: Stanford University Press, 1996), p. 211.

4 Soriano suggests that Perrault's son Pierre Darmancour may have written the prose stories, while his father wrote the verses; there is no real evidence of this. See Marc Soriano, *Les Contes de Perrault. Culture Savante et Traditions Populaires* (Paris: Gallimard, 1996), p. 337.

5 An excellent study of the fairy tale vogue is Lewis Carl Seifert, *Fairy Tales, Sexuality, and Gender in France, 1690–1715* (Cambridge: Cambridge University Press, 1996).

6 Paul Hazard, *The European Mind 1680–1715* [1935], trans. J. Lewis May (Harmondsworth: Penguin, 1973).

7 Famously argued by Bettelheim. See Bruno Bettelheim, *The Uses of Enchantment: The Meaning and Importance of Fairy Tales* (London: Penguin, 1991), p. 169.

8 Such as the Grimms' 'Fitcher's Bird'. Jacob Grimm and Wilhelm Grimm, *The Complete Fairy Tales* (Ware: Wordsworth, 1997).

9 The troll shows up in Nordic tales, such as the Norwegian 'My Hen is in the Mountain'. Peter Christen Asbjørnsen and Jørgen Moe, 'Høna Tripper I Berget', trans. George Webb Dasent, in *Norske Folkeeventyr* (Oslo: Christiania, 1859).

10 'How the Devil Married Three Sisters', in Thomas Frederick Crane, *Italian Popular Tales* (New York: Houghton Mifflin, 1885), pp. 78–81.

11 The tale 'The Robber Bridegroom' is collected by the Grimms, but some of the most interesting variations are those recorded in the English tradition, such as 'The Oxford Student' and 'The Girl Who Got Up a Tree'. For a full discussion of this tradition and its implications see Victoria E. Anderson, *Behind Closed Doors: Bluebeard and Women Writing* (Unpublished PhD Thesis, University of Leeds, 2005), pp. 120–41. See also Katharine M. Briggs, *A Dictionary of British Folk Tales in the English Language*, vol. 1, (London: Routledge and Kegan Paul, 1971).

12 Edward Lane, *The Thousand and One Nights: Commonly Called, in England, the Arabian Nights' Entertainments*, vol. 1 (London: John Murray, 1859).

13 For an interesting discussion see Francois Flahault, 'Barbe-Bleue Et Le Desir De Savoir', *Ornicar* 17/18 (1979), pp. 70–87.

14 'et le reste à se marier elle-même à un fort honnête homme, qui lui fit oublier le mauvais temps qu'elle avait passé avec la Barbe Bleue'. Charles Perrault, *Histoires ou Contes du Temps passé*, ed. Frédéric de Scitivaux (Paris: Larousse, 1999), p. 59.

15 Philip E. Lewis, *Seeing through the Mother Goose Tales: Visual Turns in the Writings of Charles Perrault* (Stanford: Stanford University Press, 1996), p. 201.

16 Elizabeth W. Harries, 'Simulating Oralities: French Fairy Tales of the 1690s', *College Literature* 23/2 (1996), p. 111.

17 Catherine Orenstein, *Little Red Riding Hood Uncloaked: Sex, Morality, and the Evolution of a Fairy Tale* (New York: Basic, 2002), p. 57.

18 See Abbé de Choisy, *The Transvestite Memoirs of the Abbé De Choisy*, trans. R. H. F. Scott (London: Peter Owen, 1973).

19 There has been much argument over whether it was Perrault himself or his youngest son Pierre Darmancour who wrote the stories. See Marc Soriano, *Le Dossier Perrault* (Paris: Hachette, 1972); Marc Soriano, *Les Contes De Perrault: Culture Savante Et Traditions Populaires* (Paris: Gallimard, 1977), esp. chapter 8.

20 There are two major works devoted to *preciosité* from the period, one being Somaize's *Dictionnaire des Precieuses*, the other *La Précieuse, ou le Mystére des Ruelles* by the Abbé de Pure.

21 Alan Dundes, *Little Red Riding Hood: A Casebook* (Madison: University of Wisconsin Press, 1989), p. 3.

22 There is no possibility of proof, but leading theorists consider research on the matter to be conclusive. Cf. Jack Zipes, *Fairy Tales and the Art of Subversion: The Classical Genre for Children* (New York: Routledge, 1991), p. 28; Soriano: *Les Contes De Perrault*, p. 150; Paul Delarue, *Le Conte Populaire Français*, vol. 1 (Paris: Editions Erasme, 1957), pp. 337–8.

23 Cf. Paul Delarue, *The Borzoi Book of French Folk Tales*, trans. Austin Fife (New York: Alfred A. Knopf, 1956), pp. 230–32.

24 Jack Zipes, *The Trials and Tribulations of Little Red Riding Hood* (London: Heinemann, 1983), p. 9.

25 Lewis: *Seeing through the Mother Goose Tales*, p.174.

26 There is, nonetheless, a valid argument to be had in terms of gender bias within

the Aarne–Thompson system. See especially Toborg Lundell, 'Gender-Related-Biases in the Type and Motif Indexes of Aarne and Thompson', in *Fairy Tales and Society: Illusion, Allusion and Paradigm* (Philadelphia: University of Pennsylvania Press, 1989), pp. 146–63. See also Antti Aarne, *The Types of the Folktale: A Classification and Bibliography*, trans. Stith Thompson, 2nd edn (Helsinki: Suomalainen Tiedeakatemia, Academia Scientiarum Fennica, 1961).

27 Harries: 'Simulating Oralities', pp. 100–16.

28 For an excellent assessment see Domna C. Stanton, 'The Fiction of Préciosité and the Fear of Women', *Yale French Studies* 62 (1981), pp. 107–34.

29 Mikhail Bakhtin, *The Dialogic Imagination*, trans. Caryl Emerson and Michael Holquist (Austin: University of Texas Press, 1981), p. 5.

Chapter 1. Bluebeard's Curse

1 Willa Cather, *O Pioneers!* (New York: Penguin, 1994), p. 80.

2 J. R. R. Tolkien, 'On Fairy-Stories', in *The Tolkien Reader* (New York: Ballantine, 1966), p. 26. Calvino's observation is cited by Anthony Minghella in *The Talented Mr Ripley: A Screenplay* (New York: Hyperion, 1999), p. xi.

3 Margaret Atwood, *True Stories* (Toronto: Oxford University Press, 1981), p. 2.

4 See Joanna Russ, 'Somebody's Trying to Kill Me and I Think It's My Husband: The Modern Gothic', *Journal of Popular Culture* 4 (1973), pp. 666–91. Mary Ann Doane has also written about these films in *The Desire to Desire: The Woman's Film of the 1940s* (Bloomington: Indiana University Press, 1987), p. 123, as has Andrea Walsh, *Woman's Film and Female Experience: 1940–1950* (New York: Praeger, 1984).

5 Jane Campion comments on the pantomime in an interview with Thomas Bourguignon and Michel Ciment, 'Entretien avec Jane Campion', *Positif* 338 (1993), p. 6. In an interview conducted by Vincent Ostria and Thierry Jousse, Campion observes that she read 'Bluebeard' after finishing the screenplay and before filming *The Piano* 'Entretien avec Jane Campion', *Cahiers du cinéma*, 467/8 (1993), p. 20. Sara Halprin points out that the pantomime prefigures Stewart's attack on Ada: 'The silhouetted figure of Bluebeard brandishing an axe at his wife is echoed in the image of Stewart striding home with his axe; the script tells us that when Ada hands Flora the fateful piano key, "her black shadow behind the sheet recalls the macabre play".' See Sara Halprin, 'A Key to *The Piano*', *Women's Review of Books* 11/10–11 (1994), p. 35.

6 Sue Gillett comments on Stewart's 'acquisitive, proprietorial' nature. See her 'Lips and Fingers: Jane Campion's *The Piano*', *Screen* 36 (1995), p. 285, and Barbara Johnson focuses on the film's ending. See Barbara Johnson 'Muteness Envy', in Diana Fuss (ed.), *Human, All Too Human* (New York: Routledge, 1996), pp. 131–48.

7 William Rothman reads Alex's secret in psychoanalytic terms: 'Bergman has betrayed him by giving another man the key to the room to which only he and his mother had access, the room that contains the secret which grounds his intimate relationship with his mother. The suggestion is that the key marked *Unica* (union, eunuch) which unlocks the Grant/Bergman relationship and ultimately unites them unlocks as well that secret that Rains is sexually not really a man.' See 'Alfred Hitchcock's *Notorious*', *Georgia Review* 4 (1975), pp. 908–9.

8 *Spellbound* (Alfred Hitchcock, 1945).

9 Stephen Jenkins discusses the 'battle of voice(over)s' in *Secret beyond the Door* in

'Lang: Fear and Desire', in S. Jenkins (ed.), *Fritz Lang: The Image and the Look* (London: BFI, 1981), p. 109.

10 Richard Maltby, 'Film Noir: The Politics of the Maladjusted Text', *Journal of American Studies* 18 (1984), p. 53.

11 Slavoj Žižek, '"The Thing That Thinks": The Kantian Background of the *Noir* Subject', in Joan Copjec (ed.), *Shades of Noir: A Reader* (London: Verso, 1993), p. 223.

12 Linda Williams, 'When the Woman Looks', in Mary Ann Doane, Patricia Mellencamp, and Linda Williams (eds), *Re-vision: Essays in Feminist Film Criticism* (Los Angeles: American Film Institute, 1984), pp. 83–99.

13 Francis Iles, *Before the Fact* (New York: Doubleday, 1932), p. 287.

14 The translations from Perrault are my own and based on *Contes/ Charles Perrault: Textes établis et présentés par Marc Soriano* (Paris: Flammarion, 1989).

15 The critical voices are cited and documented in Maria Tatar, *The Hard Facts of the Grimms' Fairy Tales* (Princeton: Princeton University Press, 1987), p. 161.

16 Bruno Bettelheim, *The Uses of Enchantment: The Meaning and Importance of Fairy Tales* (New York: Knopf, 1976), p. 300.

17 Vladimir Propp, *The Morphology of the Folktale*, 2nd edn (Austin: University of Texas Press, 1968).

18 John R. Searle, *Speech Acts: An Essay in the Philosophy of Language* (Cambridge: Cambridge University Press, 1969); Jacques Derrida, *Limited Inc*, ed. Gerald Graff, trans. Samuel Weber and Jeffrey Mehlman (Evanston: Northwestern University Press, 1969); Judith Butler, *Excitable Speech: A Politics of the Performative* (New York: Routledge, 1997).

19 J. L. Austin, *How To Do Things with Words*, 2nd edn (Cambridge: Harvard University Press, 1962), p. 8.

20 Walter Benjamin, 'The Storyteller: Reflections on the Works of Nikolai Leskov', in *Illuminations*, ed. Hannah Arendt, trans. Harry Zohn (New York: Schocken, 1968), pp. 83–109.

21 Marjorie Bard, *Shadow Women: Homeless Women's Survival Stories* (Kansas City: Sheed & Ward, 1990).

22 Margaret Atwood, 'Grimms' Remembered', in Donald Haase (ed.), *The Reception of Grimms' Fairy Tales: Responses, Reactions, Revisions* (Detroit: Wayne State University Press, 1993), pp. 290–92.

Chapter 2. Bluebeard, Hero of Modernity

This is a revised version of a chapter in Mererid Puw Davies, *The Tale of Bluebeard in German Literature from the Eighteenth Century to the Present* (Oxford: Oxford University Press, 2001), pp. 162–201. Unless otherwise indicated, English translations are by the author.

1 Frank Wedekind, *Spring Awakening* [1891], trans. Edward Bond (London: Eyre Methuen, 1980), p. 25. 'Es liegt etwas Tragisches in der Rolle des *Blaubart*. Ich glaube, seine ermordeten Frauen insgesamt litten nicht soviel wie er beim Erwürgen jeder einzelnen.' Frank Wedekind, *Frühlings Erwachen: Eine Kindertragödie* [1891], in Wedekind, *Werke in drei Bänden*, ed. Manfred Hahn, vol. 1 (Berlin and Weimar: Aufbau, 1969), pp. 95–165.

2 Paul Banks, 'Images of the Self: *Duke Bluebeard's Castle*', in Nicholas John (ed.), *The Stage Works of Béla Bartók*, English National Opera Guide 44 (London: John Calder, 1991), p. 7.

3 Charles Perrault, 'Bluebeard' [1697], in *The Fairy Tales of Charles Perrault*, trans. Angela Carter (London: Gollancz, 1977), pp. 29–41; Charles Perrault, 'La Barbe Bleue', in *Contes*, ed. Jean-Pierre Collinet (Paris: Gallimard, 1981), pp. 147–54.

4 Cf. Mererid Puw Davies, *The Tale of Bluebeard in German Literature from the Eighteenth Century to the Present* (Oxford: Oxford University Press, 2001), pp. 97–131; Hartwig Suhrbier, 'Blaubart: Leitbild und Leidfigur', in Hartwig Suhrbier (ed.), *Blaubarts Geheimnis: Märchen und Erzählungen, Gedichte und Stücke* (Cologne and Düsseldorf: Diederichs, 1984), p. 30.

5 Cf. Davies: *The Tale of Bluebeard*, pp. 132–61; Mererid Puw Davies, 'Laughing Their Heads Off: Some Nineteenth-century Comic Versions of the Bluebeard Tale', *German Life and Letters* 55/4 (2002), pp. 329–47.

6 Today, four eighteenth-century and some seventeen nineteenth-century German Bluebeard texts are known. The twentieth century produced at least thirty such texts. Periods which produced particular concentrations of Bluebeard material are, roughly, 1850–70 (eight versions); 1905–25 (twelve versions) and 1967 onwards (at least twelve).

7 Herbert Eulenberg, 'Ritter Blaubart', in *Ausgewählte Werke in fünf Bänden*, vol. 2 (Stuttgart: Engelhorn, 1925), pp. 271–324; Georg Trakl, 'Blaubart: Ein Puppenspiel', in *Dichtungen und Briefe: Historisch-kritische Ausgabe*, eds Walther Killy and Hans Szklenar, vol. 1 (Salzburg: Otto Müller, 1969), pp. 435–45; Karl Schoßleitner, 'Prinz Blaubart', *Der Brenner* 3/7–8 (1911), pp. 203–22, 247–62; Reinhard Koester, 'Ritter Blaubart' [1911], in Hartwig Suhrbier (ed.), *Blaubarts Geheimnis: Märchen und Erzählungen, Gedichte und Stücke* (Cologne and Düsseldorf: Diederichs, 1984), p. 160; Alfred Döblin, 'Der Ritter Blaubart', in *Erzählungen aus fünf Jahrzehnten* (Olten and Freiburg im Breisgau: Walter, 1979), pp. 76–86; El Hor, 'Ritter Blaubart' [1913], in Hartwig Suhrbier (ed.), *Blaubarts Geheimnis: Märchen und Erzählungen, Gedichte und Stücke* (Cologne and Düsseldorf: Diederichs, 1984), pp. 160–61; Georg Kaiser, 'Gilles und Jeanne', in *Werke*, vol. 5 (Frankfurt am Main, Berlin and Vienna: Propyläen/Ullstein, 1972), pp. 746–811.

8 'Ich liebe dich, mein lieber Herr.' El Hor: 'Ritter Blaubart', p. 161.

9 '[Paolo] habe sich mit Leib und Seele einem bösen Untier verkauft. Das läge aus Urzeiten auf dem alten Meeresgrunde, dort auf der Heide; in der Klippe hause es und brauche alle paar Jahre einen Menschen. Es klänge wie ein Märchen und sei doch wahr.' El Hor: 'Ritter Blaubart', p. 83.

10 Cf. Davies: *The Tale of Bluebeard*, pp. 74–5. This once influential theory has now been dismissed.

11 'für alle'. Kaiser: 'Gilles und Jeanne', p. 811.

12 Cf. Suhrbier: 'Blaubart', pp. 30, 34.

13 'da graute es mir, wie auf einmal […] dies Schloß auf uns zusprang, mit den düstern Fenstern, die uns anstierten'. Eulenberg: 'Ritter Blaubart', p. 277.

14 In Perrault's text the wife does run downstairs to open the forbidden room; however, it seems that that room is on the ground floor, a contemporary detail, since in seventeenth-century France, the ground-floor suite of rooms in a *grand bourgeois* home was generally 'Monsieur's' domain.

15 This fact may also be explained partially by the German tale tradition, since in the related tale 'Fitcher's Bird' (1819), the villain and his household are burnt to death.

16 'Du hast mir keine gute Mutter ausgesucht! Von ihr kam dieses sklavenhafte Niedrigsein, das mich hinunterzwingt[,] mich klein zu machen und mich anzuschmiegen.' Schoßleitner: 'Prinz Blaubart', p. 253.

17 This fact quite undermines Bruno Bettelheim's canonical but unfounded assertion that earlier versions of the tale are incontrovertibly about the heroine's sexual infidelity, either real or desired. Cf. Bruno Bettelheim, *The Uses of Enchantment: The Meaning and Importance of Fairy Tales* (London: Thames and Hudson, 1976), pp. 300–11.

18 'Wirst du mich töten?'/'Ja.'/'Warum tötest du die Frauen?'/'Frag nicht.'/'Wann wirst du mich töten?'/'Fürchtest du dich?'/'Nein—ich liebe dich dafür.' El Hor: 'Ritter Blaubart', pp. 160–61.

19 'Wäre nicht bei den Frauen jetzt die Unzucht und Gottlosigkeit so groß, so wäre der arme Ritter befreit von dem Tier.' Döblin: 'Der Ritter Blaubart', p. 83.

20 Wedekind: *Spring Awakening*, p. 25; 'unmenschlich[e] Bescheidenheit', Wedekind: *Frühlings Erwachen*, p. 125.

21 '*Ein Kellergewölbe im Schloß, kahl und kalt. Nur hinten* [...] *liegen auf weißen Schüsseln fünf blutige verweste Frauenköpfe.*' Eulenberg: 'Ritter Blaubart', p. 286.

22 'Er zerrt sie in die Tiefe. Man hört einen gellenden Schrei. Dann tiefe Stille. Nach einiger Zeit erscheint Blaubart, bluttriefend, und trunken außer sich.' Trakl: 'Blaubart', p. 445.

23 'Es war ein beweinenswerter Mensch, der da sterben mußte.' Eulenberg: 'Ritter Blaubart', p. 324.

24 'Daß er gerade dort die stärkste Notwendigkeit fühlt zu töten, wo es ihm am schwersten fällt, gerade *die* Frau zu töten, die am besten zu ihm passen würde, die er am meisten liebt [...] Wenn sogar dieser Fall tragisch endet, dann ist überhaupt keine Rettung mehr zu erwarten, denn jener Frauen, die weniger zu ihm passen, die er weniger liebt, wird er sich noch viel leichter entledigen.' Karl Schoßleitner, 'Das Blaubart-Thema', *Der Brenner* 4/15 (1911–12), pp. 516–17.

25 'Wir hassen uns alle. Wir sind nur zu feige oder zu faul, es uns zu sagen'; 'Durch Blut sehen wir in alles hinein. Jedes Messer schließt das Rätsel des Blutes auf.' Eulenberg: 'Ritter Blaubart', pp. 282, 283.

26 Walter Puchner, 'Mädchenmörder', in Kurt Ranke *et al.* (eds), *Enzyklopädie des Märchens: Handwörterbuch zur historischen und vergleichenden Erzählforschung*, vol. 8 (Berlin: de Gruyter, 1975), pp. 1407–13. Cf. Davies: *The Tale of Bluebeard*, pp. 78–80.

27 This association is first made in secondary literature in Konrad Hofmann, 'Über die älteste Quelle der Blaubartsage', *Romanische Forschungen* 1 (1883), p. 434.

28 'Sein Bart war spitz zugeschnitten und so glatt und glänzend wie ein schwarzes Pantherfell, mit einem stahlblauen Schimmer darauf [...] Da lachte sie und fing mit der hohlen Hand das Regenwasser auf, das aus seinem Bart tropfte und trank es.' El Hor: 'Ritter Blaubart', pp. 160–61. The idea of the blue beard as a symbol of sexuality has become widely accepted in secondary literature too.

29 'Lust peitschen Haß, Verwesung und Tod/[...] soll ich dich Kindlein ganz besitzen—/Muß ich, Gott will's den Hals dir schlitzen!' Trakl: 'Blaubart', p. 444.

30 'Nach den Sprichwörtersammlungen des sechzehnten Jahrhunderts bedeutet Blaubart einen Mann, der einen dichten schwarzen Bart hat. Nach der Meinung jener

Zeit wurde ein solcher *Blaubart* für einen gebornen [*sic*] *Don Juan* und *Frauenver-führer* gehalten.' Hofmann: 'Über die älteste Quelle der Blaubartsage', p. 434.

31 Leopold Schmidt, 'Rezniceks *Ritter Blaubart*', *Berliner Tageblatt* 57/31 (1920), pagination not available.

32 Sigmund Freud, 'Psycho-Analysis and the Establishment of the Facts in Legal Proceedings' [1906], quoted in Jacques Le Rider, *Der Fall Otto Weininger: Wurzeln des Antifeminismus und Antisemitismus*, trans. Dieter Hornig (Munich: Löcker, 1985), p. 174.

33 'Und sah er sich im Lustgenießen,/nach dem sein Blut verzweifelt schrie,/in eine Frau hinüberfliessen—/erschlug er sie.' Koester: 'Ritter Blaubart', p. 160.

34 'All diese Liebe [...] dieses Hinströmen und Verfließen—: ein rasend geiler Mörderlust am eigenen Selbst, ein Taumel durch Vernichtungstode unseres Selbstgefühls.' Schoßleitner: 'Prinz Blaubart', p. 220.

35 Cf. Suhrbier: 'Blaubart'.

36 Ruth B. Bottigheimer, *Grimms' Bad Girls and Bold Boys: The Moral and Social Vision of the Tales* (New Haven: Yale University Press, 1987), pp. 27–9.

37 Cf. Jacques Le Rider, *Modernity and Crises of Identity: Culture and Society in Fin-de-Siècle Vienna*, trans. Rosemary Morris (Cambridge: Polity, 1993), pp. 77–161.

38 Otto Weininger, *Sex and Character: An Investigation of Fundamental Principles*, trans. Ladislaus Löb (Bloomington and Indianapolis: Indiana University Press, 2005), pp. 299–300.

39 'wenn alle Weiblichkeit Unsittlichkeit ist, so muß das Weib aufhören Weib zu sein, und Mann werden', Otto Weininger, *Geschlecht und Charakter: Eine prinzipielle Untersuchung* (Munich: Matthes & Seitz, 1980), p. 452.

40 'Nie haben die Deutschen ein solches Bedürfnis gefühlt, den bretonischen Ritter, der sie wie in Wahlverwandtschaft anzog, durch Empfindsamkeit zu sühnen. Sie wolltenihnalsMörder.SieließendemStoff seineKonturen und das Barbarische, das der deutschen Gier entgegenkommt, Sinnliches und Geistiges zu vermählen.' Paul Wiegler, 'Der gute Blaubart', *Die neue Rundschau* 20/4 (1909), p. 1679.

41 The libretto was written by Maeterlinck in 1899–1902 and first performed in Paris in 1907. Maurice Maeterlinck, *Ariane et Barbe-bleue* (Paris: Erato Disques, 1984). Text included with the recording directed by Armin Jordan.

42 'D'abord il faut désobéir: c'est le premier devoir quand l'ordre est menaçant et ne s'explique pas.—Les autres ont eu tort et les voilà perdues pour avoir hésité.' Maeterlinck: *Ariane et Barbe-bleue*, p. 7.

43 John Lemprière, *A Classical Dictionary* (London: Routledge and Kegan Paul, 1947), p. 74.

44 Cf. Le Rider: *Modernity and Crises of Identity*, pp. 147–61, esp. pp. 157–61.

45 'monde inondé d'espérance'. Maeterlinck: *Ariane et Barbe-bleue*, p. 75.

46 Simon Broughton, 'Bartók and World Music' in Nicholas John (ed.), *The Stage Works of Béla Bartók*, English National Opera Guide 44 (London: John Calder, 1991), p. 19.

47 Jean-Michel Palmier, 'Otto Weininger, Wien und die Moderne', in Jacques Le Rider and Norbert Leser (eds), *Otto Weininger: Werk und Wirkung* (Vienna: Österreichischer, 1984), pp. 83–4.

48 Banks: 'Images of the Self', p. 8.

49 Béla Balázs, *A kékszakállú herceg vara* [1810], parallel text Hungarian and English

libretto, trans. John Lloyd Davies, in Nicholas John (ed.), *The Stage Works of Béla Bartók*, English National Opera Guide 44 (London: John Calder, 1991), p. 46.

50 Balázs: *A kékszakállu herceg vara*, p. 48.
51 Balázs: *A kékszakállu herceg vara*, p. 47.
52 Balázs: *A kékszakállu herceg vara*, p. 60.
53 Balázs himself is said to have had highly contradictory feelings with regard to contemporary debates regarding the emancipation of women. See Banks: 'Images of the Self', pp. 8–9.

Chapter 3. Béla Bartók's *Duke Bluebeard's Castle*

1 Béla Balázs, *A kékszakállu herceg vara* [1810], parallel text Hungarian and English libretto, trans. John Lloyd Davies, in Nicholas John (ed.), *The Stage Works of Béla Bartók*, English National Opera Guide 44 (London: John Calder, 1991), p. 46.
2 Lionel Carley (ed.), *Delius: A Life in Letters* (Aldershot: Scolar, 1988), p. 57.
3 János Demény (ed.), *Béla Bartók Letters* (London: Faber, 1971), p. 111.
4 Balázs (the Hungarian version of Blaise) was born in 1884 as Herbert Bauer.
5 Demény: *Béla Bartók Letters*, pp. 123–4.
6 Demény: *Béla Bartók Letters*, p. 132.
7 György Kroó, 'Duke Bluebeard's Castle', *Studia Musicologica Academiae Scientarum Hungaricae* 1/3–4 (1961), p. 270.
8 The play is mentioned in a piece by Balázs on Maeterlinck published in *Nyugat*, 8 (1908), <http://epa.oszk.hu/00000/00022/nyugat.htm> (accessed 23 January 2006).
9 Carl S. Leafstedt, *Inside Bluebeard's Castle: Music and Drama in Béla Bartók's Opera* (Oxford: Oxford University Press, 1999), p. 39. The quotation is taken from an article on Maeterlinck published by Balázs in the first volume of the journal *Nyugat* ('The West') in January 1908.
10 Béla Bartók, *Bluebeard's Castle*, English trans. Christopher Hassall (Vienna: Universal Edition, 1952), p. 1.
11 Leafstedt: *Inside Bluebeard's Castle*, p. 202. Translated by Leafstedt.
12 Cited in Kroó: 'Duke Bluebeard's Castle', pp. 217–18. *Bécsi Magyar Újság* was the Viennese Hungarian News—the political newspaper of radical and Communist exiles from Miklós Horthy's right-wing Hungarian regime.
13 Kroó: 'Duke Bluebeard's Castle', p. 217. The Székely region of Transylvania now lies in Romania.
14 Bartók: *Bluebeard's Castle*, p. 5.
15 Carl S. Leafstedt, 'Judith in "Bluebeard's Castle": The Significance of a Name', *Studia Musicologica Academiae Scientarum Hungaricae* 36/3–4 (1995), Proceedings of the International Bartók Colloquium, Szombathely, 3–5 July 1995, Part I, p. 430.
16 Sigmund Freud, *The Taboo of Virginity* [1917], trans. Joan Riviere, in *On Sexuality*, Pelican Freud Library, vol. 7, ed. Angela Richards (London: Penguin, 1997), p. 281.
17 Leafstedt: *Inside Bluebeard's Castle*, p. 44.
18 Bartók: *Bluebeard's Castle*, pp. 17–18.
19 Bartók: *Bluebeard's Castle*, pp. 167–70.
20 Kroó: 'Duke Bluebeard's Castle', p. 303. That Bartók should dedicate his only opera—which apparently warns lovers not to attempt to learn too much about their partners, and (at least for Kroó) stresses the isolation of the creative artist—

to his first wife, Márta Ziegler, whom he had married in the autumn of 1909, might tempt a crass autobiographical interpretation, but there seems to be too little solid evidence to support such a reading. What is absolutely certain however is that she was very closely involved in the preparation of the score, acting as Bartók's copyist in the lengthy period leading to its realization. Three of the various manuscript sources of the work are in her hand: a copy of the vocal score which was used by Universal Edition as an engraver's copy; a copy of the full orchestral score; and a copy of the second version of the opera's ending. See Leafstedt: *Inside Bluebeard's Castle*, pp. 128–130.

21 Susan McClary, *Feminine Endings: Music, Gender and Sexuality* (Minnesota: University of Minnesota Press, 1991), p. 4.

22 Bartók: *Bluebeard's Castle*, pp. 159–60.

23 See David Cooper, 'Bartók's Orchestral Music and the Modern World', in A. Bayley (ed.), *The Cambridge Companion to Bartók* (Cambridge: Cambridge University Press, 2001), pp. 45–61. Judit Frigyesi argues that Bartók derives processes of transformation from *verbunkos*. See Chapter 8 of her *Béla Bartók and turn-of-the-century Budapest* (Berkeley: University of California Press, 1997).

24 Bartók: *Bluebeard's Castle*, p. 94. For a discussion of *Style hongrois* characteristics, see Jonathan Bellman, 'Toward a Lexicon for the *Style hongrois*', *The Journal of Musicology* 9/2 (1991), pp. 214–37.

25 See David Cooper, *Bernard Herrmann's* The Ghost and Mrs Muir: *A Film Score Guide* (Lanham: Scarecrow, 2005), pp. 20–28.

26 See, for example, Fred Lerdahl and R. Jackendoff, *A Generative Theory of Tonal Music* (Cambridge: MIT Press, 1983), and Fred Lerdahl, *Tonal Pitch Space* (New York: Oxford University Press, 2001). Research by Anirudh D. Patel offers evidence from neuroimaging data that suggests a correspondence between syntactic processing of linguistic and musical syntax. 'Language, Music, Syntax, and the Brain', *Nature Neuroscience* 6/7 (2003), pp. 674–81.

27 Except perhaps for intramusical ones such as resolution, relative tension or closure, which are in fact probably better understood as syntactical elements.

28 Cooper: *Bernard Herrmann's* The Ghost and Mrs Muir, p. 20.

29 Cooper: *Bernard Herrmann's* The Ghost and Mrs Muir, p. 22.

30 Gino Stefani, 'A Theory of Musical Competence', *Semiotica* 66/1–3 (1987), pp. 9–15.

31 In equal temperament, the frequency of the F# equals the frequency of the lower C multiplied by $2^{0.5}$.

32 Bartók: *Bluebeard's Castle*, pp. 103–4.

33 One might consider this a translation of a graphic representation of the involuntary movement of the shoulders in response to cold or fear, into a musical gesture (a rapid down-up-down-down figure).

34 *Tremolo* is the Italian for trembling or shivering—a very rapid reiteration of a pitch. *Sul ponticello* literally means bowing *on* the bridge of the instrument, but in practice this involves playing close to it, an effect which produces an odd timbre with prominent high harmonics.

35 Sándor Veress, 'Bluebeard's Castle', *Tempo* 13 (1949), pp. 32–7 and 14 (1949–50), pp. 25–35.

36 Veress: 'Bluebeard's Castle', p. 27.

37 Bruno Bettelheim, *Uses of Enchantment: The Meaning and Importance of Fairy Tales* (London: Penguin, 1978), pp. 300–1.

38 See Sigmund Freud, *The Dissolution of the Oedipus Complex* [1924], trans. Joan Riviere, in *On Sexuality*, Pelican Freud Library, vol. 7, ed. James Strachey and Angela Richards (London: Penguin, 1997), pp. 315–22. It should be noted that this article postdates *Bluebeard's Castle*, both play and first draft of the opera, by more than fourteen years. It is also arguable that the blood motif is intended to encode Judith's hysterical response to blood, which in Freudian terms calls to mind the taboo of menstruation.

39 Leafstedt: *Inside Bluebeard's Castle*, p. 180.

40 In fact bells normally have an unusual harmonic profile with a minor rather than major third.

41 One could usefully compare the textures in this section with those found in Stravinsky's 1910 ballet *The Firebird*.

42 Demény: Béla Bartók Letters, p. 83.

43 Bartók: *Bluebeard's Castle*, pp. 20–21.

44 Frigyesi: *Béla Bartók and turn-of-the century Budapest*, p. 241.

45 The fifth strophe of the prologue in the word-for-word translation given at the back of the Universal Edition study score (UE13641). Bartók: *Bluebeard's Castle*, unpaginated final recto and verso pages.

Chapter 4. A Tale of an Eye

1 Béla Bartók, *Bluebeard's Castle*, English trans. Christopher Hassall (Vienna: Universal Edition, 1952).

2 E. Sidney Hartland, 'The Forbidden Chamber', *Folk-lore Journal* 3 (1885), p. 193.

3 Marguerite Loeffler-Delachaux, *Le Symbolisme Des Contes De Fées* (Paris: L'Arche, 1949), pp. 98–9.

4 Mircea Eliade, *Rites and Symbols of Initiation* (New York: Harper & Row, 1958), p. 8.

5 Eliade: *Rites and Symbols of Initiation*, pp. 28–9.

6 '[…] the monthly segregation of women is a custom documented principally among nomadic hunters and pastoral peoples, that is, in societies that deal with animals and their products (meat, milk) and in which menstrual blood is regarded as unlucky; whereas the initiatory segregation of girls is a custom peculiar to matriarchal societies.' Eliade: *Rites and Symbols of Initiation*, p. 44.

7 Eliade: *Rites and Symbols of Initiation*, p. 47.

8 Paul Saint-Yves, *Les Contes De Perrault Et Leurs Récits Parallèles* (Paris: Emile Nourry, 1923), p. 380.

9 Saint-Yves: *Les Contes De Perrault*, p. 382.

10 Marc Soriano, *Les Contes De Perrault: Culture Savante Et Traditions Populaires* (Paris: Gallimard, 1996), p. 164.

11 Sigmund Freud, 'The "Uncanny"' [1919], trans. Joan Riviere, in *The Standard Edition of the Complete Psychological Works of Sigmund Freud*, vol. 17, ed. James Strachey (London: Hogarth, 1955) p. 222.

12 'D'abord elle ne vit rien, parce que les fenêtres étaient fermées; avec quelques moments elle commença a voir que la plancher était tout couvert de sang caillé, et que dans ce sang se miraient les corps de plusieurs femmes mortes et attachées le long des murs (c'étaient toutes les femmes que la Barbe Bleue avait épousées

et qu'il avait égorgées l'une après l'autre). Elle pensa mourir de peur [...]' Charles Perrault, *Contes*, ed. Marc Soriano (Paris: Flammarion, 1991) p. 263. Translation mine.

13 Philip E. Lewis, *Seeing through the Mother Goose Tales: Visual Turns in the Writings of Charles Perrault* (Stanford: Stanford University Press, 1996), p. 213.

14 E. T. A. Hoffmann, *Tales of Hoffmann*, trans. R. J. Hollingdale (Harmondsworth: Penguin, 1982), p. 87.

15 Hoffmann: *Tales of Hoffmann*, p. 88.

16 Hoffmann: *Tales of Hoffmann*, p. 91.

17 Jane Marie Todd, 'The Veiled Woman in Freud's "Das Unheimliche"', *Signs* 11/3 (1986), p. 521.

18 A comical scene in *The Sandman* describes the anxieties of young men unsure as to whether or not their own fiancées are automata. 'To counter any suspicion, there was an unbelievable amount of yawning and no sneezing at all the tea-circles.' Hoffmann: *Tales of Hoffmann*, p. 122.

19 Todd: 'The Veiled Woman', p. 523.

20 Sigmund Freud, 'Fetishism' [1927], trans. Joan Riviere, in *The Standard Edition of the Complete Psychological Works of Sigmund Freud*, vol. 21, ed. James Strachey (London: Hogarth, 1955) p. 162.

21 Hoffmann: *Tales of Hoffmann*, p. 123.

22 Soriano comments on the unexpected appearance of Sister Anne. See Soriano: *Les Contes De Perrault*, p. 165.

23 Samuel Weber, 'The Sideshow, Or: Remarks on a Canny Moment', *MLN* 88 (1973), pp. 1102–33.

24 Auguste Villiers de l'Isle Adam, *Claire Lenoir Et Autres Contes Insolites* (Paris: Flammarion, 1984), p. 121.

25 Weber: 'The Sideshow', p. 1130.

26 Mererid Puw Davies, *The Tale of Bluebeard in German Literature from the Eighteenth Century to the Present* (Oxford: Oxford University Press, 2001).

27 Carl S. Leafstedt, *Inside Bluebeard's Castle: Music and Drama in Béla Bartok's Opera* (New York: Oxford University Press, 1999), p. 185.

28 Oscar Wilde, *Lady Windermere's Fan; Salome; A Woman of No Importance; An Ideal Husband; The Importance of Being Earnest*, ed. Peter Raby (Oxford: Clarendon, 1995), p. 74.

29 Béla Balázs, *A kékszakállu herceg vara* [1810], parallel text Hungarian and English libretto, trans. John Lloyd Davies, in Nicholas John (ed.), *The Stage Works of Béla Bartók*, English National Opera Guide 44 (London: John Calder, 1991), p. 60.

30 See William I. Brustein, *Roots of Hate: Anti-Semitism in Europe before the Holocaust* (Cambridge: Cambridge University Press, 2003), esp. chapter 2.

Chapter 5. Hidden Debates Under a Baroque Surface

I wish to thank Mererid Puw Davies for many ideas and hints. Additional thanks to Tirdad Zolghadr for advice regarding writing this text in English. Unless otherwise stated, all English translations are my own.

1 Jacques Deslandes, *Le boulevard du cinéma à l'époque de Georges Méliès* (Paris: Les éditions du cerf, 1963), pp. 15–31. The American magician Harry Houdini chose his name as a reference to Robert Houdin.

2 'Georges Méliès', *Internet Movie Database*, <http://www.imdb.com/name/nm 0617588/> (accessed 28 July 2007). See also Ephraim Katz, Fred Klein, Ronald Dean Nolden, *The Macmillan International Film Encyclopedia*, 4th edn (London: Macmillan, 2001), pp. 928–30.

3 Tom Gunning, 'The Cinema of Attractions: Early Film, Its Spectator and the Avant-Garde', in Thomas Elsaesser and Adam Barker (eds), *Early Cinema: Space, Frame, Narrative* (London: BFI, 1990), pp. 56–62).

4 Gunning: 'Cinema of Attractions'.

5 Despite his other innovations Méliès never started to move the camera and this is perhaps one reason that led to the end of his film production in 1913.

6 'Celui qui compose un sujet cinématographique de fantaisie doit être un artiste épris de son art […], cherchant avant tout à faire disparaître le squelette du scénario sous les délicates arabesques dans lesquelles on l'enveloppe […]. C'est toujours à cela que je me suis attaché et c'est encore ma passion et ma joie.' Deslandes: *Le boulevard du cinéma*, p. 23.

7 In 1898 the British film pioneer George Albert Smith made the silent film *Faust and Mephistopheles* in the UK, and was also a direct concurrent of Méliès regarding movie tricks. Méliès made two more films about Faust (1898, 1903), a popular story at that time, in Paris for example, with operas by Hector Bérlioz (1828 and 1846), Charles Gounod (1859) and Hervé (1869).

8 'Méliès and Early Films', *The Missing Link* <http://www.mshepley.btinternet.co.uk/melies2.htm> (accessed 28 July 2007).

9 The Bibliothèque nationale de France keeps records on many of these. Some versions of possible interest cannot be discussed here, e.g. *Mahomet Barbe-bleue ou La Terreur des Ottomanes* by Oury and Merle (Paris, Théâtre des Variétés, premiere 1811), *Madame Barbe-bleue* by Lockroy-Choquart (Paris, Théâtre du Vaudeville, premiere 1843), or *Barbe Bleuette* by Najac and Thomé (Paris, Hôtel Continental, premiere 1889).

10 Eugène Sue, *Le Morne-au-Diable* [1842] (Paris: Ernest Flammarion, [n.d.]). English translation: Eugène Sue, *The Female Bluebeard or the Adventurer* (London: W. Strange, 1845).

11 'C'est tout simple; cette pauvre femme-là n'a pas d'idée de ce que c'est qu'un aimable et galant gentilhomme.' Sue: *Le Morne-au-Diable*, p. 20.

12 'Mordioux! je vais la voir, lui plaire, la séduire. Pauvre femme… elle ne se doute pas que son vainqueur est à sa porte! […] le bonheur lui arrive sur les ailes de l'amour.' Sue: *Le Morne-au-Diable*, p. 63.

13 Jacques Offenbach, *Barbe-bleue, Opéra-bouffe en 3 actes* (Paris Théâtre des Variétés, premiere 1866).

14 'Gerade in diesem Gaukelspiel aber, dieser jähe Umschlag von Szenen der Todesfurcht in ausgelassene Lustigkeit antwortete dem Verlangen des Publikums, sich über die schreckliche Katastrophe hinwegzusetzen, die es vorausahnte. […] Die Operette gewährte—ein weiterer Grund ihres Erfolges—dem demokratischen Lebensgefühl breiten Raum.' Siegfried Kracauer, *Jacques Offenbach und das Paris seiner Zeit* [1937] (Frankfurt am Main: Suhrkamp, 1976), p. 258.

15 Amanda Holden (ed.), *The New Penguin Opera Guide* (London: Penguin, 2001), pp. 640–41; Volker Klotz, *Operette. Porträt und Handbuch einer unerhörten Kunst* (Kassel: Bärenreiter, 2004), pp. 589–97.

16 Joris-Karl Huysmans, *Là-bas* [1891] (Paris: Librairie Plan 1966).

17 Huysmans: *Là-bas*, p. 17.

18 Georges Méliès: *Barbe-bleue*. (France, black and white, silent) part of *Méliès Magic Show*, fifteen short films by Georges Méliès (1997 Société Méliès), on the French–English DVD package, *Méliès the Magician* (Arte France Développement, 2001). The first version of a film called *Barbe-bleue* is kept at the Bibliothèque du film in Paris, a one-minute filmlet made by Les Frères Lumières from 1897. After Méliès, the Frères Pathé realized *Barbe Bleue* in 1907, a film which is still conserved at the British Film Institute in London, followed by versions by J. Searle Dawley (1909) and Edison Manufacturing Company (1909) in the USA—neither of which I have yet located.

19 Jacques Mény, *The Magic of Méliès*, 130 min (Paris: Sodaperaga, 1997), part of the French–English DVD package, *Méliès the Magician* (Paris: Arte France Développement, 2001).

20 'Méliès and Early Films', as cited in n. 8.

21 'Das scheint mir eine reine Schikanerie und eine Beleidigung, grad so, als wenn mir einer ein Bierkrug zum Trinken vorsetzen tät, in dem nix drin wär. Eine Beleidigung und Blamasch! Das tät ich einmal nit leiden.' Franz Graf von Pocci, 'Blaubart' [1859], in *Lustiges Komödienbüchlein* (Leipzig: Insel, 1907), p. 91.

22 'D'abord elle ne vit rien, parce que le fenêtres étaient fermées; après quelque moments elle commença à voir que le plancher était tout couvert de sang caillé, et que dans ce sang se miraient les corps de plusieurs femmes mortes et attachées le long des murs (c'était toutes le femmes que la Barbe Bleue avait épousées et qu'il avait égorgées l'une après l'autre).' Charles Perrault, 'La Barbe Bleue' [1697], in *Contes*, ed. Jean-Pierre Collinet (Paris: Gallimard, 1981), p. 151.

23 In Perrault's version, the key is bewitched, for which the expression is used 'la clé était Fée' (Perrault: 'La Barbe Bleue', p. 151). It is therefore remarkable that the godmother first seems to step out of the giant key.

24 Darragh O'Donoghue, 'Georges Méliès', <http://www.sensesofcinema.com/contents/directors/04/melies.html> (accessed 28 July 2007).

25 Perrault: 'La Barbe Bleue', p. 153. *Dragon*: cavalryman on a lighter horse. *Mousquetaire*: foot soldier armed with a musket. Both are soldiers of the centralized and absolute kingdom of France against the obsolete and isolated Bluebeard. By killing him, they also kill his old-fashioned way of executing his antiquated rules and punishment system, replacing them by a new *Weltanschauung*.

26 Guy Gauthier, 'Von Jules Verne zu Méliès oder Von der Gravur zur Leinwand', in F. Kessler, S. Lenk, and M. Loiperdinger (eds), *Georges Méliès: Magier der Filmkunst* (Basel, Frankfurt am Main: Stroemfeld/Roter Stern, 1993), pp. 53–8.

27 Maurice Maeterlinck, 'Ariane et Barbe-bleue', in *Aglavaine et Sélysette, Ariane et Barbe-bleue, Soeur Béatrice* (Bruxelles: P. Lacombiez; Paris: P. Lamm, 1901). German translation: Maurice Maeterlinck, *Blaubart und Ariane oder die vergebliche Befreieung*, in *Zwei Singspiele*, trans. Friedrich von Oppeln-Bronikowski (Jena: Eugen Dietrichs, 1901).

28 Michel Corvin, *Le théâtre de Boulevard* (Paris: Presses Universitaires de France, 1989), p. 8.

Chapter 6. *Hommes Fatals*

1 Bureau of Justice Statistics Crime Data Brief, 'Intimate Partner Violence, 1993–2001', February 2003, cited in 'Abuse in America' *The National Domestic Violence Hotline*, <http://www.ndvh.org/educate/abuse_in_ america.html> (accessed 1

August 2008). Among all female murder victims in 1995, 26 per cent were slain by husbands or boyfriends, while 3 per cent of the male victims were slain by wives or girlfriends. FBI statistics, <http://www.fbi.gov/ucr/ucr95prs. htm> (accessed 1 August 2008).

2 Gayatri Chakravorty Spivak, 'French Feminism in an International Frame', in *In Other Worlds: Essays in Cultural Politics* (London and New York: Methuen, 1987), p. 150.

3 Teresa de Lauretis, *Technologies of Gender: Essays on Theory, Film and Fiction* (Basingstoke: Macmillan, 1987), p. 5.

4 For the idea of rape as a form of murder of the self, see Mieke Bal, *Reading Rembrandt: Beyond the Word/Image Opposition* (Cambridge: Cambridge University Press, 1991), pp. 60–93.

5 Susan Brownmiller, *Against Our Will: Men, Women and Rape* (London: Secker and Warburg, 1975).

6 In the play/film script, the direct Bluebeard reference in Agatha Christie's text has been removed. In her short story, the wife's anxious curiosity about her husband's earlier love life solicits from him a grave question about the dangers of her pursuing this Bluebeard's bloody chamber stuff. In saying this, he is unconsciously admitting to a murderous past which she does not yet fully suspect.

7 Gayle Rubin, 'The Traffic in Women: Notes on the "Political Economy" of Sex', in Rayna R. Reiter (ed.), *Toward an Anthropology of Women* (New York: Monthly Review, 1975) pp. 157–210.

8 Vladimir Propp, *Morphology of the Folktale* [1958], trans. Laurence Scott, ed. Louis A. Wagner (Austin: University of Texas Press, 1968).

9 Rubin: 'The Traffic in Women', p. 183.

10 Sigmund Freud, 'Totem and Taboo' [1913], trans. James Strachey and Anna Freud, in *The Origins of Religion*, Pelican Freud Library, vol. 14, ed. Albert Dickson (London: Penguin, 1985), pp. 43–224.

11 See John Fletcher and Martin Stanton (eds), *Jean Laplanche: Seduction, Translation, Drives* (London: Institute of Contemporary Arts, 1992).

12 Gilles de Rais was executed in 1440. There is no consensus amongst modern historians about the truth of his crimes which some number at 800 sexually motivated murders. For a significant study of the still controversial documents, see Georges Bataille, *The Trial of Gilles de Rais*, trans. R. Robinson (New York: Amok, 1991).

13 Sigmund Freud, 'Three Essays on the Theory of Sexuality' [1905], trans. James Strachey, in *On Sexuality*, Pelican Freud Library, vol. 7, ed. Angela Richards (London: Penguin, 1977), pp. 33–170.

14 Luce Irigaray, 'Women on the Market', in *This Sex which is not One* [1977], trans. Catherine Porter and Carolyn Burke (Ithaca: Cornell University Press, 1985), p. 187.

15 Irigaray: 'Women on the Market', p. 186.

16 Irigaray: 'Women on the Market', p. 186.

17 Freud: 'Three Essays', pp. 128–38.

18 Victor Klemperer, *The Language of the Third Reich: A Philologist's Notebook* [1957], trans. Martin Brady (London: Continuum, 2006).

19 Barbara Ehrenreich, 'Foreword', in Klaus Theweleit, *Male Fantasies I: Women, floods, bodies, history*, trans. Stephen Conway (Cambridge: Polity Press, 1987), p. ix.

20 Ehrenreich: 'Foreword', pp. xi–xii.

21 Ehrenreich: 'Foreword', p. xv.

22 Ehrenreich: 'Foreword', p. xv.

23 Angela Carter, 'The Bloody Chamber', in *The Bloody Chamber and Other Stories* (London: Penguin, 1979), p. 40.

Chapter 7. The Enigma of Homecoming

1 Vivian Sobchack, 'Lounge Time: Postwar Crises and the Chronotope of *Film noir*', in Nick Browne (ed.), *Refiguring American Film Genres: Theory and History* (Chicago: University of Chicago Press, 1986), p. 130. For an overall discussion of the emergence and development of film noir, see James Naremore, *More Than Night: Film noir in its Contexts* (Berkeley: University of California Press, 1998) and see a discussion of the change in women's economic and social power with the onset of the war, in Phil Hardy (ed.), *The BFI Companion to Crime* (London: Cassell, 1997). For a discussion of the historical context of film noir, see Michael Walker '*Film noir:* Introduction', in Ian Cameron (ed.), *The Movie Book of Film noir* (London: Studio Vista, 1992), pp. 8–37.

2 Paul Schrader tellingly argues that a further explanation for the resilience of noir style in post-war Hollywood was the presence of immigrant actors, directors, screenplay writers, and technicians, whose own loss of home brought with it not only the cultural pessimism underwriting many of the noir scripts and whose schooling in German Expressionism inflected the visual style of distortion privileged by noir. As Schrader explains, 'When in the late Forties, Hollywood decided to paint it black, there were no greater masters of chiaroscuro than the Germans.' Paul Schrader, 'Notes on *Film noir*', in Alain Silver and James Ursini (eds), *Film noir Reader* (New York: Limelight, 1996), p. 55.

3 Sobchack: 'Lounge Time', p. 131.

4 Richard Maltby, 'The Politics of the Maladjusted Text', in Ian Cameron (ed.), *The Movie Book of Film noir* (London: Studio Vista, 1992), pp. 39–48.

5 It might be fruitful to crossmap William Wyler's *The Best Years of Our Lives* (1946), a fictional cinematic refiguration of the veterans' difficult return home, onto John Huston's *Let There Be Light* (1946), documenting the efforts—but implicitly also the failure—of the rehabilitation clinics set up after the war to treat traumatized veterans and make them fit enough to return home. The fact that Huston's documentary, commissioned by the US War Department, was never released suggests that although his film was conceived as part of an ideology of reintegration, it also portrayed the impossibility of truly effacing the traces of war trauma.

6 Willard Waller, *The Veteran Comes Home* (New York: Dryden, 1944), p. 13, cited in Dana Polan, *Power and Paranoia: History, Narrative, and the American Cinema, 1940–1950* (New York: Columbia University Press, 1986), p. 246.

7 Polan: *Power and Paranoia*, p. 247. For a discussion of film noir as a cultural negotiation of changes in images of masculinity brought about by the end of the war, see Frank Krutnik, *In a Lonely Street: Film noir, Genre, Masculinity* (New York and London: Routledge, 1991).

8 Benjamin Bowker, *Out of Uniform* (New York: Norton, 1946), p. xi, cited in Polan: *Power and Paranoia*, p. 247.

9 Polan: *Power and Paranoia*, p. 253.

10 Sobchack: 'Lounge Time', p. 166.

11 Deborah Thomas, 'How Hollywood Deals with the Deviant Male', in Ian Cameron (ed.), *The Movie Book of Film noir* (London: Studio Vista, 1992), pp. 50–70.

12 Gaston Bachelard, *The Poetics of Space: The Classic Look at How We Experience Intimate Places*, trans. Martia Jolas (Boston: Beacon, 1994), p. xxxvii.

13 I take the crossmapping between Bachelard's equation of home and psychic abodes and the scenarios of homelessness celebrated by film noir from Sobchack's historical and cultural contextualization of film noir in 'Lounge Time', even though she does not consider Fritz Lang's *Secret Beyond the Door*. For a discussion of the seminality of homelessness in film noir, see also Dean MacCannell, 'Democracy's Turn: On Homeless Noir', in Joan Copjec (ed.) *Shades of Noir* (New York: Verso, 1993), pp. 279–97.

14 Sigmund Freud, 'Beyond the Pleasure Principle' [1920], trans. James Strachey, in *The Standard Edition of the Complete Psychological Works of Sigmund Freud*, vol. 18, ed. James Strachey (London: Hogarth, 1955), p. 15 ff. See also my own discussion of the conjunction between representations of feminine death and the *fort–da* game in Elisabeth Bronfen, *Over Her Dead Body: Death, Femininity, and the Aesthetic*, rev. edn (Manchester: Manchester University Press, 1996), pp. 15–38.

15 Elizabeth Cowie, '*Film noir* and Women', in Joan Copjec (ed.), *Shades of Noir* (New York: Verso, 1993), pp. 148–50, highlights the proximity between *Secret Beyond the Door* and the bluebeard fairy tale, as does Tom Gunning, in *The Films of Fritz Lang: Allegories of Vision and Modernity* (London: BFI, 2000), who argues that Lang stages female agency uncovering male guilt.

16 Mary Ann Doane, *The Desire to Desire: The Woman's Film of the 1940s* (Basingstoke: Macmillan, 1988), p. 134.

17 As Michael Walker notes, Lang's *Secret Beyond the Door* recalls not only Hitchcock's repeated appropriation of psychoanalytic tropes but also the manner in which Freudian discourse had taken hold of Hollywood's cinematic language by the 1940s, in large part because of the European psychoanalysts who had immigrated to California. Walker: '*Film noir*'.

18 Peter Bogdanovich, *Fritz Lang in America* (London: Studio Vista, 1967), p. 73. See also Tom Gunning's discussion of the way *Rebecca* served as Fritz Lang's source of inspiration, even though the appropriation and incorporation was by no means a simple gesture of plagiarism; Gunning: *The Films of Fritz Lang*, pp. 345–8.

19 Gunning: *The Films of Fritz Lang*, p. 350.

20 Karin Hollinger, '*Film noir*, Voice-over, and the *Femme Fatale*', in Alain Silver and James Ursini (eds), *Film Noir Reader* (New York: Limelight, 1997), p. 257. For a more general discussion of the feminine voice-over, see Kaja Silverman, *The Acoustic Mirror: The Female Voice in Psychoanalysis and Cinema* (Bloomington: Indiana University Press, 1988).

21 Lotte Eisner, *Fritz Lang* (New York: Da Capo, 1976), p. 275.

22 See Michel Chion, *The Voice of Cinema*, trans. Claudia Gorbman (New York: Columbia University Press, 1999).

23 Slavoj Žižek, 'I Hear You with My Eyes: or, the Invisible Master', in Renata Salecl and Slavoj Žižek (eds), *Gaze and Voice as Love Objects* (Durham: Duke University Press, 1996), p. 93.

24 Gunning: *The Films of Fritz Lang*, p. 352.

25 Mladen Dolar, 'At First Sight', in Renata Salecl and Slavoj Žižek (eds), *Gaze and Voice as Love Objects* (Durham: Duke University Press, 1996), pp. 130–31.

26 Dolar: 'At First Sight', p. 142.

27 With Mark's architectural theory, Fritz Lang offers a noir inflection of the affec-
 tive value of rooms and other modes of abode that Gaston Bachelard discusses
 as a topophilia concerned with felicitous space. For Bachelard, poetics of space
 is also concerned with determining 'the human value of the sorts of space that
 may be grasped, that may be defended against adverse forces, the space of love',
 admitting, however, that, attached to its positive value, other imagined values
 might well become dominant. It is the force of the imagination that renders
 homes, conventionally perceived as eulogized spaces, uncanny, precisely because
 'space that has been seized upon by the imagination cannot remain indifferent
 space […] it has been lived in, not in its positivity, but with all the partiality of the
 imagination'; Bachelard: *The Poetics of Space*, p. xxxvi. It is precisely this dark yet
 unavoidable force that Lang explores in the analogy he presents between the psy-
 chic apparatus and the uncanny home of his noir couple.

28 Reynold Humphries, *Fritz Lang: Genre and Representation in His American Films* (Bal-
 timore: John Hopkins University Press, 1989), p. 150. Tom Gunning rightly notes
 that once *Secret Beyond the Door* is crossmapped onto *Rebecca* we notice a significant
 difference in the presentation of the uncanny rooms that the two films' death-
 possessed protagonists, Mark and Danvers, show to the respective young brides.
 The invisible presence invoked by Mark is not a person but rather a 'past incident,
 a murder', the scene of violence, not 'the object of death'. Gunning: *The Films of
 Fritz Lang*, p. 366.

29 Humphries: *Fritz Lang*, p. 155.

30 Gunning: *The Films of Fritz Lang*, p. 356. Here Gunning argues against the point
 made by Mary Ann Doane, who equates the end of Celia's voice-over with the
 death of female subjectivity, as well as against Stephen Jenkins's contention that
 the film actually investigates Celia, solves her mystery, and ends by fixing her in
 her place 'within the terms of its order'. See Stephen Jenkins, 'Lang: Fear and
 Desire', in S. Jenkins (ed.), *Fritz Lang: The Image and the Look* (London: BFI, 1981),
 p. 104.

31 Gunning: *The Films of Fritz Lang*, p. 361.

32 Michael DuPlessis compares this final tableau to a pietà composition, with Celia
 'looking down at him with "maternal" solicitude', Michael DuPlessis, 'An Open
 and Shut Case: *Secret Beyond the Door*', *Spectator* 19/2 (1990), pp. 5–23.

33 Dolar: 'At First Sight', pp. 149–50.

Chapter 8. Dying for Art

I am grateful to Steve Crook for generous assistance with access to Michael Powell's
Duke Bluebeard's Castle; and to Thelma Schoonmaker-Powell and the Powell Estate for
permission to consult and reproduce notes and sketches from the production held in
BFI Special Collections.

1 Translation by Nicolas Vázsonyi, in his article '*Bluebeard's Castle:* The Birth of Cin-
 ema from the Spirit of Opera', *Hungarian Quarterly* 46/178 (2005), <http://www.
 hungarianquarterly.com/no178/17.html> (accessed 4 August 2007).

2 On cinema's relationship to earlier arts, see Terry Ramsaye, *A Million and One
 Nights: A History of the Motion Picture Through 1925* [1926] (New York: Simon &
 Schuster, 1986), esp. 'The Prehistory of the Screen', and chapter 1, 'From Aris-

totle to Philadelphia'. See also Nicholas Vardac, *Stage to Screen. Theatrical Origins of Early Film: David Garrick to D. W. Griffith* [1949] (New York: Da Capo Press, 1987).

3 On Schoenberg's unrealized hope to incorporate film in his experimental opera, see my account: Ian Christie, 'Film as a Modernist Art', in Christopher Wilk (ed.), *Modernism: Designing a New World* (London: V&A Publications, 2006), p. 299.

4 Joseph H. Auner, 'Arnold Schoenberg: Begleitmusik zu einer Lichtspielszene (1930)', *American Symphony Orchestra: Dialogues & Extensions*, <http://www.americansymphony.org/dialogue.php?id=268&season=1998-1999 (accessed 29 July 2008).

5 Berg's opera, left unfinished at his death in 1935 but subsequently completed by Friedrich Cerha in 1979, calls for a silent film as an interlude in Act II, covering Lulu's arrest, imprisonment and escape from prison.

6 Leon Botstein, 'Der Rosenkavalier: The Silent Film', *American Symphony Orchestra: Dialogues & Extensions*, <http://www.americansymphony.org/dialogue.php?id=387&season=1993-1994 (accessed 29 July 2008). Botstein's claims, however, were disputed by a *New York Times* critic, Alex Ross, 'Review/Music; "Rosenkavalier", the film, in Reconstruction', *New York Times*, 25 December 1993, <http://query nytimes.com/gst/fullpage.html?res=9F0CE3D81030F936A15751C1A965958 260> (accessed 29 July 2008).

7 A similar fate befell Grigori Kozintsev and Leonid Trauberg's 1929 film *The New Babylon*, with its Modernist score by the young Dimitri Shostakovich, which had a disastrous premiere and was largely forgotten until the 1980s.

8 Kevin Brownlow's reconstruction of *Napoleon* owed much of its popular success to Carl Davis's new score (and less to Carmine Coppola's rival score), rather than the original by Honegger. On the revival of interest in new and original scores for silent films, see Ian Christie, 'Sounds for Silents', *Sight and Sound* 3/3 (1993), pp. 18–21.

9 See, for instance, Kenneth Macpherson, 'As Is: By the Editor', *Close Up* 5/1 (1929), pp. 7–8.

10 Macpherson again, just months later, after seeing Hitchcock's *Blackmail*, in Kenneth Macpherson, 'As Is: By the Editor', *Close Up* 5/4 (1929), pp. 257–63. See also Eisenstein's hope to add a 'counterpoint' soundtrack to *The General Line*, documented in Jay Leyda and Zina Voynow, *Eisenstein at Work* (London: Methuen, 1985), pp. 38–40.

11 Christie: 'Film as a Modernist Art', pp. 306–7.

12 Ramsaye: *Million and One Nights*, p. xiii.

13 Richard Wagner, *The Art-Work of the Future*, trans. William Ashton Ellis, Richard Wagner's Prose Works, vol. 1, ed. William Ashton Ellis (London: Routledge and Kegan Paul, 1892), pp. 183–4.

14 This link may have been first made in publicity for the new Gloria–Palast cinema in Berlin in 1926, according to Janet Ward, 'Kracauer versus the Weimar Film-City', in Kenneth S. Calhoon (ed.), *Peripheral Visions: the Hidden Stages of Weimar Cinema* (Detroit: Wayne State University Press, 2001), p. 26.

15 Wagner was the major influence on Appia's conception of modern abstract staging, although he did not design his own *Ring* until near the end of his life in 1925–6. Reinhardt took up many of Appia's principles and added the architectural use of lighting. See Richard C. Beacham, *Adolphe Appia: Artist and Visionary of the Modern Theatre* (Philadelphia: Harwood Academic, 1994), pp. 9–13; 244–46.

16 Balázs quoted in a booklet note by Paul Griffiths for the BBC Proms perform-ance of *Bluebeard's Castle* published on CD (London: Warner Classics, 2005), p. 4.

17 Sergei Eisenstein, 'Dickens, Griffith and the Film Today' [1944], in *Film Form: Essays in Film Theory*, ed. and trans. Jay Leyda (New York and London: Harcourt Brace, 1949), pp. 195–255. The idea of Dickens anticipating and shaping cinema has since been developed in Grahame Smith, *Dickens and the Dream of Cinema* (Manchester: Manchester University Press, 2003).

18 In the sense that a number of works on a similar theme make up a composite or inter-text, as in the 'Petersburg text' outlined in Julian Graffy, 'Zamyatin's "Friend-ship" with Gogol', *Scottish Slavonic Review* 14 (1990), pp. 145–6.

19 On Powell's career, partnerships and reputation, see Ian Christie, *Arrows of De-sire: the Films of Michael Powell and Emeric Pressburger*, 2nd edn (London: Faber, 1994).

20 Details of the series of collaborations between high-profile artists in different media that Powell worked on in the early 1950s appear in the second volume of his memoirs, *Million Dollar Movie* [1992], rev. edn (London: Mandarin, 1993). On *The Golden Years*, see Andrew Moor, 'Autobiography, the self and Pressburger–Powell's *The Golden Years* project', *Screen* 46/1 (2005), pp. 15–31. And on the pro-posed collaboration with Glass, see 'Dossier on Michael Powell's Late Projects', *Film Studies* 2 (2001), pp. 99–104.

21 *Luna de Miel* was a Spanish–UK co-production, which includes a performance of *El amor brujo*, danced and choreographed by the flamenco star, Antonio, with Rosita Segovia. *Anna Pavlova*, a USSR–UK co-production directed by Emil Lo-tianou, originated as a project by Powell, although when the production was taken up by Mosfilm, his role was diminished and he is credited only as 'Western Ver-sion Supervisor'.

22 A notable exception, perhaps unsurprisingly, is the article by Bruce Babbington and Peter William Evans, 'Matters of Life and Death in Powell and Pressburger's *The Tales of Hoffmann*', in Jeremy Tambling (ed.), *A Night in at the Opera: Media Representations of Opera* (Luton: John Libbey/Arts Council of Great Britain, 1994), pp. 145–67.

23 Powell: *Million Dollar Movie*, pp. 103, 320. In one of his last public appearances, at the Midnight Sun Festival in Tampere, Finland, in 1987, Powell declared that *The Tales of Hoffmann* was 'probably the best thing I ever did'.

24 For Powell's views in the early 1970s, see the interview by Richard Collins and Ian Christie, 'The Expense of Naturalism: interview with Michael Powell', *Monogram* 3 (1972), pp. 32–8.

25 On the film's sources and interpretation, see Ian Christie, *A Matter of Life and Death* (London: BFI, 2000).

26 For Eisenstein's appreciation of Disney and claim that 'Willie the Whale' had in-fluenced *Ivan the Terrible*, see Sergei Eisenstein, *Eisenstein on Disney*, trans. Alan Up-church, ed. Jay Leyda (London: Methuen, 1988).

27 However, in *The Life and Death of Colonel Blimp* (1943) a theatre visit to *Ulysses* by Stephen Phillips makes an allegorical comment on the hero's predicament as a re-turning soldier. See Michael Powell, *The Life and Death of Colonel Blimp*, ed. Ian Christie (London: Faber, 1994), pp. 273–5.

28 Powell and Pressburger had direct experience of Korda as an impresario, since he had first brought them together in 1939, and would back them again after *The*

Red Shoes caused a rupture with Rank. There is also the intriguing *mise en abyme* of Korda having commissioned a Svengali story for his own wife to perform.

29 *Black Narcissus* had attracted wide acclaim, including an Academy Award for its colour cinematography by Jack Cardiff, and pioneered what Powell would call the 'composed film', fitting images to pre-existing music. See Michael Powell, *A Life in Movies* [1986], 2nd edn (London: Faber, 2000), p. 582.

30 The novel based on the film which Powell and Pressburger co-wrote in the late 1970s is more explicit about such touring Russian companies as a feature of cultural life in the interwar years: 'They were legendary characters, those Russian impresarios [...] First came Diaghilev. He started it all; the others followed.' Michael Powell and Emeric Pressburger, *The Red Shoes* (New York: Avon, 1978), p. 6.

31 Characters risk or sacrifice their lives in the struggle against Nazism in Powell and Pressburger's *49th Parallel* (1942), *One of Our Aircraft is Missing* (1943), *A Matter of Life and Death* (1946), and in their production of *The Silver Fleet* (1943). Powell's motto appears in *A Life in Movies*, p 653.

32 Powell: *A Life in Movies*, p. 631.

33 Dinah Birch, 'A poker inside him' [review], *Times Literary Supplement*, 20 May 2005, p. 3.

34 This account of the ballet draws on a largely technical article on the making of the film, which also contains some unusually precise descriptions of the ballet scenario: George Turner, 'The Red Shoes: A Ballet for Camera', *American Cinematographer* 79/2 (1998), pp. 102–8.

35 *Lady in the Dark*, with songs by Kurt Weill and Ira Gershwin, was filmed by Mitchell Leisen in 1944, starring Ginger Rogers.

36 Andrew Moor, *Powell and Pressburger: A Cinema of Magic Spaces* (London: I.B.Tauris, 2005), pp. 214.

37 Moor: *A Cinema of Magic Spaces*, pp. 213–15.

38 *A Matter of Life and Death* was planned as a film to appear during the war, but was delayed until 1946. On the mythic underpinning of this film, see Christie: *A Matter of Life and Death*, pp. 23–8.

39 In versions of the Faust story, the scholar is tempted by Mephistopheles's displays of power. Svengali is a manipulative hypnotist who gains power over the eponymous singer Trilby in George Du Maurier's 1894 novel.

40 Powell: *A Life in Movies*, p. 629.

41 On antecedents for the film's portrayal of heaven, see Christie: *A Matter of Life and Death*, pp. 23, 47, 76.

42 On techniques used in *The Red Shoes*, see Jack Cardiff, *Magic Hour: the Life of a Cameraman* (London: Faber, 1996), pp. 93–4; Nanette Aldred, 'Hein Heckroth and The Archers', in Ian Christie and Andrew Moor (eds), *The Cinema of Michael Powell: International Perspectives on an English Filmmaker* (London: BFI, 2005), pp. 194–8.

43 Powell's later work has increasingly been linked with the Neo-Romantic movement in British art of the 1940s, which embraced painting, sculpture, poetry, music and dance, but was later marginalized by the rise of neo-modernist movements in the later 1950s. See David Mellor (ed.), *Paradise Regained, The Neo-Romantic Imagination in Britain 1935–55* (London: Lund Humphries, 1993). Other examples of this Neo-Romanticism in cinema would include Jean Cocteau's *Orphée* (1950), with its eerie 'zone' serving a similar function to the expanded stage

of the *Red Shoes* ballet, and Albert Lewin's *Pandora and the Flying Dutchman* (1951), also bringing myth into the modern world.

44 For details of these, see Powell: *Million Dollar Movie*, pp. 186–7; also 'Dossier on Michael Powell's Late Projects', pp. 93–9.

45 The *Elusive Pimpernel* was originally conceived as a musical comedy, with lyrics by Denis Arundell, but became instead a picturesque swashbuckler, to Powell's lasting regret. Arundell, however, was asked to prepare the new English libretto of the *Tales of Hoffmann*.

46 The only such case in opera, according to Arthur Jacobs and Stanley Sadie, *The Pan Book of Opera* (London: Pan, 1984), p. 306.

47 Arnold Böcklin, *Toteninsel*, 1880.

48 In, for instance, the narration of Philip Leacock's film, *Festival in London* (1951).

49 George Orwell, 'The Lion and the Unicorn: Socialism and the English Genius' (London: Secker & Warburg, 1941). Text available at <http://www.k-1.com/Orwell/ index.cgi/work/essays/lionunicorn.html> (accessed 14 August 2008).

50 Powell: *Million Dollar Movie*, p. 94.

51 For contemporary music and dance reviews, see *The Musical Times*, June 1951, and three reviews in *Public Opinion*, 24 April 1951. Raymond Durgnat's often-quoted response first appeared in his pioneering article [signed 'O. O. Green'], 'Michael Powell', *Movie* 14 (1965); reprinted in Ian Christie (ed.), *Powell, Pressburger and Others* (London: BFI, 1978), pp. 65–74.

52 Michael Powell and Hein Heckroth, 'Making Colour Talk', *Kinematograph Weekly*, 9 November 1950; reprinted in Kevin Gough-Yates (ed.), *Michael Powell in Collaboration with Emeric Pressburger* (London: BFI, 1971).

53 For an artist's view of early Technicolor, see Paul Nash, 'The Colour Film', in Charles Davy (ed.), *Footnotes to the Film* (London: Lovat Dickson/Readers' Union, 1938), pp. 116–34. In the *Kinematograph Weekly* article (cited above, n. 52) Powell stresses his close liaison with the Technicolor laboratory on saturation.

54 Aldred: 'Hein Heckroth and the Archers', p. 199.

55 Sigmund Freud, 'The Uncanny' [1919], trans. James Strachey, in *Art and Literature*, Penguin Freud Library, vol. 14, ed. James Strachey and Albert Dickson (Harmondsworth: Penguin, 1985), p. 350 ff.

56 Natacha Thiéry, 'That Obscure Object of Desire: Powell's Women, 1945–50', in Ian Christie and Andrew Moor (eds), *Cinema of Michael Powell: International Perspectives on an English Filmmaker* (London: BFI, 2005), pp. 224–38.

57 Thomas Elsaesser, 'The Tales of Hoffmann', *Brighton Film Review* 1 (1968); reprinted in Ian Christie (ed.), *Powell, Pressburger and Others* (London: BFI, 1978), pp. 62–5.

58 Wagner: *Art-Work of the Future*, pp. 206–7.

59 Theodor Adorno, *In Search of Wagner*, trans. Rodney Livingstone (London: New Left, 1981), pp, 101, 106–7. Quoted in Andreas Huyssen, 'Adorno in Reverse', in *After the Great Divide: Modernism, Mass Culture and Postmodernism* (Basingstoke: Macmillan, 1986), pp. 39–41.

60 Miriam Hansen, 'The Mass Production of the senses: classical cinema as vernacular modernism', in Linda Williams and Christine Gledhill (eds), *Reinventing Film Studies* (London: Arnold, 2000), p. 333.

61 On the damning critics' reaction to the film, see Ian Christie, 'The Scandal of *Peeping Tom*', in Ian Christie (ed.), *Powell, Pressburger and Others* (London: BFI, 1978), pp. 53–8.

62 The line spoken by the blind Mrs Stephens, referring to Mark Lewis's obsessive filming, is quoted in Ian Christie and David Thompson (eds), *Scorsese on Scorsese*, 3rd edn (London: Faber, 2003), p. 20.

63 Villiers de l'Isle's Adam's novels *L'Eve future* (1886) and *Axël* (1890) both feature reclusive damaged male heroes; J. K. Huysmans' *A Rebours* (*Against Nature*) (1884) revolves around his fastidious hero Des Esseintes; Edgar Allan Poe's Roderick Usher, in 'The Fall of the House of Usher', the best known of the author's many damaged males, was an influence on French Symbolism (and a late Powell project); Maurice Maeterlinck's *Pelléas et Mélisande* (1892) provided the basis for Debussy's opera, and Maeterlinck also wrote a version of the Bluebeard story, *Ariane et Barbe-bleue* (1901); Hanns Carstop is the convalescent hero of Thomas Mann's *The Magic Mountain* (1924). Most of these, and the Symbolist tradition underpinning them, are discussed in Edmund Wilson, *Axel's Castle* (New York: Scribner, 1931).

64 Franz Wedekind's linked plays *Erdgeist* (*Earth Spirit*) (1895) and *Pandora's Box* (*Die Büchse der Pandora*) (1902) traced the ruinous career of Lulu, who meets her nemesis at the hands of Jack the Ripper in London.

65 Laura Mulvey, 'The Light That Fails: A Commentary on *Peeping Tom*', in Ian Christie and Andrew Moor (eds), *Cinema of Michael Powell: International Perspectives on an English Filmmaker* (London: BFI, 2005), p. 154.

66 Mulvey: 'The Light That Fails', p. 155.

67 The ballet film was *The Sorcerer's Apprentice*, co-produced by Twentieth Century Fox and Norddeutscher Rundfunk in 1956 and filmed in Hamburg. Immediately before this, Heckroth had served as production designer on The Archers' version of *Die Fledermaus, Oh Rosalinda!!* (1955), after a four-year break in their output since *The Tales of Hoffmann*.

68 Letter of 18 May 1963, from correspondence in Powell Papers, BFI Special Collections, Box 123.01.

69 C. G. Jung died in 1961. A television interview by John Freeman in 1959 had made him known to a large audience, and led to a popular illustrated book: C. G. Jung, *Man and His Symbols* (London: Aldus, 1964). A new edition of Jolande Jacobi's standard introduction also appeared in 1962 as a Routledge paperback, with colour illustrations that included 'The Snake of the Passions'. See Jolande Jacobi, *The Psychology of C. G. Jung* [1942] (London: Routledge, 1964), pl. 2, after p. 114.

70 Vázsonyi: '*Bluebeard's Castle*', p. 3.

71 Vázsonyi: '*Bluebeard's Castle*'. Strangely, in view of his overall argument, Vázsonyi refers only in passing to 'the one video' of the work, which is presumably Powell's film.

72 See Ian Christie, 'L'avant-garde internationale et le cinéma', in E. Toulet (ed.), *Le Cinéma au rendez-vous des arts, années 20 et 30*, catalogue of an exhibition by the Bibliothèque nationale de France at the Galerie Colbert, Paris (Paris: Bibliothèque nationale de France, 1995), pp. 68–76.

73 Wagner: *Art-Work of the Future*, p. 193.

74 Jay David Bolter and Richard Grusin, *Remediation: Understanding New Media* (Cambridge: MIT Press, 1998).

75 The *Parsifal* films have been restored by the Motion Picture Division of the US Library of Congress, and presented by the silent film music specialist Gillian An-

derson. For details see: <http://www.gilliananderson.it/film.asp?IDPellicola= 26> (accessed 29 July 2008). A set of Magic Lantern slides based on Josef Hoffmann's original stage designs for the inaugural *Ring der Nibelungen* cycle at Bayreuth in 1876 was widely available in the late nineteenth century.

76 See Martin Loiperdinger (ed.), *Oskar Messter: Filmpionier der Kaiserzeit* and *Oskar Messter, Erfinder und Geschäftsmann*, KINtop Schriften 2 & 3 (Basel: Roter Stern, 1994).

77 Erica Carter and Rodney Livingstone, 'Béla Balázs, *Visible Man, or the Culture of Film* (1924)', *Screen* 41 (2000), pp. 91–108. The only other translated text by Balázs on cinema is a digest of separate works, including passages from *Visible Man*: Béla Balázs, *Theory of the Film: Character and growth of a new art*, trans. Edith Bone (London: Dennis Dobson, 1952).

78 Carter and Livingstone: 'Béla Balázs', p. 99.

79 Susan Sontag, 'Syberberg's *Hitler*', in *Under the Sign of Saturn* (London: Writers and Readers Cooperative, 1983), p. 142.

80 Powell, Letter of 7 September 1987, Powell Papers, BFI Special Collections; printed in *Film Studies* 2 (2000), p. 103.

81 Richard Wagner, *Das Bühnenfestspielhaus zu Bayreuth* (Leipzig, 1873), quoted in Beacham: *Adolphe Appia*, p. 14.

82 The struggle with pride, and the need for sacrifice, in love are central to *A Matter of Life and Death*, *I Know Where I'm Going* and *The Red Shoes*. And the loneliness of those who refuse this surrender is equally central to *A Canterbury Tale*, *The Life and Death of Colonel Blimp*, and Powell's last film, *Age of Consent*.

83 Both of these are undated, from the Powell Papers, by courtesy of Thelma Schoonmaker-Powell.

84 Powell had a long-standing interest in new modes of production, and chaired a team reporting on the possibilities of 'Independent Frame' production, making extensive use of back-projection and prefabrication, within the Rank Organisation in the late 1940s. Production papers from *Bluebeard's Castle* show that he personally supervised every aspect of the film, including specifying the 'opticals' required for special effects. In 1978, he wrote subtitles for the film's first presentation on a big screen, in the National Film Theatre retrospective, 'Powell, Pressburger and Others'.

85 See my account of this, together with other instances of early recording devices in fiction, Ian Christie, 'Villiers, Verne, Lumière: Film and the Business of Immortality', in Patrick McGuinness (ed.), *Symbolism, Decadence and the Fin de Siècle: French and European Perspectives* (Exeter: University of Exeter Press, 2000), pp. 114–16.

86 Vázsonyi: '*Bluebeard's Castle*'.

87 Powell wanted to add *The Miraculous Mandarin* and a biographical film about Bartók to *Bluebeard's Castle* to make a trilogy. See Christie: *Arrows of Desire*, p. 110.

88 The passage from near the beginning of Powell's second volume of memoirs, begins: 'From my very first film, I was a high priest of the mysteries. I took my authority for granted.' Powell: *Million Dollar Movie*, p. 16.

89 Powell's gravestone, in Avening, Gloucestershire, bears the inscription: 'Film director and optimist'. At the time of writing, in early 2008, plans are in hand for the restoration and public screening of *Bluebeard's Castle*.

BIBLIOGRAPHY

Aarne, Antti, *The Types of the Folktale: A Classification and Bibliography*, trans. Stith Thompson, 2nd edn (Helsinki: Suomalainen Tiedeakatemia, Academia Scientiarum Fennica, 1961).

Adorno, Theodor, *In Search of Wagner*, trans. Rodney Livingstone (London: New Left, 1981).

Aldred, Nanette, 'Hein Heckroth and The Archers', in Ian Christie and Andrew Moor (eds), *The Cinema of Michael Powell: International Perspectives on an English Filmmaker* (London: BFI, 2005), pp. 187–206.

Asbjørnsen, Peter Christen and Moe, Jørgen, 'Høna Tripper I Berget', trans. George Webb Dasent, in *Norske Folkeeventyr* (Oslo: Christiania, 1859).

Atwood, Margaret, *True Stories* (Toronto: Oxford University Press, 1981).

—— 'Grimms' Remembered', in Donald Haase (ed.), *The Reception of Grimms' Fairy Tales: Responses, Reactions, Revisions* (Detroit: Wayne State University Press, 1993), pp. 290–92.

Auner, Joseph H., 'Arnold Schoenberg: Begleitmusik zu einer Lichtspielszene (1930)', *American Symphony Orchestra: Dialogues & Extensions*, <http://www.americansymphony.org/dialogue.php?id=268&season=1998-1999> (accessed 29 July 2008).

Austin, J. L., *How To Do Things with Words*, 2nd edn (Cambridge: Harvard University Press, 1962).

Babbington, Bruce and Evans, Peter William, 'Matters of Life and Death in Powell and Pressburger's *The Tales of Hoffmann*', in Jeremy Tambling (ed.), *A Night in at the Opera: Media Representations of Opera* (Luton: John Libbey/Arts Council of Great Britain, 1994), pp. 145–67.

Bachelard, Gaston, *The Poetics of Space: The Classic Look at How We Experience Intimate Places*, trans. Martia Jolas (Boston: Beacon, 1994).

Bakhtin, Mikhail, *The Dialogic Imagination*, trans. Caryl Emerson and Michael Holquist (Austin: University of Texas Press, 1981).

Bal, Mieke, *The Point of Theory: Practices of Cultural Analysis* (Amsterdam: University of Amsterdam Press, 1994).

—— *The Practice of Cultural Analysis: Exposing Interdisciplinary Interpretation* (Stanford: Stanford University Press, 1999).

—— *Reading Rembrandt: Beyond the Word/Image Opposition* (Cambridge: Cambridge University Press, 1991).

—— *Travelling Concepts in the Humanities: A Rough Guide* (Toronto: University of Toronto Press, 2002).

Balázs, Béla, *A kékszakállu herceg vara* [1810], parallel text Hungarian and English libretto, trans. John Lloyd Davies, in Nicholas John (ed.), *The Stage Works of Béla Bartók*, English National Opera Guide 44 (London: John Calder, 1991), pp. 45–60.

—— *Theory of the Film: Character and growth of a new art*, trans. Edith Bone (London: Dennis Dobson, 1952).

Banks, Paul, 'Images of the Self: *Duke Bluebeard's Castle*', in Nicholas John (ed.), *The Stage Works of Béla Bartók*, English National Opera Guide 44 (London: John Calder, 1991), pp. 7–12.

Bard, Marjorie, *Shadow Women: Homeless Women's Survival Stories* (Kansas City: Sheed & Ward, 1990).

Bartók, Béla, *Bluebeard's Castle*, libretto by Béla Balázs, trans. Christopher Hassall (Vienna: Universal Edition, 1952).

Bataille, Georges, *The Trial of Gilles de Rais*, trans. R. Robinson (New York: Amok, 1991).

Beacham, Richard C., *Adolphe Appia: Artist and Visionary of the Modern Theatre* (Philadelphia: Harwood Academic, 1994).

Bellman, Jonathan, 'Toward a Lexicon for the *Style hongrois*', *The Journal of Musicology* 9/2 (1991), pp. 214–37.

Benjamin, Walter, 'The Storyteller: Reflections on the Works of Nikolai Leskov', in *Illuminations*, ed. Hannah Arendt, trans. Harry Zohn (New York: Schocken, 1968), pp. 83–109.

Bettelheim, Bruno, *The Uses of Enchantment: The Meaning and Importance of Fairy Tales* (London: Penguin, 1991).

Birch, Dinah, 'A poker inside him', *Times Literary Supplement*, 20 May 2005, p. 3.

Bogdanovich, Peter, *Fritz Lang in America* (London: Studio Vista, 1967).

Bolter, Jay David and Grusin, Richard, *Remediation: Understanding New Media* (Cambridge: MIT Press, 1998).

Botstein, Leon, 'Der Rosenkavalier: The Silent Film', *American Symphony Orchestra: Dialogues & Extensions*, <http://www.americansymphony.org/dialogue.php?id=387&season=1993-1994> (accessed 29 July 2008).

Bottigheimer, Ruth B., *Grimms' Bad Girls and Bold Boys: The Moral and Social Vision of the Tales* (New Haven: Yale University Press, 1987).

Bourguignon, Thomas and Ciment, Michel, 'Entretien avec Jane Campion', *Positif* 338 (1993), pp. 6–11.

Bowker, Benjamin, *Out of Uniform* (New York: Norton, 1946).

Briggs, Katharine M., *A Dictionary of British Folk Tales in the English Language*, vol. 1 (London: Routledge and Kegan Paul, 1971).

Bronfen, Elisabeth, *Over Her Dead Body: Death, Femininity, and the Aesthetic*, rev. edn (Manchester: Manchester University Press, 1996).

Broughton, Simon, 'Bartók and World Music', in Nicholas John (ed.), *The Stage Works of Béla Bartók*, English National Opera Guide 44 (London: John Calder, 1991), pp. 13–20.

Brownmiller, Susan, *Against Our Will: Men, Women and Rape* (London: Secker and Warburg, 1975).

Brustein, William I., *Roots of Hate: Anti-Semitism in Europe before the Holocaust* (Cambridge: Cambridge University Press, 2003).

Buchanan, Judith, and Powell, Michael, 'Dossier on Michael Powell's Late Projects', *Film Studies* 2 (2001), pp. 99–104.

Bureau of Justice Statistics Crime Data Brief, 'Intimate Partner Violence, 1993–2001', February 2003, cited in 'Abuse in America', *The National Domestic Violence Hotline*, <http://www.ndvh.org/educate/abuse_in_america.html> (accessed 1 August 2008).

Butler, Judith, *Excitable Speech: A Politics of the Performative* (New York: Routledge, 1997).

Canepa, Nancy (ed.), *Out of the Woods: The Origins of the Literary Fairy Tale in Italy and France* (Detroit: Wayne University Press, 1997).

Cardiff, Jack, *Magic Hour: the Life of a Cameraman* (London: Faber, 1996).

Carley, Lionel (ed.), *Delius: A Life in Letters* (Aldershot: Scolar, 1988).

Carter, Angela, 'The Bloody Chamber', in *The Bloody Chamber and Other Stories* (London: Penguin, 1979), pp. 7–41.

Carter, Erica and Livingstone, Rodney, 'Béla Balázs, *Visible Man, or the Culture of Film* (1924)', *Screen* 41 (2000), pp. 91–108.

Cather, Willa, *O Pioneers!* (New York: Penguin, 1994).

Chion, Michel, *The Voice of Cinema*, trans. Claudia Gorbman (New York: Columbia University Press, 1999).

Choisy, Abbé de, *The Transvestite Memoirs of the Abbé De Choisy*, trans. R. H. F. Scott (London: Peter Owen, 1973).

Christie, Ian, *Arrows of Desire: the Films of Michael Powell and Emeric Pressburger*, 2nd edn (London: Faber, 1994).

—— 'L'avant-garde internationale et le cinéma', in E. Toulet (ed.), *Le Cinéma au rendez-vous des arts, années 20 et 30* (Paris: Bibliothèque nationale de France, 1995), pp. 68–76.

—— 'Film as a Modernist Art', in Christopher Wilk (ed.), *Modernism: Designing a New World* (London: V&A Publications, 2006), pp. 297–310.

—— *A Matter of Life and Death* (London: BFI, 2000).

—— 'The Scandal of *Peeping Tom*', in Ian Christie (ed.), *Powell, Pressburger and Others* (London: BFI, 1978), pp. 53–8.

—— 'Sounds for Silents', *Sight and Sound* 3/3 (1993), pp. 18–21.

—— 'Villiers, Verne, Lumière: Film and the Business of Immortality', in Patrick McGuinness (ed.), *Symbolism, Decadence and the Fin de Siècle: French and European Perspectives* (Exeter: University of Exeter Press, 2000), pp. 105–21.

Christie, Ian and Thompson, David (eds), *Scorsese on Scorsese*, 3rd edn (London: Faber, 2003).

Collins, Richard and Christie, Ian, 'The Expense of Naturalism: interview with Michael Powell', *Monogram* 3 (1972), pp. 32–8.

Cooper, David, 'Bartók's Orchestral Music and the Modern World', in A. Bayley (ed.), *The Cambridge Companion to Bartók* (Cambridge: Cambridge University Press, 2001), pp. 45–61.

—— Bernard Herrmann's *The Ghost and Mrs Muir: A Film Score Guide* (Lanham: Scarecrow, 2005).

Corvin, Michel, *Le théâtre de Boulevard* (Paris: Presses Universitaires de France, 1989).

Cowie, Elizabeth, '*Film noir* and Women', in Joan Copjec (ed.), *Shades of Noir* (New York: Verso, 1993), pp. 121–66.

Crane, Thomas Frederick, 'How the Devil Married Three Sisters', in *Italian Popular Tales* (New York: Houghton Mifflin, 1885), pp. 78–81.

Davies, Mererid Puw, 'Laughing Their Heads Off: Some Nineteenth-century Comic Versions of the Bluebeard Tale', *German Life and Letters* 55/4 (2002), pp. 329–47.

—— *The Tale of Bluebeard in German Literature from the Eighteenth Century to the Present* (Oxford: Oxford University Press, 2001).

de Lauretis, Teresa, *Technologies of Gender: Essays on Theory, Film and Fiction* (Basingstoke: Macmillan, 1987).

DeJean, Joan, *Tender Geographies: Women and the Origins of the Novel in France* (New York: Columbia University Press, 1991).

Delarue, Paul, *The Borzoi Book of French Folk Tales*, trans. Austin Fife (New York: Alfred A. Knopf, 1956).

—— *Le Conte Populaire Francais*, vol. 1 (Paris: Editions Erasme, 1957).

Demény, János (ed.), *Béla Bartók Letters* (London: Faber, 1971).

Derrida, Jacques, *Limited Inc*, ed. Gerald Graff, trans. Samuel Weber and Jeffrey Mehlman (Evanston: Northwestern University Press, 1969).

Deslandes, Jacques, *Le boulevard du cinéma à l'époque de Georges Méliès* (Paris: Les éditions du cerf, 1963).

Doane, Mary Ann, *The Desire to Desire: The Woman's Film of the 1940s* (Basingstoke: Macmillan, 1988).

Döblin, Alfred, 'Der Ritter Blaubart', in *Erzählungen aus fünf Jahrzehnten* (Olten and Freiburg im Breisgau: Walter, 1979), pp. 76–86.

Dolar, Mladen, 'At First Sight', in Renata Salecl and Slavoj Žižek (eds), *Gaze and Voice as Love Objects* (Durham: Duke University Press, 1996), pp. 129–53.

Dundes, Alan, *Little Red Riding Hood: A Casebook* (Madison: University of Wisconsin Press, 1989).

DuPlessis, Michael, 'An Open and Shut Case: *Secret Beyond the Door*', *Spectator* 19/2 (1990), pp. 5–23.

Durgnat, Raymond [O. O. Green], 'Michael Powell' [1965], in Ian Christie (ed.), *Powell, Pressburger and Others* (London: BFI, 1978), pp. 65–74.

Ehrenreich, Barbara, 'Foreword', in Klaus Theweleit, *Male Fantasies I: Women, floods, bodies, history*, trans. Stephen Conway (Cambridge: Polity, 1987), pp. ix–xvii.

Eisenstein, Sergei, 'Dickens, Griffith and the Film Today' [1944], in *Film Form: Essays in Film Theory*, ed. and trans. Jay Leyda (New York and London: Harcourt Brace, 1949), pp. 195–255.

—— *Eisenstein on Disney*, trans. Alan Upchurch, ed. Jay Leyda (London: Methuen, 1988).

Eisner, Lotte, *Fritz Lang* (New York: Da Capo, 1976).

El Hor, 'Ritter Blaubart' [1913], in Hartwig Suhrbier (ed.), *Blaubarts Geheimnis: Märchen und Erzählungen, Gedichte und Stücke* (Cologne and Düsseldorf: Diederichs, 1984), pp. 160–61.

Eliade, Mircea, *Rites and Symbols of Initiation* (New York: Harper & Row, 1958).

Elsaesser, Thomas, 'The Tales of Hoffmann' [1968], in Ian Christie (ed.), *Powell, Pressburger and Others* (London: BFI, 1978), pp. 62–5.

Eulenberg, Herbert, 'Ritter Blaubart', in *Ausgewählte Werke in fünf Bänden*, vol. 2 (Stuttgart: Engelhorn, 1925), pp. 271–324.

Flahault, Francois, 'Barbe-Bleue Et Le Desir De Savoir', *Ornicar* 17/18 (1979), pp. 70–87.

Fletcher, John, and Stanton, Martin (eds), *Jean Laplanche: Seduction, Translation, Drives* (London: Institute of Contemporary Arts, 1992).

Freud, Sigmund, 'Beyond the Pleasure Principle' [1920], trans James Strachey, in *The Standard Edition of the Complete Psychological Works of Sigmund Freud*, vol. 18, ed. James Strachey (London: Hogarth, 1955), pp. 1–64.

—— *The Dissolution of the Oedipus Complex* [1924], trans. Joan Riviere, in *On Sexuality*, Pelican Freud Library, vol. 7, ed. Angela Richards (London: Penguin, 1997), pp. 315–22.

—— 'Fetishism' [1927], trans. Joan Riviere, in *The Standard Edition of the Complete Psychological Works of Sigmund Freud*, vol. 21, ed. James Strachey (London: Hogarth, 1955), pp. 147–57.

—— *The Taboo of Virginity* [1917], trans. Joan Riviere, in *On Sexuality*, Pelican Freud Library, vol 7, ed. Angela Richards (London: Penguin, 1997), pp. 265–83.

—— 'Three Essays on the Theory of Sexuality' [1905], trans. James Strachey, in *On Sexuality*, Pelican Freud Library, vol. 7, ed. Angela Richards (London: Penguin, 1977), pp. 33–170.

—— 'Totem and Taboo' [1913], trans. James Strachey and Anna Freud, in *The Origins of Religion*, Pelican Freud Library, vol. 14, ed. Albert Dickson (London: Penguin, 1985), pp. 43–224.

—— 'The "Uncanny"' [1919], trans. Joan Riviere, in *The Standard Edition of the Complete Psychological Works of Sigmund Freud*, vol. 17, ed. James Strachey (London: Hogarth, 1955), pp. 217–52.

Frigyesi, Judit, *Béla Bartók and turn-of-the century Budapest* (Berkeley: University of California Press, 1997).

Gauthier, Guy, 'Von Jules Verne zu Méliès oder Von der Gravur zur Leinwand', in F. Kessler, S. Lenk, and M. Loiperdinger (eds), *Georges Méliès: Magier der Filmkunst* (Basel, Frankfurt am Main: Stroemfeld/Roter Stern, 1993), pp. 53–8.

Gillett, Sue, 'Lips and Fingers: Jane Campion's *The Piano*', *Screen* 36 (1995), pp. 277–87.

Graffy, Julian, 'Zamyatin's "Friendship" with Gogol', *Scottish Slavonic Review* 14 (1990), pp. 139–80.

Grimm, Jacob, and Grimm, Wilhelm, *The Complete Fairy Tales* (Ware: Wordsworth, 1997).

Gunning, Tom, 'The Cinema of Attractions: Early Film, Its Spectator and the Avant-Garde', in Thomas Elsaesser and Adam Barker (eds), *Early Cinema: Space, Frame, Narrative* (London: BFI, 1990), pp. 56–62.

—— *The Films of Fritz Lang: Allegories of Vision and Modernity* (London: BFI, 2000).

Halprin, Sara, 'A Key to *The Piano*', *Women's Review of Books* 11/10–11 (1994), pp. 35–8.

Hansen, Miriam, 'The Mass Production of the senses: classical cinema as vernacular modernism', in Linda Williams and Christine Gledhill (eds), *Reinventing Film Studies* (London: Arnold, 2000), pp. 332–50.

Hardy, Phil (ed.), *The BFI Companion to Crime* (London: Cassell, 1997).

Harries, Elizabeth W., 'Simulating Oralities: French Fairy Tales of the 1690s', *College Literature* 23/2 (1996), pp. 100–15.

Hartland, E. Sidney, 'The Forbidden Chamber', *Folk-lore Journal* 3 (1885), pp. 193–242.

Hazard, Paul, *The European Mind 1680–1715* [1935], trans. J. Lewis May (Harmondsworth: Penguin, 1973).

Heath, Stephen, 'Joan Riviere and the Masquerade', in Victor Burgin, James Donald and Cora Kaplan (eds), *Formations of Fantasy* (London: Methuen, 1986), pp. 45–61.

Hoffman, E. T. A., *Tales of Hoffman*, trans. R. J. Hollingdale (Harmondsworth: Penguin, 1982).

Hofmann, Konrad, 'Über die älteste Quelle der Blaubartsage', *Romanische Forschungen* 1 (1883), pp. 434–5.

Holden, Amanda (ed.), *The New Penguin Opera Guide* (London: Penguin, 2001).

Hollinger, Karin, '*Film noir*, Voice-over, and the *Femme Fatale*', in Alain Silver and James Ursini (eds), *Film Noir Reader* (New York: Limelight, 1997), pp. 243–59.

Humphries, Reynold, *Fritz Lang: Genre and Representation in His American Films* (Baltimore: John Hopkins University Press, 1989).

Huysmans, Joris-Karl, *Là-bas* [1891] (Paris: Librairie Plan 1966).

Huyssen, Andreas, 'Adorno in Reverse', in *After the Great Divide: Modernism, Mass Culture and Postmodernism* (Basingstoke: Macmillan, 1986), pp. 16–43.

Iles, Francis, *Before the Fact* (New York: Doubleday, 1932).

Irigaray, Luce, 'Women on the Market', in *This Sex Which Is Not One* [1977], trans. Catherine Porter and Carolyn Burke (Ithaca: Cornell University Press, 1985), pp. 170–91.

Jacobi, Jolande, *The Psychology of C. G. Jung* [1942] (London: Routledge, 1964).

Jacobs, Arthur and Sadie, Stanley, *The Pan Book of Opera* (London: Pan, 1984).

Jacquin, Maud, 'Preface', trans. Sheila Malovany-Chevalier, in Alice Anderson, *Bluebeard* (Paris: Frac Paca, 2007). Available online at <http://www.alice-ander-

son.org/texts.htm/MAUD%20JACQUIN%20on%20Fairy%20Tales.pdf> (accessed 27 June 2008).

Jenkins, Stephen, 'Lang: Fear and Desire', in S. Jenkins (ed.), *Fritz Lang: The Image and the Look* (London: BFI, 1981), pp. 38–124.

Johnson, Barbara, 'Muteness Envy', in Diana Fuss (ed.), *Human, All Too Human* (New York: Routledge, 1996), pp. 131–48.

Jung, C. G., *Man and His Symbols* (London: Aldus, 1964).

Kaiser, Georg, 'Gilles und Jeanne', in *Werke*, vol. 5 (Frankfurt am Main, Berlin and Vienna: Propyläen/Ullstein, 1972), pp. 746–811.

Katz, Ephraim, Klein, Fred, and Nolden, Ronald Dean, *The Macmillan International Film Encyclopedia*, 4th edn (London: Macmillan, 2001).

Klemperer, Victor, *The Language of the Third Reich: A Philologist's Notebook* [1957], trans. Martin Brady (London: Continuum, 2006).

Klotz, Volker, *Operette. Porträt und Handbuch einer unerhörten Kunst* (Kassel: Bärenreiter, 2004).

Koester, Reinhard, 'Ritter Blaubart' [1911], in Hartwig Suhrbier (ed.), *Blaubarts Geheimnis: Märchen und Erzählungen, Gedichte und Stücke* (Cologne and Düsseldorf: Diederichs, 1984), p. 160.

Kracauer, Siegfried, *Jacques Offenbach und das Paris seiner Zeit* [1937] (Frankfurt am Main: Suhrkamp, 1976).

Kristeva, Julia, 'On the Extraneousness of the Phallus; or, the Feminine Between Illusion and Disillusion', in *The Sense and Non-sense of Revolt: The Powers and Limits of Psychoanalysis* [1996], trans. Jeanine Herman (New York: Columbia University Press, 2000), pp. 94–106.

Kroó, György, 'Duke Bluebeard's Castle', *Studia Musicologica Academiae Scientarum Hungaricae* 1/3–4 (1961), pp. 251–340.

Krutnik, Frank, *In a Lonely Street: Film noir, Genre, Masculinity* (New York and London: Routledge, 1991).

Lane, Edward, *The Thousand and One Nights: Commonly Called, in England, the Arabian Nights' Entertainments*, vol. 1 (London: John Murray, 1859).

Laruccia, Victor, 'Little Red Riding Hood's Metacommentary: Paradoxical Injunction, Semiotics & Behavior', *MLN* 90/4 (1975), pp. 517–34.

Le Rider, Jacques, *Der Fall Otto Weininger: Wurzeln des Antifeminismus und Antisemitismus*, trans. Dieter Hornig (Munich: Löcker, 1985).

—— *Modernity and Crises of Identity: Culture and Society in Fin-de-Siècle Vienna*, trans. Rosemary Morris (Cambridge: Polity, 1993).

Leafstedt, Carl S., *Inside Bluebeard's Castle: Music and Drama in Béla Bartók's Opera* (Oxford: Oxford University Press, 1999).

—— 'Judith in "Bluebeard's Castle": the Significance of a Name', *Studia Musicologica Academiae Scientiarum Hungaricae* 36/3–4 (1995), pp. 429–47.

Lemoine-Luccioni, Eugenie, *La Robe* (Paris: Seuil, 1983).

Lemprière, John, *A Classical Dictionary* (London: Routledge and Kegan Paul, 1947).

Lerdahl, Fred, *Tonal Pitch Space* (New York: Oxford University Press, 2001).

Lerdahl, Fred, and Jackendoff, R., *A Generative Theory of Tonal Music* (Cambridge: MIT Press, 1983).

Lewis, Philip E., *Seeing through the Mother Goose Tales: Visual Turns in the Writings of Charles Perrault* (Stanford: Stanford University Press, 1996).

Leyda, Jay and Voynow, Zina, *Eisenstein at Work* (London: Methuen, 1985).

Loeffler-Delachaux, Marguerite, *Le Symbolisme Des Contes De Fées* (Paris: L'Arche, 1949).

Loiperdinger, Martin (ed.), *Oskar Messter: Filmpionier der Kaiserzeit* and *Oskar Messter, Erfinder und Geschäftsmann*, KINtop Schriften 2 & 3 (Basel: Roter Stern, 1994).

Lundell, Toborg, 'Gender-Related Biases in the Type and Motif Indexes of Aarne and Thompson', in *Fairy Tales and Society: Illusion, Allusion and Paradigm* (Philadelphia: University of Pennsylvania Press, 1989), pp. 146–63.

MacCannell, Dean, 'Democracy's Turn: On Homeless Noir', in Joan Copjec (ed.) *Shades of Noir* (New York: Verso, 1993), pp. 279–97.

Macpherson, Kenneth, 'As Is: By the Editor', *Close Up* 5/1 (1929), pp. 7–8.

——'As Is: By the Editor', *Close Up* 5/4 (1929), pp. 257–63.

Maeterlinck, Maurice, 'Ariane et Barbe-Bleue', in *Aglavaine et Sélysette, Ariane et Barbe-Bleue, Soeur Béatrice* (Bruxelles: P. Lacombiez; Paris: P. Lamm, 1901).

Maeterlinck, Maurice, *Blaubart und Ariane oder die vergebliche Befreiung*, in *Zwei Singspiele*, trans. Friedrich von Oppeln-Bronikowski (Jena: Eugen Dietrichs, 1901).

Maltby, Richard, 'Film Noir: The Politics of the Maladjusted Text', *Journal of American Studies* 18 (1984), pp. 49–71.

—— 'The Politics of the Maladjusted Text', in Ian Cameron (ed.), *The Movie Book of Film noir* (London: Studio Vista, 1992), pp. 39–48.

McClary, Susan, *Feminine Endings: Music, Gender and Sexuality* (Minnesota: University of Minnesota Press, 1991).

'Méliès and Early Films', *The Missing Link* <http://www.mshepley.btinternet.co.uk/melies2.htm> (accessed 28 July 2007).

Mellor, David (ed.), *Paradise Regained, The Neo-Romantic Imagination in Britain 1935–55* (London: Lund Humphries, 1993).

Minghella, Anthony, *The Talented Mr Ripley: A Screenplay* (New York: Hyperion, 1999).

Moor, Andrew, 'Autobiography, the self and Pressburger–Powell's *The Golden Years* project', *Screen* 46/1 (2005), pp. 15–31.

—— *Powell and Pressburger: A Cinema of Magic Spaces* (London: I.B.Tauris, 2005).

Mulvey, Laura, 'The Light That Fails: A Commentary on *Peeping Tom*', in Ian Christie and Andrew Moor (eds), *Cinema of Michael Powell: International Perspectives on an English Filmmaker* (London: BFI, 2005), pp. 143–55.

—— 'Pandora's Box: Topographies of Curiosity', *Fetishism and Curiosity* (Bloomington: Indiana University Press; London: BFI, 1996), pp. 53–64.

Naremore, James, *More Than Night: Film noir in its Contexts* (Berkeley: University of California Press, 1998).

Nash, Paul, 'The Colour Film', in Charles Davy (ed.), *Footnotes to the Film* (London: Lovat Dickson/Readers' Union, 1938), pp. 116–34.

O'Donoghue, Darragh, 'Georges Méliès', <http://www.sensesofcinema.com/contents/directors/04/melies.html> (accessed 28 July 2007).

Orenstein, Catherine, *Little Red Riding Hood Uncloaked: Sex, Morality, and the Evolution of a Fairy Tale* (New York: Basic, 2002).

Orwell, George, 'The Lion and the Unicorn: Socialism and the English Genius' (London: Secker & Warburg, 1941). Available online at <http://www.k-1.com/Orwell/site/work/essays/lionunicorn.html> (accessed 14 August 2008).

Ostria, Vincent, and Jousse, Thierry, 'Entretien avec Jane Campion', *Cahiers du cinéma*, 467/8 (1993), pp. 17–20.

Palmier, Jean-Michel, 'Otto Weininger, Wien und die Moderne', in Jacques Le Rider and Norbert Leser (eds), *Otto Weininger: Werk und Wirkung* (Vienna: Österreichischer, 1984), pp. 80–95.

Patel, Anirudh D., 'Language, Music, Syntax, and the Brain', *Nature Neuroscience* 6/7 (2003), pp. 674–81.

Perrault, Charles, 'La Barbe bleue' [1697], in *Contes*, ed. Jean-Pierre Collinet (Paris: Gallimard, 1981), pp. 147–51.

—— 'Bluebeard' [1697], in *The Fairy Tales of Charles Perrault*, trans. Angela Carter (London: Gollancz, 1977), pp. 29–41.

—— *Contes*, ed. Marc Soriano (Paris: Flammarion, 1991).

—— *Contes/Charles Perrault:Textes établis et présentés par Marc Soriano* (Paris: Flammarion, 1989).

—— *Histoires ou Contes du Temps passé*, ed. Frédéric de Scitivaux (Paris: Larousse, 1999).

—— *Histoires ou Contes du Temps passé avec des Moralitez* (Paris: C. Barbin, 1697).

Pocci, Franz Graf von, 'Blaubart' [1859], in *Lustiges Komödienbüchlein* (Leipzig: Insel, 1907).

Polan, Dana, *Power and Paranoia: History, Narrative, and the American Cinema, 1940–1950* (New York: Columbia University Press, 1986).

Powell, Michael, *The Life and Death of Colonel Blimp*, ed. Ian Christie (London: Faber, 1994).

—— *A Life in Movies* [1986], 2nd edn (London: Faber, 2000).

—— Letter of 7 September 1987, *Film Studies* 2 (2000), p. 103.

—— *Million Dollar Movie* [1992], rev. edn (London: Mandarin, 1993).

Powell, Michael and Heckroth, Hein, 'Making Colour Talk' [1950], in Kevin Gough-Yates (ed.), *Michael Powell in Collaboration with Emeric Pressburger* (London: BFI, 1971).

Powell, Michael and Pressburger, Emeric, *The Red Shoes* (New York: Avon, 1978).

Propp, Vladimir, *Morphology of the Folktale* [1958], trans. Laurence Scott, ed. Louis A. Wagner (Austin: University of Texas Press, 1968).

Puchner, Walter, 'Mädchenmörder', in Kurt Ranke *et al.* (eds), *Enzyklopädie des Märchens: Handwörterbuch zur historischen und vergleichenden Erzählforschung*, vol. 8 (Berlin: de Gruyter, 1975), pp. 1407–13.

Ramsaye, Terry, *A Million and One Nights: A History of the Motion Picture Through 1925* [1926] (New York: Simon & Schuster, 1986).

Ross, Alex, 'Review/Music; "Rosenkavalier", the film, in Reconstruction', *New York Times*, 25 December 1993, <http://query.nytimes.com/gst/fullpage.html?res=9F0CE3D81030F936A15751C1A965958260> (accessed 29 July 2008).

Rothman, William, 'Alfred Hitchcock's *Notorious*', *Georgia Review* 4 (1975), pp. 884–927.

Rubin, Gayle, 'The Traffic in Women: Notes on the "Political Economy" of Sex', in Rayna R. Reiter (ed.), *Toward an Anthropology of Women* (New York: Monthly Review, 1975), pp. 157–210.

Russ, Joanna, 'Somebody's Trying to Kill Me and I Think It's My Husband: The Modern Gothic', *Journal of Popular Culture* 4 (1973), pp. 666–91.

Safouan, Moustapha, *La Sexualité féminine sans la doctrine freudienne* (Paris: Seuil, 1976).

Saint-Paul, Yves, *Les Contes De Perrault Et Leurs Récits Parallèles* (Paris: Emile Nourry, 1923).

Schmidt, Leopold, 'Rezniceks *Ritter Blaubart*', *Berliner Tageblatt* 57/31 (1920), pagination not available.

Schoßleitner, Karl, 'Das Blaubart-Thema', *Der Brenner* 4/15 (1911–12), pp. 513–26.

—— 'Prinz Blaubart', *Der Brenner* 3/7–8 (1911), pp. 203–22, 247–62.

Schrader, Paul, 'Notes on *Film noir*', in Alain Silver and James Ursini (eds), *Film noir Reader* (New York: Limelight, 1996), pp. 53–64.

Searle, John R., *Speech Acts: An Essay in the Philosophy of Language* (Cambridge: Cambridge University Press, 1969).

Seifert, Lewis Carl, *Fairy Tales, Sexuality, and Gender in France, 1690–1715* (Cambridge: Cambridge University Press, 1996).

Silverman, Kaja, *The Acoustic Mirror: The Female Voice in Psychoanalysis and Cinema* (Bloomington: Indiana University Press, 1988).

Smith, Grahame, *Dickens and the Dream of Cinema* (Manchester: Manchester University Press, 2003).

Sobchack, Vivian, 'Lounge Time: Postwar Crises and the Chronotope of *Film noir*', in Nick Browne (ed.), *Refiguring American Film Genres: Theory and History* (Chicago: University of Chicago Press, 1986), pp. 129–70.

Sontag, Susan, 'Syberberg's *Hitler*', in *Under the Sign of Saturn* (London: Writers and Readers Cooperative, 1983), pp. 137–65.

Soriano, Marc, *Les Contes de Perrault. Culture Savante et Traditions Populaires* (Paris: Gallimard, 1996).

—— *Le Dossier Perrault* (Paris: Hachette, 1972).

Spivak, Gayatri Chakravorty, 'French Feminism in an International Frame', in *In Other Worlds: Essays in Cultural Politics* (London and New York: Methuen, 1987), pp. 134–53.

Stanton, Domna C., 'The Fiction of Préciosité and the Fear of Women', *Yale French Studies* 62 (1981), pp. 107–34.

Stefani, Gino, 'A Theory of Musical Competence', *Semiotica* 66/1–3 (1987), pp. 9–15.

Sue, Eugène, *The Female Bluebeard or the Adventurer* (London: W. Strange, 1845).

Suhrbier, Hartwig, 'Blaubart: Leitbild und Leidfigur', in Hartwig Suhrbier (ed.), *Blaubarts Geheimnis: Märchen und Erzählungen, Gedichte und Stücke* (Cologne and Düsseldorf: Diederichs, 1984), pp. 11–79.

Tatar, Maria, *The Hard Facts of the Grimms' Fairy Tales* (Princeton: Princeton University Press, 1987).

—— *Secrets Beyond the Door: The Story of Bluebeard and His Wives* (Princeton: Princeton University Press, 2004).

Thiéry, Natacha, 'That Obscure Object of Desire: Powell's Women, 1945–50', in Ian Christie and Andrew Moor (eds), *Cinema of Michael Powell: International Perspectives on an English Filmmaker* (London: BFI, 2005), pp. 224–38.

Thomas, Deborah, 'How Hollywood Deals with the Deviant Male', in Ian Cameron (ed.), *The Movie Book of Film noir* (London: Studio Vista, 1992), pp. 50–70.

Todd, Jane Marie, 'The Veiled Woman in Freud's "Das Unheimliche"', *Signs* 11/3 (1986), pp. 519–28.

Tolkien, J. R. R., 'On Fairy-Stories', in *The Tolkien Reader* (New York: Ballantine, 1966), pp. 3–73.

Trakl, Georg, 'Blaubart: Ein Puppenspiel', in *Dichtungen und Briefe: Historisch-kritische Ausgabe*, eds. Walther Killy and Hans Szklenar, vol. 1 (Salzburg: Otto Müller, 1969), pp. 435–45.

Turner, George, '*The Red Shoes*: A Ballet for Camera', *American Cinematographer* 79/2 (1998), pp. 102–8.

Vardac, Nicholas, *Stage to Screen. Theatrical Origins of Early Film: David Garrick to D. W. Griffith* [1949] (New York: Da Capo Press, 1987).

Vázsonyi, Nicolas, '*Bluebeard's Castle:* The Birth of Cinema from the Spirit of Opera', *Hungarian Quarterly* 46/178 (2005), <http://www.hungarianquarterly.com/no178/17.html> (accessed 4 August 2007).

Veress, Sándor, 'Bluebeard's Castle', *Tempo* 13 (1949), pp. 32–7 and 14 (1949–50), pp. 25–35.

Villiers de l'Isle Adam, Auguste, *Claire Lenoir Et Autres Contes Insolites* (Paris: Flammarion, 1984).

Wagner, Richard, *The Art-Work of the Future*, trans. William Ashton Ellis, Richard Wagner's Prose Works, vol. 1, ed. William Ashton Ellis (London: Routledge and Kegan Paul, 1892).

Walker, Michael, '*Film noir:* Introduction', in Ian Cameron (ed.), *The Movie Book of Film noir* (London: Studio Vista, 1992), pp. 8–37.

Waller, Willard, *The Veteran Comes Home* (New York: Dryden, 1944).

Walsh, Andrea, *Woman's Film and Female Experience: 1940–1950* (New York: Praeger, 1984).

Ward, Janet, 'Kracauer versus the Weimar Film-City', in Kenneth S. Calhoon (ed.), *Peripheral Visions: the Hidden Stages of Weimar Cinema* (Detroit: Wayne State University Press, 2001), pp. 21–33.

Warner, Marina, *From the Beast to the Blonde: On Fairytales and Their Tellers* (London: Chatto & Windus, 1994).

Weber, Samuel, 'The Sideshow, Or: Remarks on a Canny Moment', *MLN* 88 (1973), pp. 1102–33.

Wedekind, Frank, *Frühlings Erwachen: Eine Kindertragödie* [1891], in *Werke in drei Bänden*, ed. Manfred Hahn, vol. 1 (Berlin and Weimar: Aufbau, 1969), pp. 95–165.

—— *Spring Awakening* [1891], trans. Edward Bond (London: Eyre Methuen, 1980).

Weininger, Otto, *Geschlecht und Charakter: Eine prinzipielle Untersuchung* (Munich: Matthes and Seitz, 1980).

—— *Sex and Character: An Investigation of Fundamental Principles*, trans. Ladislaus Löb (Bloomington and Indianapolis: Indiana University Press, 2005).

Wiegler, Paul, 'Der gute Blaubart', *Die neue Rundschau* 20/4 (1909), pp. 1679–80.

Wilde, Oscar, *Lady Windermere's Fan; Salome; A Woman of No Importance; An Ideal Husband; The Importance of Being Earnest*, ed. Peter Raby (Oxford: Clarendon, 1995).

Williams, Linda, 'When the Woman Looks', in Mary Ann Doane, Patricia Mellencamp, and Linda Williams (eds), *Re-vision: Essays in Feminist Film Criticism* (Los Angeles: American Film Institute, 1984), pp. 83–99.

Wilson, Edmund, *Axel's Castle* (New York: Scribner, 1931).

Woolf, Virginia, *Three Guineas* [1938] (Harmondsworth: Penguin, 1977).

Zipes, Jack, *Breaking the Magic Spell: Radical Theories of Folk and Fairy Tales* (London: Heinemann 1979).

—— *Fairy Tales and the Art of Subversion: The Classical Genre for Children* (New York: Routledge, 1991).

—— *The Trials and Tribulations of Little Red Riding Hood* (London: Heinemann, 1983).

—— *When Dreams Came True: Classical Fairy Tales and Their Tradition* (London: Routledge, 1999).

Žižek, Slavoj, 'I Hear You with My Eyes: or, the Invisible Master', in Renata Salecl and Slavoj Žižek (eds), *Gaze and Voice as Love Objects* (Durham: Duke University Press, 1996), pp. 90–126.

—— '"The Thing That Thinks": The Kantian Background of the *Noir* Subject', in Joan Copjec (ed.), *Shades of Noir: A Reader* (London: Verso, 1993), pp. 199–226.

CONTRIBUTORS

Victoria Anderson is Lecturer in Visual Cultures at the University of London's Goldsmiths' College. Her PhD, *Behind Closed Doors: Bluebeard and Women Writing*, was completed in 2006 at the University of Leeds, where she studied Fine Art and Cultural Studies. She has published articles on literature and film and is currently preparing a monograph based on her doctoral research, entitled *Outfoxed: The Secret Life of a Fairy Tale* and which is scheduled for publication by I.B.Tauris in 2009. She is in the preparatory stages of new research on the semiotics of rape in art, literature and culture and is also writing a novel, a narrative of post-war immigration and alienation.

Elisabeth Bronfen is Professor of English and American Studies at the University of Zurich and, since 2007, Global Distinguished Professor at New York University. She did her PhD at the University of Munich, on literary space in the work of Dorothy M. Richardson's novel *Pilgrimage*, as well as her habilitation, five years later. A specialist in nineteenth- and twentieth-century literature, she has also written articles in the area of gender studies, psychoanalysis, film, cultural theory and visual culture. Her book publications are *Over Her Dead Body. Death, Femininity and the Aesthetic* (Manchester University Press, 1996) and a collection of essays, *Death and Representation*, co-edited with Sarah W. Goodwin (Johns Hopkins University Press, 1993). Further books are *The Knotted Subject: Hysteria and its Discontents* (Princeton University Press, 1998); the monograph *Sylvia Plath* (Northcote Press, 1998); *Dorothy Richardson's Art of Memory: Space, Identity, Text* (Manchester University Press, 1999); *Home in Hollywood: The Imaginary Geography of Cinema* (Columbia University Press, 2004); a collection of essays on recent scholarship in gender studies, co-edited with Misha Kavka and entitled *Feminist Consequences: Theory for the New Century* (Columbia University

Press, 2000); *A Die Diva. Geschichte einer Bewunderung* (Schirmer und Mosel, 2002). A further recent publication is her collection of essays *Liebestod und Femme Fatale: Der Austausch sozialer Energien zwischen Oper, Literatur und Film* (Suhrkamp, 2004). A cultural history of the night, *Tiefer als der Tag gedacht. Szenen der Nacht,* will appear in 2008. Current research projects include a book on Queen Elizabeth I as the first diva, an introduction to the writings of Stanley Cavell (Junius, forthcoming), and a book on War Cinema (under contract with Rutgers University Press).

Ian Christie is a film historian, curator and broadcaster. He has written and edited books on Powell and Pressburger, Russian cinema, Scorsese and Gilliam; and worked on exhibitions ranging from *Film as Film* (Hayward Gallery, 1979), *Eisenstein: His Life and Art* (MoMA Oxford, 1988) and *Twilight of the Tsars* (Hayward Gallery, 1991) to *Spellbound* (Hayward Gallery, 1996) and *Modernism: Designing a New World* (Victoria and Albert Museum, 2006). In 2006 he was Slade Professor of Fine Art at Cambridge University, with a series of lectures entitled 'The Cinema Has Not Yet Been Invented'. A Fellow of the British Academy, he is currently Professor of Film and Media History at Birkbeck College, Director of the London Screen Study Collection and Vice-President of Europa Cinemas.

David Cooper is Professor of Music and Technology and Dean of the Faculty of Performance, Visual Arts and Communications at the University of Leeds. He is a composer and musicologist who has published extensively about the music of Bartók, film music and the traditional music of Ireland. He is author of the Cambridge Handbook on Bartók's Concerto for Orchestra and two monographs on film scores by Bernard Herrmann. Current projects include a book on the traditional music of Northern Ireland and its diaspora and a major study of the music of Bartók for Yale University Press.

Mererid Puw Davies studied at Magdalen College and St John's College, Oxford, and at Hamburg University. She held a Prize Fellowship at Magdalen before becoming a Lecturer in German at University College London.

Mererid Puw Davies's book *The Tale of Bluebeard in German Literature from the Eighteenth Century to the Present* was published by Oxford Uni-

versity Press in 2001. Mererid Puw Davies has also published several articles about the Bluebeard material, as well as on other aspects of myth and fairy tale in German literature and film and she has co-edited a book on autobiographies by women. She has also held an Alexander von Humboldt Research Fellowship at the Freie Universität Berlin and a Leverhulme Research Fellowship during which she has pursued her current research and published on the writings and cultural practices of the 1960s protest movements in the Federal Republic of Germany. She is currently completing a monograph on the representation of the Vietnam conflict in West Germany. Mererid Puw Davies is also interested in the translation of poetry, notably from and into Welsh and other lesser-used languages, and has worked, translated and published with poets and translators in lesser-used languages across Europe. Her publications include: *The Tale of Bluebeard in German Literature from the Eighteenth Century to the Present* (Oxford: Oxford University Press, 2001); 'Laughing Their Heads Off: Nineteenth-century Comic Versions of the Bluebeard Tale', *German Life and Letters* 55/4 (2002), pp. 329–47; 'Encoding the Division of Germany in the Tale of "Bluebeard": Helga Schubert's "Das verbotene Zimmer" and Other Stories', *New Comparison* 31 (2001), pp. 35–56; '"Du bist in einem Mörderhaus": Representing German History Through the *Märchen* of "Blaubart" and "Der Räuberbräutigam" in Works by Dieter Hildebrandt and Helma Sanders-Brahms', in Mary Fulbrook and Martin Swales (eds), *Representing the German Nation: History and Identity in Twentieth-century Germany* (Manchester: Manchester University Press, 2000), pp.118–35; '*In Blaubarts Schatten*: Murder, *Märchen* and Memory', *German Life and Letters* 50/4 (1997), pp. 491–507, also in: Margaret Littler (ed.), *Gendering German Studies: New Perspectives on German Literature and Culture* (Oxford: Blackwell, 1997), pp. 113–29.

Michael Hiltbrunner is currently working towards a doctorate on the Bluebeard tale at the University of Zurich. He also works as an academic researcher at the Institute for Contemporary Arts Research (<http://www.ifcar.ch>) at the University of the Arts Zurich.

He has presented papers on Bluebeard at conferences in Leeds (2005), Manchester (2006), Rio de Janeiro (2007) and London (2008) and worked as a researcher at University College London (UCL) and the École des hautes études en sciences sociales (EHESS) in Paris, funded by the Swiss National Foundation for Scientific Research

(2008–9). His article '"*Literarisches Unding*", Ludwig Tieck und seine Arabeske *Die sieben Weiber des Blaubart* von 1797' was published in *Kultur & Gespenster* 5 (2007), pp. 173–81.

Griselda Pollock is Professor of Social and Critical Histories of Art and Director of the Centre for Cultural Analysis, Theory and History (CentreCATH), University of Leeds. She works between histories of art and cultural studies with special interests in Modern Jewish Studies, Feminist Studies in the Visual Arts and Psychoanalysis and Aesthetics. A series of strategic interventions, starting from *Old Mistresses: Women, Art and Ideology* (with Roszika Parker, 1981), through *Vision and Difference* (1988, recently reissued as a Routledge Classic, 2004) to *Generations and Geographies in the Visual Arts: Feminist Perspectives* (1996) and *Differencing the Canon: Feminist Desire and the Writing of Art's Histories* (1999), have systematically challenged dominant phallocentric and Eurocentric models of art and cultural history. She is currently working on trauma and cultural memory in a trilogy of books including a study of Charlotte Salomon, and post-modern engagements with psychoanalysis and aesthetics. She is directing a research project title 'Concentrationary Memories: The Politics of Representation of the Holocaust' and is editing a major series of books in cultural analysis starting with *Conceptual Odysseys* (2007). Recent publications include *Psychoanalysis and the Image* (2006), *Encountering Eva Hesse* (2006), *Museums after Modernism* (2007) and *Encounters in the Virtual Feminist Museum* (2007) and forthcoming *Theatre of Memory: Charlotte Salomon's* Leben? oder Theater? (2008). Further information is available on CentreCATH's website: <http://www.leeds.ac.uk/cath/>.

Maria Tatar served as Dean for the Humanities at Harvard and teaches courses on German culture, folklore, and children's literature. She is the author of *Lustmord: Sexual Murder in Weimar Germany*, *The Hard Facts of the Grimms' Fairy Tales*, *The Annotated Brothers Grimm*, and *The Annotated Hans Christian Andersen*. Currently at work on a volume called *Enchanted Hunters*, she is investigating the transformative power of childhood reading. She has written for *The New York Times*, *The New Republic*, *Slate*, and other publications and is the recipient of fellowships from the Guggenheim Foundation, the Radcliffe Institute for Advanced Study, and the National Endowment for the Humanities.

INDEX